SECOND NATURE

Four Early San Diego Landscape Painters

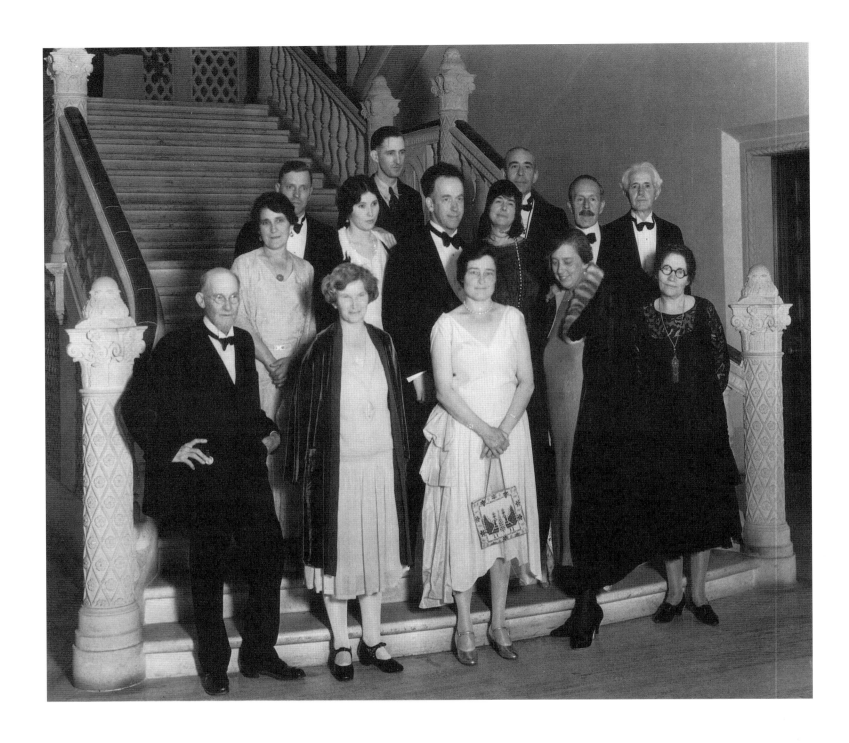

Members of the Contemporary Artists of San Diego pose with their wives and other family members at the foot of the grand staircase of the San Diego Museum of Art on the occasion of their first exhibition at the museum in 1929.
First row *(from left)*: Charles A. Fries, Alice Fries King, Dorothea Mitchell, Mellicent Lee, and Elizabeth "Frankie" Reiffel.
Second row: Mrs. James Tank Porter, Eileen Jackson, Alfred R. Mitchell, Grace Scofield Bonnet, Leslie Lee, and Charles Reiffel.
Back row: Everett Gee Jackson and Leon Bonnet. Maurice Braun, Donal Hord, Otto Schneider and Elliot Torrey are not shown.
Photograph courtesy of the San Diego Museum of Art Archives.

Martin E. Petersen

SECOND NATURE

Four Early San Diego Landscape Painters

With a Foreword by Everett Gee Jackson

San Diego Museum of Art

Prestel

Second Nature: Four Early San Diego Landscape Painters (June 1- August 18, 1991),
an exhibition organized by the San Diego Museum of Art,
is made possible by a grant from The Fieldstone Foundation.

Front cover:
Maurice Braun, *Summer Moon over El Capitan Mountain* (detail), plate 25
Back cover:
Charles Reiffel, *Harbor Night*, plate 92

Color photography: Philipp Scholz Rittermann
Black and white copy photography: Roy Robinson

Prestel-Verlag
Mandlstrasse 26, D-8000 Munich 40, Federal Republic of Germany
Tel: (89) 38 17 09 0; Fax: (89) 38 17 09 35

Library of Congress Catalog Card Number: 91-61384

Designed by Dietmar Rautner, Munich
Edited by Julie Dunn and Moira Banks
Publication Production coordinated by David Hewitt, Head of Publications
and Sales, San Diego Museum of Art

Typeset by OK Satz GmbH, Gröbenzell
Color separations by Gewa-Repro GmbH, Gerlinger und Wagner, Munich
Printed and bound by Passavia Druckerei GmbH, Passau
Printed in Germany

ISBN 0-937108-12-X soft cover (SDMA Catalogue)
ISBN 3-7913-1135-2 hard cover (trade edition)

Contents

Acknowledgments

The San Diego Museum of Art is pleased to present this exhibition of works created between the late nineteenth century and World War II by four early San Diego artists who found their greatest inspiration in the Southern California landscape. Charles Arthur Fries, whose arrival in 1896 made him the first prominent painter to settle in San Diego, became noted for his desert scenes. Maurice Braun, who recorded Southern California's atmospheric and decorative subtleties, is credited with bringing the San Diego art scene to national attention. Braun's student, Alfred R. Mitchell, was a San Diego resident who went on to attain national recognition for his bold and colorful treatment of the area's landscape. Charles Reiffel was a nationally recognized painter when he settled in San Diego in 1926. His name appeared frequently in the media alongside those of a number of independent artists who were challenging the academic tradition at that time. Robert Henri welcomed him into his circle of associates. Reiffel's interpretations of the area were regarded by his patrons as the most original of the early San Diego painters.

Family members and acquaintances of the artists represented in this exhibition have been most generous in sharing information about them, especially Dr. Charlotte White, daughter of Maurice Braun; Mrs. Alice King Fries, grand daughter of Charles A. Fries; and Mrs. Mary Sadler, niece of Alfred R. Mitchell. Friends who recalled the artists with fond memories include Mrs. Monica Borglum Davies, daughter of sculptor Solon Borglum; Everett Gee Jackson San Diego painter and colleague of the four; Mrs. Jeannette Kanst Mathewson, whose father represented these artists in his Los Angeles gallery; and Carl Schmidt and Henrick Van Haelewyn, Silvermine colleagues of Charles Reiffel.

Recognition for the realization of this exhibition must be given to museum staff members who labored to make it a reality: Martin E. Petersen, curator of the exhibition; David Hewitt, who administered the catalogue's publication; Louis Goldich, Dan Ratcliffe, and Anne Streicher in the registrar's department, who handled the logistics in bringing the material together; Lucy T. Schwab, Donna Price, Barbara Smith, and Valerie Watson, who spent hours typing and preparing the copy for the catalogue; Mitchell W. Gaul and his Design and Installation staff; and the library staff, Nancy Emerson and Claire Eike. Others who must be recognized for their enthusiastic support include Mary Allely, Special Collections, San Diego Public Library; Charles L. Beck; Mary Beck, Director of the Hoosier Art Salon; Ann Marie Boyce, art consultant; Susan B. Daniels, Assistant Librarian, Buffalo and Erie County Historical Society; Retired Captain Theodore Davie, Thomas Sefton Collection; David M. Debs, Natural History Museum, Los Angeles; Jane Detora, Director/Curator, T. W. Wood Art Gallery; Linda Fisk, Museum of Man, San Diego; Daniel Jacobs, Orr's Gallery, San Diego; Douglas Jones, Jones Gallery, La Jolla; Bruce Kamerling, Curator of Collections, San Diego Historical Society; Michael Kizhner Fine Art; Dr. Clark S. Marlor, Salmagundi Club, New York City; Annette Masling, Librarian, Albright-Knox Gallery; Nancy D. W. Moure, Los Angeles; Eric L. Mundell, Reference Librarian, Indiana Historical Society; Kevin Munnelly, City of San Diego; Edward J. Nygreen, Curator of Collections, Corcoran Gallery; Marilyn O'Rourke, Librarian, New Canaan Historical Society; Barbara Pope, San Diego Historical Society; Ray Redfern, Redfern Art Gallery, Laguna Beach; Anne Smith, Los Angeles County Museum of Art; Andrew Stasik, Silvermine Guild Arts Center; George Stern, George J. Stern Fine Arts, Irvine; Jean Stern, Encino; George Thackery, San Diego; Shirley Vienesse, San Diego Art Institute; Mary F. Ward, County of San Diego; Ruth Westphal; and Noraleen Young, Librarian, Indiana State University.

Finally, we recognize San Diego area residents who were willing to share both their memories and their collections, and without whose interest and cooperation this exhibition may never have materialized, among them Charles Best, Mr. and Mrs. Jack Borchers, Stan Brelin, Kathleen Briggs, Stuart Brown, Mrs. Lawrence Cairn Cross, Mrs. Kirk Butler, Retired Rear Admiral and Mrs. M. E. Dornin, Steve Hagar, Kenneth Hill, Mr. and Mrs. Murray Holloway, Mr. and Mrs. Joseph Jessop, Hamilton Marston, William Organza, Donald Perry, Mrs. Alice Peshel, Mr. and Mrs. Hubert Price, Mr. and Mrs. Robert Rock, Mrs. Harry Streicher, and Mr. and Mrs. Doyle Wells.

Steven L. Brezzo
Director, San Diego Museum of Art

Foreword

by Everett Gee Jackson

Prior to coming to San Diego to live in 1928, I had been a young art student in Mexico City at a time when the "Mexican Art Renaissance" was in full swing. Such painters as Diego Rivera, Jose Clemente Orozco, Jean Charlot, and David Alfaro Siquieros were painting exciting pictures on the walls of public buildings, and it seemed that the people were thinking and talking about nothing but art. The only acquaintances my wife and I had were either artists or people who wrote about art. The spirit of art seemed to be the very air we were breathing. When we realized we would be moving to San Diego, California, I began to worry that there might not be any people in that area with an interest in art.

I need not have worried. Shortly after our arrival in that small city of sunshine and flowers, I discovered that San Diego had a lively art community. It was different from that in Mexico City; its members were not concerned with political and social problems. Such issues did not move San Diego artists to paint. What seemed to motivate them most forcefully was the sunshine on eucalyptus trees. Unlike the Mexican artists, they found nothing disagreeable in their social environment, and seemed to be inspired by the visual world around them.

In 1928 the art community in San Diego included six or seven mature professional painters, two sculptors, and a seemingly endless number of enthusiastic students of outdoor painting. Most, if not all, of those students belonged to an organization known as the Art Guild, which held monthly meetings where the subject of art was discussed and where the members cultivated friendships. In addition to the Art Guild, there was a much larger group made up of individuals who had an interest in art and wanted to support it, but not necessarily to buy it. These individuals were the dues-paying members of the Fine Arts Society, which supported the handsome new Fine Arts Gallery (now the San Diego Museum of Art) located in beautiful Balboa Park. It was here that the Art Guild held its monthly meetings. To complete the picture of the San Diego art community as it existed in 1928, it should be added that the art director of the Fine Arts Gallery was Reginald H. Poland. Partly because of the comparative isolation of San Diego at that time, Poland was able to take a great interest in the art activity of the local community.

Because of my being accepted as a member of the Art Guild in 1928, I became acquainted with many of its members, including the gifted professional artists Charles Reiffel, Alfred R. Mitchell, Maurice Braun, Otto H. Schneider, and local sculptor Donal Hord. The following year, Hord and I were invited to become members of a newly formed professional art organization known as the Contemporary Artists of San Diego. At the meetings of that group I met the distinguished painter Charles A. Fries, who was the oldest of the local artists. At that time I also became acquainted with the president of the organization, James Tank Porter (the other local sculptor), and the painters Elliot Torrey, Leslie W. Lee, and Leon D. Bonnet.

Of those painters who were members of the Contemporary Artists of San Diego, the four treated in this volume were basically landscape painters. Although all four had at times created figure composition and portraits, they were the artists who felt completely free with pure landscape, devoid of any human reinforcements. The featured painters are Charles Reiffel, Maurice Braun, Charles A. Fries, and Alfred R. Mitchell; what I write here about these distinguished men comes mainly from memory.

The most memorable characteristic of Charles Reiffel was his cheerful enthusiasm. He possessed what Rene Dubos called the "God Within," and he made those who met him feel they were living in a world of magic and wonder. He was also extremely generous.

One day he came to look at a painting I had recently completed in a garage, which was my "studio" at that time. When he saw the painting he exclaimed, "You must send it to the San Francisco Art Association Annual!" The next day he returned, bringing a frame for the painting, and insisted on helping me crate it for shipment.

Reiffel was very close to his colleagues in the Contemporary Artists of San Diego group, and encouraged them constantly with his enthusiasm. My wife and I went a number of times with him and his wife, Frankie, into Baja California to paint. Once we were sitting side by side in a little Mexican village street, painting the same subject. I was impressed by his confidence. He looked at the subject and painted it spontaneously, his white hair flying in the Mexican breeze, and didn't stop work to contemplate his painting until it was completed. Watching him paint, and studying his art, I came to feel that Reiffel's painting had something in common with that of the Mexican artist Orozco, even though it appeared different. The similarity was, I believe, its quality of energetic movement.

Maurice Braun, like Charles Reiffel, was a delightful personality, but the two men were very different. While Charles was exuberant, Maurice was quiet, serious, and serene. Being a devout believer in theosophy, he looked at life from a universal viewpoint, and this may explain the beautiful and restful quality in his paintings. I remember Braun as a rather small figure, with a short, pointed beard, and very thick glasses. I always considered him an intellectual man, who lived in a world that he believed had no beginning and no end. I am sure he felt himself to be an indestructible part of that endless and everlasting world.

Charles A. Fries was also small in stature, with a quiet nature but a twinkle in his eye. I remember him as always wearing a little gray felt hat, which tapered to a point. Although he was already elderly when I first met him, he possessed a youthful spirit. His great love seemed to be the desert and the mountains around it. The unique quality of softness in his paintings of the desert must certainly derive from something he discovered there, for he would never have added anything he had not seen and felt himself. (Although, when I once commented to him about that softness, he assured me it came from his use of kerosene oil as a medium!)

Alfred R. Mitchell was the secretary-treasurer of the Contemporary Artists of San Diego. He was the last of my fellow members in that group of painters and sculptors to die, leaving me as the last survivor. His paintings appear to be representational in style, even though he was a close student of modern trends in art. At the San Diego State College Art Department, where I then worked, there was a large collection of color prints of works of art in all styles, for use in art history classes, and Mitchell often came to study them, seeming to prefer looking at the modern ones, although these were stylistically the furthest removed from his own.

Mitchell brushed his hair straight backward, forming a fairly high wavy outline that about paralleled his nose. Unlike most of the other painters, he was able to make a living by selling his paintings. When the Contemporary Artists disbanded after a few years, Mitchell announced that some money was left in the treasury, and the members decided that it should be used for a membership dinner in a downtown restaurant. All the members were present at the dinner. Donal Hord and I were asked to read the menu out loud, since we were by then the only members whose eyes were free of cataracts.

Everett Gee Jackson has contributed to the San Diego art scene for nearly sixty years. After completing studies at the Art Institute of Chicago, the native Texan came to San Diego in 1928. Two years later, he joined the art faculty at San Diego State University. He retired as chairman of the department in 1963, after thirty-three years of service as an educator and administrator.

A lithographer, painter, and author, Jackson's work has been shown and published nationally, receiving numerous honors and awards. This nonagenarian's illustrations have enhanced the published classics of the Limited Editions Club and Heritage Press. He has been recognized for his interest in and promotion of Mexican and Latin American art. The artist was not only a colleague, but also a good friend of the four painters represented in this exhibition.

Introduction

"You never hear anyone in New York called a 'local' artist."
　　　　　　—Laddie John Dill *Art-Talk,* April/May 1989

During the eighteenth and early nineteenth centuries, artists—including John Woodhouse Audubon (1812-62), John Mix Stanley (1814-72), George Catlin (1794-1872), and a host of amateurs—accompanied exploratory and missionary expeditions in order to record the uncharted topography of California. When these artists passed through the San Diego area, they were generally uninspired by the frontier conditions and the sagebrush-covered landscape they encountered. Nearly one hundred years later, leaving their studios for the open air, American artists were seduced by Southern California's unique landscape and brilliant light, which they committed to canvas.

Stylistically, early California works—currently referred to as plein-air paintings—manifest the out-of-doors origin they share with their nineteenth-century French predecessors. To what extent the Barbizon painters or the Impressionists influenced the California artists, however, remains conjectural. Many early American artists knew these French works only second-hand, although admittedly, some Americans had studied in France. Certainly, the California artists arriving from the East Coast were aware of the Impressionist movement, with its broken brushwork and its decorative style. The works of the plein-air school do exhibit some resemblance, both in subject and in technique, to those of the Impressionists. However, the early California artists' diversity of treatment would seem to indicate that the greatest debt they owe the Impressionists is for their example of breaking with tradition, thus allowing their artistic successors the freedom to express themselves in terms of a personal vision and an independent style. This was Impressionism's universal legacy, a legacy that established the creative milieu for the acceptance of today's many "isms." The resultant diversity of style is, perhaps, the principal characteristic of twentieth-century art.

Early *Los Angeles Times* art critic Arthur Millier saw the California landscape painter approaching his subject with the same honesty as his predecessors of the Hudson River School. For Millier, however, the artists of the earlier American group depicted "the facts of the earth confronting them," while the Southern California artists sought "a true portrayal of the brilliant light which transfigures his scene."[1] The scenes are frequently repeated under different lighting conditions. The writer concludes that "without a French Impressionist movement this tendency (so called California Impressionism) would probably have developed spontaneously from the very nature of the landscape and the climate."[2] The extraordinary light, the variant landscape features, and a climate conducive to living out of doors year-round had been the basic attractions for many of California's early twentieth-century artists. Millier's observations provide today's viewers with a context in which to consider Southern California landscape painting.

The four painters included in this exhibition—Maurice Braun, Charles Arthur Fries, Alfred R. Mitchell, and Charles Reiffel—were pre-World War II San Diego artists whose works belong to the mainstream of American art. While it is customary today to label them "California artists" or "regional artists," they considered themselves a part of the national art scene. Their activities, supported by media coverage from New York to Los Angeles and numerous exhibition catalogues from the nation's leading museums, suggest that this was not mere boasting. Their backgrounds paralleled that of the majority of their American colleagues and included the usual academic training, augmented by study and travel abroad, allowing them first-hand knowledge of the treasures housed in the world's leading cultural centers.

The latest styles emanating from these centers may or may not have exerted a lasting influence on these artists; it remains for the present generation of writers to appraise their efforts. Exposure of their work in the leading academies and exhibitions at major museums provided prestigious awards, assured them acceptance as professionals, and added to their recognition in the national register of American artists. They appear to be regionalists only from a present-day viewpoint and only in light of the fact that they resided and worked in San Diego.

Charles Reiffel was admittedly a self-trained painter, but in a sense the others were also largely self-trained when it came to landscape painting. Landscape, as a subject, was not taught at the American academies, which emphasized draftsmanship and the human figure. Any artist selecting landscape as his choice of subject matter had to seek independent study or strike out on his own. For example, Mitchell, the youngest of the four, augmented his studies at the Pennsylvania Aca-

demy of Fine Arts with work under Daniel Garber, who was to become a lifelong friend.

Landscape painting, it would seem, has had the longest run as subject matter in the annals of American art history, preferred by artist and patron. Today, works by these Southern California painters are eagerly sought and collected, admired from coast to coast. Perhaps it is because they represent one of the last regional areas to be discovered by modern scholarship. Perhaps their subjects are a nostalgic reminder of a natural frontier rapidly disappearing with the march of progress. Recently, several important exhibitions have been developed with a focus on California painting, and interpretive material is beginning to appear on the subject. Much of what is written, and the exhibitions that have appeared, have generally acquainted the viewing public with a large number of obscure California artists. It is our intention to focus in on a substantial body of work by four San Diego painters whose activities on the national art scene were paralleled by and related to their roles—as teachers, organizers, and administrators—in the development of the local cultural scene.

<div align="right">

Martin E. Petersen
Curator of American Art,
San Diego Museum of Art

</div>

1 Introductory essay by Arthur Millier from the catalogue *A Private Collection of Some Living Artists of Southern California,* 1929. The exhibition circulated to Columbus, Ohio; Tucson, Arizona; and San Diego, California.
2 *Ibid.*

Essays

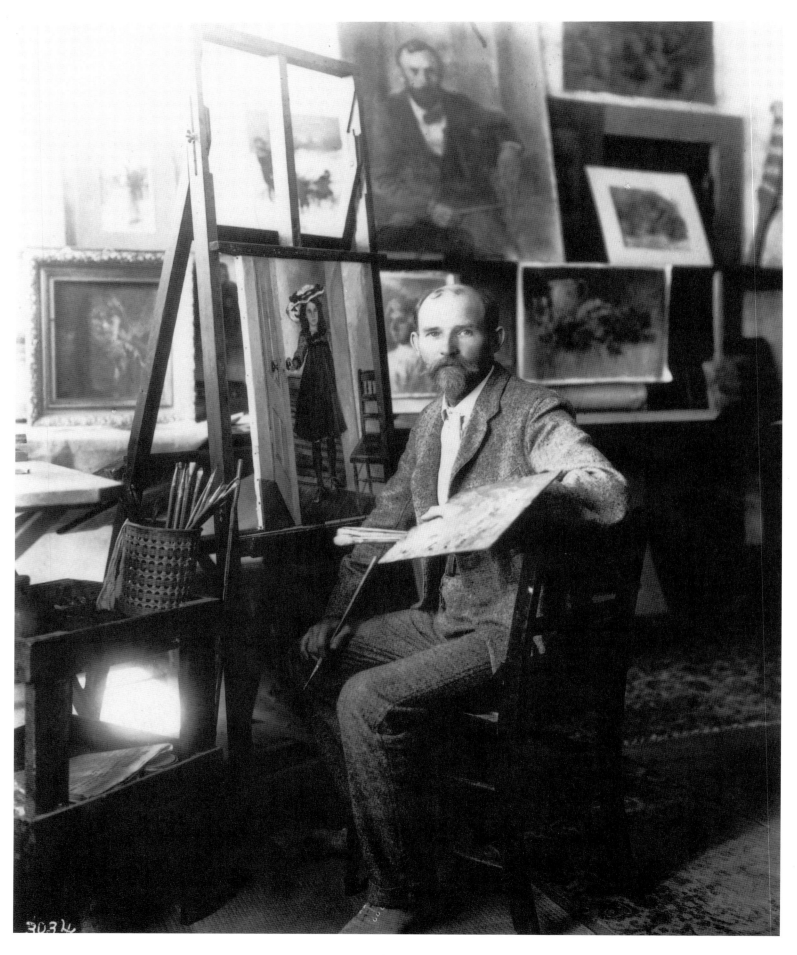

30314

12 *Charles Arthur Fries*

Charles Arthur Fries
(1854 - 1940)

John and Martha Ann (*née* Harper) Fries were blessed with eleven children. Three died in childhood. John was uncommunicative but steady as a clock, and Martha was a mother in every way, according to Charles Arthur, their seventh-born child. John was nearly thirty and Martha eighteen when they married, and both died young—at sixty-eight and fifty-two years of age respectively. Charles recalled his father as an unsuccessful entrepreneur attempting with less than glowing results to support his sizable brood.[1] John and his father had built a candle factory in their backyard only to see it burn down. He had also built a "fluid washing plant" on the same site which met with a similarly unfortunate end. It was as a member of the Cincinnati police force that John seemed to survive the longest stretch of employment, although here he sustained injuries from an incident which he carried with him for the rest of his life. Thugs jumped him and "one punched a hole through his nose with his knuckles."[2]

In 1856 the Fries family, descendants of Quakers and pioneers, had moved to Cincinnati from Hillsboro, where Charles Arthur had been born on 14 August 1854. Once in Cincinnati, they moved within the city to a number of addresses, including Pleasant Street, Twelfth Street, Cutter Street, and the suburb of Plainsville. At the last address, Fries's father died, and the family moved back into town. Even as a child, young Charles had a "hankering to draw."[3] His production at the time seems to have been impressive. He had painted a cut of pork ribs so realistically that an old Irish woman thought it to be the real thing suspended in front of a meat market.[4]

From 1872 (when the artist was eighteen years old) to 1874, Fries was an apprentice lithographer, working with an old hand press at Gibson and Company, a "quaint little attic shop in a regular Dickens setting" in Cincinnati that was operated by two English brothers.[5] Fries's brother-in-law Arthur Bradley, husband of his sister Georgiana, had made it possible for him to obtain an apprenticeship.[6] Salaries ranged from nothing the first year as an apprentice or journeyman, up to a very paltry two dollars and fifty cents the second year, with an increase of about fifty cents each successive year for the next five years. Fries's fellow workers in the shop included Robert F. Blum (1857-1903) and Edward Potthast (1857-1927). According to Fries, Blum "painted the first thing he ever tried in my studio, a study of peaches. He started to learn the trade a year or two after I had started, and he didn't take much interest; he poked fun at me in my desire to attend art school. But finally he was bitten by the bug, and he would come over to my room and loaf around."[7] After four years, Fries quit. At Gibson's he had worked on the production of many circus posters for pioneer circus man John Robinson.

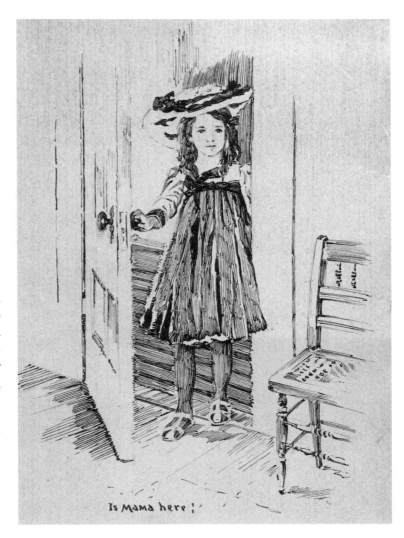

Is Mama here!

Fig. 1 The artist is shown seated at his easel in his studio. An ink drawing in the San Diego Museum of Art collection may have served as a preparatory sketch for the painting the artist is working on. Francis E. Patterson, photographer. Photograph courtesy of the San Diego Historical Society.

Fig. 2 *Is Mama Here!* by Charles A. Fries, ink drawing, in the collection of the San Diego Museum of Art (1928: 046a). Photograph courtesy of the San Diego Museum of Art Archives.

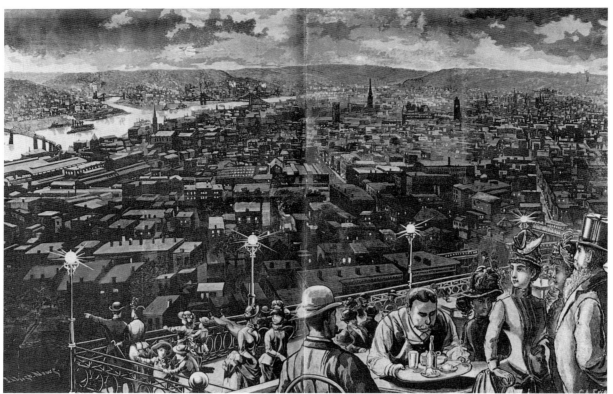

Fig. 3 This engraving by C. A. Fries appeared as a double-page reproduction in the *Cincinnati Illustrated News* in 1886 during the Exposition. It earned wide recognition for the artist. Landmarks shown include the Newport Bridge, Newport, Kentucky; the Licking River; the suspension bridge, Covington, Kentucky; Highland House Terrace; and M. E. Adams. Photograph courtesy of the San Diego Museum of Art Archives.

He realized, however, that the position was totally inadequate as a means by which to measure success, to indicate any real achievement, or to provide any hope of advancement.

Fries had ambitions to do illustrations for such major publications as *Harper's Weekly*. He went to work for the *Cincinnati Commercial Gazette* as staff photographer and lithographer, and in 1874 began studying art at night school and at the Cincinnati Art Academy (formerly the MacMicken School of Design, from which the Academy and the Association evolved) three and a half days a week. Here he and Blum were members of an outstanding group which included Kenyon Cox (1836-1919), Frank Duveneck (1849-1919), Henry Farny (1847-1916), and John H. Twachtman (1853-1902), all of whom distinguished themselves in the annals of American art history.

The school was practically a free school at the time, "in those gay days when men students wore swallow tail coats and derbys to art school" and when "Cincinnati was the Paris of America."[8] Among his responsibilities, Fries, with Richard Henry Hammond (b. 1854), formed a committee of two to find models to pose in the nude. In 1874, while a student, Fries won a silver medal for a drawing from an antique image entitled *The Wrestlers,* the first of many awards he would receive.[9] Additionally, he was exhibiting at the Ohio Mechanics' Institute (now the Ohio College of Applied Science) in the nineteenth session of the School of Design.

The young art student was also studying independently with Charles T. Weber (1825-1911), the Cincinnati portrait painter and founder of the MacMicken School. Portraiture was a specialty that seemed to assure any budding artist his bread and butter, although it was a pursuit that was not without drawbacks for the artist. "Charley, for heaven's sake, don't be a portrait painter! First you must satisfy yourself, then the sitter, and all her sisters, cousins, and aunts."[10] According to Fries, Weber, was "somewhat the type of Longfellow, a fine character and had a great reverence for his profession. He boasted of Indian blood in his veins."[11] Although Fries never completely deserted portraiture, which he could handle quite skillfully, he was to become known essentially as a landscape painter.

It was in 1876 that Fries and fellow artist Richard Hammond decided to go abroad.[12] They skirted Philadelphia, where the Exposition was in progress, and went to New York via Niagara Falls. It was their intention to work in London to support themselves and, concurrently, to study at the schools there in between jobs. However, despite planning and good intentions, they both became discouraged within a short time. Hammond's decision to return home prohibited Fries from making the trip to Paris for which he longed. Instead, he compromised with a tour through other English areas and Scotland before sailing for home. They had stayed away far less than the two years they had planned. In later years Fries confessed that "most of studying was about how my money was going to get me home."[13]

Fries's own work seems to have been unaffected by the styles and trends in Europe at the time. Impressionism had made its initial appearance two years earlier in 1874, shocking critics and public alike. It is interesting to speculate, had the artist followed the urge to go to Paris, as to whether his own style might have been influenced by the art scene

there. Apparently, Fries left no recorded reaction to the wave of new art styles emanating from the French front.

Having been trained as a graphic artist, however, it would have been difficult for Fries to sacrifice form and structure for the sake of a broken brushstroke and a vaporous atmosphere of bright color. Fries's palette tended toward neutral hues. Works by plein-air artists of the Barbizon school are more obviously related to his works if, indeed, foreign influences do exist. Their works, done in the open, are characterized by a landscape setting bathed in an atmosphere of sunshine and fresh air. These qualities Fries was to find and introduce into his landscapes of Southern California in years to come.

The return trip of twenty-one days was plagued by winter storms on the Atlantic Ocean that caused some anxious moments for the two artists. When Fries arrived home he discovered that he and his friend were being mourned, presumed dead following a railroad accident at Ashtabula, Ohio, in which thirty-four passengers were killed, one of whom was named Hammond. [14]

Shortly after their return, the two artists established a studio at 60 West Fourth Street. At this address the Eccentric Club, with Charles Weber as its leader, was formed. This was essentially a social group made up of artists, which held a banquet each year. When a member left, his plate would remain there as a token of remembrance. Fries recalls that "we met for several years at the banquet, but the guys became scattered and it was discontinued." [15] Camping out was another activity in which the group engaged, usually headed by Weber, who was "an expert in cooking fish," and who "used the old Indian method of covering up the fish scales and all with clay and cooking them in hot coals.… It was certainly fine." [16] Life on Fourth Street was remembered with fond affection in later years.

During the next few years, Fries traveled into the southeastern area of the United States photographing and sketching, [17] initially with a traveling companion known as Captain Boyd. [18] For a time, Fries boarded with a family named Scroggins in Trion Factory, Georgia, where he counted eleven people sleeping in one room. He was appalled by the abject poverty evident in the area, which was to leave a lasting impression upon the artist and may well have contributed to his lifelong socialist views. The depression he must have felt, conditioned by the milieu, was only intensified when he received word of his mother's death after succumbing to pneumonia. Sadly he was unable to attend her last rites. Her death had occurred shortly after his departure and word of her demise was late in reaching him in Georgia.

He was on the move at least once more in 1877, accompanying Cincinnati artist Tom Lindsay, who had been commissioned by the New York Central Railroad to paint views all over the Lehigh Valley. Most of the works Fries did that summer were lost. He had used burnt sienna which turned black, resulting in ruin. He seems not to have been discouraged, however, and continued to work and develop.

For many late nineteenth- and early twentieth-century American painters, the newspapers provided a source of income. In 1883 in Cincinnati, *The Week* carried an item which noted that "there are good artists and enough of them in and around Cincinnati to supply the needs of an illustrated weekly … substantiated in this issue." [19] The newspaper also carried an illustration by one of those promising young artists in the community, Charles A. Fries. The illustration was captioned "Pony Tracks at the Zoo," and depicted one of the famous tourist attractions of that city.

In 1886 Fries executed an illustration that brought him recognition beyond regional boundaries. During that Exposition year, he was commissioned to do a bird's-eye view of Cincinnati. "A scene from the Top of the Highland House; Cincinnati in 1886" (Fig. 3) appeared in the *Illustrated News* in September. [20] Most of Fries's lithographs are unrecorded but were reproduced in such publications as *Harper's Weekly, Century Magazine,* and *Leslie's* during the 1870s and 1880s.

Fries's whereabouts in 1887 can be traced through the pages of the Cincinnati *Illustrated News* during the course of the year. April's editions included the artist's impressions of Birmingham, Alabama. Apparently, the excitement of the Derby attracted his interest, as evidenced by his illustrations in the May issues, while the buildings of the Dueber Watchcase Company of Canton, Ohio, provided him with subject matter for several July issues. Meanwhile, back in Cincinnati, the wreck of the C W & B Railroad Company of 7 June 1887, and the tragic fire on State Avenue in August were two events the artist covered for the *Illustrated News.*

On 26 May 1887 Fries married Addie Davis (1858-1944), whom he had met through his sister Mina (Sarah Minerva) when Addie came to board at the Fries home. A writer associated with *The Voice,* a prohibition newspaper, Addie later sometimes published poetry under the pseudonym Warner Willis Fries, the name of their son who died in infancy. [21] Literary talent seemed to characterize Addie's family. Her brother, known in Florida as the "Father of St. Petersburg," had established the F. A. Davis Medical Book Publishing Company in Philadelphia. About this time, Fries was illustrating well-known classics, including *McGuffey's Reader* and Eggleston's *History of the United States.* Fries and Addie moved to New York City in the autumn of 1887.

Six months after his arrival there, the artist began working for the Central Lithographic Company as an illustrator. Ace Cassidy, with whom Fries had worked in Cincinnati, was now foreman of the art department for Central Lithographic, but even with Ace's help, Fries was able to secure only one order, for an illustration in the magazine *St. Nicholas.* During this period, income from portrait commissions and anatomy drawings for doctors paid the rent. [22] While at the lithography shop, Fries met Charles Reiffel (1862-1942), also a lithographer. Like Fries, Reiffel was eventually to settle in Southern California, in San Diego. Here they renewed a friendship which would endure throughout their lives.

On 4 March 1888, a son, Warner Willis Fries, was born to Addie and Charles, but he died in May of typhoid and malnutrition, having literally starved to death. [23]

The economic situation must have improved, for in 1890 Fries purchased a two-story house, including forty acres of land with a barn, in Vermont. He assumed the role of gentleman farmer, reading farm journals and raising chickens. [24] He had contracted malarial fever, and thought the fresh country air would be beneficial to his health. However, a fire destroyed not only the building but also any good intentions or real ambitions Fries may have had regarding his agricultural pursuits. The artist later admitted that the fire probably started when he put a barrel of ash in the barn a day too early.[25] This calamity was softened by an event in his life that added a spark of joy: the birth of a daughter, Alice, born in 1890 at Corona, Long Island.

On 17 September 1896 the Fries family left Waitsfield, Vermont, for California. The loss of the Vermont farm, where Charles admitted he did as much painting as farming, and Addie's fragile health had prompted the artist to consider relocating to Santa Barbara. [26] The New England landscape had provided themes for his work done in Vermont: "snow scenes by sunlight, moonlight, and twilight; of 'sugar camps' and other woodland scenes; of the tender greens of early spring in the East, and of the rich warm coloring of a New England autumn." [27] Fries later recalled that he discovered it "was the country I was hankering for and not exactly farming." [28]

After traveling from New England via Montreal and Chicago, Fries surveyed the Southern California area by stages. Upon the recommendation of Charles Fletcher Lummis (1859-1928), California historian and publisher of *Land of Sunshine* (subsequently *Out West Magazine*), the artist and his family set up house in the unoccupied ancient Mission of San Juan Capistrano, south of Los Angeles. [29] Permission to do so was granted by Judge R. Egan, who was in charge of the old Franciscan ruins. Fries was assured by Lummis, whom he had met through mutual friends, that this was "the most typically Mexican of southern California's towns." [30] Housing was at a premium in the area, and Fries paid the rent with a painting to the Landmark Club. [31] This unique setting became home; for the next five months the refectory house was their living quarters, and the cloisters were used for sleeping.

While in residence in this former religious sanctuary, Fries produced two paintings that were to receive wide recognition during his lifetime. *Too Late* depicts a child who has obviously just died. [32] A physician stands by helplessly and the mother is shown prostrate across the body of her lost little one. The subject was suggested to Fries by a personal incident. Alice, his daughter, came down with typhoid fever on her birthday, 6 October. Eight years earlier, the infant son of Fries had succumbed to the same affliction. Happily, Alice survived. Years later Addie reflected, "Nineteen years ago today Alice lay at the gates of death in the old Capistrano Mission, and that was a day as fair as this and Sunday too.

How much we have to be thankful for." [33] The artist used his daughter and the attending doctor, Alexander Rowen, "an inveterate rumhound" in the frontier tradition, as models in the setting of a room in the old mission, with its typical adobe fireplace. [34] Rowen's lifestyle seemed to have little effect on his longevity; at ninety-eight he was still rational, although confined to a rest home. Addie, horrified at the idea of such a picture, refused to pose. Fries turned to the only other English-speaking woman in the community, the postmistress Jessie Millard English, who consented to model as the mother.

Too Late, according to one source, "has been shown an infinite number of times and places, pirated and plagiarized, it has traveled around the world to homes, pharmacies, and hospitals." [35] Reaction among Fries's friends and family the first few months after its completion was mixed, even though the painting was destined to become perhaps the artist's best-known work. A neighbor, Judge Bacon, who lived across the river from the mission and who had been hospitable to the Fries family, said upon seeing the work, "I wouldn't have that picture in my home for $50.00 a day." [36] Considering the subject, the artist felt that to be a compliment. Addie, because of the picture's connotations, never cared for the painting.

While at the mission, Fries painted a second important work — called *Lace Maker* or *Making Drawn Work* — that was a portrait of Señora Verdugo, the elderly and nearly blind wife of the mission caretakter. [37] She is shown seated, in three-quarter-length profile, doing needlework. These two pictures were the artist's first major California works. Parenthetically, neither painting was a landscape, for which the artist was to become best known.

After some months in the mission at San Juan Capistrano, the Fries family moved further south to San Diego, a sleepy village with a population of about 16,000 to 17,000, arriving in February 1897. [38] The *mañana por la mañana* attitude there appealed to them, and it was their home for the remainder of the artist's life. They first settled on Sixteenth Street, renting from Mat Sherman, who gave his name to Sherman Heights. One of the early pioneers of the city, Sherman was referred to by Fries as a "splendid man."

When Fries arrived in San Diego, it was no place for an artist. He found only one other artist in permanent residence, Ammi Merchant Farnham (1846-1922).[39] Upon Farnham's death, he took over the role of Dean of San Diego Painters. Among the earliest of his new friends was Ed Davis, who had studied at the Philadelphia Academy of Art but was now a cattleman at Mesa Grande.

Established in the community, Fries found shopkeepers at first reluctant to hang his works in their store windows, art being considered a frivolity in this frontier village. A few, however, must have granted him permission, for in 1898 he was exhibiting in Butt's Art Store, and in 1901 Thearle and Company held a large exhibition and sale of his works that was to continue annually for approximately the next ten

years. It was usually a large show, consisting of over a hundred works. Fries was also a frequent exhibitor at the public library. He fared better in other California cities such as San Francisco, Oakland, and Berkeley, where he showed with some consistency during the first decade of the twentieth century. Jokingly, in these early years, he was referred to as "the eucalyptus artist."[40]

Early San Diego pioneer George W. Marston (1850-1946) purchased his first work of a western scene, *Cattle at Capistrano* (Harmsen Collection; also known as *Cattle Drive Through Gaviotta Pass*). Other prominent early families of San Diego, including U.S. Grant, Jr., soon owned his works as well.

Even though the artist painted genre, portraits, and still lifes, as well as eucalyptus subjects, it is as a painter of the California desert that Fries was to become best known. "Mr. Fries paints directly from Nature, and his studies are original canvases, handled with all the freshness of first impression."[41] Not only did he sketch on the spot, he actually braved winds and sand, setting up his easel to paint a work at its original site. His pipe was his usual companion. The Laguna Mountains, east of San Diego, provided one of his favorite camping areas.[42] His landscapes were bathed in light, which emphasized their essential qualities as well as highlighting their physical appearance.[43] This literal impression might be considered a result of the artist's early training as a lithographer and his uncompromising attitude toward nature.

A self-styled realist, the artist, in his choice of subject and inspiration, discovered that "nature was good enough for him."[44] The San Diego *Evening Tribune* commented: "His works are the result of a background of sound drawing and close values."[45] "What the artist offers is the California landscape, an unabashed and competent impression," wrote Reginald H. Poland (1893-1975), director of the San Diego Museum of Art. "Mr. Fries' pictures are not sensational; they suggest no attempt to be the greatest pictures on earth, nor do they boast cleverness, nor suave, inveigling, surface charm. They are honest, straightforward, substantial pictures of handsome scenes, every bit of whose beauty is revealed to all who are human and who have the right attitude toward the world's worth-while offerings.... We know no one who can so well picture the southern California desert."[46] E. M. Bush, in the *Santa Fe Magazine*, wrote that "His works proclaim California's message of space and sunshine, and beauty for all."[47]

While Fries painted the landscape, Addie continued writing. She had a children's column in the San Diego *Sun*, one of early San Diego's first cosmopolitan newspapers, and organized a society for the blind.

After his first successful San Diego exhibition at Thearle's Music Rooms and public library in 1901, Fries and his family made a wagon trip to Yosemite with the apparent intention of not returning and of seeking greener pastures of inspiration for his art.[48] The experience taught him that all he needed

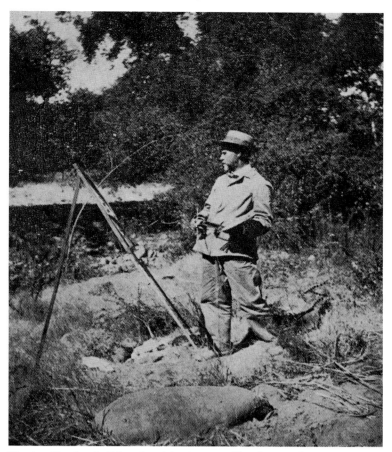

Fig. 4 Charles A. Fries sketching in one of his favorite haunts in the Lagunas in 1906. A news photograph, photographer unknown. Photograph courtesy of the San Diego Art Institute.

was San Diego and its environs. With the exception of this extended trip, he never again wandered too far from the Southern California area.[49]

A farewell party on 29 March 1901 prefaced the departure of the Fries family on 3 April.[50] Having spent about eighty-five dollars on provisions and a camp wagon drawn by two gray mares, Lucy and Mary, they left on the arduous trip, which was to last nearly six months. Addie kept a journal of the trek which detailed their locations as well as reporting their misadventures. At Orange, their horses were frightened by a relatively new contraption known as an automobile. Here the artist exhibited a few works at Stone's Store.[51] In mid-April the family was camping among the Indians at a lake west of San Bernardino. On 23 April, Addie became ill with a fever that caused her to become delirious, wander off, and get lost on several occasions. On 1 May they were camped at Echo Park, and renewed their acquaintance with Charles Lummis. Ten days later, their stop at Ventura coincided with the visit of President William McKinley. The month ended with a visit with the Englishes, and with Fries sketching and painting around Arroyo Grande. During the month of June the party visited Paso Robles, San Miguel, King City, Soledad, and Monterey. Here the artist spent three and a half weeks working. On 13 July Fries left Pacific Grove, arriving at

Merced Canyon on 30 July. Yosemite at last! The artist and his family luxuriated in the grandeur of the spectacular landscape for another three weeks, despite obvious hardships. They left on 23 August. General discomfort, rough roads, and other mishaps convinced the Fries family that San Diego looked extremely good. On 9 September they sold their camping gear and horses and took a train via Stockton to San Francisco. By sail and steamer, they headed south toward San Diego and arrived in August. Later, in a letter to members of her family, Addie admitted that during the trip "we did not visit a place which we had liked as well as San Diego."[52]

For an income the artist turned to teaching, a pursuit he continued off and on. Among his most prominent students were Aime Baxter Titus (1883-1941), who developed into a fine local painter, and playwright Anita Loos (b. 1893).[53] At first, there were few students.

Although he could be considered a frontier artist because he often chose to portray subject matter pertaining to that southwestern genre, Fries was also a "frontier artist" because he tested the limits set by artists who came before him, particularly in terms of the physical challenges he was willing to undertake.[54] Being of a restless nature, he was always seeking new sources of inspiration for his art, as well as stimulation for a richer life. He had arrived in California at a time when the western United States was still relatively unsophisticated and unsettled; men were seeking new fortunes, new lives, or both. He, too, had suffered "gold fever," and had speculated in Arizona and in Southern California.[55] In her journal, Addie noted that Fries, as a stockholder, was invited by a Mr. Roach to the Silverado Mine property, "forty miles by auto."[56] Life in the West was rustic, if not simple. Journeys between communities took hours, if not days, and the artist and his movements were considered worthy of newspaper reports (Figs. 5 and 6). The artist's seventy-five-mile ride on his "wheels" (a bicycle) was considered high adventure.[57]

The artist's biographer, Ben F. Dixon, relates details of many of the artist's sketching trips into the surrounding areas. Unfortunately, dating is difficult to resolve in many cases. Much of the information Dixon records was provided when the artist was in his advanced years, which had dimmed specific details considerably.

For the next twenty-five years, the artist established a routine of making art sketching trips yearly, often days or weeks at a time. Between 1918 and 1934 he made forty-nine trips for a total of 358 days in camp.[58]

Between 1901 and 1905 the family had moved frequently, from a two-story house on Twenty-Fourth and Logan Avenue, to Ninth and 'E' Street, to Thirtieth and El Cajon, and to Chollas Valley. The latter addresses were chosen to accommodate Fries's new venture of keeping bees. Finally they moved to the St. James Hotel annex, motivated perhaps by a domestic rift. Addie took their daughter and moved out. Fries's depression over his inability to sell his work—and also his beekeeping—were the apparent cause of the split. Addie sold newspapers for a short time to support herself and her daughter. Eventually the artist disposed of the bees and moved to the hotel annex also. He maintained a studio on the first floor and, briefly, in a nearby building.

During this time of spiritual depression, Fries painted an allegorical work which received some celebration. *The Spirit of Competition* (Fig. 7) was exhibited at Packard's Book Store, 751 Fifth Street, and is referred to as being among his greatest works. A large-format work, the picture shows a great stagecoach drawn by five horses. Figures on the stage are struggling for first place. In the background, flames and smoke rise from burning homes and ruined fields. To the left, a group of revelers are drowning their sorrows in drink. A young girl weeps over a dead baby at their feet. There is a total absence of hope, comfort, or peace, save in the grave. A newspaper item acknowledged a "most careful study."[59]

At this time Fries bought several lots on 'F' Street near Twenty-Eighth for eighty dollars. U. S. Grant, Jr. also offered him some property in exchange for a number of pictures completed in Yosemite. Here he built a small cabin affectionately known as "Cabin in the Bush" (Figs. 1 and 2), which became his studio after being the family's temporary home. "This section of the city was then quite sparsely settled, so we were almost alone among the flowers and birds. There were neighbors not far from us, and a wide and beautiful view."[60]

Several lots at Fourteenth and 'E' Streets also had been included in the transaction with Grant. These the artist sold upon the advice of Daniel Cleveland, a prominent San Diego citizen who was sitting for his portrait at the time and whom Fries consulted. The $2500 he received was used in building a permanent home at the 'F' Street location, "Ivy Lodge." Located on a hillside, it commanded a view of both the Pacific Ocean and the mountains.[61] "Cabin in the Bush" was retained as a studio.

Established at his new home and studio in 1906, the artist began small journals recording his works. While incomplete, they provide titles for about 1700 items; after his death, the journals were maintained by his daughter. The artist's domestic and economic situation had definitely improved.

Since 1904 the local cultural scene had been developing. With several other San Diego artists, Fries formed the San Diego Art Association, the community's first cultural group devoted to the visual arts. This association, incorporated on 18 February 1904, was a parent group of the Fine Arts Society whose membership would maintain and operate the San Diego Museum of Art, then called the Fine Arts Gallery of San Diego. Fries was elected to the board, a post he held in 1905 and 1906.

In 1906 Fries again exhibited nearly two hundred paintings at Thearle's, where he had had his first large San Diego show five years earlier. According to one newspaper item, one of the works on display won first prize at a San Antonio, Texas, International Exposition.[62] No other details are mentioned. The second successful showing was a prelude to settling per-

Fig. 5 Charles Fries and a friend going into the back country to paint, in the days when "horse power" meant something other than power under the hood of a car. Photograph courtesy of Mrs. Alice Psaute.

manently in 1907 in the newly completed home at 2876 'F' Street. The artist had built the house of adobe with his own hands.

Intrigue marked the beginning of 1909, when fifteen pictures were stolen from a local display.[63] On the evening of 5 February, the theft of a selection of paintings from a loan exhibition sponsored by the San Diego Art Association on view at the public library aroused community indignation and embarrassment. Three works by Fries were taken: a landscape, a fruit still life of peaches and grapes, and a portrait of a small boy entitled *The Vagabond.* The artist, like many of the others whose works had been stolen, offered a reward of fifty dollars for their return. Fortunately, the paintings were recovered in April from a warehouse in Los Angeles.

On a happier note, in 1909 the San Diego Art Association purchased a work by Fries. According to a spokesman, "With this purchase, we have inaugurated that section of the program which calls for the purchase of the work of our local artists, when practicable, as tending to encourage and develop local art among us."[64] This unknown and unlocated work

was transferred to the permanent collection of the Fine Arts Society of San Diego when the Association was superseded by the Society in 1926.

In the relatively culturally limited decades at the beginning of the twentieth century in San Diego, Fries's works were eagerly viewed by the public, if one is to believe the glowing reports of the local press. His one-man shows at Thearle and Company's Music Rooms and in the public library were frequently extended to accommodate those who wanted to see them. During the first decade of the century, Fries was already lauded as "one of California's foremost exponents in art."[65] The landscape beckoned him and he would spend most of his time painting its many moods. Excursions such as his trip to Alpine in 1913 to do studies of the Cuyamacas were commonplace. That year he was accompanied by Ray Anderson, a former art student at Pittsburgh and an Alpine resident.

Between 1910 and 1920 Fries became caught up in the whirlwind of art activity that was taking place in the community during that period. By 1911 he was earning plaudits outside of the state. In that year he was awarded a silver

medal for his entry in an exhibition sponsored by the Fine Arts Association of Seattle, Washington. In 1915 he won another silver medal for a portrait, a third prize, exhibited in the Panama California Exposition in San Diego. Two years later, in 1917, the new Kanst Gallery in Los Angeles showed a large selection of Fries's pictures as its first offering. This gallery, according to Esther Bush, was "the mecca for tourists all over the world who seek the best in California art."[66] The critics were kind.[67]

In 1919 Fries was elected president of the San Diego Art Guild. In noting the occasion, an unknown writer mentioned that "his paintings are admired wherever exhibited.... Theodore Roosevelt, who was a great observer and who knew the great outdoors, stopped long to admire the paintings by Fries when he visited the Exposition."

Sketching trips over the years frequently took the artist to Alpine, Coyote Wells, Encinitas, Flinn Springs, and the Laguna Mountains. During the course of the next decade, the 1920s, his trips throughout the county continued to inspire the artist's brush, and he exhibited extensively.

In 1918 the La Jolla Art Association was officially established, an event that coincided with the construction of a new library designed by the San Diego architect William Templeton Johnson (1877-1957). Fries was among the Asso-

ciation's founding members. With Martha Vintliff, Maurice Braun, Helen DeLange, Lillian Fenn, Alice Klauber (1871-1951), and Albert L. Valentein (1862-1925), he was appointed to serve as a member of the jury committee. The realization of this organization had been encouraged by the new library facility, with its adequate exhibition space, and by the desire for growth within the art community.[68] In 1920 the Friends of Art sponsored its first exhibition for the purpose of bringing quality art shows into San Diego: the *California Art Club of Los Angeles.* Fries, as a club member of good standing, was represented by two works, *Cliffs on Point Loma* and *Heights of the Mountains.*

During the 1920s, personal affairs included the marriage of his daughter, Alice, on 31 December 1920. In 1923 the artist was the recipient of international accolades when French critics praised his works in a Los Angeles exhibition.[69] He was asked to submit a photograph of *Natural Grandeur* to be reproduced in a Paris journal. A New York one-man show at the Ainslee Gallery in January 1925 represented yet another personal achievement for the artist. The gallery was described as "one of the most exclusive and respectable Fifth Avenue galleries in New York, which caters to a worldwide clientele, though exhibiting only American moderns—Inness, Blakelock, Homer, Duveneck, Whistler, Twachtman, Wyant, et

Fig. 6 Charles Fries *(right)*, shown with a friend on a painting excursion into the San Diego back country. Photograph courtesy of Mrs. Alice Psaute

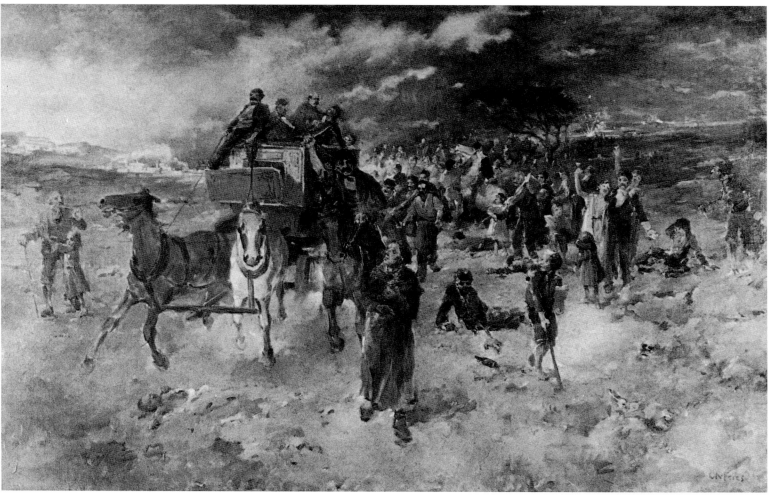

Fig. 7 *The Spirit of Competition,* oil on canvas, 37 x 56 inches (present location unknown). According to Fries, the scene depicts a large stagecoach which forms the center of interest and which bears many passengers both inside and outside. He intended it to be an allegorical depiction of the spirit of competition of the United States, in which all want to get on the wagon with little concern for the well-being of others over whom they ride roughshod in an effort to get a free ride to success. It is a work atypical of the artist. Photograph courtesy of the San Diego Museum of Art Archives.

cetera."[70] During that year the Friends of Art was incorporated as the Fine Arts Society of San Diego, whose membership, including Fries, was to administrate the operations of the community's new Fine Arts Gallery scheduled to open in February 1926.

The opening of the new museum, given to the city by Mr. and Mrs. Appleton S. Bridges, was the fulfillment of a dream for many civic and cultural leaders. Just prior to the opening, members of the Women's College Club approached the artist about the purchase of a work of art to be presented to the museum for the occasion. They selected *Naked Grandeur,* a typical Southern California landscape, but specified that a change of title would be desirable.[71] The painting, retitled *Rugged Grandeur,* hung in the inaugural exhibition. Fries was in attendance at the opening festivities, returning home later that evening "covered with honors."[72]

He returned dejected from the opening reception of his one-man show in La Jolla, however, depressed by the poor showing. Economically the show was, nevertheless, a success in the long run, for he sold seven works for a sum of just over $500.

During the course of the year, his busy exhibition schedule included a two-man show with an acquaintance from his New York years, Charles Reiffel, who was now an established San Diego artist and a frequent visitor at the Fries home.

On 22 January 1929 a group of artists met to organize with the purpose of exhibiting and promoting their own art. The name they selected was the Associated Artists of San Diego. At their August meeting that same year, they changed the name to the Contemporary Artists of San Diego. It was the first organization of professional artists in San Diego.[73] Members in addition to Fries included painters Leon Durant Bonnet (1868-1936), Maurice Braun, Everett Gee Jackson, Leslie W. Lee (1871-1951), Alfred R. Mitchell, Charles Reiffel, and Otto H. Schneider (1875-1946), and sculptors Donal Hord (1902-66) and James Tank Porter (1883-1962). Porter was elected president.

Braun, Fries, and Reiffel were appointed to handle details of the first exhibition of their works to be held at the Hotel San Diego, 20 July through 18 August 1929. There were no sales, and to add further fuel to the fire of disappointment, Sam

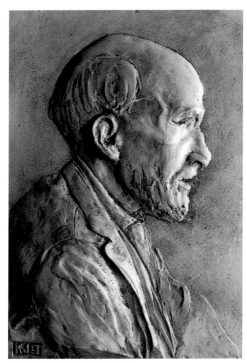

Porter "demanded" a picture as payment for the use of his hotel.[74] A program was initiated, and subsequent exhibitions were held locally and in other nearby Southern California communities until 1936, when the organization ceased to exist.

The receipt book of the group indicates that between 1930 and 1934, Fries disposed of ten works, including *Arid Country*, *Behold the Work of the Lord*, *Desert Montains*, *Eucalypti at Sunset*, *Foot of Grossmont*, *A Mountain Ranch*, *Mussey Grade*, *Nature's Backyard*, and *Oaks and Hills of Montezuma*. There is no record known to date of the final two years of the organization. The support members of the group paid a fifty-dollar annual fee to the organization, and were then awarded paintings or sculpture, including the works mentioned above, through the drawing of lots at yearly exhibitions.

Fries's full maturity as an artist coincided with the years of the organization. The artist's palette now became noticeably brighter and more colorful. One reviewer noted in an exhibition of Fries's work at the San Diego Museum of Art that they "show a tendency to indulge in more color than we have been accustomed to expect from him. What might be called 'Fries Green', a soft blue-gray green is present but he is using more violet and red tones than before."[75] Another writer also commented on the artist's use of "brighter colors and brilliance of lighting" in a later review.[76]

At about this time, one reviewer noted a "new dramatic and romantic vein" revealed in his work, supporting this observation by illustrating *The Rustlers* and *Rugged Grandeur*.[77] It should be pointed out, however, that it was merely a reappearance of this style, since both were earlier works by the artist, the former being anecdotal and among his first to be painted in California. Romanticism does color his subjects in most of his works in the sheer magnetism and appeal the area had for the artist.

In the summer of 1932 Fries was invited to represent the inaugural exhibition in the El Sueño Gallery, which opened at 3324 Adams Avenue on 23 July. He was the first artist invited by Margaret Grenell, who was in charge of the gallery. One reviewer of his show noted the variety of subject matter the San Diego area offered for the artist, "spacious panoramas as have made large picture windows indispensable to local architects. Variety is what makes San Diego County ideal for painting."[78]

The year 1934 was an occasion to reflect on Fries's eighty years, thirty-four of them spent as an artist in San Diego. Exhibitions, parties, and special events honored the artist, who was still producing award-winning pictures, according to the local press. The San Diego Museum of Art held a one-man retrospective exhibition in August, consisting of forty-five works. At the end of the year in the Art Guild Annual Exhibition, Fries won second prize for his oil, *Entrance to San Diego River Gorge*. The Guild also hosted a birthday celebration for the artist at the home and gardens of his colleague Maurice Braun. Congratulatory messages appeared frequently, especially in the letters columns of the newspaper. In one such source, the writer was extremely grateful for the artist's landscapes. Apparently, fire had destroyed sixty acres of oak-covered land in Montezuma Valley near Warner's Springs. For the author of the letter, Fries had captured the oak as well as the eucalyptus for posterity.[79]

Summarizing his life, the artist acknowledged that "it took me 35 years as an artist to be able to make my living painting....But, some-how, I have had a good laugh about something every day."[80] His achievement was noteworthy, as one local writer pointed out, because "there were no schools of landscape painting in the early careers of men like Braun and Fries. They developed their work absolutely under the inspiration of the great California out-of-doors."[81]

Economically, the Contemporary Artists of San Diego proved a dismal failure as a money-making venture. During the late 1930s, in an era still economically depressed, government funds were used to support artists through the Federal Works Progress Administration. Fries was a participant in the program, but pride and the feeling of prostituting their talent prevented others from accepting such aid. On the positive side, the project did offer the artist an opportunity to paint what he wished when he wished. It was a sense of security at least that allowed him to indulge in his favorite subject matter without pressure. In Fries's case, this was Southern California landscapes. Eventually, the finished paintings for "non-relief," as the artist referred to them, ended up gracing the walls of libraries, schools, and similar public institutions. There is an extensive list recorded in the artist's journals.

The year 1936 was a cause for celebration and personal thanksgiving for Fries, as he celebrated his eighty-second

year. At the time, aviation was a pioneer San Diego industry, and Fries had his first airplane ride as a special treat. Back on the ground, he declared it was "one of the most thrilling experiences of my married life."[82] The next year, the artist and his wife celebrated their golden wedding anniversary.

In 1936 Fries made his last sketching trip into the mountains. The ventures were beginning to drain him physically. He was at Decanso, twenty miles east of San Diego, when sudden illness forced him to return home.[83] While working for the Federal Art Project in 1937, the artist produced sixty large canvases for civic buildings in the city. The effort taxed his strength further, and his recovery was slow.[84]

The artist's health began to deteriorate at a quickening pace by 1940, his eighty-sixth year. He was unable to receive visitors on his birthday, and he died at his home on 15 December. Dr. H. H. Bard conducted last rites at the First Unitarian Church. To quote from an article in the *Los Angeles Times* in 1938, Fried had "carried the torch alone through the early years of art in San Diego. His works reflect nature in her happiest moods."[85]

Notes

1 Ben F. Dixon, *Too Late* (San Diego: San Diego Historical Society, 1969), 16f.
2 *Ibid.*, 17.
3 *Ibid.*
4 *Ibid.* Another temporary business venture of John's.
5 K. M. Kahle, San Diego *Sun*, 27 September 1933.
6 Dixon, *Too Late*, 19.
7 *Ibid.*, 20.
8 *Ibid.*
9 *Ibid.*, 14, 19.
10 *Ibid.*, 23.
11 *Ibid.*
12 Dixon, *Too Late*, 22. Part of Fries's money for the trip was raised by the local church where he illustrated Sunday school lessons on the blackboard. About $40 was collected.
13 Kahle, San Diego *Sun*, 27 September 1933.
14 Dixon, *Too Late*, 20.
15 *Ibid.*, 23.
16 *Ibid.*
17 *Ibid.*, 24.
18 *Ibid.* Captain Boyd, of the same address as Fries, had a wonderful imagination. A great storyteller, he was always the hero of his tale.
19 Cincinnati, *The Week*, 22 September 1886.
20 Cincinnati, *Illustrated News*, 18 September 1886.
21 Unidentified and undated item in the Museum scrapbook.
22 Dixon, *Too Late*, 27.
23 *Ibid.*
24 Kahle, San Diego *Sun*, undated.
25 Dixon, *Too Late*, 27.
26 *Ibid.*, 9, 31.
27 *Ibid.*, 4.
28 *Ibid.*, 30.
29 Dixon, *Too Late*, 32. A brother of Mrs. Fries had earlier settled in the community for health reasons, and may also have been an influence on their decision.
30 Unidentified and undated item in the Museum scrapbook.
31 Dixon, *Too Late*, 31.
32 In collection of the Corcoran Art Gallery, Washington, D.C.
33 Journal entry of Charles Arthur Fries, 10 October 1915.
34 Dixon, *Too Late*, 1.
35 *Ibid.*
36 Unidentified and undated item in the Museum scrapbook.
37 With Kesler Gallery, San Diego, California, 1979.
38 Journal entry of Mrs. Fries, 20 September 1926.
39 The earliest artists, mostly amateurs, arrived with military and survey expeditions. Others came to spend a few weeks, painting portraits in their quarters at local hotels. No artists who resided in San Diego for lengthy periods of time are known until Farnham and Fries. Ref.: Rebecca Lytle, unpublished Master's thesis, SDSU, 1978.
40 C. Olten, *San Diego Union*, 8 October 1967.
41 Unidentified source, dated 1919 in artist's scrapbook in the collection of the artist's grand-daughter.
42 H. B. Braun, San Diego *Evening Tribune*, 23 June 1928.

43 Kahle, *Sun*, 23 September 1933.
44 A. B. Campbell-Shields, *San Diego Union*, 5 March 1925.
45 E. S. Barney, San Diego *Evening Tribune*, 5 October 1929. Ms. Barney was an artist and a student of Henri, as well as a writer for the local press.
46 R. H. Poland, *San Diego Union*, no date.
47 E. M. Bush, *Santa Fe Magazine* (November 1917), 54.
48 Dixon, *Too Late*, 36-8.
49 M. Loring, San Diego *Sun*, 15 May 1938.
50 San Diego *Sun*, 1 April 1901; also Dixon, *Too Late*, 39.
51 Dixon, *Too Late*, 39.
52 Letter, 4 July 1907, to members of the "family circle."
53 Kahle, San Diego *Sun*, 27 September 1933.
54 *Ibid.*
55 Dixon, *Too Late*, 48.
56 Journal entry of Mrs. Fries, 19 January 1915. That day Fries also received notice that his pictures were rejected by the Exposition Art Committee, according to the same entry.
57 *Ibid.*, 57.
58 *Ibid.*
59 Unidentified item, dated 11 April 1902, in grand-daughter's scrapbook.
60 Letter, 14 November 1907, collection of artist's grand-daughter, addressed to members of the "family circle."
61 Journal entry of Mrs. Fries, collection of San Diego Historical Society.
62 San Diego *Sun*, 24 December 1906.
63 Dixon, *Too Late*, pl. 18; also San Diego *Sun*, 6 and 7 February 1909 and 8 April 1909
64 *San Diego Union*, 19 February 1909.
65 Unidentified item dated 14 December 1907, in the artist's scrapbook in the collection of his grand-daughter.
66 Bush, *Santa Fe Magazine* (November 1917), 54.
67 A. Anderson, *Los Angeles Sunday Times*, 17 October 1917, for example.
68 Unidentified and undated (possibly October 1920) item from the scrapbook of the artist in the collection of his grand-daughter.
69 "French Critics Praise Work of Local Artist," *San Diego Union*, 17 November 1923.
70 Dixon, *Too Late*, 8, 9. Intentions were for the exhibition to continue to other eastern cities including Cincinnati.
71 Journal entry of Mrs. Fries, 1926.
72 Journal entry of Mrs. Fries, 27 February 1926.
73 See M. E. Petersen, *Journal of San Diego History*, XVI (Fall 1970); also, minutes of Contemporary Artists of San Diego.
74 Minutes of Contemporary Artists of San Diego.
75 Barney, San Diego *Evening Tribune*, February 1929.
76 *San Diego Union*, 2 October 1929.
77 Poland, *San Diego Union*, 3 February 1939.
78 O. Page, San Diego *Sun*, 8 August 1932.
79 H. Strong, *San Diego Union*, 21 April 1934.
80 San Diego *Sun*, 14 August 1934.
81 Braun, San Diego *Evening Tribune*, 18 August 1934.
82 D. Hord, San Diego, unidentified newspaper, 1936.
83 Dixon, *Too Late*, 50.
84 Loring, San Diego *Sun*, 15 May 1938.
85 Anderson, *Los Angeles Times*, 23 November 1938.

24 *Maurice Braun*

Maurice Braun

(1877-1941)

Maurice Braun was born on 1 October 1877, to Ferdinand and Charlotte (née Leimdofer) Braun. His birthplace was a small town called Nagy Bittse (Nagybiesce), which was then located within the boundaries of Hungary but is now a popular resort in Czechoslovakia. Brought to the United States when he was four years old, Braun spent his youth in New York City, where the family settled at 655 East 163rd Street. He enjoyed the boyhood pursuits of the baseball diamond and the track field, and his interest in baseball was never to diminish. He devoted more time, however, to the arenas of his special interests: the Metropolitan Museum of Art and the Metropolitan Opera House.[1]

At the Metropolitan Museum the budding artist could be found copying from works on view. His was a precocious talent; when only two or three years of age, the boy was copying images on coins. An unknown writer gives a somewhat romantic picture of the artistic proclivities of the youthful Braun: "His artistic bent became apparent at an unusually early age. It is said of him that at the age of three his young friends would 'borrow' the butcher's pencil so that their small artist-chum could 'make faces for them.'"[2]

At fourteen, Braun was apprenticed to a jeweler, but he soon rebelled.[3] Even though his family could not understand why anyone would want to waste time on art, which could not be expected to bring any returns, the future artist began his professional studies at the National Academy of Fine Arts, where, from 1897 to 1900, he concentrated on portraiture and still-life painting (Fig. 9). He studied with Francis C. Jones (1857-1932), George W. Maynard (1843-1923) and Edgar M. Ward (1839-1915), all products of the French academic tradition.[5]

Following his formal training at the academy, Braun studied one year with noted American painter William Merritt Chase (1849-1916).[6] Braun's travels abroad from 1902 to 1903, to what was then still Hungary, and particularly to the cultural centers of Berlin and Vienna, allowed him the opportunity to study first-hand a wide range of paintings by the masters whose work he had admired in New York's Metropolitan Museum of Art as a boy. Although many young American artists were traveling to Paris to study art, no existing records indicate that Braun spent any of his time in Europe either painting or studying formally; it is not even known whether he ever visited Paris.[7]

Back in the United States, Braun set out to practice as a serious painter. Earnest effort and sound training from an established source, two disciplines which he had now mastered, were prerequisites for a student pursuing a professional career in art. Braun's primary concern was for an art and form that expressed his very being. This was his definition of success. What monetary rewards he earned were welcomed simply for the sustenance of life. For Braun, however, intense and serious labor alone was insufficient; inspiration was also a part of the artist's make-up, as well as a certain amount of sacrifice. Braun, a practical artist, would reduce prices for convenience's sake in an era of economic depression, a condition which characterized his age. He also advocated personal integrity, honesty—particularly with dealers—and that the artist always be a gentleman in complete control. As a teacher he attempted never to impose his personal style of painting on his students but allowed them to develop naturally.[8]

In 1909, an established New York figure and portrait painter, Braun found portraiture too constraining artistically and he left for California to escape the influence of other artists working in the area. He became a pioneer of western American art and achieved renown as a respected landscape painter.[9] This was at a time when art historians noted that "Landscape painting is undoubtedly the most popular branch of our art, and the one most encouraged by dealers" and foreign artists would remark that "it seems...American artists paint nothing but landscapes."[10]

As an early California artist, Braun was inspired to interpret the state's natural landscape (Fig. 12). Southern California offered many new opportunities. The colors and forms of the region were a revelation. Brown grasses, blue mountains, and rugged rock formations were to provide endless challenges relative to the interplay of light and color with the artist's strong sense of composition. Braun was captivated by the area. He repeated the landscape frequently, always seeking a new interpretation of mood and expression.

During this crucial period in the artist's professional career, when he was searching for expression and style, Braun revived his student-day interest in theosophy.[11] It was perhaps

Fig. 9 Maurice Braun shown in his studio in the Isis Theater Building in 1918. Photograph courtesy of San Diego Museum of Art Archives.

Fig. 10 Maurice Braun, a student in the class of 1899 at the National Academy of Design, New York City, is pictured third from right in the second row. The instructor, Edgar M. Ward, is seated in the front row *(extreme left)*. Photograph courtesy of San Diego Museum of Art Archives.

the philosophic nature of the group of local artists, as well as their interest in archaic civilizations, particularly Greece and the Orient, transferred into valid and real art forms, such as drama, literature, and music, that appealed to Braun.

In San Diego Braun soon sought out the small but highly serious and intellectual circle of theosophists. At the recently established International Headquarters on Point Loma he joined such men as Welsh poet Kenneth Morris, novelist Talbot Mundy (1879-1940), Mayan culture specialist William Gates, composer Rex Dunn, and art historian Osvald Sirén (1879-1966), who were all attracted to the Theosophical Society directed by Katherine Tingley (1847-1929).[12] Morris, Gates, and Dunn made their home at the Headquarters. Sirén often visited when en route to the Orient from Sweden, where he was founder and director of the Institute of Asiatic Antiquities. He was a world authority on Asian art. Madame Tingley, however, urged Braun to continue his professional career rather than to immerse himself in the activities of the

Headquarters' community, but the artist remained an active member of the society throughout his lifetime.

Tenets of the society—its transcendentalism, speculative thoughts on the nature of God, man, and the universe, with an emphasis on brotherhood—may have had an effect on the artist's style, at least for an unknown writer of the *New York Tribune* who perceived that "Mr. Braun has expressed new moods of nature rather than the facts of landscape."[13] This understanding of Braun's view is too often missed, or confused with inaccurate attributions to an involvement with Indian yogi practices. Rather, the thrust of the concepts central to the theosophical movement which Braun embraced was an idealistic concern for the universality of simple views of harmony in nature as they are expressed in the art and culture of ancient civilizations.[14]

Braun considered art to be far deeper than a purely visual experience, more subjective and mystical than objective and reportorial. It has been noted that he avoided what he re-

garded as contrived and stylistic trends, and distanced himself from the idea of art as a "way of looking at things," in an effort to let nature speak for herself and to capture fundamental qualities.[15] He wrote, in his final year:

"Let us remember that method, style, subject and all the rest are merely the clothing in which the thing itself, 'Art', is enclosed....It is the aroma of the message that is important.... We find many artists searching for new principles, but they only discover, even [in] the most ancient art, the same fundamental rules or laws that every true work of art submits to are so much nature's own laws that they may be looked upon as practically changeless....Let the real aim of art and purpose of the student who wishes to penetrate the mysteries of art be, therefore, the achievement of inner vision."[16]

Curiously, some people today tend to view the early California artists as prosaic and isolated individuals who knew nothing of the art world of their time, or earlier. This was probably never true of these artists, and certainly not of Braun. Although he was an individualist, focused on his own agenda for his work and finding it endlessly challenging, Braun remained intensely interested in, if not always enthusiastic about, contemporary art developments. Before 1930 he traveled annually for a number of years through the East, South, and Midwest visiting art centers and galleries. He was a great admirer of many of his contemporaries in the United States and in Europe. Ever an art historian at heart, he had an objective eye for fine achievements of many kinds. He identified most deeply in spirit, perhaps, with the great landscape artists of China.

The artist's success in synthesizing his beliefs and his art was brought into focus for John Fabien Kienitz, former chairman of the Department of Art History at the University of Wisconsin. Kienitz wrote in the preface to the catalogue of the memorial retrospective of the artist's works at the M. H. de Young Memorial Museum in San Francisco in 1954:

"Maurice Braun's serenity before the vexations of life and the complexities of nature impressed all who knew him. He was an artist of deep philosophical conviction for whom all expressions of life were divine. So it is natural that in the look and feel of his work you should find pastoral peace. This peace is born of his sense of wholeness. Through an interplay of religious respect and esthetic resolve he found equilibrium and this was for him, as it can be for us, the secret of life itself. In his own small yet distinctive way Maurice Braun was able, out of a comparable largeness of vision, to create space and color relations not unrelated to the superb formal clarity reached by Cézanne."[17]

The Southern California landscape school grew with a sympathetic response from eastern painters such as Braun and his contemporaries Charles A. Fries, Charles Reiffel, Leon D. Bonnet, Elliot Torrey (1867-1949), and others who succumbed to its climate and countryside. Braun's landscapes be-

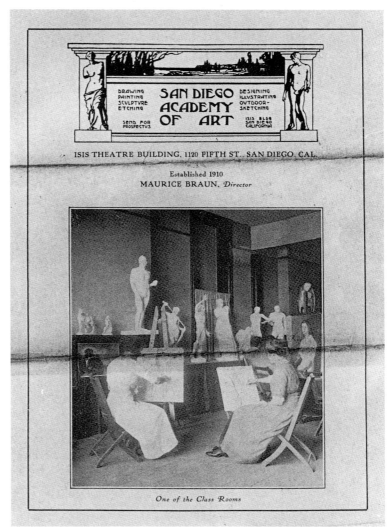

Fig. 11 In his studio Maurice Braun opened the San Diego Academy of Art in 1910. The promotional brochure for the academy offered a diversity of classes in drawing, painting, sculpture, etching, illustrating, and outdoor sketching.
Photograph courtesy of the San Diego Museum of Art Archives.

came known for their "impressionistic" and "decorative qualities" as art writers emphasized the significance of the artist's "close study of out door effects of light."[18] The light and airy style reminiscent of French Impressionism and of his own teacher, William Merritt Chase, may have influenced Braun. His sympathy for the California scene he attributed to the appeal of "its bigness, its richness and its optimism."[19]

Braun's paintings were vehicles for spreading the image of the familiar eucalyptus trees gracing the Southern California area. "Where a tree appears in his landscape it is nearly always characteristically the Eucalyptus which in his California work lends itself to such a great variety of effect and mood, an indication that, like the Oak in New England and English landscape, the Eucalyptus will endear itself as typically California" (Fig. 13).[20] Undoubtedly Braun contributed, although not exclusively, to the establishment of that imagery as a part of the Southern California pictorial vocabulary. Today the term "Eucalyptus School" is uttered fre-

quently in a derogatory sense, a reference to painters, both amateurs and others, whose canvases are bountifully arrayed with groves of such trees. Before Braun, Charles Arthur Fries bore this sobriquet and may have been impeded by his association with the "Eucalyptus School."

The decade between 1910 and 1920 may be looked upon as the artist's formative years. At the turn of the twentieth century, American art was in a critical state of transformation. The New York Armory Show of 1913 left its indelible mark. Traditions in art thereafter would be cast aside. Modern European art movements were introduced which stirred artists and public alike, and labels began to be applied to new trends in American art as styles changed rapidly under the influences from abroad and as critics sought to define those trends. On the West Coast, Braun remained apart from the resultant confrontation of traditionalists and modernists. He was certainly aware, however, of the excitement created by the modern rebels and their impact upon the national art scene.

One of Braun's first accomplishments in San Diego was the founding of a Fine Arts Academy, which opened in June 1910.[21] Here he exhibited his first major painting, *San Diego Landscape, Bay and City—San Diego* (collection of Mr. and Mrs. William Dick), a large canvas showing the city lying low along the shore. Over the scene, in a large expanse of sky, hover masses of clouds. This was included, along with seventy-four other works, in the artist's first major West Coast exhibition.[22] The academy, including his studio, was located in the Isis Theater, formerly the Fisher Opera House, on 'B' Street.[23] Classes in designing, drawing, and painting, in addition to outdoor sketching, were offered. Among his first students to attain national recognition was Alfred R. Mitchell.[24] Mitchell was the first of San Diego's artists to receive his initial professional training here. After further study in the East, Mitchell returned to become a resident painter of note.

Soon after his arrival, Braun was exhibiting his Southern California landscapes in the East, where they met with favorable critical acclaim as early as 1911.[25] Between 1910 and 1915 Braun exhibited annually at the National Academy in New York, as well as in annual exhibitions of contemporary American painting at the Carnegie Institute, Pittsburgh, the Art Institute of Chicago, the Pennsylvania Academy of Fine Arts, Philadelphia, and the Detroit Museum of Art.[26] In November 1915 he had his first one-man show at the Milch Gallery in New York City. This was not Braun's premiere showing in New York, however, since he had been a frequent exhibitor at the National Academy since 1910.[27] None the less, this important one-man show met with what would become customary critical accolades. That year, and in 1916, Braun was the recipient of gold medals at the World's Fairs, in San Diego for his *San Diego Hills* and *California Hills*, and in San Francisco for *Eucalypti* and an unknown work. In 1915 he had submitted *Hills and Valley, Sunlit Hills* and *Morning:*

The Hillside,[28] and all three had been accepted by the jury for the San Francisco Panama International Exposition.

At this time there was an active art community in both Northern and Southern California, and artists from both groups exhibited their works in both of these expositions. Moreover, top honors at both fairs went to San Diego's Maurice Braun, a fact that is seldom noted in the histories of that period.

Ever encouraging the cultural growth of the community, Braun was instrumental in organizing local artists into the San Diego Art Guild. He became its first treasurer upon its formation in 1915, and served as its second president from 1917 through 1918. A few years later, when the San Diego Fine Arts Society was formed to operate the newly proposed art museum that was to open in 1925, Braun was off painting in the East. Although he was not one of the original founders, he became a lifelong active member upon his return to San Diego.

In 1917 Braun was represented on the West Coast by the Kanst Art Gallery, Los Angeles, where he was that dealer's biggest drawing card (Fig. 14). He had also interested the Macbeth Gallery in New York City in his work and, subsequently, in representing him on the East Coast. Braun wrote to Mitchell at the Pennsylvania Academy of Fine Arts that his work "from now on [would] be carried by them....I feel highly flattered as I know he [Macbeth] is rather averse to taking on new men unless they are unusually good, and often not even then."[29] Apparently, Macbeth had seen something special in Braun's work.

Throughout 1918 much of the artist's energy was engaged in the details of exhibiting from coast to coast, an experience that became routine for him during the 1920s and 1930s. The year began with major one-man shows in Los Angeles and San Francisco, comprising seventeen and thirty works respectively.[30] In May the Babcock Gallery, New York City, featured him in a solo exhibition.[31] It was his first there, and a second was to follow two years later.[32]

Braun had never wandered too far from the local setting for his inspiration until 1918, when he made a trip to Yosemite to fulfill a commission. He worked there for several weeks, reveling in the majesty of the awesome giant trees and lush green meadows. One work completed during this time was the popular *Inspiration Point* (location unknown), which received its share of complimentary press coverage when it went on local display.[33]

Personal happiness came to Braun when he took as his bride Hazel Boyer (1887-1946), formerly of St. Louis, Missouri, on 30 January 1919. She later became one of the most prominent art writers on the West Coast, especially influential through her column in the San Diego *Evening Tribune* and contributions to several California art journals. That year brought the artist further professional achievement as he exhibited with the newly organized Ten Painters Club in Los Angeles at the Kanst Art Gallery.[34] Other members of this

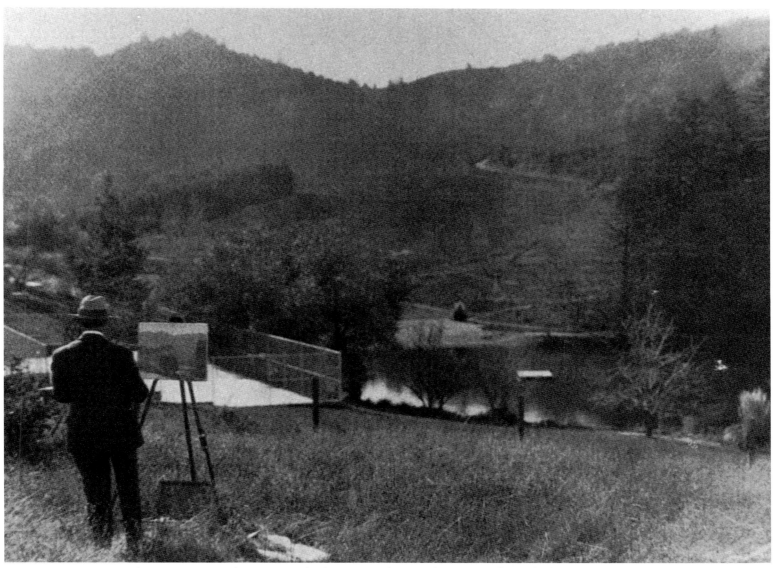

Fig. 12 Maurice Braun shown painting in the San Diego back country. Photograph courtesy of Dr. Charlotte White.

group included Benjamin Brown (1865-1942), Pasadena; Roi Clarkson Colman (1884-1945), Laguna Beach; Edgar Payne (1882-1947), Laguna Beach and Hollywood; Guy Rose (1867-1921), San Gabriel and Pasadena; Hanson Smith, Los Angeles; and Marion Kavanaugh Wachtel (1876-1954), Chicago and Los Angeles. The artist was also invited to exhibit in a group show at the Detroit Museum of Art and at the Albright Gallery, Buffalo.[35] Elsewhere, he was complimented for his work exhibited at Pomona, which one writer found "undoubtedly the finest [exhibition] which has ever been shown at Pomona College."[36] Seemingly blessed with success in both his personal and his professional life, Braun gave up most of his students during the year in order to keep up with his own work.[37] By this time he was well known in national art circles as the interpreter of California and the West.

If 1919 had been a good year for sales, 1920 proved even better. In addition, the artist received portrait commissions from several local civic leaders and firms, and he painted likenesses of Joseph W. Sefton, Sr. and Myron T. Gilmore (b. 1847), both commissioned by the San Diego Savings Bank.[38] Today, these portraits grace the boardroom of the bank's central offices in downtown San Diego.

It was during the 1920s that Braun was at his "zenith of popularity," according to one writer, who supported his opinion by citing the fact that popular periodicals such as the *Literary Digest* (13 March 1926), *California Southland* (June 1926), *Touring Topics* (May 1928), and *National Motorists* (June 1931) were then using reproductions of his works on their covers.[39]

Adding to all this good fortune, the birth of a daughter brought the artist further joy. Charlotte Le Clere, the Brauns' first child, was born on 19 January 1920. That summer the painter spent some time in the Mesa Grande region, where he produced twenty-four pictures that received the expected favorable reception at a fall exhibition in San Diego. Successive trips to the area were to follow.[40]

During the 1920s Braun divided his time between the East and West Coasts. After twelve years in San Diego, and feeling an urge to paint more of America, he planned to be away several years working in New York and New England.[41] He departed San Diego on 1 June 1921, stopping first in the Rocky Mountain region to explore and to paint the Wasatch Mountains of Utah and Colorado, and remaining for six weeks on a ranch near Georgetown.[42] The artist delighted in the varying landscapes across the continent. He particularly enjoyed Missouri; autumn found him painting in the Ozarks and along the Missouri River.[43] Twenty-nine colored pencil sketches made in Colorado were displayed in the art room of the public library in St. Louis in September.[44] At Healy Gallery in that same city in November, one critic compared his work favorably with that of Chauncey Ryder (1868-1949).[45] At this time a son, Ernest Boyer, was born to the Brauns in St. Louis on 13 September 1921. Today, Ernest is an award-winning nature photographer.

During the first winter months in New York City, where Braun's reputation as an artist of the East and West had preceded him, the couple established an apartment studio at 2301 Creston Avenue, well heated and ventilated, with excellent working conditions.[46] Business flourished during this period.[47] A year later, the Brauns settled in a little colonial cottage in Connecticut, near an artists' colony at Silvermine. Here he remained happily working for almost another year. He later opened a studio for a short time at Old Lyme. This community attracted the leading painters of the day, such as Henry W. Ranger (1858-1949), the first important American artist to work there, and particularly the so-called American Impressionists, such as Childe Hassam (1859-1935).

While in the East, Braun's exhibition activities continued at a rapid pace. In his shows, scenes of the waterfront and New England landscapes were now included for the first time. Braun continued to produce coastal scenes throughout his career; many were variations on this theme, often imaginary compositions of boats and buildings. In 1923 Braun exhibited not only with the Lyme Art Association, but also in Hartford and in New York City's Macbeth Gallery. Meanwhile, he sent paintings on exhibition to Dallas, Wichita, and other southwestern cities. In Dallas, fourteen pictures were sold within fifteen minutes of the show's opening. At the end of the second day, the show was sold out.[48]

By November 1923 Braun had closed his Old Lyme studio and was working in Hartford, Connecticut. January or February 1924 brought the artist back to his San Diego residence.[49] In 1924 he and his family built a new Point Loma home on Silvergate Place designed by Richard Requa (1881-1941), one of the community's leading architects. For the next five years Braun was to spend a part of each year in Connecticut, usually in the autumn and early winter.

During the mid 1920s the artist was painting in Texas and the Southwest. In 1926 he was working in Dallas, Houston, and San Antonio.[50] Picture titles reveal a wide choice of subject matter resulting from these trips, among them *Cottonwoods in Colorado*, *The Catalina Mountains*, and *Texas Blue Bonnets*.

In 1929 Braun joined with ten other San Diego artists to form the Contemporary Artists of San Diego.[51] This group included painters Alfred R. Mitchell, Leon Durand Bonnet, Charles Arthur Fries, Everett Gee Jackson, Leslie W. Lee, Charles Reiffel, Otto H. Schneider, and Elliot Torrey. The group also counted among its members two sculptors, James Tank Porter and Donal Hord. Porter was elected president, and Mitchell secretary-treasurer. Their intention was the promotion of local art and artists on a national level and the development of a wider appreciation of fine local art both at home and outside the area. The artists modeled their program after that of the Grand Central Art Gallery of New York City. Membership consisted of artists and local art patrons. The latter contributed funds for two years, which entitled them to draw for a work of art at the end of each major gallery exhibition featuring the artists. The artists showed as a group at the Fine Arts Gallery of San Diego for six years, from 1930 to 1936, except in 1935 during the California Pacific International Exposition. Other exhibitions of their works occurred concurrently as far away as Pasadena and Los Angeles, and in a local downtown sales room which they maintained from 1 December 1931 to 30 April 1932.[52] It proved to be an impractical venture and a financial failure in a period of national economic difficulty. After six local exhibitions, and with the death of Bonnet in 1936, this first organization of major San Diego artists became a part of history.

At the apex of his career, in 1929, Braun won a $2000 award at the Witte Museum of Art in San Antonio, Texas, for a painting, *Texas Fields*, now in the permanent collection of that institution.[53] The painting depicts a blanket of wild flowers beneath a group of oak trees. It was awarded third prize within the competitive theme of landscapes based on Texas wild flowers. According to one account, the picture was the second by Braun to enter the permanent collection of the Witte Museum.[54] In April of that year he was also awarded a $350 prize by the Gardena High School, Los Angeles, in their sponsored exhibition of works by Southern California artists.[55] During the summer of 1930 Braun was to receive $350 from the Chicago Galleries Association as a prize in the Ninth Semi-Annual Exhibition for his picture *Village Brook in Winter* (location unknown).[56] While the artist's financial condition was certainly enhanced, it was 1929 and October would bring the Wall Street crash. The grave economic situation the country was about to endure was to affect the future status of artists in general.

Fig. 13 *Tree Study* by Maurice Braun, colored drawing, 11 3/4 x 9 3/4 inches. In the collection of the San Diego Museum of Art (1928: 038.6).

Fig. 14 Braun's Los Angeles dealer, John Frederick Kanst *(right)*, his wife, and daughter Jannette flank the Braun family—Hazel, Charlotte, and Ernest—in front of the Kanst Gallery in Hollywood in 1931. Photograph courtesy of Mrs. Jannette Kanst Mathewson.

From the beginning of the year Braun was preoccupied with his busy exhibition schedule. In February 1929 the Jules Kievets Gallery in Pasadena featured him in a one-man show comprising forty works. At the invitation of the Vose Gallery of Boston, his picture *Mountain Heights* (location unknown) was included in an exhibition Vose sponsored at the Biltmore Hotel in Los Angeles. He also participated in the annual exhibition of Southern California artists at the Fine Arts Gallery of San Diego. These were only samples of his West Coast schedule; press notices also indicated exhibitions in the Midwest and East.[57]

The Brauns were in the East from September through December 1929. In a letter to Mitchell regarding details of the organization of the Contemporary Artists of San Diego, the artist mentions painting along Boston's North Shore for several weeks. He and his wife were also enjoying New York's art scene, even though dealers were "wailing about hard times."[58]

The effects of the Depression years and the innovative styles of contemporary art are cited frequently as reasons for the declining fame of many of the early artists, including Braun, during the 1930s. While programs were assisting artists under the Civil Works Administration, Braun never participated in the San Diego area. To augment his income, he was again giving instruction in painting. Junior and senior high school students from Hoover and Chula Vista, and adults in the Adult Education Program were among students meeting at the Chula Vista Art Center, various schools, and at his Point Loma studio. During this period, when many art-

ists were discouraged by the sobering aspects of the economic climate, Braun's attitude seemed to provide optimistic impetus to his own endeavors. He is often quoted as saying, "No one can take away our love of work, our joy in painting; life in reality is beauty and harmony and we are challenged to give this message to the world."[59]

Conditions of these bleak years did not seem to deter his enthusiasm. Newspaper clippings indicate that he continued to exhibit from coast to coast, in such cities as Indianapolis, Los Angeles, Memphis, Montgomery, New York City, and San Francisco, as well as in La Jolla and San Diego, all with the same critical acclaim as in preceding decades, although there was a serious decline in sales. In 1934 his painting *Wharf Building* (location unknown) received the $100 Leisser-Farnham Prize at the Fine Arts Gallery of San Diego; it was the most popular work in an exhibition of Southern California artists. A six-week tour on the New England coast four years earlier had resulted in the production of a series of paintings, including this prizewinner.[60] During the 1930s Braun remained as independent as ever, pursuing his own goals and new explorations of content and color. His paintings continued to sell, although very slowly, primarily in the Midwest and on the East Coast, accounting for more than two-thirds of the meager family income.

In January 1935 Braun joined fellow San Diego artists Anni Baldaugh (1886-1954) and Charles Reiffel in the First Annual Exhibition of the Academy of Western Painters in Los Angeles. These three artists were among a distinguished list of American painters who made up the academy, which in-

cluded Paul Lauritz (1889-1976), its president, Carl Oscar Borg (1879-1947), Maynard Dixon (1871-1946), Nicolai Fechin (1881-1955), Armin Hansen (1886-1957), Frank Tenney Johnson (1874-1939), and William Wendt (1865-1946).[61] Braun's own exhibition pace continued, even though sales were few and the artist's financial sources dwindled. His prolific output helped to keep the proverbial wolf away; the artist bartered paintings for goods and services. He even managed to drive a prestigious Pierce-Arrow, which he received in trade for some paintings from a Los Angeles art dealer.

Braun was frequently, but not exclusively, a studio painter. When he first began painting in California, he would often paint large canvases in the field. Usually, however, he would make either a small oil or color pencil sketch *in situ*. These sketches were essentially studies of light, form, and texture, either on a panoramic scale or smaller details of rocks or trees. From some of the sketches, larger works were developed and completed in the studio. Although he was an academician, he took the color sense of Modernism and applied it to his own style. Through his choice of palette, the artist captured those evasive seasonal moods: the cool, sobering somberness of winter; the rejuvenated spirit of spring; the languid idleness of summer; and the nostalgic beauty of autumn. A student of composition, Braun sought to capture a sense of place and time. His realistic treatment was tempered by poetic moods of color, correct composition, and the ability to render what nature offered without alteration. While he may not have been a disciple of any modern school, he recognized that "the fad of modernistic movement has unconsciously helped the artist's cause, for it has awakened a widespread interest in painting that was nonexistent before."[62] What he found lacking in modern art was "purpose and its relation to life." The doctrine of art for art's sake was not enough. It must also inspire and uplift.[63] Technically, the artist's mature works of the late 1920s are marked by a greater strength and intensity, and reveal a freer and more painterly style. The short, broken brushstroke and the greater apparent freedom may be attributed to his appreciation of Chase and the Impressionists. It could be further credited to his earlier use of the palette knife as noted by a *Los Angeles Times* art critic: "Braun has a technique that is always broad and direct ... and when he takes up a palette knife—which is pretty often—he displays the same distinguishing freedom of handling. He sees forms, the splendid mountain forms and broad stretches of valley so characteristic of California, in a big way, giving weight and solidity to his interpretation."[64] The writer was commenting on the artist's work from his first decade in San Diego. Works of the second decade are characterized by definite outline and thinner paint application, but are not without a certain bravura common to the moderns of his day.

During the 1930s Braun increasingly became a student of the art of China and Japan, Oriental philosophy, and the natural sciences, particularly biology and astronomy. These interests are noticeable in his art as a number of still life

Fig. 15 A formal portrait of the artist. Photographer unknown. Photograph courtesy of Dr. Charlotte White.

paintings become filled with motifs suggestive of the Far East: a ceramic T'ang horse, a single flower in a vase. Other still life paintings were inspired by flowers in his own garden. The influence of Braun's intensified interests was sensed by Kienitz in the following observation:

"Absolute composure rules his studies of still life. It is impossible for him to look at what was small or large in nature, or among man's things, without translating what he saw into lucid and harmonious arrangement. Here, as elsewhere in his art, delicate relations of line, form, and color are simply signs of an even more exquisite fineness which he knew to be basic in nature. In the art of this man you may well find an oriental, even peculiarly Chinese bent. You may agree that he paints as an apostle of resignation whose spirit is like those men of Sung who could see the tragic in the turn of an Autumn leaf and still, somehow, never be defeated by it."[65]

Other critics noted an increasing number of still life paintings from the artist's brush which conveyed, for at least one, a "more tender personal mood," discerning a new development in the artist's œuvre.[66] In the mid 1930s one critic rediscov-

ered Braun as portrait painter in a pleasurable way. His painting of a girl, *Jo Bobbie* (MacConnell collection), came as a surprise to the writer, who, in reviewing a show of Braun's work, compared its dreamy quality to that of Velázquez.[67]

During the last decade of his life, Braun continued his involvement with the Theosophical Society's activities and became a member of the directors' cabinet. In 1937 he headed the art department of the Theosophical University, which had been organized and chartered in 1919. His wife was an instructor in the history of art.[68] When events led to the necessity of relocating the headquarters of the society, the Brauns were suggested as a committee of two to make recommendations as to future sites. The golden age of the Theosophical Society had passed.[69]

On the afternoon of 7 November 1941, the artist and his wife had just addressed the Chula Vista Women's Club, where he showed a few of his works. After the program, while he was putting the pictures in his car, he fainted. After resting until six o'clock in the evening, he asked to be driven home. At 8:30 p.m. he died, a victim of a heart attack. Braun, who had just returned from a painting excursion in the Julian Hills, had not been ill, and his death was completely unexpected. Private services were conducted at the Theosophical Temple on Point Loma where he had been a member for over thirty years.[70]

In 1951 a large memorial exhibition of Braun's work was held at the Fine Arts Gallery of San Diego, and three years later he was remembered by a memorial retrospective in San Francisco.[71]

Obscured by imported modern movements and innovations, the art of Braun and other early artists outside the major cultural centers is being re-evaluated for a new generation. Certainly, Braun was San Diego's most important artist during the first three decades of the present century, familiarizing a whole generation between 1900 and 1930 with the Southern California landscape. He noted prophetically in 1928: "California has already contributed to the history of art in America but she is destined to add far more brilliant pages, not in individual effort, but in the great number of artists who will take part in making here a culture which is not yet imagined."[72] His vision of the future seems to have arrived.

Braun's artistic success was founded in thorough training and a respect for good craftsmanship. His gentle nature and immaculate demeanor and dress reflected the discipline he applied to his art (Fig. 15). While he approached nature objectively, he infused it with poetic and emotional atmospheric moods that are appealing to viewers, admired by critics, and collected by museums.

A former director of the Fine Arts Gallery of San Diego, Thomas B. Robertson, summed up the artist's importance, writing in a 1951 article that, during the early years in San Diego, Maurice Braun made that city's leading contribution to the national art scene.[73] He was certainly the best known of San Diego's first painters.

Fig. 16 When the San Diego Fine Arts Gallery, now the San Diego Museum of Art, opened in 1926, Hazel Boyer Braun became the art critic for the San Diego *Evening Tribune*. She gave a prominent place in her column to the work of local artists and provided carefully researched reviews of major as well as more obscure art events and acquisitions. When the Brauns travelled across the country visiting national art exhibits, these were reported in the column. Her column reflected the scope of the interest she and Maurice Braun shared in art history and, just as importantly, in their vision for the future in San Diego and in western culture in general. She consistently pointed to broader horizons for the permanent collections of the San Diego Museum of Art, with special emphasis on the need for an Oriental art collection locally and in all art museums along the Pacific rim. Her column continued until she moved to New York City in 1943. She accepted the position of director of field work for the Theosophical Society and established a reading room and center at Carnegie Hall. She died on 26 March 1946.
Photograph by Oscar Maurer, courtesy of Dr. Charlotte White.

1 "Maurice Braun: Painter," *San Diego Magazine* (December-January 1951-2), 2, 15.

2 *San Diego Union*, 3 March 1929.

3 Katherine M. Kahle, San Diego *Sun*, 4 October 1933.

4 Reginald H. Poland, "The Divinity of Nature in the Art of Maurice Braun," *Theosophical Path* 34 (May 1928), 474.

5 The number of years the artist remained at the academy varies with the source. Most agree it was four years and that by 1902 the artist was in Europe. *San Diego Union*, 18 November 1951.

6 *Dallas Morning News*, 11 February 1923. Chase was one of the most influential art teachers in the history of American painting. He was among the first to absorb the technique of the French Impressionists and spread its methods.

7 *Ibid.* While local press sources include Paris in the artist's itinerary, Braun was never in that city, according to his daughter. Conversation, 21 February 1975.

8 Braun's description of an artist gleaned from correspondence to Alfred R. Mitchell, a local artist who first studied with Braun, provides an apt description of Braun himself. See especially, letters, 20 November 1916; 23 April 1917; 18 December 1919. These letters were a gift to the San Diego Museum of Art from Mrs. Alfred R. Mitchell and are in the vertical files of the Art Reference Library.

9 *New York Herald*, 11 February 1923.

10 Sadakichi Hartmann, *A History of American Art* (New York, 1901), 1, 107.

11 According to one source, Braun had known Madame Tingley in New York as a boy, but this episode is not verified and is probably not true, according to the artist's daughter. See Emmet A. Greenwalt, *The Point Loma Community in California 1897-1942* (Berkeley, 1955), 124.

12 "Maurice Braun: Painter," *San Diego Magazine*, 13ff. Kenneth Morris led the Celtic revival of literature in Wales and Ireland. Osvald Sirén was a specialist in early Italian painting, as well as being a world authority on Oriental art. These two shared with Braun an enthusiasm for Eastern philosophy.

13 *New York Tribune*, 21 November 1915.

14 Greenwalt, *The Point Loma Community in California*, 31, 79.

15 Harold Kerr, San Diego *Independent*, 19 March 1939.

16 Hazel Boyer Braun, San Diego *Tribune-Sun*, 22 November 1941. The quote was noted as being from a book Braun was preparing at the time of his death. Entitled *Art for Everyone*, it was never published.

17 M. H. de Young Memorial Museum, San Francisco. *Maurice Braun: Retrospective Exhibition of Paintings*, March 1954. Introduction by John Fabien Kienitz.

18 For example, see Anthony Anderson, *Los Angeles Sunday Times*, 10 December 1941.

19 High School Art Gallery, Springville, Utah. *An Exhibition of Paintings by Maurice Braun*, 1942. Introduction by Reginald H. Poland.

20 San Diego *Evening Tribune*, 12 June 1911. The eucalyptus was an import of the mid 1880s and is not indigenous to Southern California.

21 *San Diego Union*, 15 June 1912.

22 San Diego *Evening Tribune*, 12 June 1911.

23 "Maurice Braun: Painter," *San Diego Magazine*, 16.

24 For the life of Mitchell, see Martin E. Petersen, *Journal of San Diego History* 19 (Fall 1973), 42-50.

25 "Maurice Braun: Painter," *San Diego Magazine*, 14.

26 Unidentified source in the possession of the artist's daughter.

27 *Ibid.*

28 *Eucalypti* was the 1916 gold medal winner in San Francisco. The 1915 winner would have been among the three works listed in the text.

29 Letter, 12 February 1917, from Braun to Mitchell. Also, letter, 23 April 1917.

30 Museum of History, Science, and Art, Los Angeles, January 1918, and Art Association, Palace of Fine Arts, San Francisco, February 1918. *Exhibition of Paintings by Maurice Braun*.

31 *New York World*, 15 May 1918.

32 *New York American Sunday*, 11 January 1920.

33 *San Diego Union*, 17 July 1918. *Touring Topics*, March 1928, relates an amusing account of the artist's trials while traveling on horseback to inaccessible areas of Yosemite. The trip is dated, erroneously, as having taken place in 1915. *Half Dome, Yosemite*, was reproduced on the cover of this issue.

34 *San Diego Union*, February 1919.

35 *San Diego Union*, 28 April 1919.

36 Pomona, *Student Life*, 14 November 1919.

37 Letter, 19 November 1919, from Braun to Mitchell.

38 *San Diego Union*, 12 December 1920. The portraits are illustrated.

39 Greenwalt, *The Point Loma Community in California*, 124.

40 San Diego *Evening Tribune*, 18 September 1920.

41 Hazel Boyer Braun, *Southwest Magazine* (March 1924), 7. Also, *Art News* (November 1923).

42 Denver *Rocky Mountains News*, 3 July 1921.

43 *St. Louis Dispatch*, 4 September 1921.

44 *St. Louis Star*, 4 September 1921.

45 Emily Grant Hutchings, *St. Louis Daily Globe-Democrat*, 6 November 1921.

46 The artist worked in New York for a full year. Letter, 30 December 1922, from Braun to Mitchell. Also, Reginald H. Poland, *Theosophical Path* (May 1928), 474.

47 Letter, 14 February, from Braun to Mitchell.

48 Helen Comstock, "Painter of the East and West," *International Studio* 80 (March 1925), 46-7.

49 *Art News* (November 1923) and other undated articles verify this date.

50 Hazel Boyer Braun, San Diego *Evening Tribune*, 14 June 1930.

51 For an account of this organization, see Martin E. Petersen, "Contemporary Artists of San Diego," *Journal of San Diego History* 16 (Fall 1970), 3f.

52 Reginald Poland, *San Diego Union*, 2 February 1930, and Petersen, *Journal of San Diego History* (Fall 1970), 3f.

53 *San Diego Union*, 25 February 1929.

54 Unidentified newspaper article in the San Diego Fine Arts Gallery file, dated 25 February 1929.

55 Reginald H. Poland, San Diego *Sun*, 27 April 1929.

56 Hazel Boyer Braun, San Diego *Evening Tribune*, 14 June 1930.

57 *San Diego Union*, 3 March 1929, and Hazel Boyer Braun, San Diego *Evening Tribune*, 8 June 1929. Also, *Chicago Evening Post*, 16 April 1929.

58 Letter, 12 November 1929, from Braun to Mitchell.

59 Hazel Boyer Braun, San Diego *Evening Tribune*, 9 May 1936.

60 *San Diego Union*, 18 September 1934, with an illustration of the work.

61 San Diego *Sun*, 5 January 1935, and San Diego *Evening Tribune*, 12 January 1935.

62 Unidentified article in the collection of the artist's daughter.

63 "San Diego Artist Gives View on Modernistic Art," unidentified source in San Diego Fine Arts Gallery file.

64 Anderson, *Los Angeles Sunday Times*, 20 January 1918.

65 M. H. de Young Memorial Museum, San Francisco; 1954, introduction by J. F. Kienitz.

66 Julia Gethman Andrews, *San Diego Union*, 31 May 1936.

67 Gethman Andrews, *San Diego Union*, 11 October 1936.

68 "Maurice Braun: Painter," *San Diego Magazine*, 43.

69 Greenwalt, *The Point Loma Community in California*, 191. The remnants of the San Diego Community of Theosophists are now located in Pasadena.

70 *San Diego Union*, 8 November 1941, obituary. Also, San Diego *Tribune-Sun*, 8 November 1941, obituary.

71 M. H. de Young Memorial Museum, San Francisco, March 1954.

72 Maurice Braun, "American Art Attains Recognition," *The Modern Clubwoman* (October 1928), 7.

73 Thomas B. Robertson, *San Diego Union*, 11 November 1951.

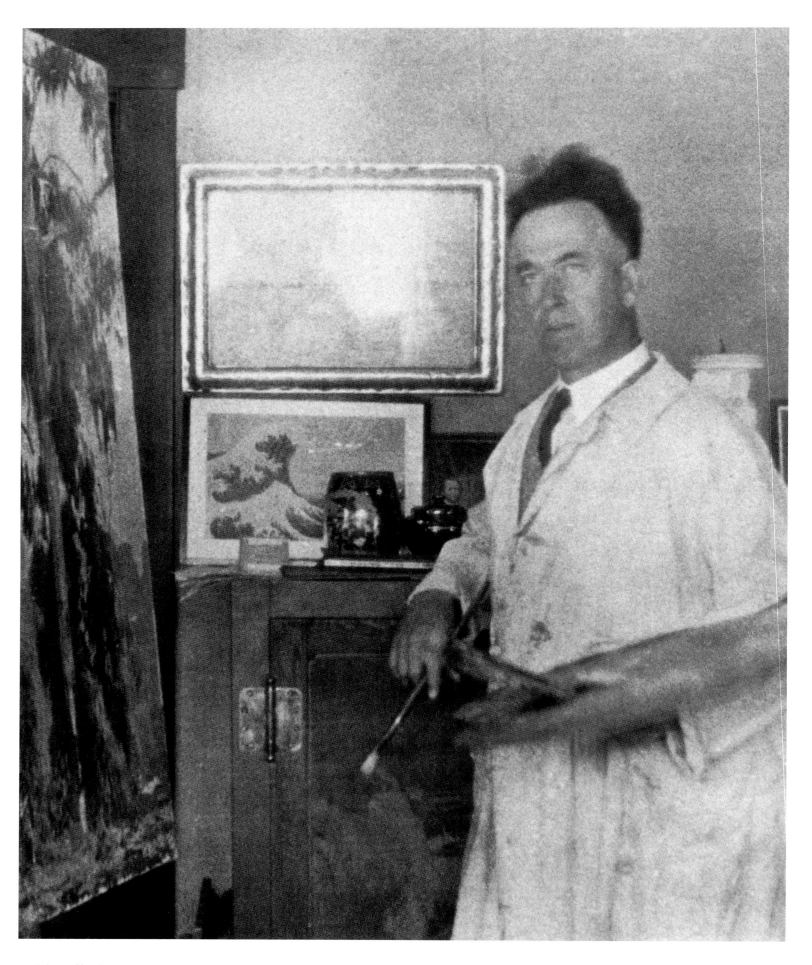

Alfred R. Mitchell

Alfred R. Mitchell
(1888 - 1972)

Alfred Richard Mitchell was the first serious artist to develop, mature, and spend his entire professional career in San Diego, California. His contributions as a painter were significant and his influence was an important factor in establishing the foundations of the current local art scene.[1]

Son of George Washington and Carrie Drake (*née* Swayze) Mitchell, Alfred, more familiarly "Fred," was born in York, Pennsylvania, on 18 June 1888. His father was of an apparently restless nature, and the family moved frequently to a number of communities in New Jersey, where George worked as a waiter, an insurance man, and a farmer. Carrie was the stabilizing factor in the family home life. While George and young Alfred merely tolerated one another, the boy's mother, an educated and cultured woman, encouraged him. Until he entered public school in Orange, New Jersey (where the family settled briefly), Carrie ran a private school, taught him independently, and fostered his interest in art. As a small child in New Jersey, Mitchell modeled animals from the clay he found along the shore of a brook near his home. In elementary school, under the guidance of a sympathetic supervisor, the budding artist produced work which delighted his classmates and teachers. Carrie, meanwhile, encouraged him to model in wax. At an early age, Mitchell showed determination to succeed as an artist.

The family, which now included a brother, George Rankin (1895 - 1986), and a sister, also named Carrie (b. 1898), moved to Eagle Rock in 1898, where they opened a short-lived restaurant business. At about this time, strained relations with his father caused the young Alfred to move to the home of his uncle Ed and aunt Eva, where he earned his living working in a drugstore. In 1903 the Mitchell family, without Alfred, moved to California, where they settled in Imperial Valley. Alfred joined them the following year and worked at odd jobs. While in El Centro, the family again pulled up stakes and headed for Nevada, lured by gold fever. En route, they stopped in Placerville for the winter. Here, Alfred found employment at a livery stable to add to the family coffers, and also worked as a cook with his father at a logging camp in the mountains nearby. In the spring of 1905 they continued on their way to the Sierras and the gold country of Nevada.

Shortly after arriving at Mina, Nevada, the family established a hotel-rooming house business, and Mrs. Mitchell

Fig. 17 Alfred R. Mitchell, the successful artist during the 1920s, shown in his studio at 1035 Twenty-Ninth Street.
Photograph courtesy of Mrs. Mary Sadler.

Fig. 18 The young Mitchell, the first figure *(right)* in the back row next to the engine, was employed in a railroad roundhouse in Mina, Nevada, when this picture was taken in 1907.
Photograph courtesy of Mrs. Mary Sadler.

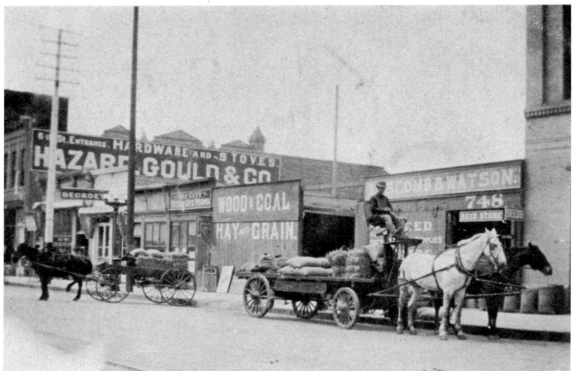

Fig. 19 After Mitchell rejoined his family in California in 1908, he worked at a number of jobs. He had worked as a drayman for the firm of Hazard-Gould prior to delivering for Luscomb and Watson, shown in the 1909 photo. His team, Dick and Dan, provided horsepower for the delivery wagon.
Photograph courtesy of Mrs. Mary Sadler.

Fig. 20 Mitchell's Cafeteria facade during a Fourth of July holiday. The cafeteria was a leading dining facility in early San Diego.
Photograph courtesy of Mrs. Mary Sadler.

Fig. 21 Alfred R. Mitchell shown at his desk in the cellar of the Mitchell Cafeteria about 1915, where he printed menu cards with rubber type.
Photograph courtesy of Mrs. Mary Sadler.

conducted a private school for the area children, since there were no other educational facilities available in that frontier community. At seventeen, the young Mitchell joined a host of would-be millionaires in the quest for precious metal. Digging for gold, however, was not profitable in the long run. During the Mina gold rush, the young artist drove a stage-coach for surveyors and others over miles of desert from Mina to Atwood, in the southeast corner of Oregon. His love of the land, particularly the desert, he attributed to this experience as a stage driver.

After his business failed, George Mitchell decided in 1907 to return to California (Fig. 18). Alfred, now employed at a railroad roundhouse, remained in Nevada, but was able to obtain free passage for the family because of his association with the railroad. The Mitchells relocated to San Diego, where they again opened a cafeteria (Figs. 20 and 21). This time, the venture was successful. Eventually they settled at 1527 Granada Avenue, where their lives assumed a degree of normalcy, and the family began to develop some roots. Alfred joined them during the course of the year (Fig. 19).

In 1911 the young Mitchell was preparing for a profession as an architect, draftsman, or engineer. Possessing a fine voice, he also began singing lessons, and he returned to clay modeling. A period of soul-searching then began for Alfred who sought to nurture his inner being. Through Professor Charles H. Sykes, a gentleman of English origin and the owner of a private school, the young student familiarized himself with the deeper aspects of literature, philosophy, and theology, interests which were to endure throughout his lifetime, as did his friendship with Sykes In time, he became a practicing member of the Unitarian congregation, because its principle of non-sectarian beliefs closely matched his own. He regularly attended Sunday evening forums, where vital questions were discussed in the cultural, political, and scientific fields by prominent specialists including Will Durant (1885-1981), Franklin D. Roosevelt (1882-1945), Bertrand Russell (1872-1970), Edna St. Vincent Millay (1892-1950), Woodrow Wilson (1856-1924), and Stanton MacDonald Wright (1890-1973).

In 1913, at the age of twenty-five, Mitchell began serious study with local landscape painter Maurice Braun, "the most distinguished artist in San Diego at the time."[2] He began concentrating on painting. The following year, Mitchell took a painting trip in the San Bernardino Mountains sketching early autumn scenes. It was the first of many working trips for the young painter.

The Panama Pacific International Exposition attracted visitors to San Francisco from all over the world in 1915. Mitchell accompanied Braun to the international fair, where the art exhibitions included examples by a host of well-known artists. Alfred was particularly aware of the Scandinavians, whose work he found "fresh and strong and large and wonderful, beautiful and thrilling."[3] At the contemporaneous 1915 Panama California Exposition in San Diego, he entered a large painting, *Coldwater Canyon, Arrowhead Hot Springs* (San Diego Historical Society), which earned him his first silver medal. The Exposition's Art Guild show featured a small landscape which also earned him an award. His work at the time reflected the influence of his teacher: "a stippled, impressionistic style of brushwork and attention to a balanced palette and color scheme."[4] According to the same source, his sketches revealed a more personal quality with

their strong color contrast and direct brushwork. On the recommendation of Braun, Mitchell applied for admission to the Pennsylvania Academy of Fine Arts, and was accepted for the fall term in 1916. The academy, the oldest professional art school in the United States, was considered to be among the finest for the aspiring young artist. At twenty-eight, Mitchell, having achieved a degree of early success as the recipient of several awards and with the sale of some of his works, seemed more mature professionally, and his instructors became colleagues and friends as well as teachers.

The New York City Armory Show of 1913 had introduced radical new styles from Europe that challenged traditional cultural standards and values in the art world. Paris became the Mecca of the young artists. Mitchell, among many, was sensitive to the changes which were occurring as sides were being chosen between the conservatives and the moderns. Of the innovative and new, he wrote: "Many contributions of modernism are here to stay.... No other school, for example, has carried the analysis and scientific use of color as far as have the impressionists. The worthwhile and valuable development will remain."[5]

His work at the time, with its brilliant color, short broken brushstrokes, and strong accent on light effects, is obviously dependent upon the Impressionist style of Childe Hassam, whom the young artist admired.[6] Mitchell briefly adapted the technique of Impressionism, although he did not embrace the deeper implications of the style.

At the academy, Mitchell's teachers represented an eastern American plein-airism. His most influential instructor was Joseph T. Pearson (1876-1951); others were Daniel Garber (1880-1958), Edwin H. Blashfield (1846-1936), Arthur B.

Carles (1882-1952), and Philip Hale (1865-1931). Charles Grafly (1862-1929) was "like a father to the young artist."[7] Although not a teacher at the academy, Edward Redfield (1869-1965) was another artist known to and admired by Mitchell. The novice painter was at the easel daily for three painting sessions of three hours each, beginning at 9:00 a.m. and continuing until 10:00 p.m. Although landscape painting was not a part of the academy's curriculum, students who opted for that subject would bring their work for critique by Daniel Garber, who was primarily a landscape painter.

While Mitchell may have sympathized with the new, he was to remain essentially a realist. In 1937 one reviewer of his work noted that "Alfred Mitchell paints drama too, but in a different way. He paints not nature's moods but her portrait in jewel-like brilliance. Delighting in strong colors, he paints dramatic contrasts rather than subtleties." This preference for strong color pre-dated his entrance into the academy. In a note written in 1964, relating to his ideas on painting, he commented:

"Some years ago, before I went to the Academy, I became interested in painting sunsets and other times of brilliant color. This brought me to realize that I would have to have the most brilliant colors obtainable....So most of my palette consists of strong colors. It is simple enough to make quiet colors by toning them down, but you can't make them brilliant unless you have brilliant colors on your palette.[9]

During the summer break in 1917, Mitchell was back in San Diego helping his parents at their cafeteria. His second year of studies was interrupted by a tour of duty in the army, beginning on 30 April 1918. As a soldier, Mitchell was assigned to duty at Camp McDowell, and shortly thereafter was transferred to Camp Fremont, near Menlo Park, California. His next assignment, with the Military Police of the 12th Infantry Division, was followed by promotion to mess sergeant. He was then stationed at Camp Lee, near Petersburg, Virginia, where he made sketches of his fellow servicemen. Mitchell was discharged on 29 February 1919, and he returned to assist the family business in San Diego once again until the beginning of the academic year, when he resumed his studies in Pennsylvania.

During the academic year 1919-20, Mitchell was awarded the Cresson European Travel Scholarship. At that time he also won the Edward Bok Philadelphia Prize from the academy's annual show. His prize-winning entry *Over the Valley* was purchased by the Reading Museum, and was the artist's first work to enter a major public collection. During the summer break in 1920, the young artist was given an exhibition of his work at Orr's Gallery in San Diego, which received praise from both public and press. His intended travels to Europe were temporarily postponed due to the effects of the recently ended war. It was during this time that Mitchell met Dorothea Webster (1884-1985), daughter of the family physician and the artist's future bride.

In 1921 the artist took advantage of the travel prize he had received, and on 8 July, with three other winners, he sailed for Europe aboard the SS *Haverford.* While at sea, Mitchell painted portraits, including one of the ship's captain, whom he had befriended.

Disembarking in England, Mitchell delighted in the historic sights and cultural institutions of London. In late summer the young artist was in Paris, where he was attracted to the Louvre and Luxembourg museums. He painted some studies of architectural landmarks such as Nôtre Dame and the Capreaux Fountain with quality supplies he purchased in Paris. It was here, too, that he met William Paxton (1869-1941), an eminent Boston artist who joined the group on occasion in touring Paris and its environs by carriage.

In September the students—accompanied by Paxton—were in Italy, where Mitchell credited Paxton "for the great time we are having."[10] From Stresa they continued to Milan, where the Boston painter took his leave of the group. In Florence Mitchell could be found painting views of the city from the hills above. From Tuscany they continued to the cultural centers of Rome, Madrid, and Amsterdam prior to boarding the *Carmania* at Southampton for their return home on 17 October. Mitchell returned to Philadelphia with a newly appreciative eye for the natural beauty of his own surroundings.

Back in San Diego by springtime of 1922, the artist showed thirty-five paintings and a selection of charcoal drawings at Orr's Gallery. From the exhibition, his painting *In the Valley* was purchased by the Marston Company Department Store. The biggest event in the life of the young artist that year, however, was his marriage to Dorothea Webster on 1 July 1922. The couple spent their honeymoon in the rustic community of Julian, where Mitchell painted several works of the picturesque San Diego back country. The area became a favorite retreat for the Mitchells. On their return to San Diego they moved into their first home, a flat at 1620 Seventh Street.

In September Mitchell began a teaching career in the adult education department of San Diego City and County Schools, a career which was to last for twenty-four years (Fig. 22). He also conducted private classes in landscape painting from 1923 until the 1960s (Fig. 23). Mitchell was elected president of the San Diego Art Guild for a two-year term. This organization, founded in 1915, represented the area's practicing artists.

Competent as a painter and a teacher, Mitchell also possessed exceptional administrative abilities, and his efforts made an impact upon the regional art scene. Guilds sprang up in several neighboring cities as a result of his skills as an organizer and artist. In Chula Vista, for example, his class of approximately twenty-five students formed the Art Guild of that community. From the first, he was a frequent exhibitor at their annual shows.

Mitchell was also instrumental in the formulation of the La Jolla Art Association, which began in 1918 when a group

Fig. 22 In room 366 in the San Diego High School and Junior College evening adult class, 1943, Alfred R. Mitchell *(standing right)* assists a student in working from a live model. During the years of World War II, many servicemen joined area art classes. Several are shown here. Photograph courtesy of Mrs. Mary Sadler.

Fig. 23 Alfred R. Mitchell at his easel is joined by his private land-scape class to paint in the open air near Bonita in 1943. Photograph courtesy of Mrs. Mary Sadler.

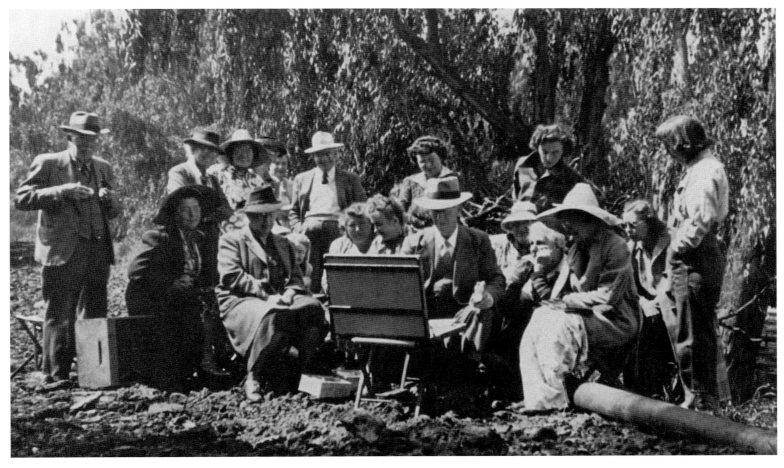

Fig. 24 Open-air art marts were one means of raising funds for artists during austere times. Alfred R. Mitchell *(right)* was the director of the County Art Mart held in 1948. Crowds gather around James Tank Porter, San Diego sculptor, who gave demonstrations. Photograph courtesy of Mrs. Mary Sadler.

of culturally minded individuals met at the home of Miss Ellen Browning Scripps (1836-1932), a community patron of the arts. Later, when the La Jolla Library was constructed in 1921, the association exhibited there. From 1951 to 1961, Mitchell was president of the group for a little less than three terms. He was an annual exhibitor in one-man shows from 1923 for forty-three consecutive years, until 1966 (Fig. 25).

When the Fine Arts Gallery of San Diego, the establishment now known as the San Diego Museum of Art, opened in 1926, Mitchell was among those community leaders who signed the incorporation papers. He had long worked for the realization of a community art museum. The San Diego Art Guild, over which he presided at the time, became a working committee of the museum membership. In the Guild's annual exhibitions held at the museum, the artist was to earn important awards in 1926, 1927, 1931, and 1937.[11]

The 1920s was a golden decade for the artist, as success followed success in sales and exhibitions, although monetary rewards were not always commensurable with critical acclaim. Following his first one-man show in La Jolla, he had a solo showing at the Fine Arts Gallery, located at what is now the south wing of the San Diego Museum of Man.[12] The exhibition comprised oil sketches done in the open landscape and filled with space and bright sunlight—plein-air painting that is identified stylistically with the landscape painting of California of that period.

In 1924 the artist was commissioned to design seven windows in the dining room of the San Diego Hotel; he com-

pleted the contract in one month. He also designed the curtain for the Balboa Theater, although neither of these works was among his most memorable efforts. During the course of 1924 the artist had one-man shows at the San Diego Hotel, in La Jolla, and at the San Diego Museum of Art (New Mexico Building location).

In the spring of 1925 the artist was painting on a small ranch on River Road in Lakeside—the Riverview Ranch near El Cajon Mountain, which had been purchased by his parents. He created a series of pictures depicting the peach orchard in bloom, described by one writer as "perhaps the freest most impressionistic works Fred is ever to create."[13]

Miss Ellen Scripps, a member of the Scripps-Howard publishing empire, purchased a painting, *Mountains in Springtime,* for $900, which gave the artist an economic boost during financially difficult times in 1926. That year, the museum in Balboa Park opened. Mitchell's *Cedar Street* represented him in the museum's First Exhibition of Arts of Southern California. During the year the Mitchells decided to spend some time in the East, attending museums and visiting with Dorothea's family. They planned to stay at least a year. In the East the artist spent a successful winter stint of painting, but it was interrupted by his father's death and the artist returned briefly to the West Coast for his funeral.

By mid 1927, the Mitchells returned to San Diego and moved into a home on Twenty-Ninth Street. Several local one-man shows featured his Pennsylvania winter scenes, marked by a "mellowing palette" and "a greater concern for a

well structured composition" noted by one writer. "The somewhat loose, heavily impastoed impressionism of his earlier works [gives] way to a more closely rendered, keenly observed, yet lyrical realism."[14] In December a group of art enthusiasts acquired *The Delaware Valley* for the San Diego Museum of Art.

Multiple personal tragedies occurred throughout the 1920s for the artist. In addition to the death of his father, a son was still-born. His sister Carrie suffered a nervous breakdown which was eventually to result in her permanent institutionalization, and his mother died in March 1927. The artist seemed to find consolation in his work, however, producing some of his best-known and finest pieces during this period.

Along with Maurice Braun, Charles Arthur Fries, Charles Reiffel, and several others, Mitchell became, in 1929, a member of the Contemporary Artists of San Diego, the professional organization that had originated as the Associated Artists of San Diego, but the death of Leon Bonnet and the unfavorable economic climate of 1929 contributed to the group's demise.[15]

While the Wall Street crash of 1929 had depleted their funds considerably, the Mitchells, nevertheless, spent a snowbound vacation in Julian in 1930, ushering in a year of work in the promotion of the art of Southern California nationally through the Contemporary Artists of San Diego, of which Mitchell was secretary. The group exhibited in San Diego and Pasadena during February, and Mitchell's own annual July show in La Jolla was also rescheduled for February. The sale of thirteen paintings from that one-man show was a much-needed economic boost for the artist. During the 1930s the Mitchells made frequent trips for both business and leisure, including to Palm Springs in 1931, and to the Pacific Northwest in the summer of 1932.

During a 1931 trip to Pennsylvania and New York, Mitchell called upon Susan Eakins (1851-1938), whose husband, artist Thomas Eakins (1844-1916), Mitchell admired throughout his life. In correspondence with Mrs. Eakins, an artist in her own right, the San Diego painter confessed an interest in her husband's "method of study."[16] As a result of the ensuing friendship, Mrs. Eakins offered a painting by her late husband to the San Diego Museum of Art. In 1937 she presented the museum with a life-sized portrait of the well-known American painter James Carroll Beckwith (1852-1917) working at his easel.

From Mitchell's La Jolla show in 1933, John Harrington Cox, president of the University of West Virginia, acquired a scene of El Cajon as a wedding gift for John D. Rockefeller, III (1906-78). A second painting by Mitchell would later be acquired by Cox for another member of the Rockefeller family. A work was also purchased at about this time by the late Mexican president General P. Ortiz Rubio (1877-1963). Correspondence in the gallery archives suggests that the acquaintance of Mitchell and Cox can be traced to 1928 or earlier. Mrs. Cox was a West Virginia representative of the

Fig. 25 Alfred R. Mitchell was an annual exhibitor at the La Jolla Art Association, which he helped form, from 1924 until 1966.
Here, with Dorothea by his side, he is shown at his last exhibition for the Association in 1966. Photograph courtesy of Mrs. Mary Sadler.

artist and sold a number of works for him until her death.[17] Cox collected work by other California artists, including Gardner Symons (1861-1930) and William Wendt (1865-1946). As a memorial to his wife he established the Mrs. Annie Bush Cox Collection of Fine Arts at Ohio Wesleyan University, to which Mitchell contributed a winter scene. The correspondence between the two men ended in 1936.

Attempts to raise funds during these economically depressed times challenged the entire art community (Fig. 24). The first open-air Art Mart held in San Diego proved to be a major undertaking. The site selected was the lawn of the public library, and the event was scheduled to begin on 10 August 1933. Mitchell had been elected to handle the affair. Correspondence between the artist and Miss Cornelia D. Pallister (b. 1899), librarian, indicates that Mitchell was pleased with the results of the three-day display and sale.[18] Three hundred

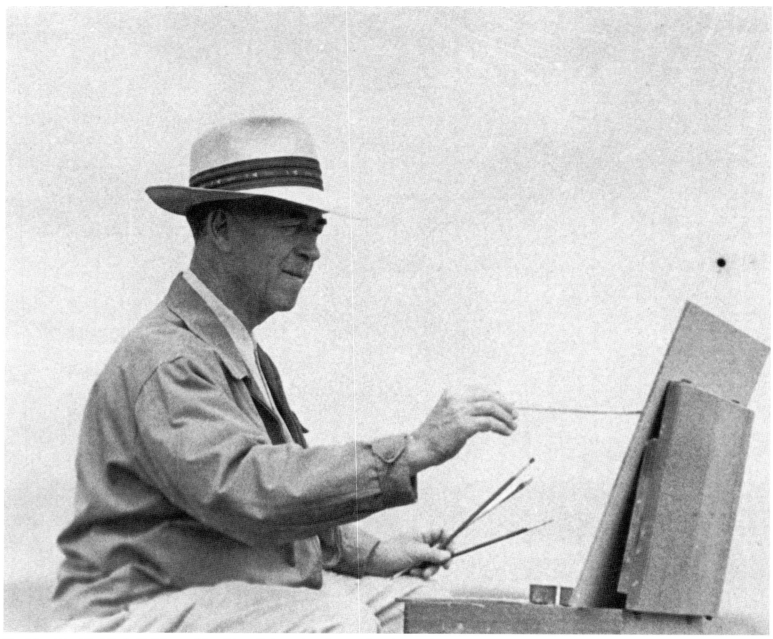

Fig. 26 Alfred R. Mitchell, "Dean of San Diego Painters", at his easel at the seashore.
Photograph courtesy of Mrs. Mary Sadler.

works were sold or bartered. The artist also began several new classes to augment his income. One was a class in Balboa Park, while another was offered in frame-making.

A private showing of forty works in the luxuriant and well-manicured gardens of Mrs. Herbert Evans was another successful event for the artist, and a second show was scheduled for the following year. Busily occupied with classes, exhibitions, and speaking engagements, Mitchell considered an excursion to Yosemite, where he planned his first painting trip to the Sierras, the highlight of 1934.

In 1937 the Mitchells moved into their new home, Deep Heath, on Thirty-First Street. It was designed by two of San Diego's leading architects, Richard Requa (1881-1941) and

Lloyd Ruocco (1907-81), and built in exchange for paintings. Hardware for the new home was cast by Mitchell's colleague James Tank Porter. The Mitchells were to reside here for the rest of their lives. In his workshop at home, the artist prepared frames for his work and that of his contemporaries.

Noteworthy accomplishments of the artist's career during the remainder of the 1930s included awards from the Buck Hills Falls Art Association in Buck Hills, Pennsylvania, and at Laguna Beach, California, where he exhibited *Above the Desert*. His first one-man show in Laguna in 1939 proved advantageous for the artist both economically and professionally, and also in that year he was represented by a work in the Golden Gate Exposition in San Francisco. While honored

to have been asked, the artist declined the directorship of the Kansas City Art Institute.

With the advent of World War II, the community geared up for the war effort. Mitchell's classes were filled to capacity when servicemen joined either to find diversion or to study painting seriously. In 1946, immediately following the war, he was in Washington, D.C., visiting galleries and friends, as he would also do in New York and Pennsylvania. In New York he noted especially the works of Georgia O'Keeffe (1887-1986), attracted by their simple forms and monumental quality. The artist conducted classes for the San Diego Business-man's Art Club throughout the decade. The group, organized by museum director Reginald H. Poland and former mayor Walter Austin, was to develop into the San Diego Art Institute, open to both men and women.

Extended trips continued throughout the remainder of the decade. In 1947 the artist was painting in Arizona and throughout California. The following year Mitchell held an invitational exhibition in his own home of works he had done since 1937. A novel sales gimmick at the time, the presentation resulted in the sale of nineteen works. In 1950 an exhibition of forty works was held in a solo showing at the Laguna Beach Museum of Art.

Mitchell's success continued professionally, but three years later he began to be less active as a teacher in the public school system. In 1953, at the age of sixty-five, Mitchell retired from the San Diego Adult School System. Some of his strongest work was yet to come. During his golden years, the artist continued to travel, paint, and exhibit. In 1956 he re-traced the route his family had taken through California a half-century earlier. His style, during this post-war period,

"…seems to be one of intensely observed realism captured with more careful, but more assured brushwork, and with thinner, more even surface paint than previously applied. The compositions…show his interest in the concept of 'opposites,'….His palette has become denser…in attempt to capture the dramatic and heightened effects of light that he prefers to the softer luminosity of his earlier work."[19]

At about that time he assumed the mantle of Dean of San Diego Painters, which he had inherited from his older colleagues Fries, Braun, and Reiffel. Still life painting became a principal motif during these later years in the artist's life (Fig. 26).

Sales increased markedly from the artist's shows in the 1960s, as society became more affluent. Mitchell continued showing until 1962, when he was seventy-five years old. He virtually retired thereafter as his health began to fail, and in 1970 he was confined to a nursing home in National City, California. He died November 1972, survived by his wife.

With the appearance of a new generation of artists in the community, many of them former students of Mitchell's, the artist's significance became apparent. One unknown writer, commenting on the twenty-eighth exhibition at the La Jolla Art Association, wrote that "His personality has shaped the San Diego Community in no small degree through the many students who have passed through his classes."[20]

Notes

1 The chronology of Alfred Mitchell's life follows that outlined by Thomas R. Anderson in his essay in the exhibition catalogue for the Museum of San Diego History, *Sunlight and Shadow: The Art of Alfred R. Mitchell, 1888-1972*, 18 June to 31 July 1988. This was the first important showing of the artist's work since a memorial exhibition had been held at the San Diego Museum of Art in 1972. No catalogue was published for the 1972 exhibition. In addition to the catalogue mentioned above, a basic reference to the artist is to be found in *Journal of San Diego History* 19 (Fall 1973), 42-50.
2 Quoted in Anderson, *Sunlight and Shadow*, 5.
3 *Ibid.*, 7.
4 *Ibid.*
5 Harold Kerr, San Diego *Evening Tribune*, 21 January 1939.
6 A portrait of the artist's wife, Dorothea, in the collection of the family, bears an obvious connection to Hassam's style. This connection was corroborated in a conversation with the late Mrs. Mitchell in 1973. The influence of Hassam was felt by many American artists at the time, and his presence in San Diego gave local artists an opportunity to meet with him personally in 1927. While staying in Coronado, Hassam produced fifty prints of the Southern California landscape, including scenes of Point Loma and Coronado.
7 Anderson, *Sunlight and Shadow*, 8.
8 Marg Loring, San Diego *Sun*, 16 May 1937.
9 Anderson, *Sunlight and Shadow*, 7.
10 *Ibid.*, 18.
11 The San Diego Art Guild, now called the Artist Guild, originated in 1915 as one of the earliest art organizations in San Diego County. They continue showing yearly at the San Diego Museum of Art. The group comprises the area's working artists.

12 Several sites in Balboa Park were designated "Fine Arts Gallery," or museum, prior to the construction of the present San Diego Museum of Art in 1926. The two prominent locations were the New Mexico Building and the south wing of the California Quadrangle, today called the Museum of Man, which was constructed for the 1915 Panama California Exposition.
13 Anderson, *Sunlight and Shadow*, 22.
14 *Ibid.*, 23.
15 For a brief history of the Contemporary Artists of San Diego, see M. E. Petersen, "Contemporary Artists of San Diego," *Journal of San Diego History* 16 (Fall 1970), 3-10.
16 Correspondence between Mitchell and Susan Eakins is in the archives of the San Diego Museum of Art.
17 Correspondence between Mitchell and Mr. and Mrs. Cox is in the archives of the San Diego Museum of Art. Some of the works sold in West Virginia through the Coxes included *California Poppies, California Coast, The Approaching Spring, Torrey Pines, La Jolla Cliffs* (to Dr. Armstrong), *El Cajon Valley* (to John D. Rockefeller, III), *Autumn in California* (collection of Mrs. Cox), *A Yellow Acacia Tree, Winter Hills, California Winter* (to Mr. and Mrs. T. R. Cowell of New York City and Palm Beach), *Looking through the Trees* (to Winifred Knutt of Morgantown, WV), *Cathedral Point, Crescent Beach* (to Isabel R. Hayes), and *El Cajon in Winter* (to Mrs. Dell Roy Richards).
18 A folio containing the letters, a list of artists represented, results of daily receipts, and other data related to the outdoor Art Mart is in the files of the California Room, San Diego Public Library Main Branch.
19 Anderson, *Sunlight and Shadow*, 31-2.
20 *San Diego Union*, 11 February 1951.

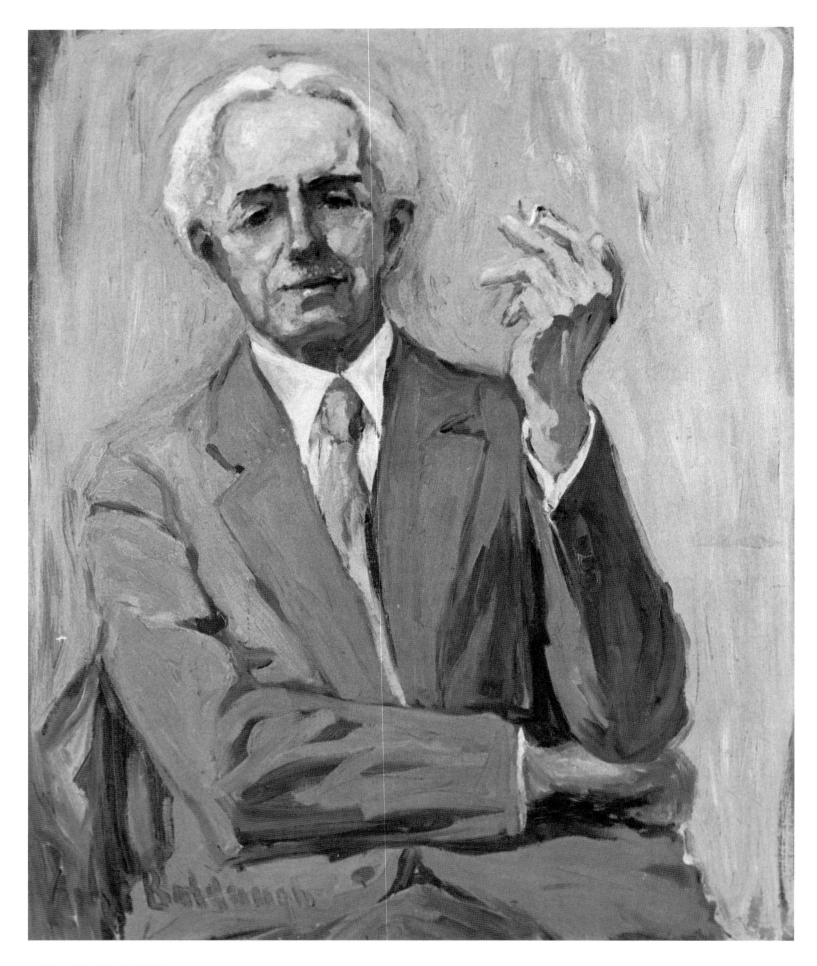

46 *Charles Reiffel*

Charles Reiffel
(1862 - 1942)

An unknown writer observed that Charles Reiffel was already ranked "among America's greatest landscape painters by no less authorities than Royal Cortissoz, Forbes Watson and Henry McBride" prior to his arrival in San Diego in 1925.[1] A few years after he established residency, *Art Digest* referred to him as "one of the foremost painters of the California landscape ... as well as ... an important original figure in American landscape painting."[2] A self-trained painter, Reiffel must be considered among the most original of San Diego's early outdoor artists.

Reiffel was born in Indianapolis, Indiana, on 9 April 1862. It was a crucial time in American history; the nation's political structure was at stake. His father, Jacob Reiffel, a native of Bavaria, emigrated to the United States in the late 1840s. His mother, Nancy Ellen Marshall, was a member of an early American family from Virginia. Tall and handsome, Charles inherited a certain demeanor, a sophistication, that became particularly pronounced in later years. He wore his shock of white hair unusually long as a cosmetic measure, to conceal a disfigured ear.[3] The bearing and manner of the artist were captured by a fellow San Diego painter, Anni Baldaugh, in her portrait of Reiffel completed in 1929, the year he became a member of the board of directors at the Fine Arts Gallery of San Diego[4] (Fig. 28). His distinguished appearance, however, concealed a charm and sense of humor that contemporaries often cite.

Reiffel's early school years in Indianapolis and Kansas City, Missouri, were spent uneventfully, revealing little evidence of the success the artist would achieve as an easel painter in later years.[5] The artist proved the exception to the belief that a professional artist must begin training early in life. A San Diego newspaper informed the reading public that: "He was 56 years old when recognition of his painting, invitations for his work at the large contemporary exhibitions, and collectors calling for his work convinced him that he could devote all his energies to his painting."[6] As a seventeen-year-old, Reiffel entered the workaday world, earning a livelihood by

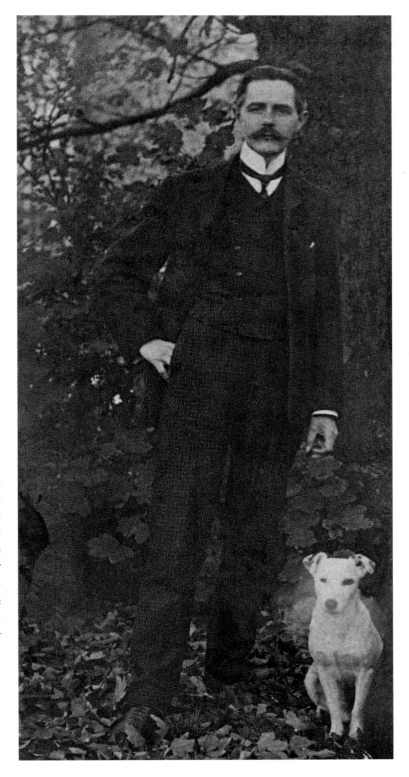

Fig. 27 The bearing and manner of Charles Reiffel has been captured in this portrait by fellow artist Anni Baldaugh (1886 - 1953) done in 1929. Oil on canvas, 30 x 24 inches, signed 1.1., San Diego Museum of Art collection.

Fig. 28 Charles Reiffel during his years in England in the 1890s. Photograph courtesy of George Stern Fine Arts.

clerking in a clothing store. For the next ten years, evidence of future pursuits in art were limited to scrawled ornamental designs of arabesques and scrolls jotted down on the backs of envelopes and on the store's wrapping paper.

The drawn line eventually led to the lithographer's stone. Apprenticed at Stowbridge Lithography in Cincinnati, Ohio, the nascent artist drew other people's designs on stone for theatrical posters. Reiffel was to practice the medium to support himself until he felt secure at making a living as a serious artist.

During these early years as a lithographer in the Midwest, Reiffel became acquainted with American artist Henry G. Keller (1870-1949), who was also employed in the shop (Fig. 29). Later, lured to New York City, the Mecca of most aspiring creative Americans during the latter half of the nineteenth century, Reiffel met yet another future San Diego painter, Charles Arthur Fries, in the printer's shop. The two were to become lifelong friends. At the Central Lithographic Company in New York, Reiffel discovered a demand for American lithographers in England. On 24 November 1891 Reiffel, accompanied by Elizabeth Flanagan (1862-1942), boarded the German-U.S. mail steamship *Lahn* bound for Southampton, for a six-year stay[7] (Fig. 30). At Nottingham the artist was hired by the Strafford Company to create poster designs for English businesses (Figs. 31 and 32). Discovering that his colleagues were practicing artists in their spare time, Reiffel decided to follow their example and began sketching seriously.

During a nine-month vacation spent travelling throughout western Europe and northern Africa, the artist made about five hundred pencil and oil sketches; the locations of most are unknown. He spent three months painting in Tangier and Morocco, according to a form he filled out for a 1934 exhibit at the Chicago Art Institute. He studied with Milwaukee-born Carl Marr (1858-1936) for several weeks at the Munich Academy, where he received his only formal training.[8] His early interest seemed to be in portraiture, but he soon turned to landscape painting as a preference.[9]

The Munich school avoided the hard colors, the dominant outline, and the heroic themes preferred by the Düsseldorf school, also a popular training ground for aspiring young artists attracted to Germany for study. Munich artists sometimes sacrificed subject matter for dazzling brushwork and blended colors, and stressed a unity of rich color and texture dealing with realistic themes. Their bold and loaded brushwork became characteristic of Reiffel's style.

After almost six years in England, the artist returned to Buffalo, New York, where he continued in the lithography business. In 1898 in Rochester, New York, he married his traveling companion Elizabeth, a girl of Irish descent. Late in life, "Frankie," as she was known to friends, was to suffer mental disorders of a paranoid and schizophrenic nature, to the dismay of acquaintances and family. No children were born to the couple, and Elizabeth survived her husband.[10]

In 1904 the Reiffels were living on Prospect Avenue in Buffalo (Fig. 33). Before the year ended, they had relocated to York Street. The 1907 *City Directory* lists the artist at Ft. Erie, Ontario, Canada.[11] A five-year residency there was interrupted for a year in 1908, when the couple was at home on Pontiac Avenue, again in Buffalo. During this period of frequent change, the artist was employed as a poster designer for the Courier Company, a lithography and book binding firm located in Buffalo. Reiffel was also beginning to exhibit seriously, notably his African and European studies.

Exhibiting as early as 1896 with the Buffalo artists, when he showed watercolors completed in Tangier and Morocco, Reiffel was encouraged to submit some sketches to an annual exhibition at the Albright-Knox Art Gallery in 1904. His watercolors, in an exhibition of Moorish subjects at the Academy of Design, had elicited critical praise from one writer who saw the artist as "a man who has a firm hand and an excellent taste in color."[12] Another saw that his works representing Tangier and England "prove Mr. Reiffel the possessor of wonderful versatility, sense of harmony and clear insight into the half-hidden beauties of nature."[13] Six drawings done

Fig. 29 Charles Reiffel, by Henry G. Keller (1870-1949), pencil sketch, 4 x 6 inches, signed l.l., in the collection of George Stern Fine Art.
Photograph courtesy of George Stern Fine Arts.

Fig. 30 Charles and "Frankie" Reiffel during the artist's only European trip spent especially in England during the 1890s.
Photograph courtesy of George Stern Fine Arts.

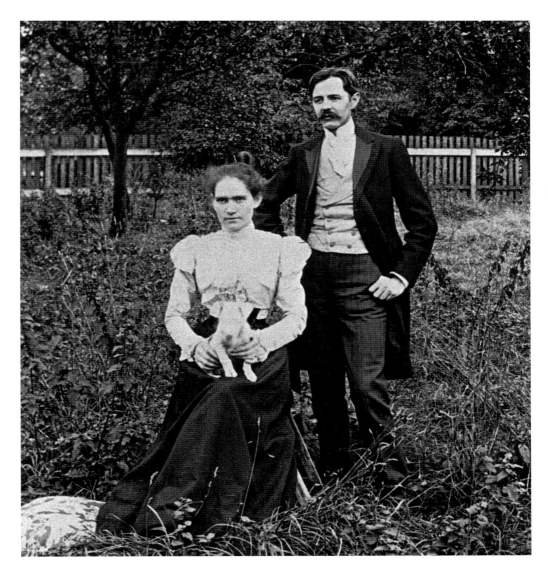

by the artist in North Africa were purchased by the director, Dr. Charles M. Kurtz, prior to the exhibition opening.[14] Critics pointed out the exceptional qualities of atmosphere and light to be found in the treatment of the exotic subjects. An unknown writer, in a review of the show, mentioned Reiffel as "a newcomer [who] has won hearty admiration for four excellent canvases. *On the Coast of Morocco* is a breezy atmospheric study, somewhat impressionistic and full of light, as a foil to his *Evening Market Scene, Tangier.*"[15] The success and sale of his works encouraged Reiffel to paint more regularly. In 1908 his first large landscape, *Moonlight on the Niagara,* won the Buffalo Society of Artists' Fellowship Prize.

Early media accounts referred to the artist as a "painter with strong decorative instincts" and as having "a strong feeling for plastic form" stylistically.[16] His palette of green, blue, and yellow was already established during these early years, and continued to dominate his work through maturity. Reviewers discussed his landscapes in glowing terms within the context of the new styles of Modernism which were influencing the American art scene, especially the work of French Impressionists Claude Monet (1840-1921) and Edouard Manet

(1832-1883). Reiffel welcomed the modern movement. He was attracted to its form and color and felt that "the artist must lend his interpretation to the subject matter."[17] When the Corcoran Gallery in Washington, D.C., acquired his *Railway Yards—Winter Evening* for $300 from its 1909 biennial exhibition of American painting, public taste seemed to prefer winter landscapes over other seasonal motifs.[18] This work compared favorably in its atmospheric quality with that of Monet's railway themes. It was Reiffel's first work to enter a major public collection.

Reiffel's pictures were being singled out for their uniqueness of color and interpretation, the vitality of nature defined in terms of undulating rhythms of line, and energetic brushwork. Leonard Alson Cline, critic for the *Detroit News,* compared his work favorably with that of the American painter John Twachtman:

"A painter of the hills is Mr. Reiffel. The thing that he delights in is the interweaving line with line, the rise and fall of the linear rhythm. It was what Twachtman made a characteristic of his own landscape; the difference between them is a

matter of strength. Twachtman is all delicacy, all vague and tenuous, and subtle and filmy. Mr. Reiffel is entirely in sympathy with the modern tendency toward pure color and light. He is not radical, but is completely contained in the channel through which the broad stream of modern representative painting flows, and within these limits it is that which his best individuality stands out."[19]

In 1908, the year in which Reiffel was elected an Allied Member of the Buffalo Chapter of the American Institute of Architects, he had shown in the Fourteenth Annual Buffalo Society of Artists Exhibition at the Albright-Knox Art Gallery and had received the Fellowship Award for *Early Winter*, yet another winter scene. The following year he sent four paintings to the same show: *Winter Evening in the Railway Yards, Winter Evening on the Niagara River, A Day in November,* and *Autumn on Saint Joseph River.* By this time he was established as a landscape painter, with his work being compared to that of Edward W. Redfield (1869-1965).

Feeling secure at last that he could earn a living as a painter, Reiffel gave up his work at Courier Company after a nine-year association. "At first, revolting against the literal exactness of the lithographic mode, Reiffel automatically became an out-and-out post expressionist."[20] There were to be reviewers who would see the influence upon his style of Paul Gauguin (1848-1903) and Vincent van Gogh (1853-1890).

In 1912 Reiffel, having deserted lithography to devote himself full-time to painting, settled in Silvermine, Connecticut, a part of three townships—New Canaan, Norwalk, and Wilton. A pre-revolutionary rural community bordered by a river of the same name, Silvermine was once the home of the Mohegan Indians and the source of an inferior grade of silver, hence its name. More than a century later, the area's picturesque landscape was the attraction for a generation of artists. Solon Borglum (1868-1922), a nationally recognized sculptor,

was the first to discover the region's natural beauty, and he convinced others to move and work there.

At first, Reiffel was annoyed to discover Silvermine was an artists' colony, when he settled into a home, rented sight unseen, near the river. Later he moved to Wilton, still considered Silvermine, on Beldon Hill. The artist was quickly embraced by the art community, where he was remembered as a "soft spoken man" who expressed his opinion with ease. Henrick Van Haelewyn, a member of the colony who studied with him, recalled that Reiffel "made friends easily" and that a particular friend of the artist was Thomas Herbert Smith. Marguerite Daggy, on the board of the Silvermine Guild of Artists, remembered him vividly and had only good words to say of the newcomer and his work. Reiffel's initial disappointment was soon dispelled, and he became one of the pioneers of the art colony and the first president of the Silvermine Artists Guild upon its incorporation in 1923.

The first artist to establish residency in Silvermine, in 1901, had been Edmund M. Ashe, a well-known illustrator. Others who followed included William A. Boring, the dean of the School of Architecture at Columbia University; Daniel Putnam Brinley (b.1879), a landscape painter; French Academy-trained Howard Logan Hildebrandt (b.1872) and his wife; Frank Townsend Hutchens (b.1869), the director of the School of Painting and Decoration at the Carnegie Institute of Technology and professor of art at Miami University; Austin W. Lord, a student of William Merritt Chase; Addison T. Miller (1860-1913); and William A. Shackelton. The art community continued to grow, with a steady influx of talent when Hamilton Hamilton (1847-1928), Lowell Brige Harrison (1854-1929), Francis Raymond Holland (b.1886), and Frederick Coffray Yohn (b.1875) settled there.

Painter Carl Schmidt (b.1889), a student of Emil Carlsen (1853-1912), who remembers Reiffel as "blossoming during his Silvermine years," was also among the early residents.

Fig. 31 A poster designed for the Great Central Railway by Charles Reiffel from his European years. The organic forms, sinuous line, and decorative border link the work to the Art Nouveau style of the era, a golden age of poster production by artists such as Lautrec, Mucha, and Chéret.
Photograph courtesy of George Stern Fine Arts.

Fig. 32 A sheet music cover designed by Charles Reiffel in 1901.
Photograph courtesy of George Stern Fine Arts.

Schmidt has only praise for Reiffel's work, which he feels expressed a "lyrical form" admired by other colleagues. Like Schmidt, Solon Borglum respected Reiffel's "experimental work," which demonstrated a concern in its "diversity" in painting, crayon, and pastel. The sculptor considered Reiffel "a coming great artist, and an artist with a great future ahead of him."[21] There were about thirty-five artists in Silvermine at the time of Borglum's death.

As early as 1904, local artists had initiated informal gatherings in the studio of Solon Borglum each Sunday morning. There was no fee for being admitted as a member of the Knockers Club (as they labelled themselves); membership was granted only by unanimous vote. Participants were required to bring their week's work to the studio for critique and discussion.

Each fall between 1907 and 1920, the Silvermine group held thirteen annual exhibitions which were widely publicized. They became showcases for the developing reputations of the colony of artists, including Reiffel. Eventually, the need for a larger exhibition space and a permanent home for all the group's activities prompted members to acquire a large barn on Silvermine Avenue, which they converted into attractive galleries now accommodating the Silvermine Guild for Artists.

During his Silvermine years, with steady cadence, Reiffel's reputation as an important and promising artist developed through exhibition activities scheduled in major cultural centers in the East and Midwest. Indiana still claimed him as a native son, and he continued to show in that state.

Between 1914 and 1918 Reiffel exhibited at the MacDowell Club, introducing him to the New York public. In an unidentified clipping, one reviewer noted, "Charles Reiffel is another painter with strong decorative instincts.... He has, however...as strong a feeling for the plasticity of form, the realization of it has come to him in the guise of discovery."[22] He also showed at the John Herron Art Institute in Indianapolis, at the Art Institute in Chicago, and at the Panama Pacific International Exposition of 1915 in San Francisco. Robert Henri (1865-1929), arguably the leading painter at the time, invited Reiffel to exhibit in San Francisco. Subsequently, Reiffel's name was frequently linked in the media with those of the Henri circle of painters that included George Bellows (1882-1925), Ernest Lawson (1873-1938), and John Sloan (1871-1951). Reiffel exhibited two works with the Society of Independent Artists in each of the years 1917 and 1918.[23] Henri had found something original and modern in Reiffel's work, heralding a freshness of vision of the American landscape.

Awards and honors were becoming commonplace for Reiffel. In 1917 he won the Norman Wait Harris Silver Medal at the First Annual Modern Exhibition at the Art Institute of Chicago, where he had submitted *In the Hills* and *Squatter's Farm.* In 1919 the artist was elected a member of the Salmagundi Club in New York City, and 1920 brought with it more

Fig. 33 Charles Reiffel shown during his Buffalo days, with sketchbook in hand. Photograph courtesy of George Stern Fine Arts.

awards to Reiffel for works submitted to the Buffalo Society of Artists, as well as a showing at the Connecticut Adacemy of Fine Arts.

Reiffel had his first one-man exhibition in Detroit at the John Hanna Galleries on Jefferson Avenue in 1921. Of his solo showing at the Dudensing Gallery, New York City, the following year, Penelope Redd wrote in the *Pittsburgh Post* of him that, "more than any other landscape artist with whom I am familiar [Reiffel] continues to render a landscape real and at the same time make it a living transcript of nature."[24] In 1922 the artist received still another Honorable Mention for *Summer Design,* described later as "Reiffel at his best."[25] He

was also included in a group exhibition at the Ebell Club in Los Angeles.

The year Reiffel was elected first president of the incorporated Silvermine Artists' Guild, he was again exhibiting on the West Coast. From the Los Angeles County Museum he won the Hatfield Gold Medal for *Summer Design*, and the following year he was exhibiting with the Silvermine Group at the Ehrich Gallery in New York City. The artist had submitted *Arcady, September*, and *Mid-summer Day* for display. Chosen as one of seventy-four artists to be included in the Venice, Italy, international exhibition in 1924, Reiffel was represented by *Arcady*, which he had exhibited in the First Pan-American Exhibition held in Los Angeles.

In 1925 Reiffel was the recipient of the Daniel Rhodes Hannah, Jr. Prize for his work in the Hoosier Salon in Chicago. It was late in the year that the artist and his wife planned a leisurely trip through New Mexico and Nevada with intentions of spending a year in Santa Fe at the artists' colony there. Avoiding a storm, they followed a circuitous route which led them to San Diego in November, where they settled temporarily in an old Victorian house on the Beck Ranch near East San Diego, intending to stay only for the winter months. The Reiffels succumbed to the environment, however, and the months turned into years. They were to remain for the rest of their lives, and Reiffel was to play an important role in the community's developing art and cultural scene.[26]

Reiffel immediately became associated with the group of artists devoted to interpreting the California landscape. His first painting completed in California was *Mountain Road*, depicting a trail in East County. Arthur Millier, critic of the *Los Angeles Times*, viewed the landscape this way:

"… a vehicle for colored light, its forms emerge and disappear hourly as the sun's rays touch from new angles.

The typical landscape painter in this group approaches his subject with the same honesty which characterized the men of that earlier group, the Hudson River School. While they, however, sought to portray the facts of earth confronting them, the southern Californian seeks a true portrayal of the brilliant light which transfigures his scene. Even without a French Impressionist movement this tendency would probably have developed spontaneously from the nature of the land and the climate."[27]

One writer saw an increased vigor in Southern California landscape paintings concurrent with the arrival of Reiffel. "Reiffel comes to us, not as another painter of pretty pictures, but as a real artist who has a rare and intelligent appreciation of what a picture should be… he does create, and is not merely an imitator of nature."[28] A San Diego painter and art writer observed that:

"he paints an aspect of our scenery that other artists have overlooked. It is not the pleasantest spot that his eye searches out, not the sheltered and shaded nook where the sun shines in peaceful security, but the open places where a bit of vegetation struggles to keep its hold upon a rocky slope, or where a homesteader is trying to gain a foothold in a mountain valley."[29]

During 1926 Reiffel exhibited frequently both in the area and elsewhere. In the local Fine Arts Gallery of San Diego, which had just opened its doors, he showed *El Capitan, My Neighbor's Garden*, and *Across the Canyon* in the First Artists of Southern California Exhibition. That year, as a juror of the museum's Seventh Annual Exhibition of Painters and Sculptors of Southern California, Reiffel's invited entry, *My Neighbor's Garden*, won the Art Guild Prize for best painting. Locally, Reiffel was also showing twelve paintings at the studio gallery of Payson Ames, a former resident of Silvermine. Elsewhere, the artist exhibited in Wilton, Aurora, and Chicago. He was invited to exhibit in the Sesquicentennial Exhibition in Philadelphia. At the second Hoosier Salon, held in the Marshall Field Art Gallery in Chicago, he entered *Across the Valley, Rockport*, and *Norwalk River in Winter*, and was awarded the Thomas Meeker Butler Prize. The Los Angeles County Museum awarded Reiffel the Preston Harrison Prize for his entry in the exhibition of Southern California Artists.

The artist repeated his earlier success in the Second Exhibition of Artists of Southern California at the Fine Arts Gallery of San Diego, winning the P. F. O'Rourke $500 Purchase Prize for *In San Felipe Valley* in 1927. He had also submitted *The Bay* to the show. In the third annual Hoosier Salon, he had shown *La Jolla Shore, Midsummer*, and *Autumn*. That year, Stendahl Galleries held the first one-man exhibition Reiffel had in Los Angeles.

Reiffel was more in demand than ever in 1928, not only as an exhibitor but also as an administrator and juror. During the year he was elected president of the San Diego Art Guild, an organization of the community's practicing artists. He was re-elected to the position the following year.

His exhibition calendar continued to offer a full schedule. The artist was represented in exhibitions in Washington, D.C., Chicago, Phoenix, and Los Angeles, in addition to San Diego. Honors were heaped upon Reiffel once again. His entry at the Phoenix State Fair won the $75 second landscape prize. *Mountain Ranch after the Rain* earned him the $250 Mrs. Keith-Spaulding Prize when it was exhibited at the Los Angeles County Museum in the California Art Club's Nineteenth Annual Exhibition. For the Corcoran Art Gallery's Centennial Exhibition, Reiffel sent *Morning, Nogales, Mexico*. When the picture was illustrated in the catalogue, Elizabeth was quoted as saying that this was the first compensation she had had for the terror of being thought a smuggler when her husband had wandered from the path to get his subject.[30]

In San Diego the artist exhibited in private galleries as well as at the Fine Arts Gallery. At the Little Gallery on Fourth

Street, he shared a show with Elliot Torrey. The Art Guild was featured in its annual exhibition at the museum in November. Reiffel's entry, *In Banner Valley*, was seen later in the newly opened Cuyamaca Club, where it was considered a permanent acquisition. The artist was also featured in a solo show at the local museum. In November 1928 Reiffel was asked to arrange and participate in an exhibition of Southern California art for the Tucson, Arizona, Art Association, which opened in Tucson in January 1929.

The success of *In Banner Valley* continued into 1929. Not only was it an acquisition prizewinner in the California Art Exposition sponsored by the Santa Cruz Art League, but it was also an entry in a circulating exhibition of work by Southern California artists shown in a number of western museums under the auspices of the Western Museum Directors Association.

Reiffel continued exhibiting throughout the Midwest at major cultural centers, in addition to the West Coast, including the Columbus Gallery of Fine Art and the John Herron Art Institute, where his *Morning, Nogales, Mexico* won the Art Association first prize. At home, the Fine Arts Gallery, where he had been elected a trustee, featured twenty-two of his works in a solo showing.

Late in 1929 Reiffel joined with ten local painters and sculptors to form the Contemporary Artists of San Diego (originally called the Associated San Diego Artists), with the intention of gaining wider recognition for the San Diego art community. This was the first serious San Diego professional artists' group, and they exhibited together for six years until the death of Leon Bonnet in 1936. During the first year they opened a downtown sales room which, for economic reasons, was short-lived.[31]

The first exhibition of the Contemporary Artists of San Diego, held at the San Diego Hotel and later shown at the city's museum, was only one local exhibition in which Reiffel participated in 1930. His work could also be seen in La Jolla; in Sacramento, where his *Silo* was awarded first prize; in Pasadena, where a similar award was conferred upon him for *In Palm Canyon*; and in Los Angeles, at the Biltmore Galleries, where he was awarded a gold medal for an entry in the Painters of the West Exhibition. His appointment to the Acquisition Committee of the Fine Arts Gallery of San Diego in 1930 did not affect his activities as an exhibiting artist. The success he achieved that year was to endure throughout the decade.

The artist was the recipient of awards for works in out-of-state exhibitions during the 1930s. Just a few examples of his success outside of California included entries in Phoenix, Arizona; Richmond, Indiana, where his *Mountain Road* won the Mary R. Falk Award; and Chicago, where the Hoosier Salon included the paintings *Mountain Ranch, After the Rain*, and *Morning, Nogales, Mexico*.[32] Reiffel's yearly entry in successive exhibitions with the Hoosier Salon in Chicago continued to earn him distinction and honors. For example,

in 1932 he won the Thomas Mac Butler Memorial Prize for *Mountain Dairy*, while his *Morning, Nogales, Mexico* received the $500 Shaffer Award in 1938.

In 1933 the painter was one of many United States artists employed by the federal government under the Civil Works Administration for a six-week period, for a salary of forty-two dollars a week. In an exhibition of works by CWA artist affiliates held in the local museum in 1934, Reiffel showed *Homesteader's Ranch, Southern California; Mountain Road*; and *Road in the Cuyamacas*.

Later in 1934 the San Diego Chamber of Commerce honored Reiffel with a resolution for his achievements during his fewer than ten years in the community:

"Whereas the artists of San Diego were displaying the work of Charles Reiffel on Friday of this week as a tribute to his dedication as a painter and in recognition for his rich contributions to the artistic community, the Chamber of Commerce takes this occasion to congratulate him and San Diego.

Charles Reiffel has won many honors throughout the country for his pictures of this region. He has been conspicuously successful in expressing the native landscape on canvas, an inspiration to other painters and a kindly advisor to all who sought his aid.

On behalf of the businessmen of San Diego we offer this resolution as grateful tribute to his accomplishments as an artist and to his helpfulness and courage as a man and citizen."[33]

The resolution by the Chamber and a concurrent exhibition of his work at the Art Cellar, the studio/gallery of painter Foster Jewell (b. 1893), were offered in some measure as a supportive gesture on the part of the community for an injustice to him and other local artists when the Board of Supervisors refused to adopt a resolution requesting that revenue assessor James Hervey Johnson (d. 1989) stop taking into account painters' unsold works.[34] This issue had been in contention for several months amid accusations of politicizing and unfair practices. The media sided with the artists. State Senator William E. Harper told a group of painters and authors that the rules of taxation would be changed. Foster Jewell threatened a national campaign against the action through his brother, Edward Alden Jewell, art critic for the *New York Times*. Most artists ignored the assessor's deputies. Reiffel, unfortunately, became a test case when two of his canvases were seized. Philosophically, he told the press, "Let him [Johnson] try to sell 'em! ... He'll do better than artists themselves."[35]

To augment his income during the lean years of the 1930s, Reiffel joined the ranks of those artists who held classes. To help raise funds—should financial support be needed in defense against the assessor's action—students and friends arranged an exhibition at the Art Cellar. Among the students who had charge of the show were Martha Thompson Forward (1889-1970), Sarah Truax (1872-1959), Leda Klauber (1881-1981), and Rose Schneider (1895-1976). The San Diego Mu-

seum of Art added its support by offering Reiffel a one-man show of recent works.

The issue of the unfair taxation of unsold works of art was apparently resolved and was quietly relegated to pages of forgotten history. There is no written evidence of the ultimate disposition of Reiffel's case, but one writer pondered the fact that the Art Guild had failed to support those ensnared by the tax situation.[36] Perhaps Reiffel's national reputation made him a more vulnerable target than lesser-known artists. Johnson "was very much surprised to learn of the existence of the Guild and had apparently not intended to discriminate unfairly. His ignorance was due to the fact that the untaxed members had kept very quiet in the thought that by so doing they would escape taxation. They, therefore, left the taxed minorities to wage the fight alone."[37]

As a member of the museum's board of trustees and of the Guild, Elizabeth Sellon (1896-1986) had been asked by gallery director Reginald H. Poland to take up the issue with the Guild, according to the 18 June 1935 minutes of the meeting of trustees. There are no later indications of their decisions. Poland had sent a comprehensive statement about the issue to *Art Digest* and to the International Association of Art Museum Directors, who unanimously voiced their disapproval of the assessor's stand. Apparently the San Diego artists won their case.

The San Diego Art Guild, later called the San Diego Artists Guild, was only one of a long list of professional organizations to which Reiffel belonged. Others included the Allied Artists of America, the American Federation of Arts, the Art Club of Washington, D.C., the Chicago Galleries Association, the Cincinnati Art Club, the Connecticut Academy of Fine Arts, the Indiana Federation of Artists, *Internationale des beaux-arts et des lettres*, the Laguna Beach Art Association, the New Canaan Art Club, the North Shore Art Association of Gloucester, and the Salmagundi Club.

In 1935, as a State (of California) Emergency Relief Administration (SERA) artist working with the county schools, Reiffel was presenting demonstrations on the use of the wax crayon in public schools, having made use of this medium since his early years in Silvermine. His unique treatment in handling wax crayons involved heating them in an oven to blend and fuse the colors.[38]

His exhibition schedule did not abate locally or elsewhere during 1935. In January Reiffel—along with two other San Diego artists, Maurice Braun and Anni Baldaugh—was represented in the First Exhibition of the Academy of Western Artists in Los Angeles. The academy comprised a roster of distinguished American painters that included Paul Lauritz (1889-1975), Carl Oscar Borg (1879-1947), Maynard Dixon (1875-1946), Nicolai Fechin (1881-1955), Armin Hansen (1886-1957), Frank Tenney Johnson (1874-1939), and William Wendt (1865-1946).

In 1936 Reiffel applied for a studio in Spanish Village, a complex of artists' studios located in Balboa Park. That year he had moved to Orange Avenue. Honored by the Unitarian Church in San Diego, Reiffel gave the membership *Wilton Lake*, painted while he was living in Connecticut. During the year, Reiffel served as pall-bearer for his colleague, Leon Bonnet. Later in 1936 an invitation was extended to Reiffel to enter the Fourth Annual California Landscape Painters Exhibition in Los Angeles. The show was sponsored by the Los Angeles Foundation of Western Art. Also in that year, the artist executed murals for San Diego High School and Lincoln High School. These were the first of the mural-sized commissions he was to receive throughout the rest of the decade.

The next year, Reiffel's scenes of San Diego Harbor and the back country, each 10 feet by 11 feet in size, were installed in the school auditorium at Memorial Junior High School.[39] In 1939, twenty-six works by Reiffel were presented to the city by the Public Art Project. They were valued at about $14,000, according to local media.

In 1940, in a collaborative venture, Reiffel was working on three large murals to decorate the council chambers at the Civic Center. The subject was historical San Diego: colonial, past, and present. Two painters, Reiffel and George E. Rhone, had submitted the winning sketches, thematically informed by the discoverer of San Diego, Juan Rodríguez Cabrillo (d. 1543), and the city's developer, Alonzo Erastus Horton (1813-1909). With the announcement of the selection of artists, the council received instant criticism. Controversy and public art seemed inextricably linked.

However, a more astute critic of the chamber murals felt they looked "very well in their niches. The color is harmonious with the wood paneling of the room and they have a certain lightness and gladness about them that makes them look pleasant."[40] The unknown writer detected, however, a disparity in the collaborative effort, noting that "it takes all the spontaneous power that Reiffel has to overcome the lack of just that quality of life and vitality in the Rhone figures. However, the whole, the composite, will serve very well, lending plenty of color and activity to the chamber."[41]

The council accepted the murals reluctantly. The artists could only smile tolerantly as Mayor P. J. Benbough attempted to take a diplomatic stance in their defense by admonishing members that "spectators don't come to criticize the murals: they come to criticize the mayor and the council...."[42] Criticism ranged from stiffness of figures to illogical perspective.

Criticism, neglect, and rejection seemed Reiffel's lot as a muralist. Most of the buildings for which his commissions were intended have succumbed to progress, and the works have been lost or are in a state of neglect. He did have a brighter moment in 1940, however, when he was selected to be included in the American art section at the Golden Gate Exposition in San Francisco.

The success Reiffel enjoyed in the East eluded him during his last fifteen years on the West Coast, even though he con-

tinued to win many important awards in major California and West Coast shows. Here, it should be noted, the artist produced the largest portion of his life's work as a serious painter. The Modernism and originality cited by writers, which made him so noteworthy in eastern art circles, was apparently a drawback in the West. His work was often considered "too modern," and his colleagues helped to support him by purchasing works out of friendship. He also bartered for goods and services. Reginald H. Poland expressed his support of Reiffel early on, and wrote a critique of one of the artist's museum exhibitions for the local press, in which he addressed the artist's lack of appeal and popularity with the general public.[43] Despite the paucity of local sales, however, Reiffel continued to earn many significant honors until his death.

The artist died in San Diego on 14 March 1942, one month before his eightieth birthday. A retrospective exhibition, intended as a celebration of his birthday, became instead a memorial tribute. It was shared with the Indianapolis Art Museum. From this memorial exhibition, the artist's work *Morning, Nogales, Mexico*, done in 1928, was purchased by his friends for the permanent collection of the Fine Arts Gallery of San Diego. "Artists love it for the quality of its texture and fine organization of the subject as much as the joy of the artist in the early morning when he was returning into California after a motor trip."[44] The picture had earned an impressive list of honors and had been frequently loaned to major museums for exhibition.

Reiffel had found his greatest inspiration in the landscape of America's Southwest.

Notes

1 *San Diego Union*, 14 November 1929. Cortissoz, McBride, and Waston were leading art critics of the day.
2 *Art Digest* (July 1928).
3 Conversation with the son of American artist Henry G. Keller.
4 *Portrait of Charles Reiffel*, oil on canvas, 30" x 24", signed (52 : 4); collection of the San Diego Museum of Art.
5 It is only in an essay in the catalogue of Reiffel's memorial show that one finds mention of a residency in Kansas City.
6 Hazel Boyer Braun, San Diego *Tribune-Sun*, 21 March 1942.
7 Elizabeth is listed on the passenger roster as E. Reiffel.
8 The time spent in Munich at the academy differs among sources. Most agree it was less than six weeks. See, for example, San Diego *Sun*, 21 September 192[9?].
9 An unidentified article in the artist's scrapbook, Stern Collection, mentions that "he began to paint people about him" at the start of his career. Few portraits are known.
10 While some sources have indicated that he was survived by his wife, other obituaries list only his brother and a nephew. There were also eight cousins in Cincinnati.
11 An unidentified article in the artist's scrapbook, Stern Collection, dateline Niles, Michigan, suggests that the artist's stay here was of a business nature. "Charles Reiffel of the National's staff of artists left for F. Erie, Ontario...." Another item stated that "Charles Reiffel is in Erie on business, but between times is busily painting for the Autumn Thumb-box exhibition by the Society of Artists and his studio at Erie Beach contains in addition several larger canvases that represent this growing artist at his best."
12 Unidentified article in the artist's scrapbook, Stern Collection.
13 Unidentified article in the artist's scrapbook, Stern Collection.
14 Unidentified article in the artist's scrapbook, Stern Collection. This piece states that the son-in-law of President Harrison bought Reiffel's first work and encouraged him in his career.
15 Unidentified article in the artist's scrapbook, Stern Collection. An unknown reviewer; the article is identified by the word "BUFFALO," written in pen.
16 Unidentified article in the artist's scrapbook, Stern Collection.
17 Harold Kerr, San Diego *Evening Tribune*, 23 January 1939.
18 R. H. Ives Gammell, *Dennis Miller Bunker* (McCann, Inc., New York, 1901), 57.
19 Quoted from *Charles Reiffel, A Memorial Exhibition of his Paintings*, catalogue of the show at the Fine Arts Gallery of San Diego, June 1942.
20 *San Diego Union*, 29 December 1935.
21 Letter from Borglum's daughter, Mrs. Monica Davies, who knew the artists well, to M. E. Petersen, 6 August 1988.
22 Unidentified article in the artist's scrapbook, Stern Collection.
23 See Clark S. Marlor, *The Society of Independent Artists: The Exhibition Records* (Park Ridge, New York, 1984).
24 Unidentified article in the artist's scrapbook, Stern Collection.
25 Reginald H. Poland, *San Diego Union*, 10 November 1929. The picture was acquired by the San Diego Museum of Art.
26 Reiffel may have been acquainted with a number of the San Diego artists prior to his arrival. He knew Fries from his lithography days in the Midwest and the East. He could have known Otto Schneider from his Buffalo days, since both exhibited with the Society of Artists at the same time. Maurice Braun had worked in Silvermine during the 1920s and undoubtedly the two met. Reiffel was known to the West Coast since he exhibited there as early as 1915.
27 Arthur Millier, Introduction, *A Private Collection by Some Living Artists of Southern California (the Henry C. Bently Collection)*, 1929, 9. The collection was shown in exhibitions in Columbus, Tucson, and San Diego.
28 E. Dwyer, "The Art of Charles Reiffel," *Argus*, April 1929, 20.
29 Esther Barney Stevens, San Diego *Evening Tribune*, 2 November 1929.
30 Quoted in Hazel Boyer Braun, San Diego *Tribune*, 17 November 1928.
31 For a brief history of the Contemporary Artists of San Diego, see M. E. Petersen, *Journal of San Diego History* 4 (Fall 1970), 3-10.
32 Julia T. M'Garvey, *San Diego Union*, date unknown [25 May 1935?]. Article in the scrapbook of Martha Miles Jones, San Diego artist, relating to Los Surenos Art Center.
33 As quoted from the *San Diego Union*, 4 November 1934.
34 James Hervey Johnson was to become the publisher of the nation's oldest newspaper, *The Truth Seeker*, thirty years later. When he died of cancer in 1988 at the age of eighty-seven, he was a rich but lonely and cantankerous old man. He left an estate estimated at about $18 million, although he lived meagerly. His lifestyle suggests that he was miserly, interested solely in money and the staunch advocacy of atheism. Reference: *San Diego Union*, 23 October 1988.
35 San Diego *Sun*, 31 October 1934.
36 *American Magazine of Art* 11 (November 1934), 609.
37 *Ibid*.
38 Letter from Carl Schmidt to M. E. Petersen, 20 February 1989, notes the uniqueness of Reiffel's method of using crayon.
39 These murals are preserved in the collection of the San Diego Historical Society.
40 Unidentified newspaper clipping in the archives of the San Diego Museum of Art.
41 *Ibid*.
42 *San Diego Union*, 4 April 1940.
43 Reginald H. Poland, *San Diego Union*, 10 November 1929.
44 San Diego *Tribune-Sun*, 23 August 1943.

C.A.Fries

Charles A. Fries
1 *Capistrano at Mussel Cove,* 1896

Charles A. Fries
2 *San Diego Bay*, c. 1904

Charles A. Fries

3　*Looking Down Mission Valley in Summer,* c. 1905

Charles A. Fries
4 *San Diego River Gorge, c.* 1905

Charles A. Fries
5 *San Diego Bay—Foot of Grape Street,* 1906

Charles A. Fries
6 *Foot of A (Street),* 1908

Charles A. Fries
7 *Evening Effect near Mirmar, c.* 1910

Charles A. Fries
8 *Eucalyptus Grove—Balboa Park before the Exposition, c.* 1910

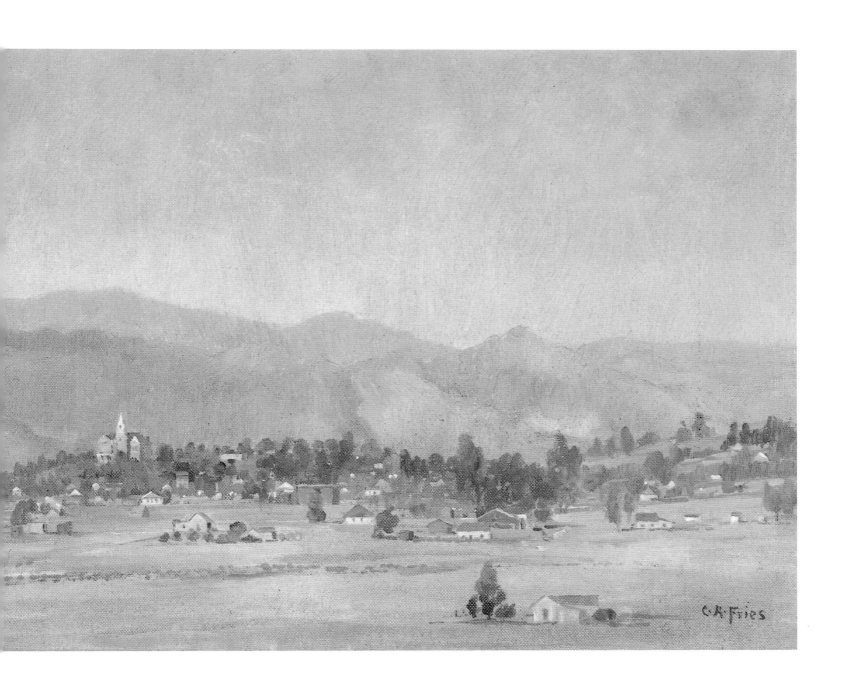

Charles A. Fries
9 *Town of Escondido, c.* 1910

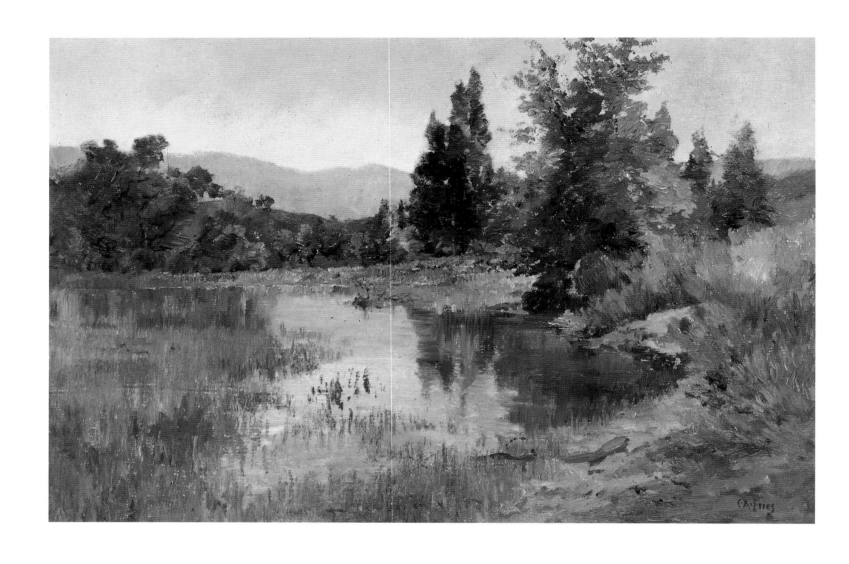

Charles A. Fries
10 *Lake from Honey Springs Ranch, c.* 1911

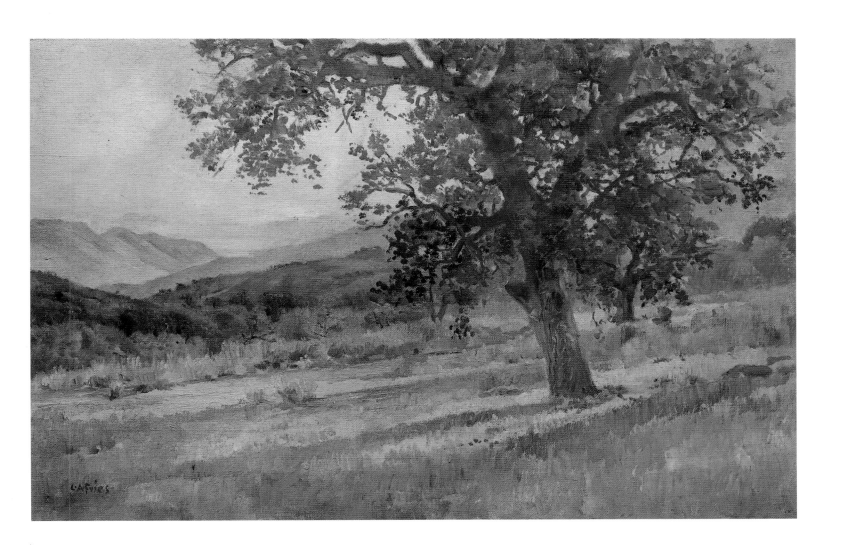

Charles A. Fries
11 *Evening from Mesa Grande, c.* 1920

Charles A. Fries
12 *Desert and Mountains, c.* 1918

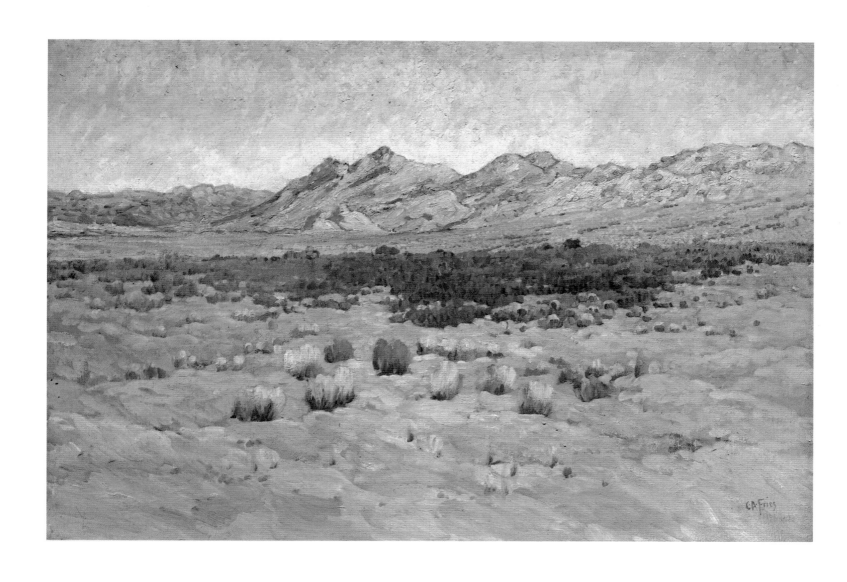

Charles A. Fries
16 *In the Light, c.* 1925-6

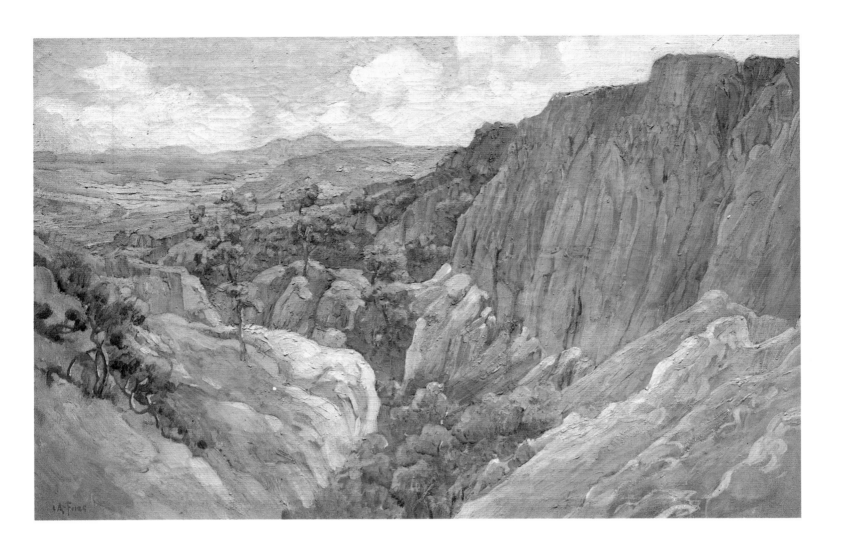

Charles A. Fries
15 *Painted Gorge at Torrey Pines*, 1919

Charles A. Fries
14 *View from My Tent on Pine Hills*, c. 1918

Charles A. Fries
13 *Balboa Bridge, c.* 1916

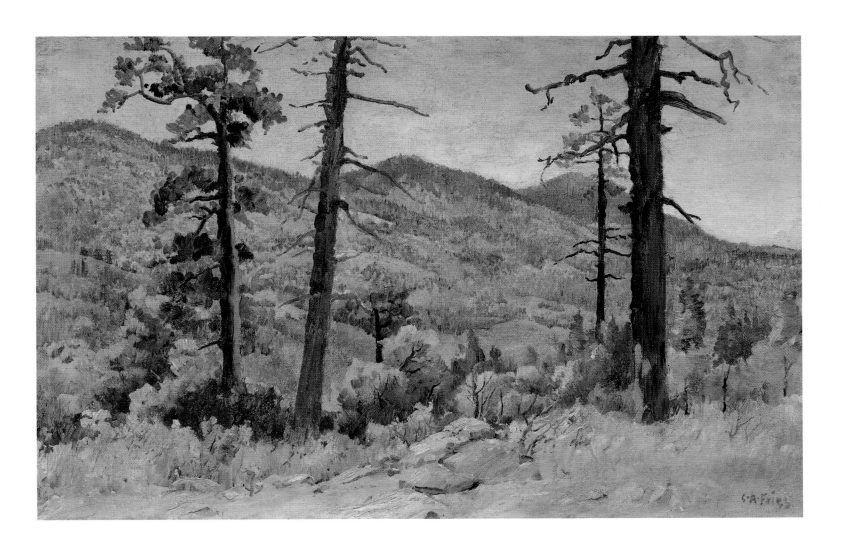

Charles A. Fries
17 *Cuyamaca Mountain from Gilmore Point, c.* 1925

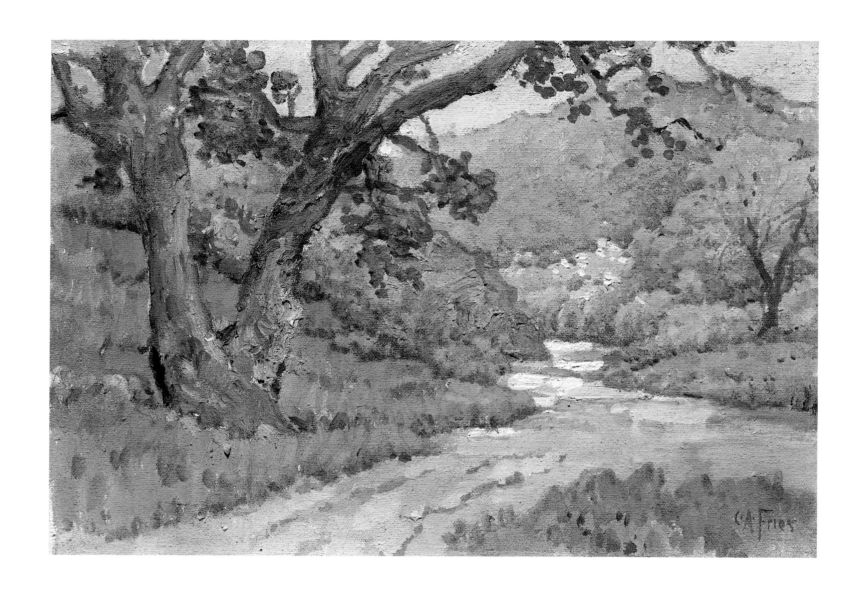

Charles A. Fries
18 *Oaks at El Monte Park, c.* 1925

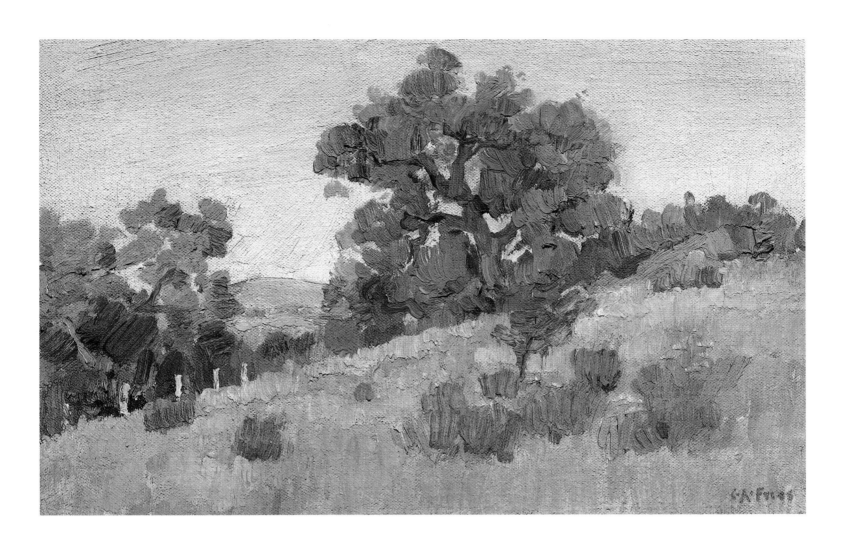

Charles A. Fries
19 *Afternoon Light, c.* 1925-30

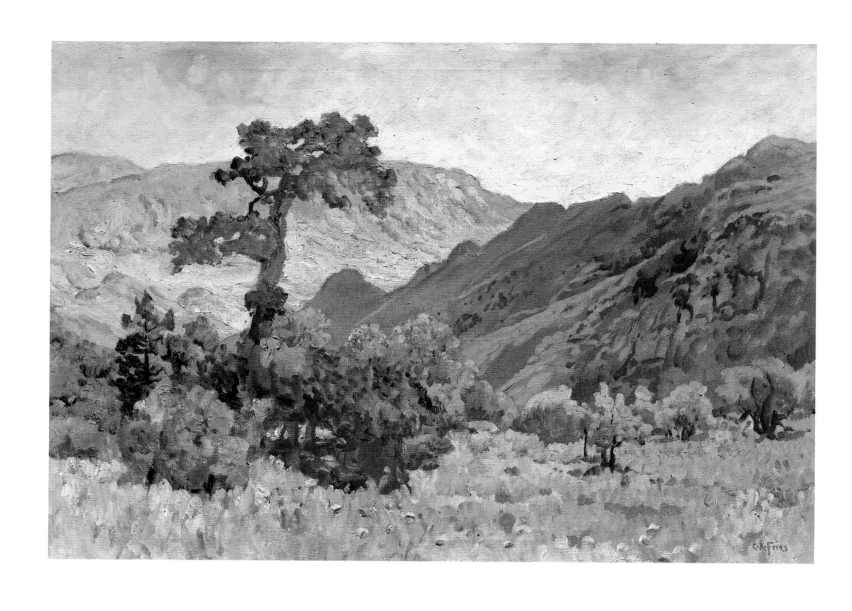

Charles A. Fries
20 *Desert from Vallecitos Point, Laguna Mountain Resort, 1928*

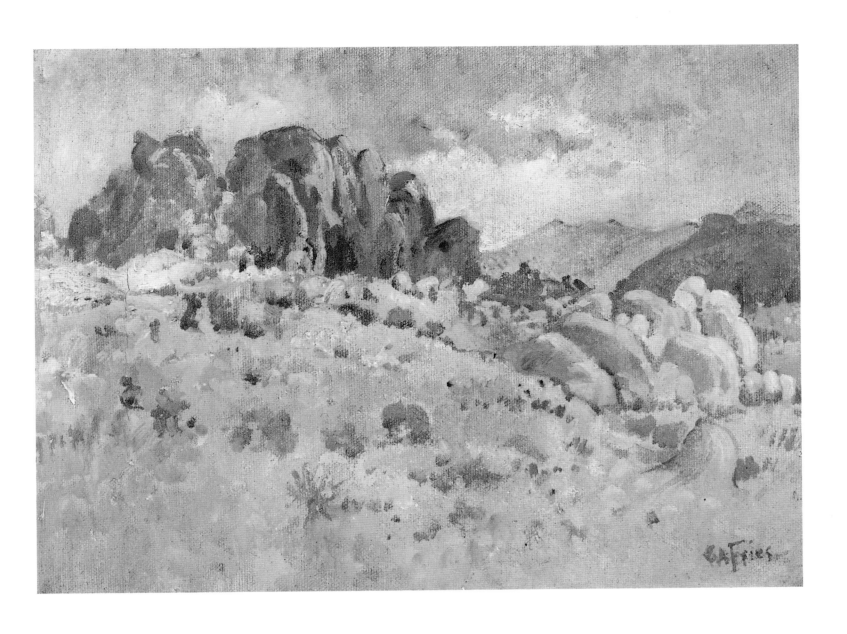

Charles A. Fries
21 *Cliffs of the Ragged Rocks, c.* 1930

Maurice Braun

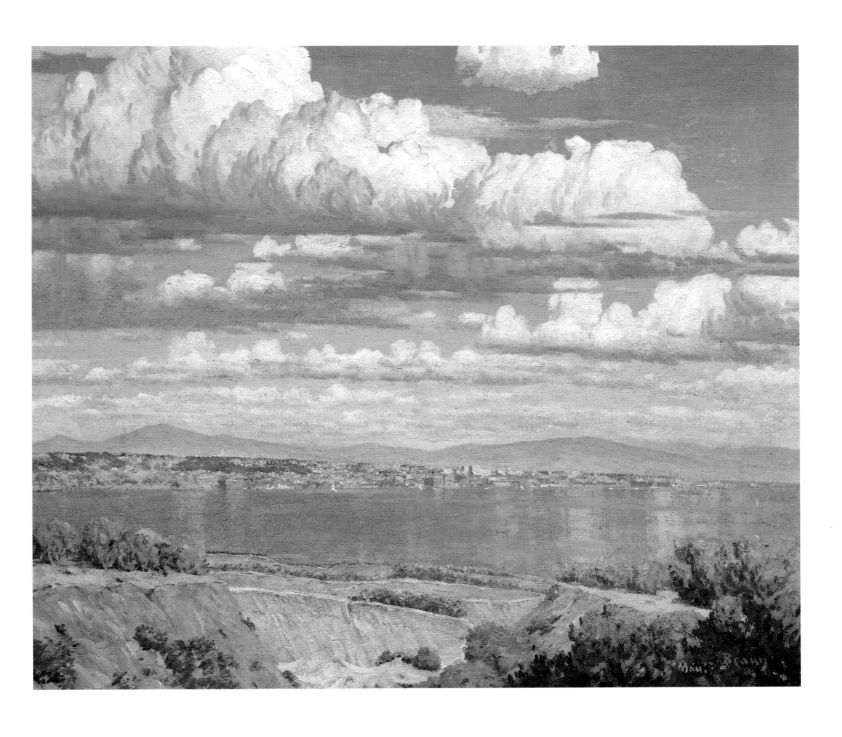

Maurice Braun
22 *Bay and City of San Diego*, 1910

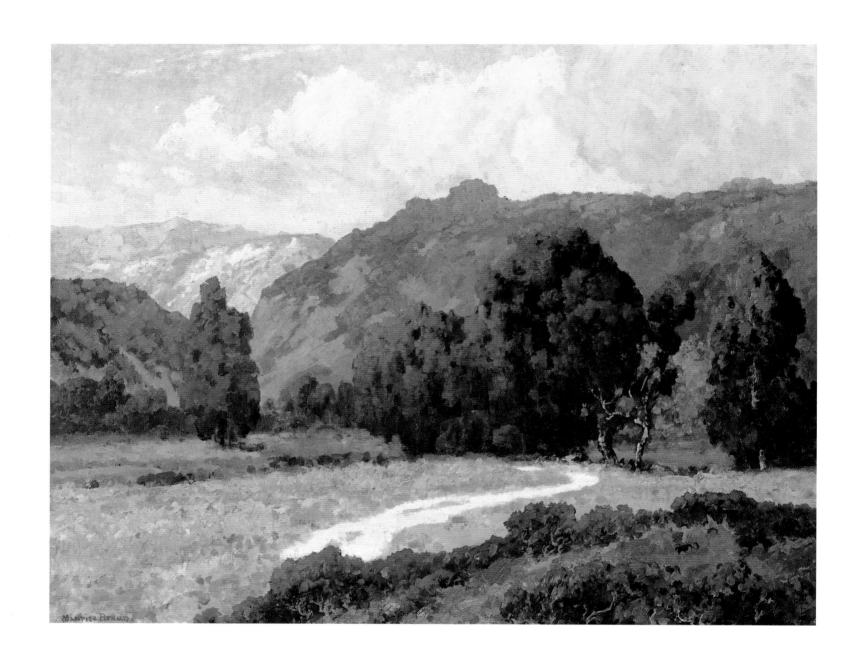

Maurice Braun
23 *The Road to the Canyon, c.* 1915

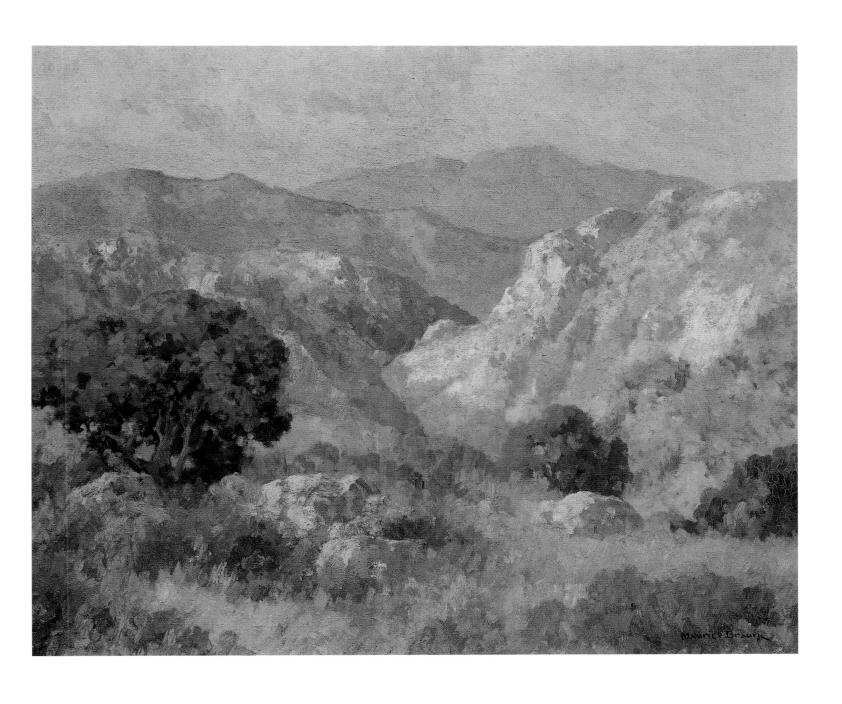

Maurice Braun
24 *Rocky Heights*, 1910-29

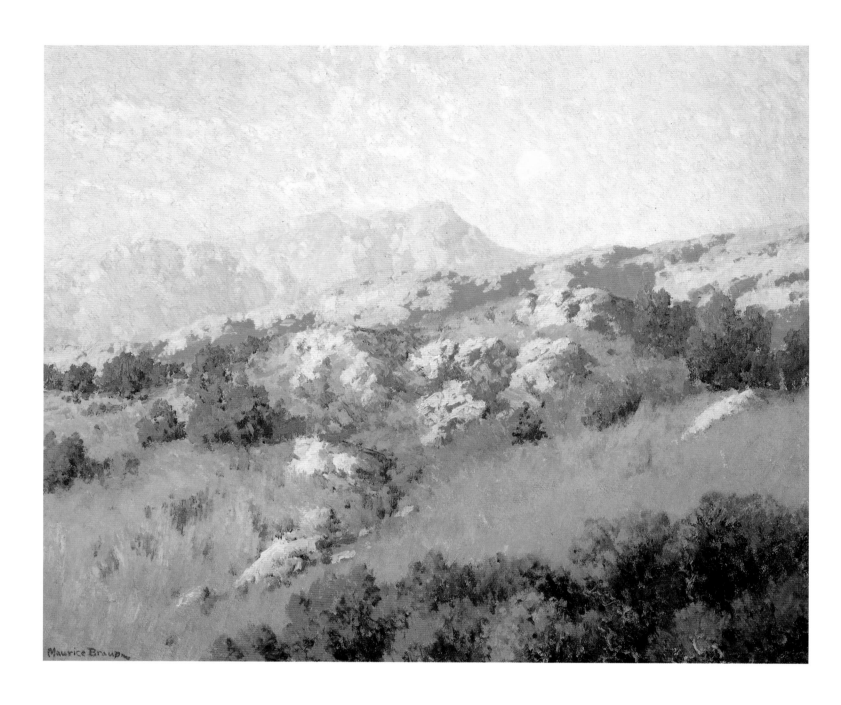

Maurice Braun
25 *Summer Moon over El Capitan Mountain, c.* 1918

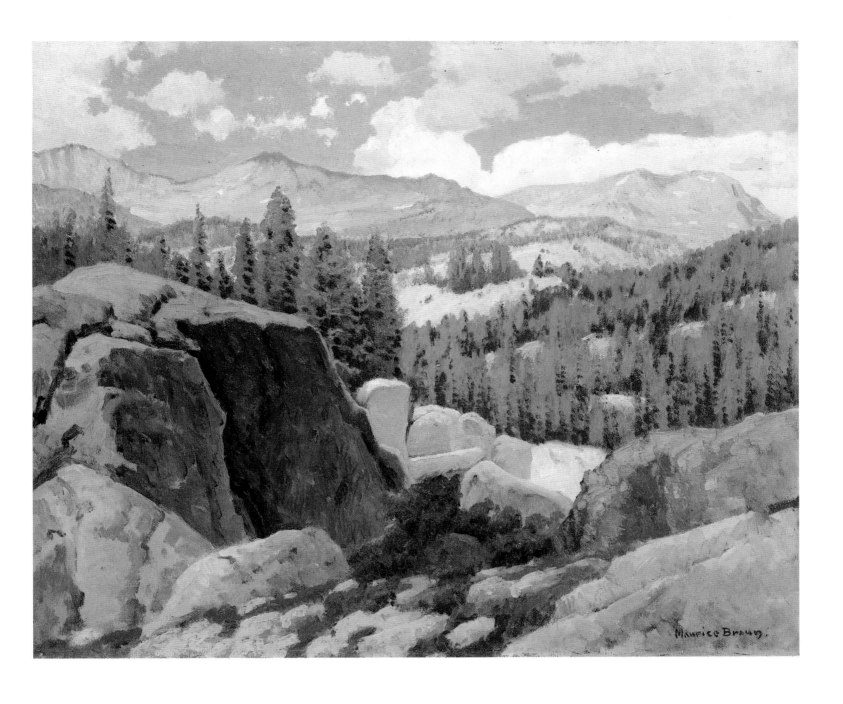

Maurice Braun
26 *High Sierras from Soda Spring, c. 1918-20*

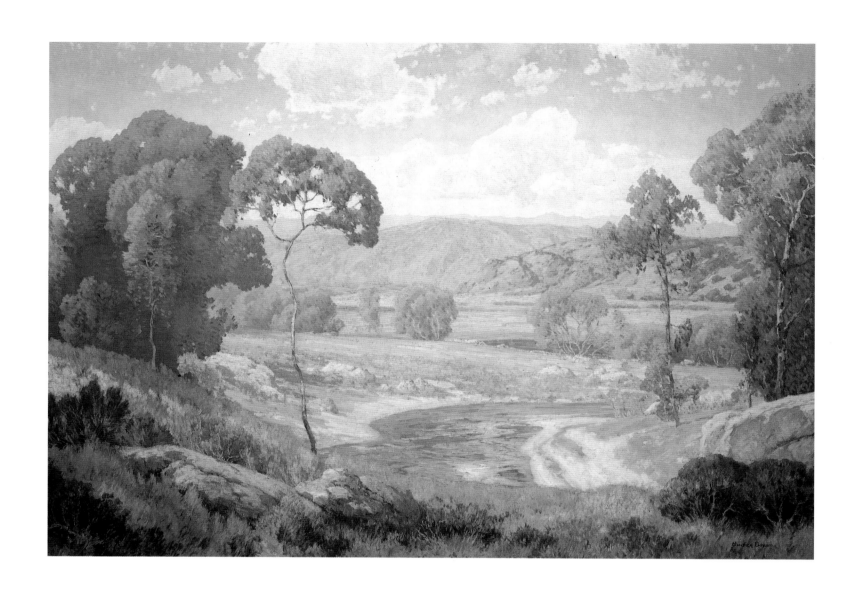

Maurice Braun
27 *Land of Sunshine, c.* 1920

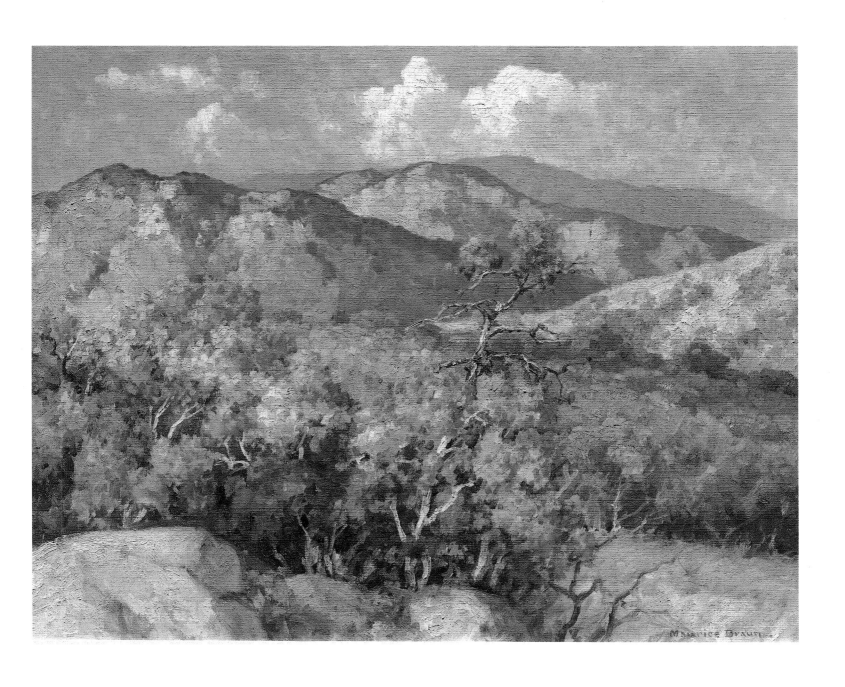

Maurice Braun
28 *Mountain Lilac—Palomar, c.* 1920

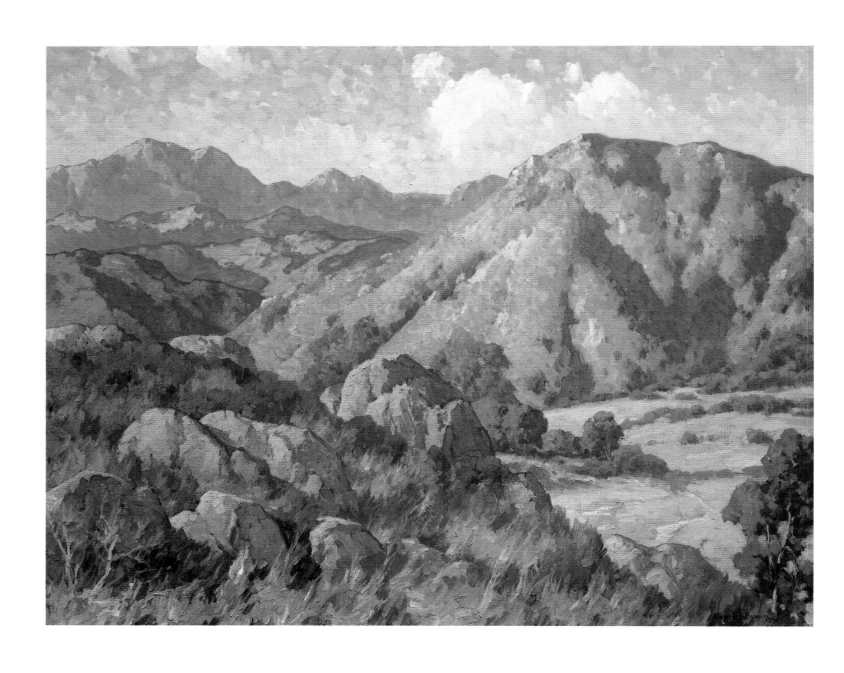

Maurice Braun
29 *Plowed Fields, c.* 1925

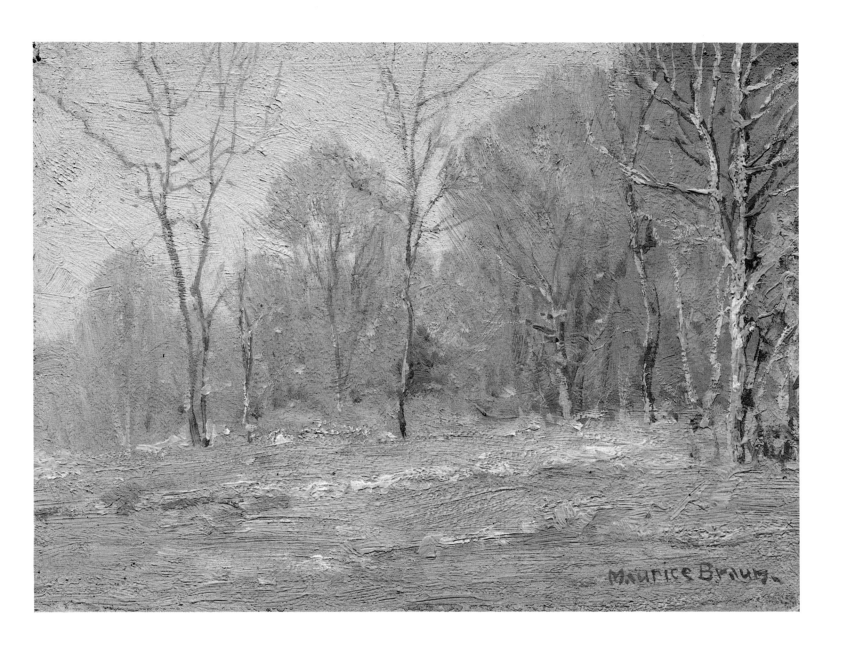

Maurice Braun
30 *Early Springtime, c.* 1923

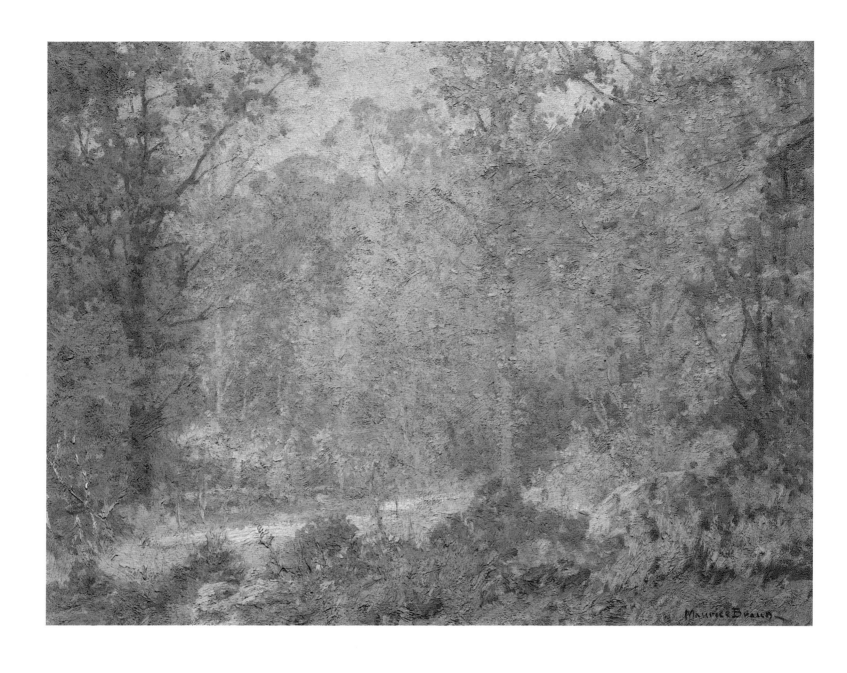

Maurice Braun
31 *Spring in the Forest, c.* 1925

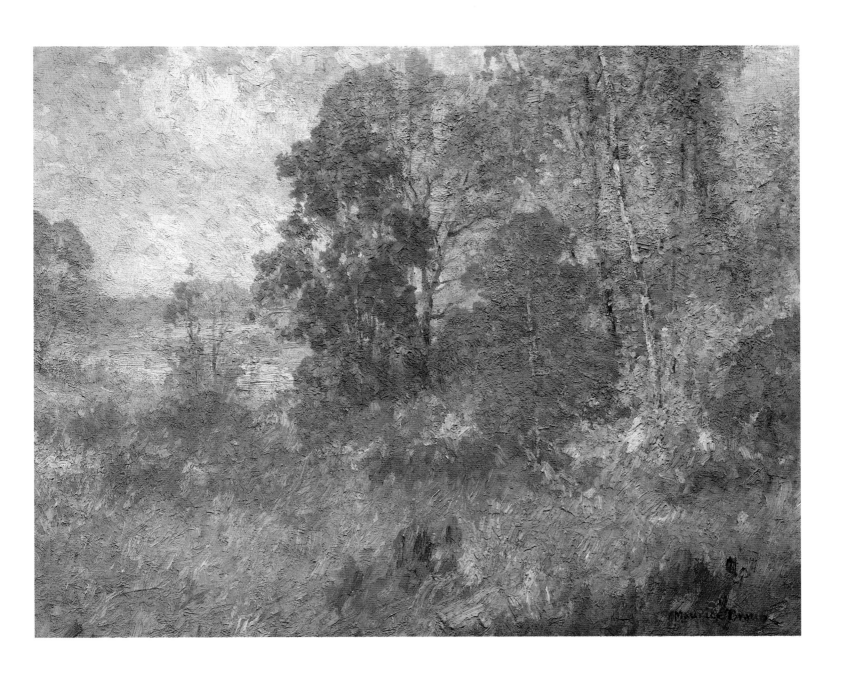

Maurice Braun
32 *Mystic Fall,* 1921-9

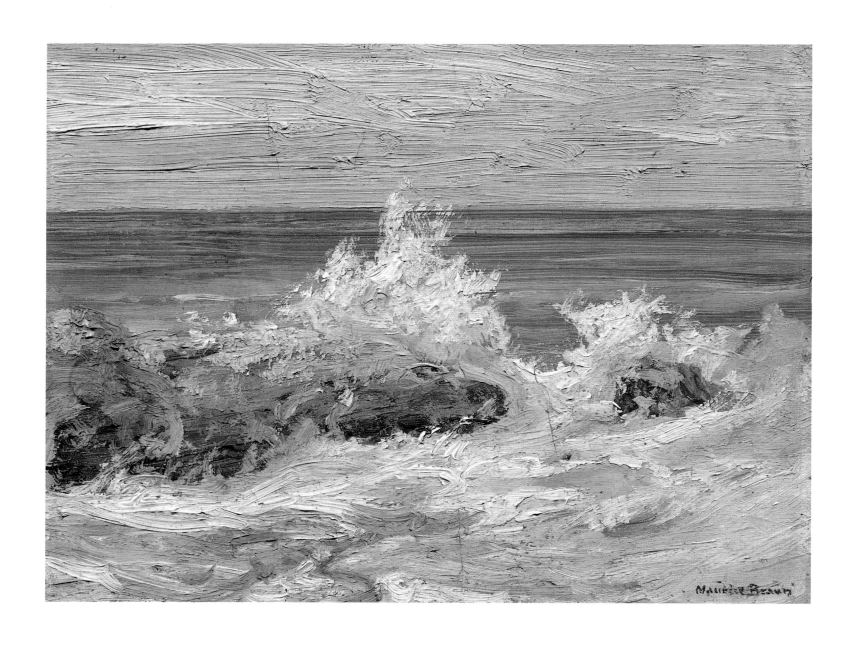

Maurice Braun
33 *At Ocean Beach, c.* 1922

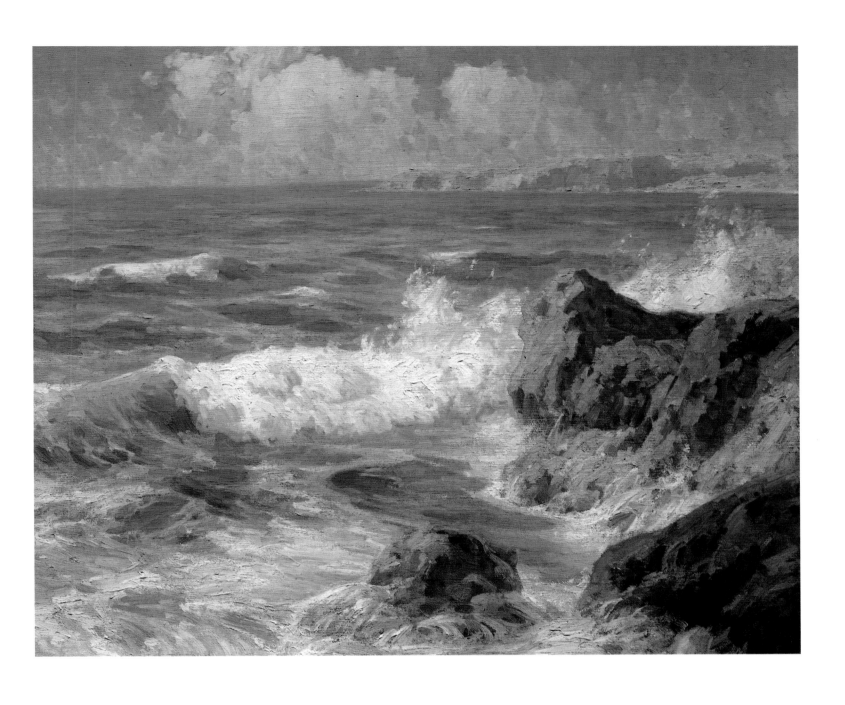

Maurice Braun
34 *San Diego Shores, c.* 1928

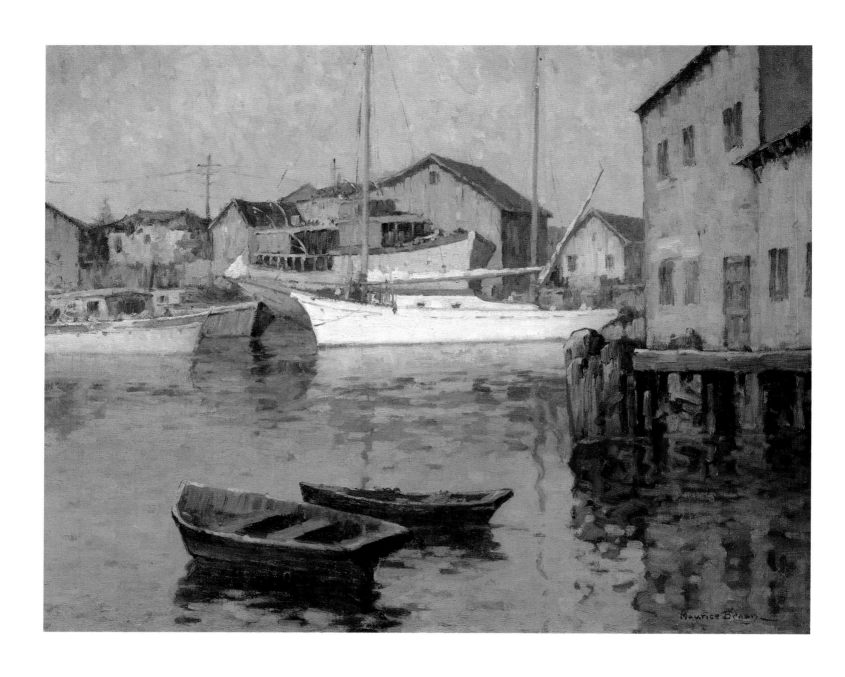

Maurice Braun
35 *Harbor Scene, c.* 1925-30

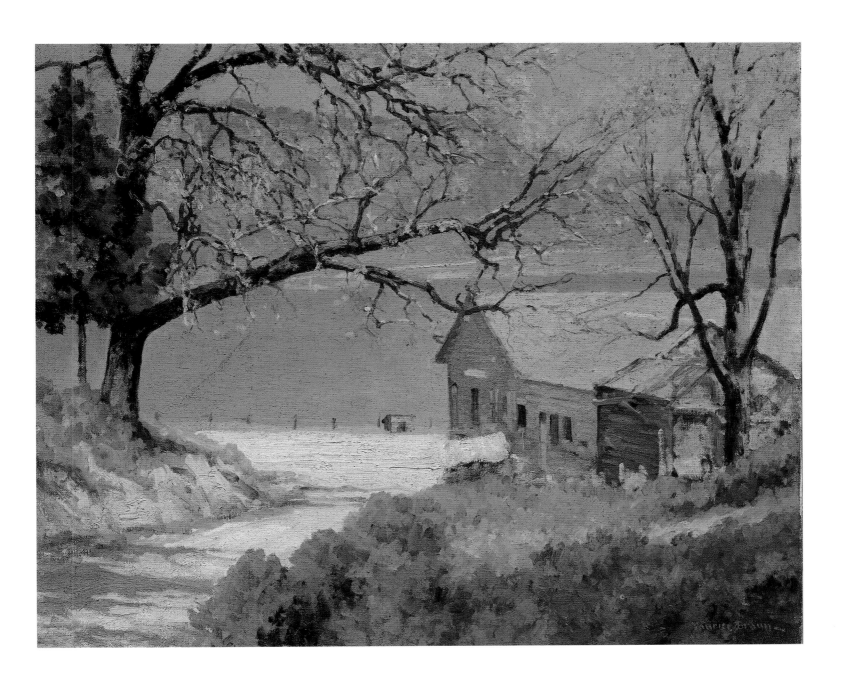

Maurice Braun
36 *Lake Cuyamaca—Old Hotel, c.* 1930

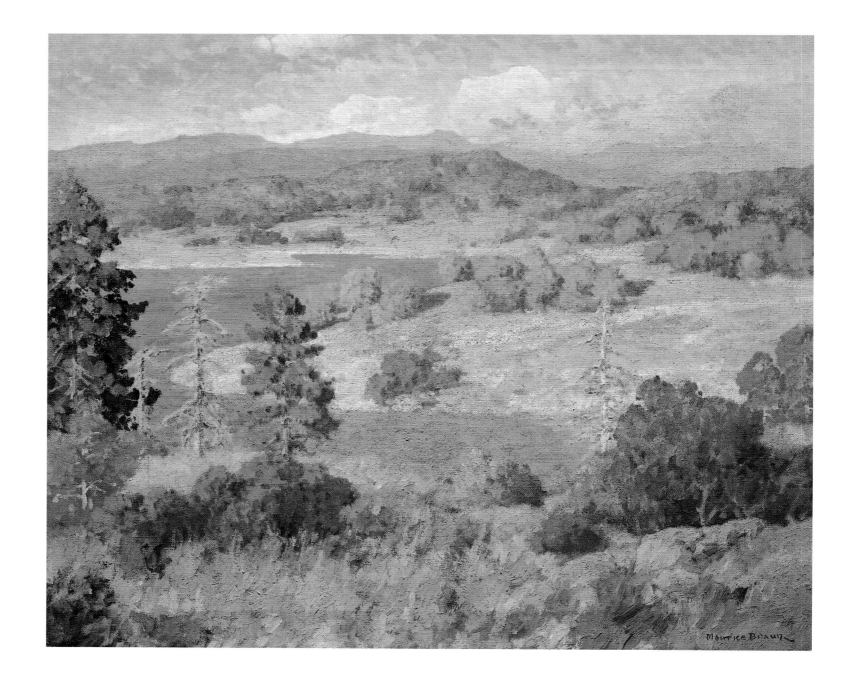

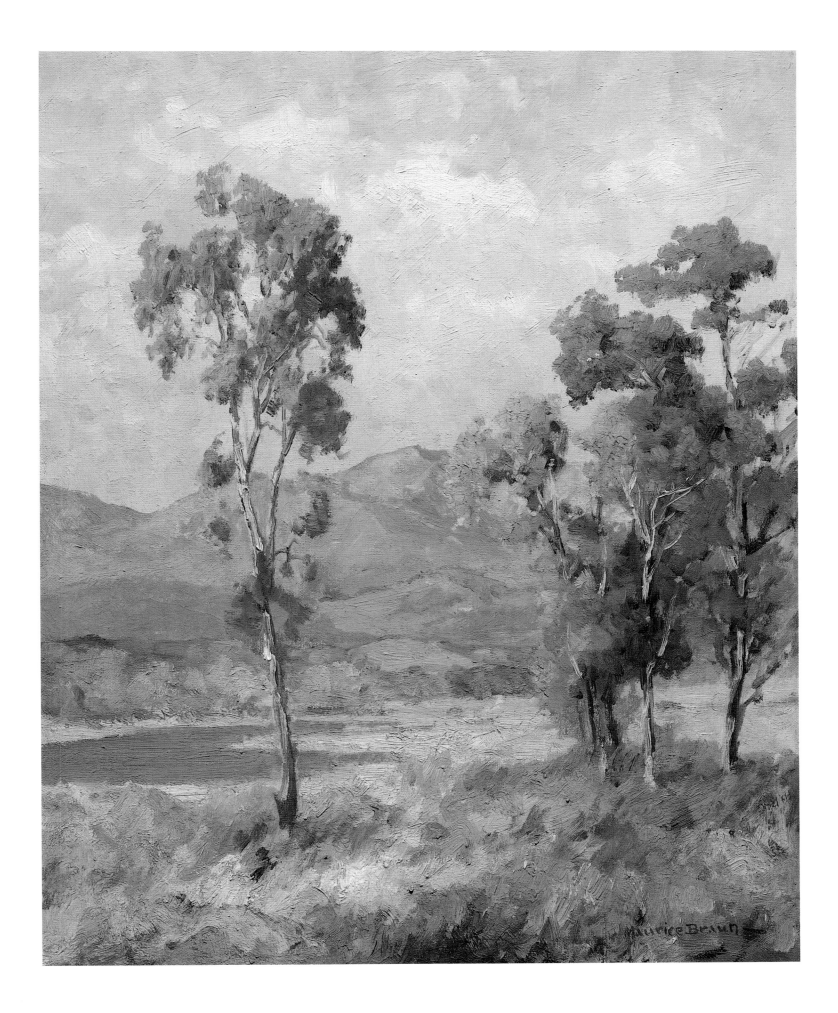

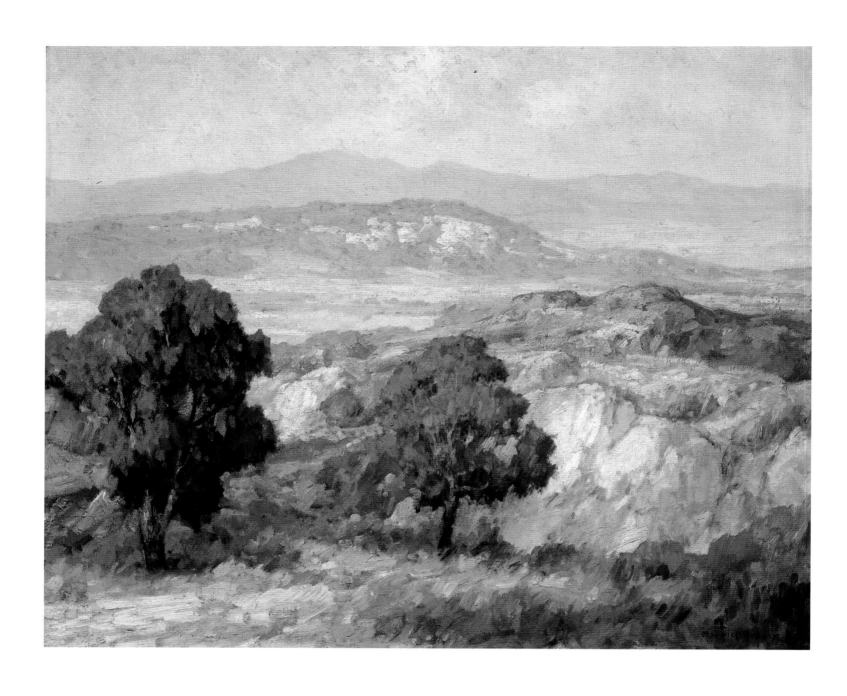

Maurice Braun
39 *Distant Hills*, c. 1935-40

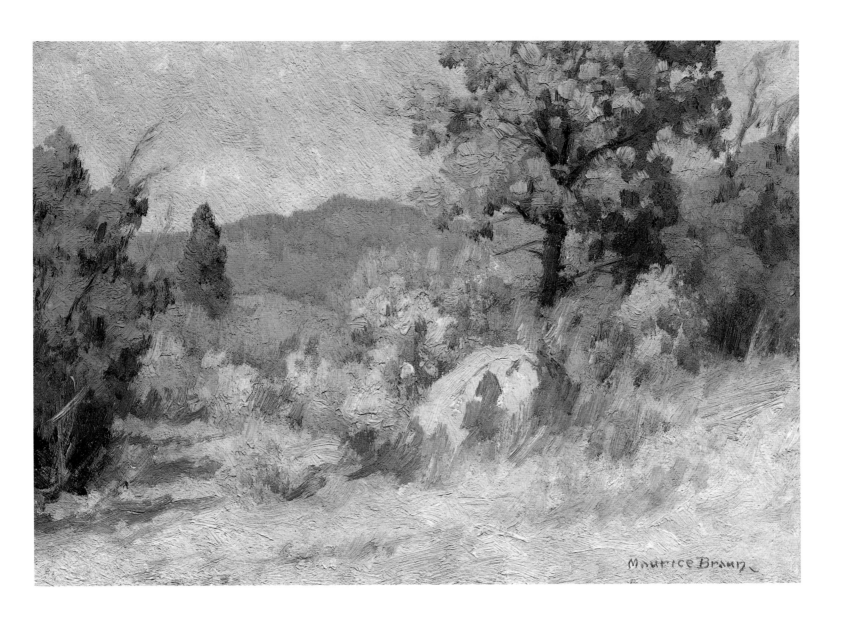

Maurice Braun
40 *Palomar Sketch, c.* 1930-5

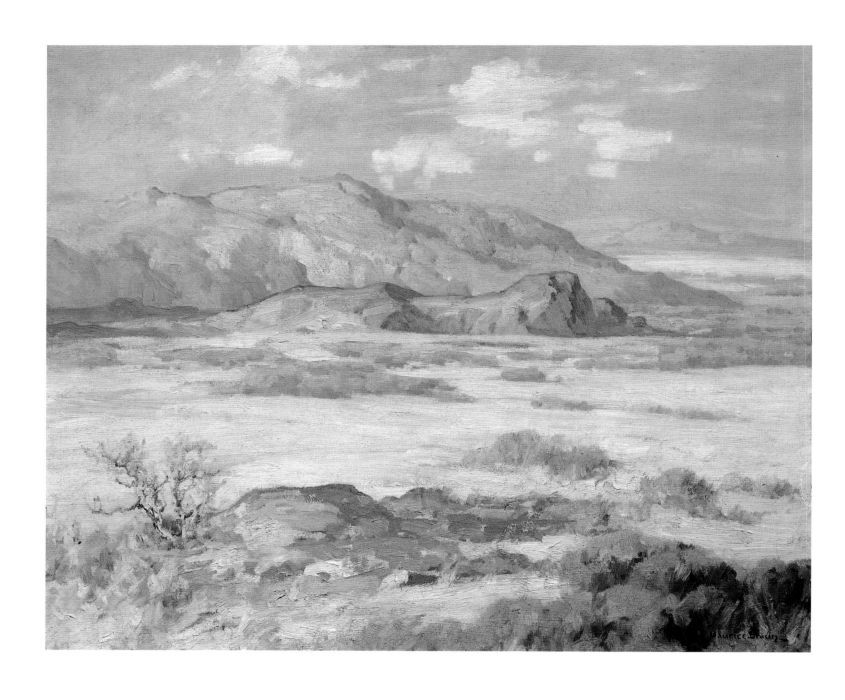

Maurice Braun
41 *The Desert, c.* 1938

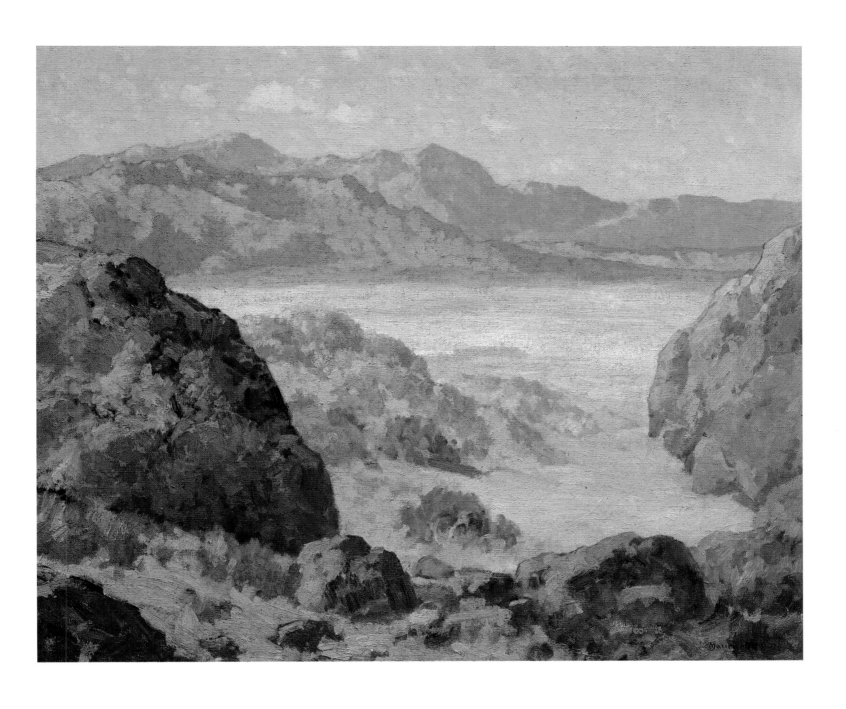

Maurice Braun
42 *Desert and Mountains, c.* 1938

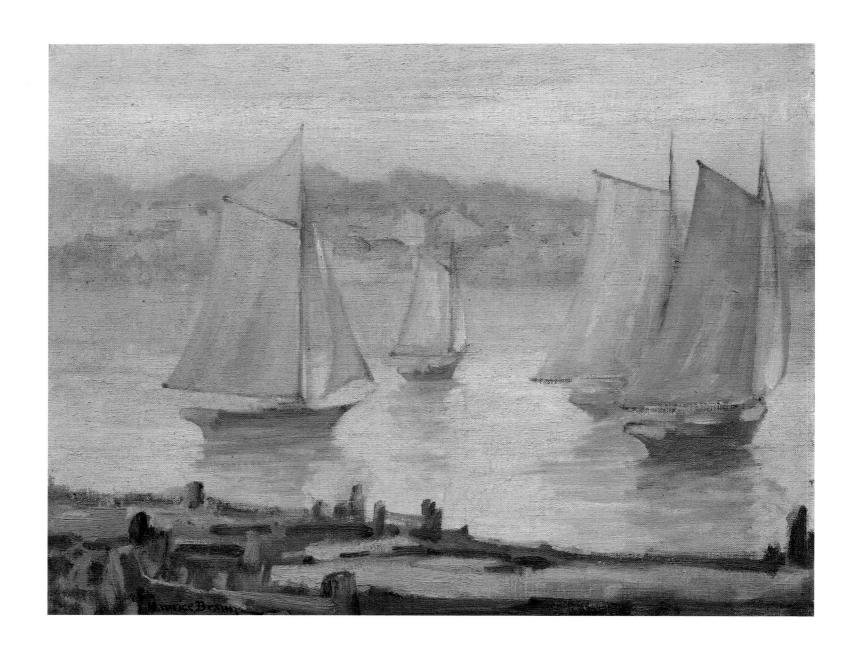

Maurice Braun
43 *Departing Fleet, c.* 1938-9

ALFRED R. MITCHELL

Alfred R. Mitchell
44 *Mission Valley, c. 1913*

Alfred R. Mitchell
45 *Eucalyptus Trees, c. 1920*

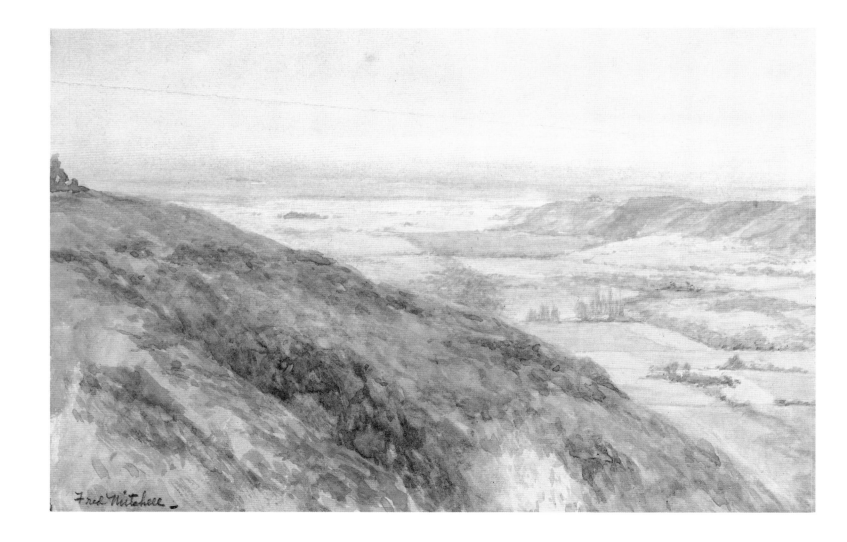

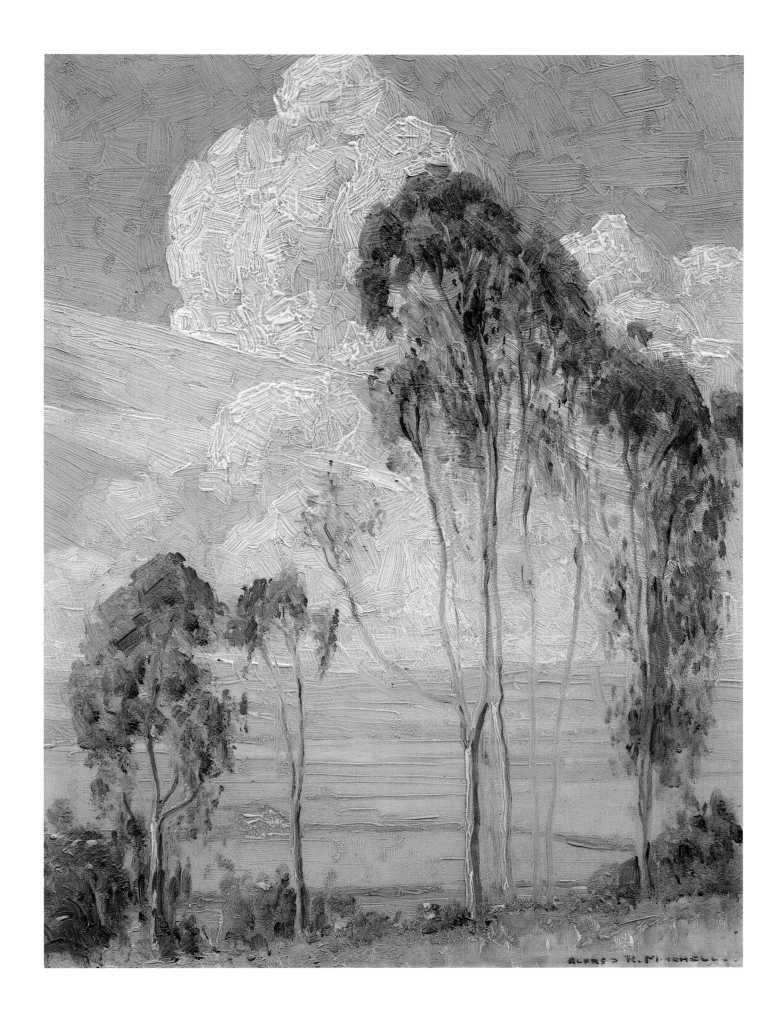

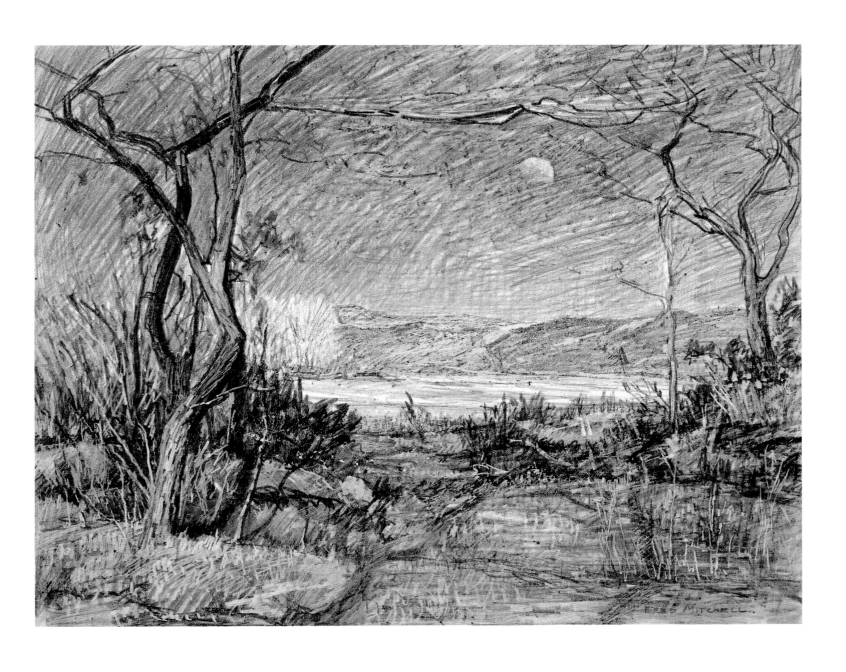

Alfred R. Mitchell
46 *Mission Valley*, before 1922

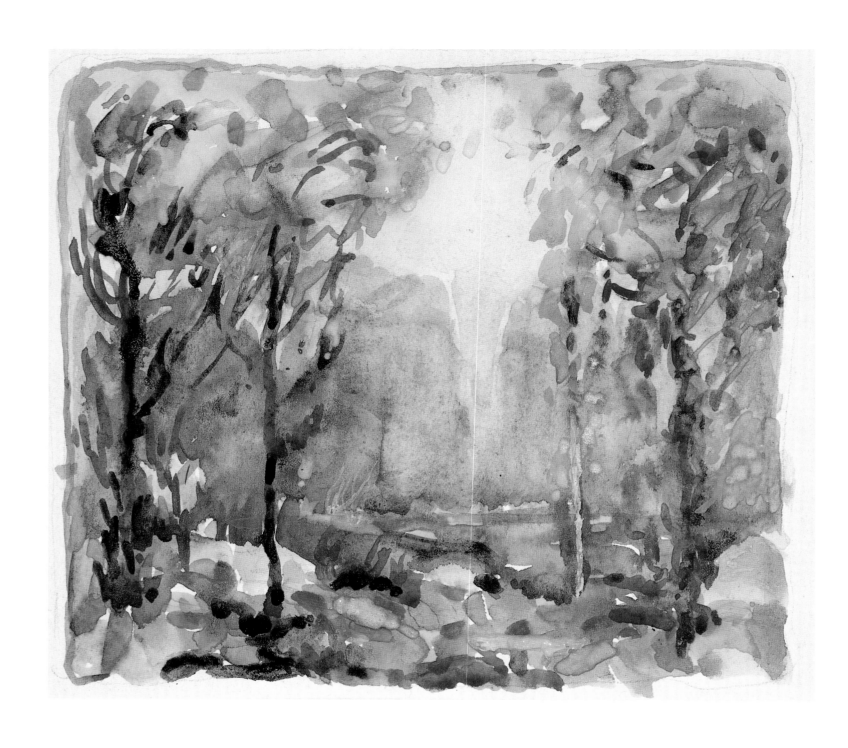

Alfred R. Mitchell
47 *The Fullness of Autumn, c.* 1920-2

Alfred R. Mitchell
48 *Untitled (Landscape with Hills and Trees)*, 1920-2

Alfred R. Mitchell
49 *Landscape with Trees*, c. 1921-2

Alfred R. Mitchell
50 *December in San Diego, c. 1925*

Alfred R. Mitchell
51 *Our Garden at 29th Street, c. 1927*

Alfred R. Mitchell
52 *On Our Porch, c. 1922*

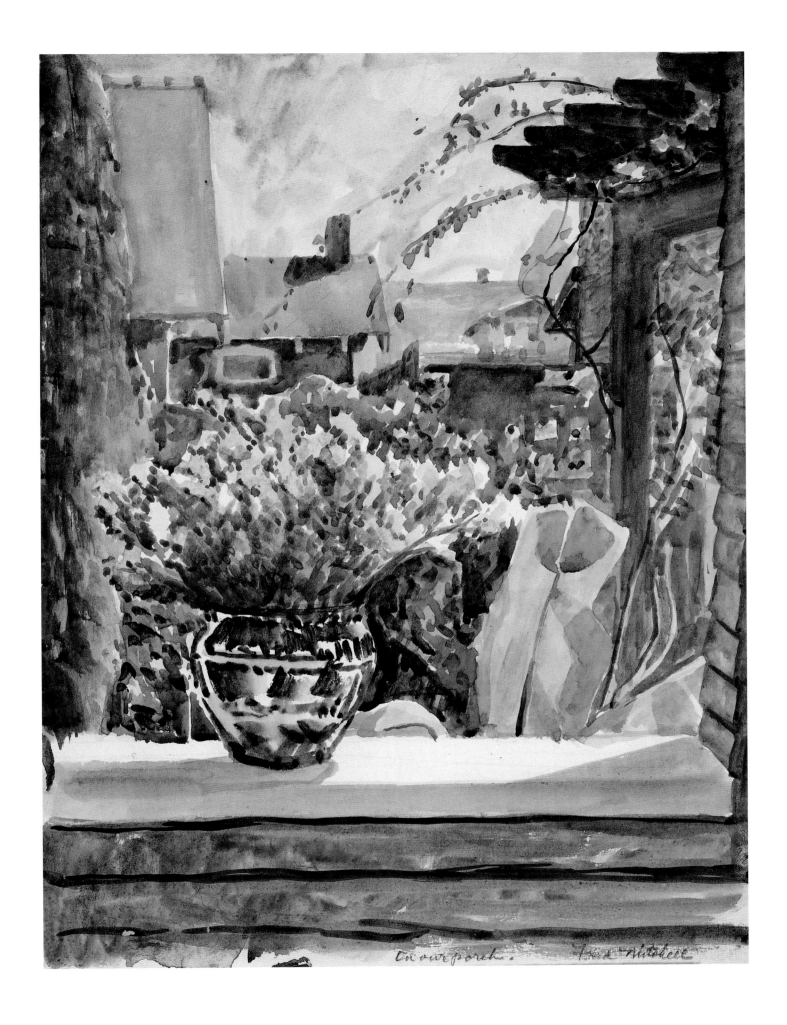

On our porch.

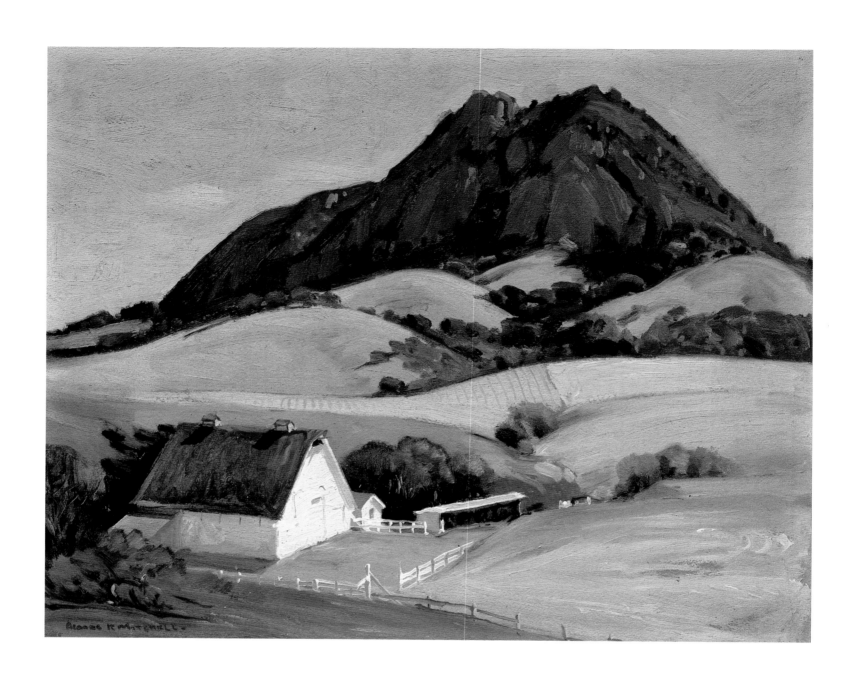

Alfred R. Mitchell
53 *Mountain Ranch, c.* 1925

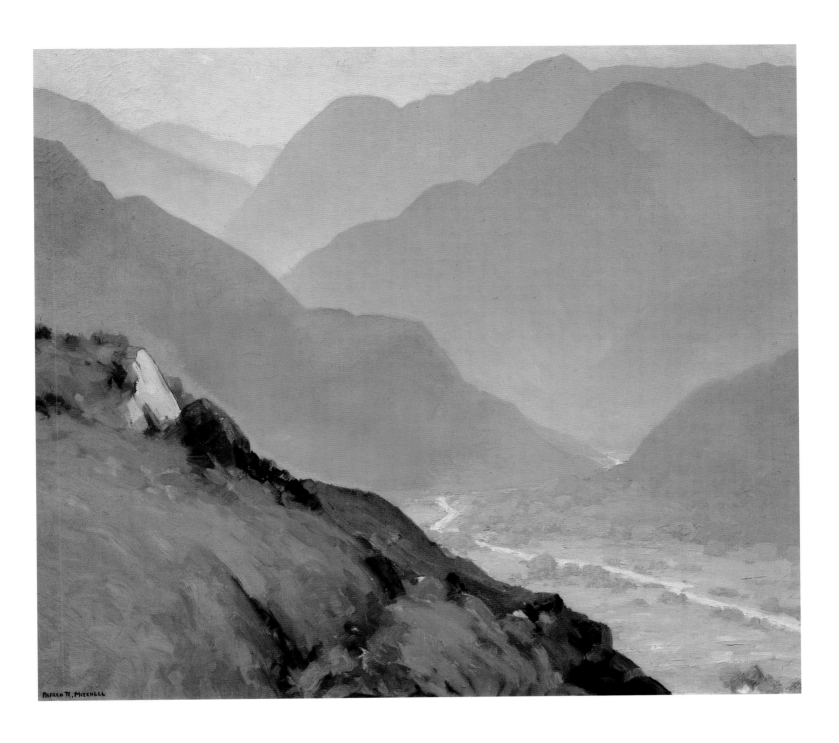

Alfred R. Mitchell
54 *The Canyon, c.* 1927

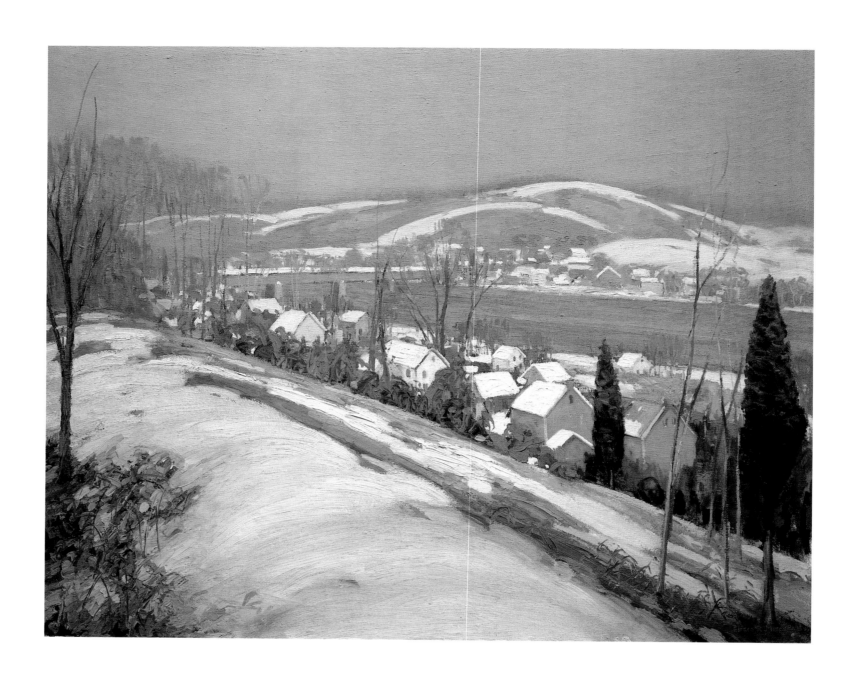

Alfred R. Mitchell
55 *Delaware Valley, c.* 1926

Alfred R. Mitchell
56 *The Mill, c.* 1926

Alfred R. Mitchell
57 *Morning on the Bay*, c. 1923

Alfred R. Mitchell
58 *Beside the Sea*, 1928-30

Alfred R. Mitchell
59 *In Evening Light,* 1930

Alfred R. Mitchell
60 *El Capitan Dam,* c. 1930

Alfred R. Mitchell
61 *The Edge of the Sea, c.* 1930-6

Alfred R. Mitchell
62 *Moonlight at Torrey Pines*, 1930-9

Alfred R. Mitchell
63 *At Torrey Pines, c.* 1930-9

Alfred R. Mitchell
64 *Torrey Pines, c.* 1930-9

Alfred R. Mitchell
65 *Calm Harbor, c. 1931-5*

Alfred R. Mitchell
66 *Study for the Baithouse,* 1938

Alfred R. Mitchell
67 *Untitled, c.* 1938

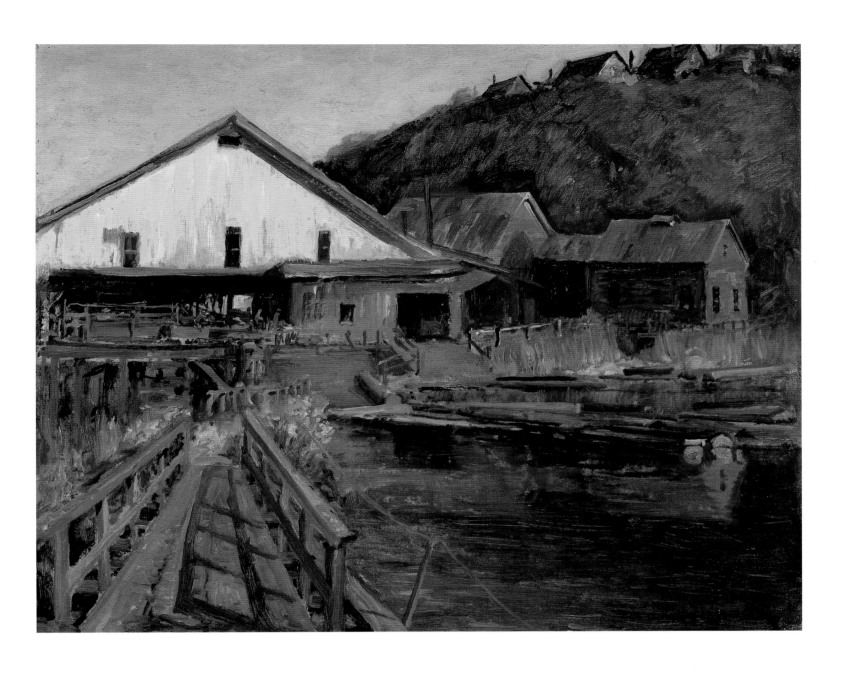

Alfred R. Mitchell
72 *Mill at Caspar, Mendocino County — Morning, c. 1947*

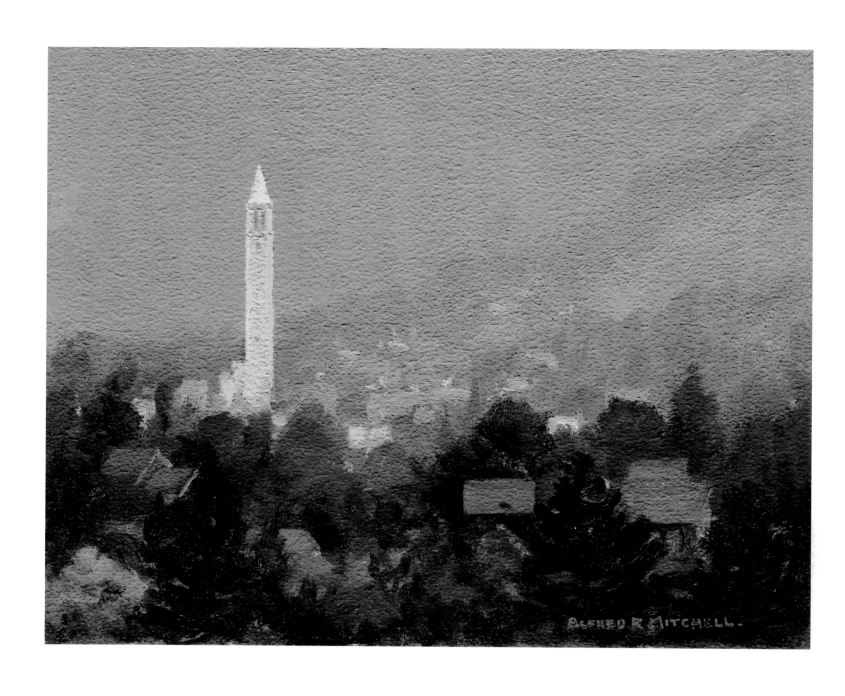

Alfred R. Mitchell
73 *Berkeley Campanile, c. 1947-50*

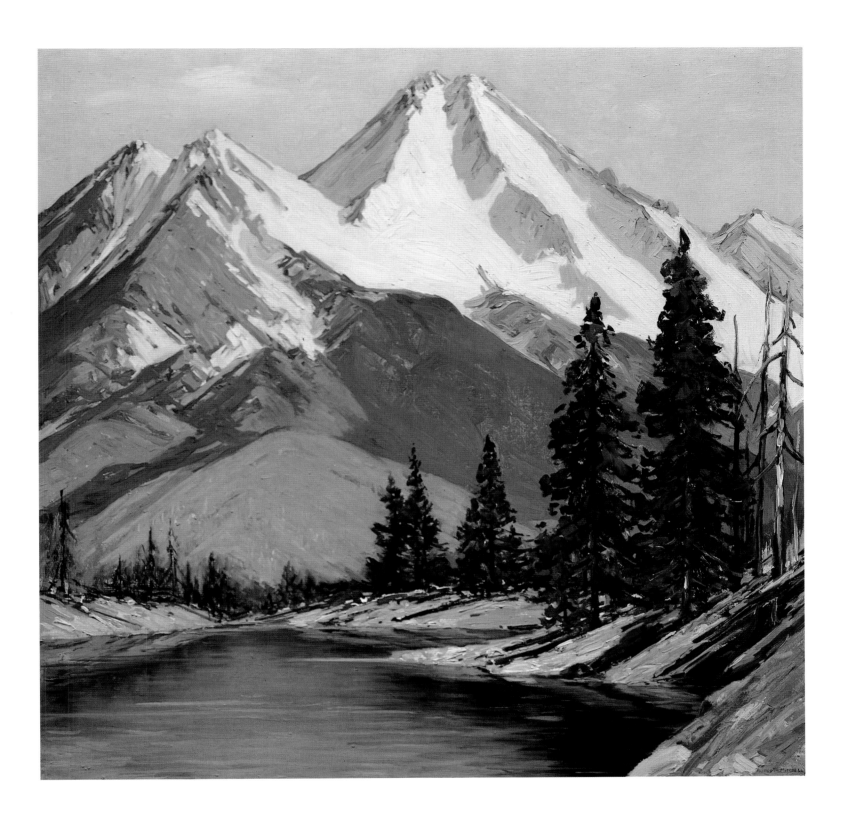

Alfred R. Mitchell
68 *Early Morning—Mt. Shasta, c. 1932*

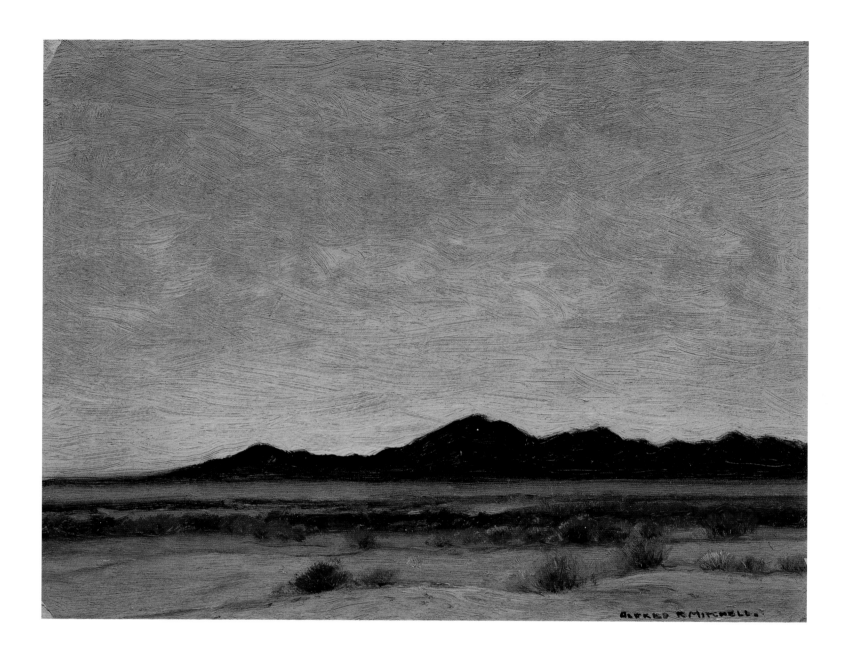

Alfred R. Mitchell
69 *Desert Dawn*, 1938

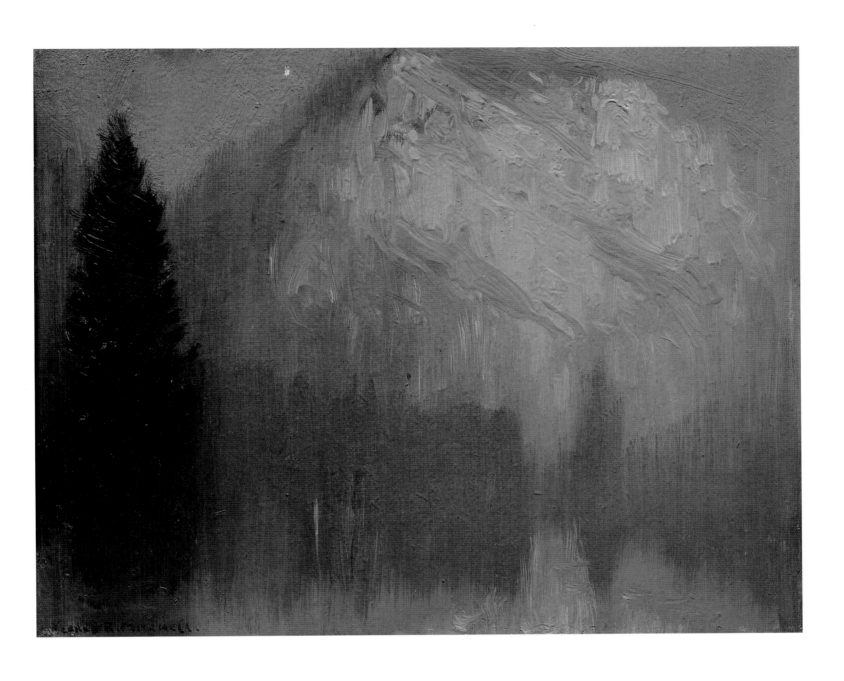

Alfred R. Mitchell
70 *Moonlight—Yosemite,* 1934

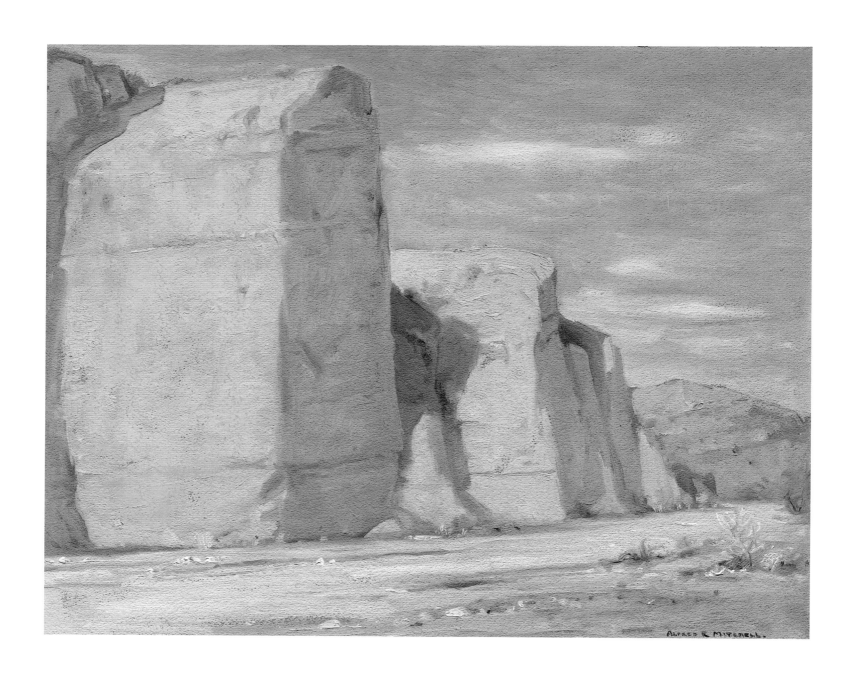

Alfred R. Mitchell
71 *Desert Cliffs, c.* 1947

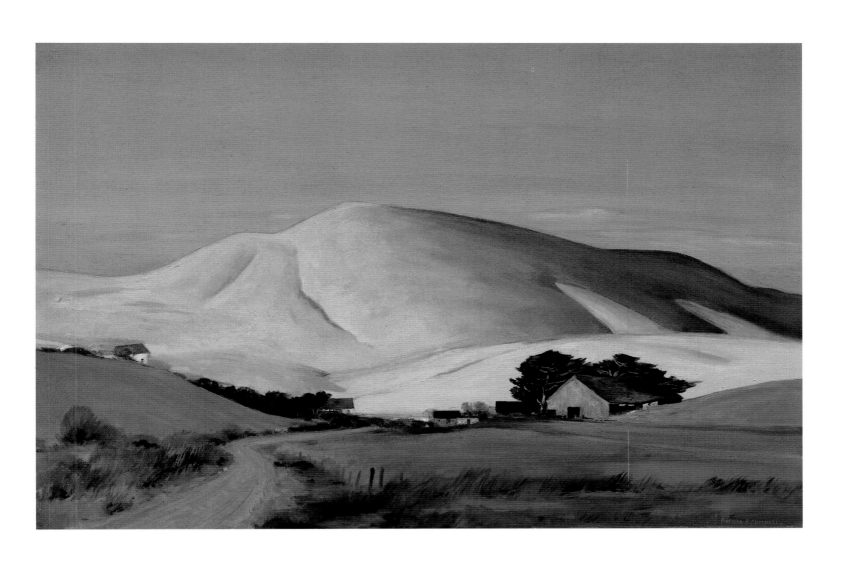

Alfred R. Mitchell
74 *Nipomo Hills, c.* 1950

Charles Reiffel

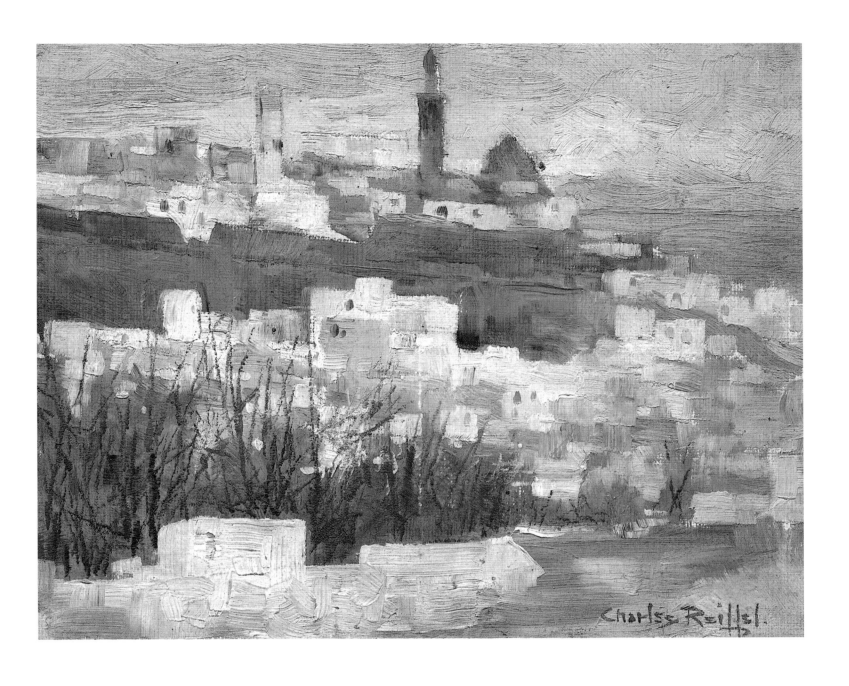

Charles Reiffel
75 *North African Scene, c.* 1895

Charles Reiffel
76 *Railway*, 1910

Charles Reiffel
77 *My Neighbor's Garden*, 1926

Charles Reiffel
78 *Highland Dairy, c.* 1927

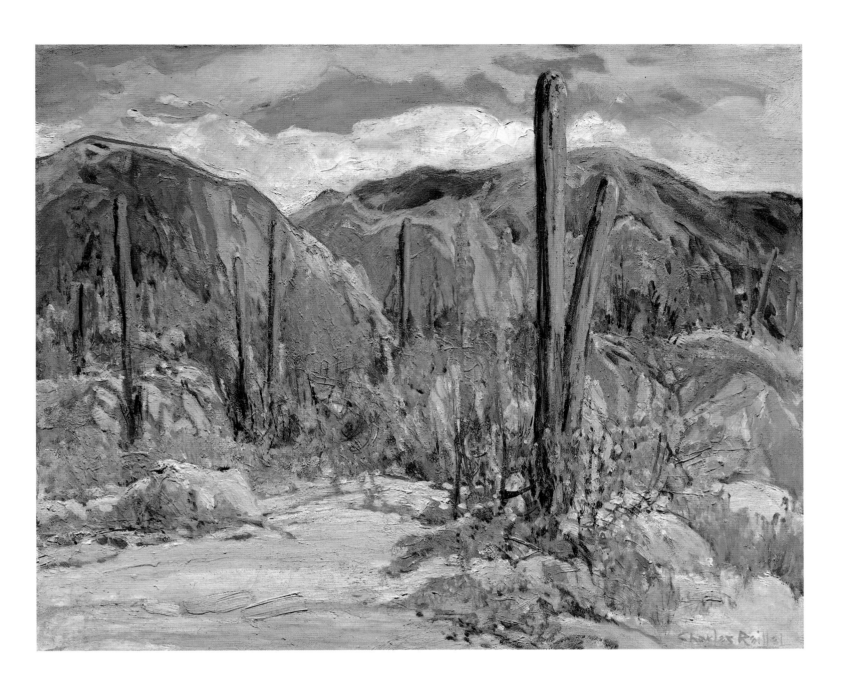

Charles Reiffel
79 *Giant Cacti—Arizona, c. 1927-30*

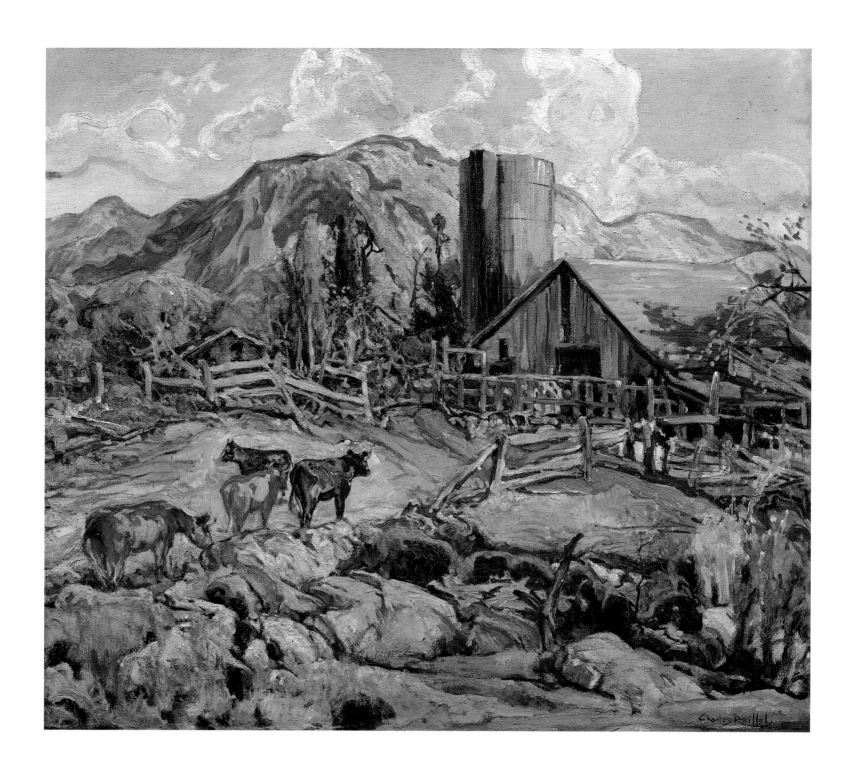

Charles Reiffel
80 *Mountain Dairy, c.* 1927-30

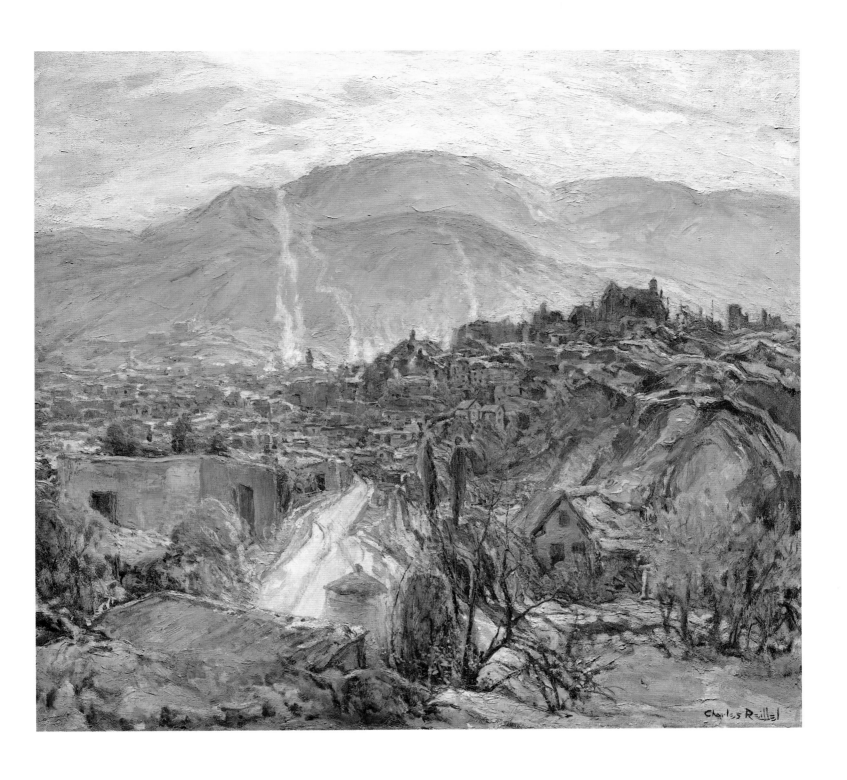

Charles Reiffel
81 *Morning, Nogales, Arizona*, 1928

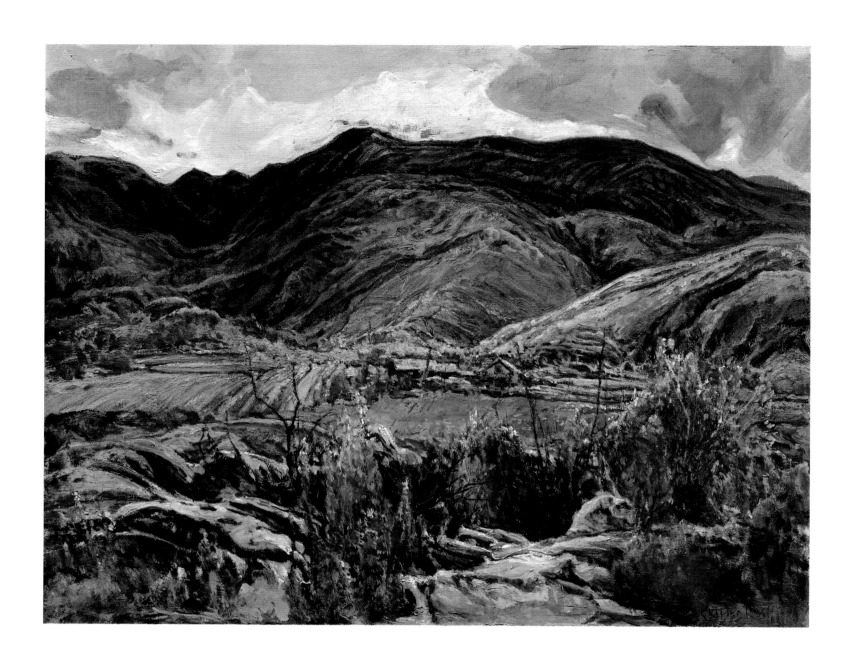

Charles Reiffel
82 *Mountain Ranch after the Rain*, 1928

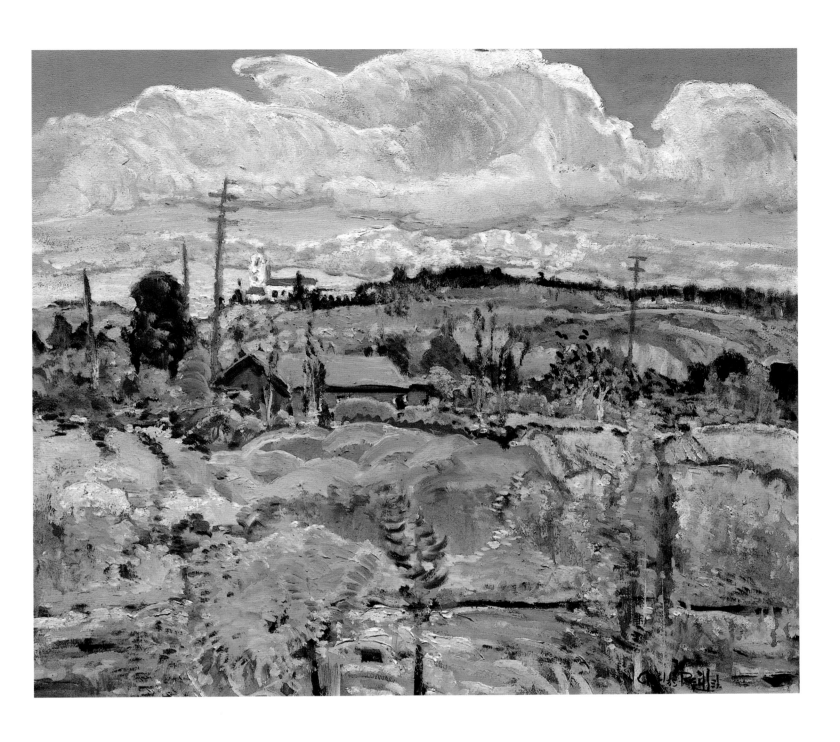

Charles Reiffel
83 *Near Old Town, c.* 1929

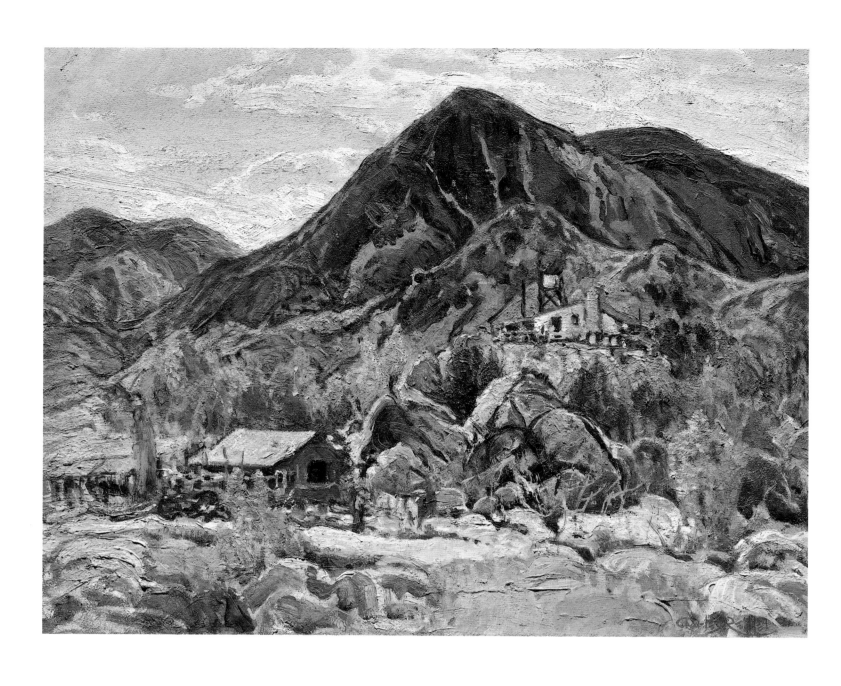

Charles Reiffel
84 *Witch Creek Mountain, c.* 1930-5

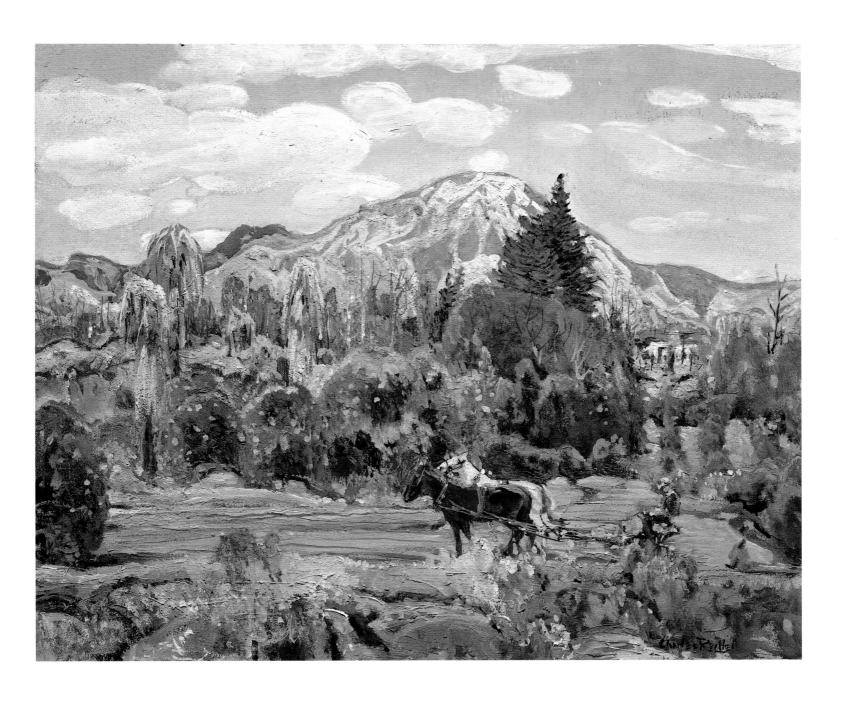

Charles Reiffel
85 *The Rancher*, 1933

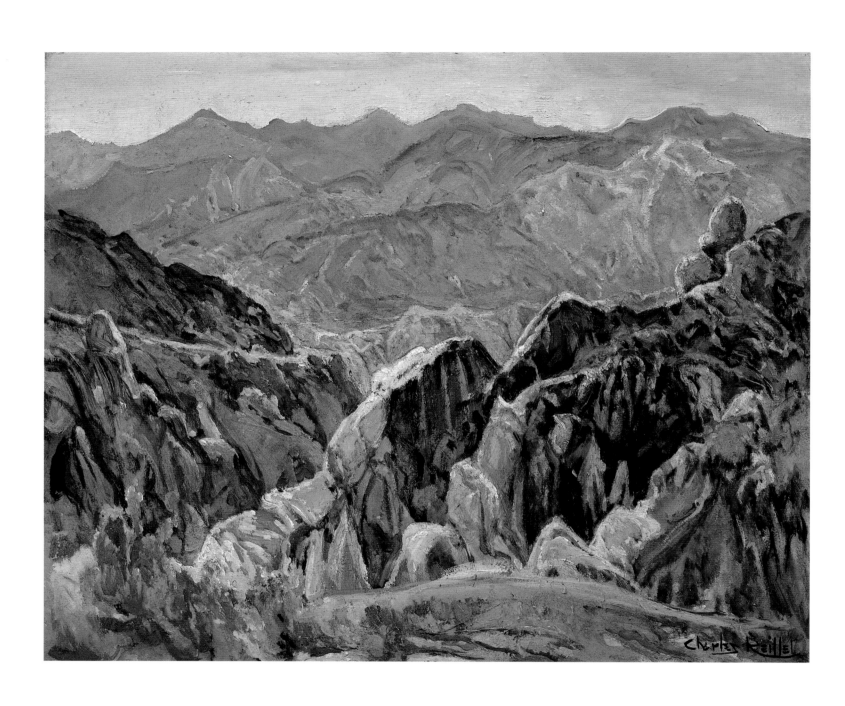

Charles Reiffel
86 *Banner Gorge*, 1932

Charles Reiffel
87 *Old Ranch—Mission Valley, c.* 1930

Charles Reiffel
88 *Beach at Del Mar*, 1931

Charles Reiffel
89 *Edge of the Valley, c. 1935-40*

Charles Reiffel
90 *Where Desert and Mountain Meet (San Jacinto), c.* 1930-5

Charles Reiffel
91 *The Storm, c.* 1935

Charles Reiffel
92 *Harbor Night*, 1937

Charles Reiffel
93 *Rainy Evening*, 1937

Charles Reiffel
94 *San Diego Waterfront*, 1938

Charles Reiffel
95 *Cormorant Cove, La Jolla*, 1936

Charles Reiffel
96 *Spring at Grossmont, c.* 1940

Charles Reiffel
97 *The Haunted Tower,* 1939

Charles Reiffel 1939

Charles Reiffel
98 *Volcan Indian Reservation,* 1941

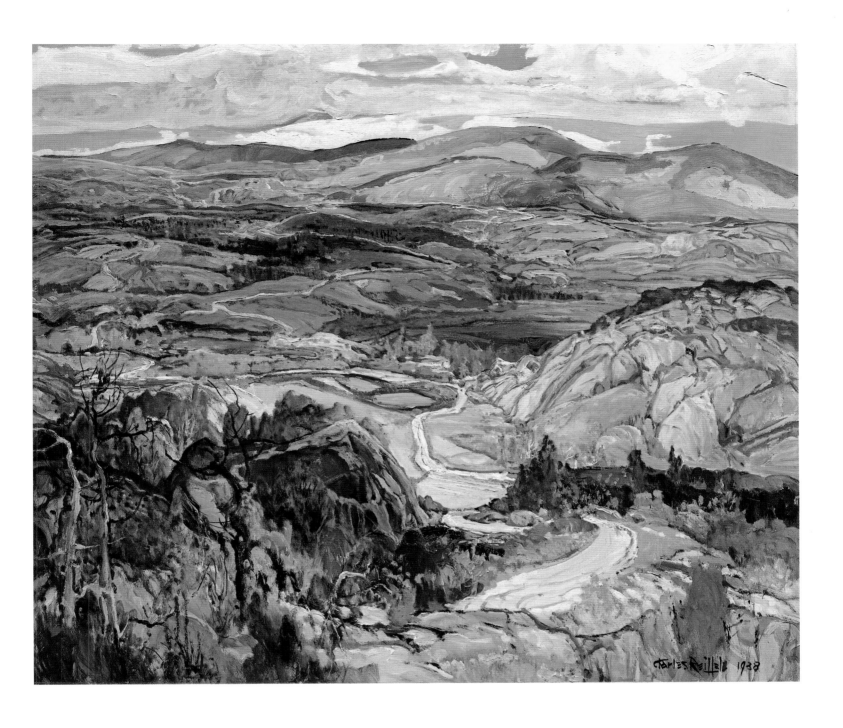

Charles Reiffel
99 *To Wander—In San Diego Back Country*, 1938

Appendix

Catalogue of Works

Charles A. Fries

1 *Capistrano at Mussel Cove*, 1896

Charles A. Fries
oil on canvas, 9 x 16³/₄ inches (22.8 x 42.5 cm),
l.r.: *C.A. Fries*
Inscribed on reverse: *#56 Muscle [sic] Cove/
Capistrano/Mission*
On reverse of frame: *Painted 1896 Capistrano
Muscle [sic] Cove Oct 6th 1915/Alice Fries King
Her Picture*

Mrs. Alice King Psaute

Provenance
Artist; Alice Fries King, his daughter; Alice King Psaute,
his grand-daughter

Bibliography
Fries Journal no. 56: *$46 Muscle [sic] Cove Capistrano,
G[ift]: Dau. Alice 10-6-15-NFS*

Remarks
By the end of his life, Fries had filled four journals
which numbered titles of nearly 1700 paintings. These
numbers are usually inscribed on the reverse of the
picture along with a cryptic device to indicate the
selling price of each work. There are three known
works, in addition to this picture, assigned the title:
666, owned at one time by Dr. Rittenhouse of La Mesa;
836, acquired by Mrs. A.B. Field; and 1129, in an
unknown collection.

2 *San Diego Bay*, *c.* 1904

Charles A. Fries
oil on canvas, 24 x 48 inches (61 x 122 cm), l.r.:
C.A. Fries

Private collection

Provenance
Artist; Mrs. Amy Armstrong (1921)

Exhibitions
One by this title exhibited in the following:
San Diego, Thearle and Company's Music Rooms,
December 1906. *Paintings by Charles Arthur Fries*,
no. 29 ($20). San Diego, Fine Arts Building (Museum of
Man), December 1920-January 1921, *Exhibition and
Sale of Paintings by Charles Fries*, no. 26.
Fine Arts Gallery of San Diego (San Diego Museum of
Art), June-August 1926, *First Exhibition of Artists of
Southern California*, no. 48.

Remarks
Unrecorded in the artist's journals.
The painting depicts Point Loma with, possibly, the
armored cruiser USS *New York* in the distance. The
fourth USS *New York* was authorized by Congress in
1888 and commissioned in 1893. It held a distinguished
record throughout its history during international
conflicts in both the Eastern and Western hemispheres.
In 1904 the *New York* became the Flagship of the Pacific
Squadron and joined cruises to Panama and Peru from
its Puget Sound base. This painting may well document
its passing by San Diego. The next year, the ship was
decommissioned in Boston for modernization.
In 1909, when the *New York* was again in service, it
underwent two name changes, first to the *Saratoga* and
then to the *Rochester*. After a life of peripatetic
adventure on the high seas for more than half a century,
the USS *New York* met an ignominious end when it was
scuttled to prevent its capture by the Japanese in
December 1941. (Rear Admiral Ernest McNeill Eller,
Introduction, *Dictionary of American Naval Fighting
Ships*, Washington D. C., Naval History Division, 1970,
v. 5, 70-1.)

3 *Looking Down Mission Valley in
Summer*, *c.* 1905

Charles A. Fries
oil on canvas, 18 x 28 inches (45.7 x 71.2 cm),
l.r.: *C.A. Fries*
Inscribed on reverse: *Looking Down Mission
Valley in Summer #240/18 x 28 ($100-)*

Orr's Gallery

Provenance
Ex-private collection

Exhibitions
1988 San Diego, Orr's Gallery, 16 April-31 May, *Plein
Air Paintings*

Bibliography
Fries Journal no. 240: *$100 Across Mission Valley
18 x 28*

4 *San Diego River Gorge*, *c.* 1905

Charles A. Fries
pastel on paper, 11⁵/₁₆ x 16⁷/₈ inches
(28.7 x 42.8 cm), l.r.: *C.A. Fries*

Dr. and Mrs. Albert A. Cutri

Bibliography
Fries Journal no. 698: *$50 San Diego River Gorge pastel
D[onated]*

5 *San Diego Bay—Foot of Grape Street*,
1906 (March)

Charles A. Fries
oil on canvas, 14 x 16 inches (35.5 x 40.6 cm),
l.r.: *C.A. Fries*
Inscribed on reverse: *San Diego Bay/#1235 Foot
of Grape St./14 x 16 70+/March 1906*

Mr. and Mrs. David E. Porter

Bibliography
Fries Journal no. 235: *$75 Foot of Grape Street 14 x 16*

6 *Foot of A (Street)*, 1908

Charles A. Fries
oil on canvas, 14¹/₈ x 24 inches (35.9 x 61.2 cm),
l.r.: *C.A. Fries*
Inscribed on reverse: *Foot of A 08/16 x 24*

Mr. and Mrs. Ferdinand T. Fletcher

Provenance
Artist; Murray (?)

Bibliography
Fries Journal no. 286: *$35 Foot of A. Street S[old]:
Murray*

Remarks
The canvas has been reduced by about two inches in
height. The format is recorded as 16 x 24 in Fries's
journal. A second signature is concealed on the canvas
wrapped around the stretcher bar at the bottom.

7 *Evening Effect near Mirmar*, *c.* 1910

Charles A. Fries
oil on canvas, 11³/₄ x 17³/₈ inches
(29.8 x 44.2 cm), l.r.: *C.A. Fries*
Inscribed on reverse: *Evening Effect Near
Mirmar/12 x 18*

Dr. and Mrs. Albert A. Cutri

Provenance
Artist; Mrs. E.W. Scripps

Bibliography
Fries Journal no. 256: *$45 Evening near Mirmar S[old]:
Mrs. E.W. Scripps*

8 *Eucalyptus Grove—Balboa Park before
the Exposition*, *c.* 1910

Charles A. Fries
oil on canvas, 18 x 13⁷/₈ inches (45.7 x 35.3 cm),
composition extended on frame: 29³/₈ x 25⁵/₈
inches (74.5 x 65.1 cm) frame size, l.l.: *C.A. Fries*
Inscribed on reverse: *Balboa Park before/the
Exposition*
Carved on frame face: *Eucalyptus Grove*

Mrs. Alice King Psaute

Provenance
Artist; Mrs. Alice King Fries, his daughter; Mrs. Alice
King Psaute, his grand-daughter

Exhibitions
One by this title was exhibited in the following:
1925 New York City, Ainslee Galleries, January,
Paintings by Charles A. Fries, no. 7

Bibliography
Fries Journal no. 1445: *$150 Balboa Park before
Exposition*

9 *Town of Escondido*, *c.* 1910

Charles A. Fries
oil on canvas, 14¹/₈ x 36 inches (35.8 x 91.4 cm),
l.r.: *C.A. Fries*
Inscribed on reverse: *Town of Escondido*

Bob and Toni Crisell

Bibliography
Fries Journal no. 438: *$100 Town of Escondido*

10 *Lake from Honey Springs Ranch*,
c. 1911

Charles A. Fries
oil on canvas, 20 x 30 inches (50.8 x 76.1 cm),
l.r.: *C.A. Fries*
Inscribed on reverse: *Lake from/Honey Springs
Ranch*

Fieldstone Company (87.06.01)

Provenance
Artist; Mrs. E.W. Scripps; with Petersen Galleries,
Beverly Hills

Bibliography
Fries Journal no. 271: *$250 Lake, Honey Spgs Ranch
S[old]: Mrs. E.W. Scripps*

Remarks
According to the artist in his book of memoirs
published by Ben Dixon, in about 1900 he moved to a
residence at Thirtieth and El Cajon, a "bee ranch out in
the country." Shortly thereafter he moved "to a ranch in
Chollos Valley, with his busy bees."

11 *Evening from Mesa Grande*, c. 1920

Charles A. Fries
oil on canvas, 20⅛ x 30¼ inches
(51.2 x 76.8 cm), l.l.: *C.A. Fries*
Orr's Gallery, San Diego (1990)

Provenance
Artist; Mrs. E.W. Scripps; with Petersen Galleries,
Beverly Hills (1985); private collection; Robert DeLapp,
Los Angeles

Bibliography
Fries Journal no. 229: *$250 Evening from Mesa Grande*
S[old]: *Mrs. E.W. Scripps*

12 *Desert and Mountains*, c. 1918

Charles A. Fries
watercolor on paper, 10¼ x 16 inches
(26 x 40.6 cm), l.r.: *C.A. Fries*
Robert and Arlene Kesler

13 *Balboa Bridge*, c. 1916

Charles A. Fries
watercolor on paper, 11⅛ x 16¼ inches
(28.2 x 42.2 cm), l.l.: *C.A. Fries*
Private collection

Provenance
Sam Hammill, San Diego architect

Bibliography
Fries Journal no. 531: *$25 Balboa Bridge, wc.*

14 *View from My Tent on Pine Hills*,
c. 1918

Charles A. Fries
gouache on paper, 6 x 9¼ inches
(15.4 x 23.5 cm), l.r.: *C.A. Fries*
Inscribed on reverse: *View From My tent on Pine
Hills*
James and Estelle Milch

Bibliography
Fries Journal no. 640: *$10 My Tent At Pine Hills
D[onated]*
Dixon, Ben F., *Too Late: The Picture and the Artist*, San
Diego, privately published, 1969

Remarks
While on a field trip to Pine Hills, east of San Diego,
during April and May in 1918, Fries recalled, "While
Miss Woodward was running the Pine Hills resort she
invited me to spend a week or so up there, which I did. I
lived in a tent with a wooden floor quite near where the
cook, his wife and little boy slept. In the evening after
their work was through, they would sing their old…
melodies. They had beautiful voices, and I enjoyed it
very much" (Ben Dixon, *Too Late*, 51).

15 *Painted Gorge at Torrey Pines*, 1919

Charles A. Fries
oil on canvas, 24 x 36 inches (61 x 91.5 cm), l.l.:
C.A. Fries
Ray Rosenberg and Jim Way

Provenance
Artist; Kenneth Schulte

Exhibitions
1925 San Diego, Little Gallery, *Paintings by Charles
A. Fries*, no. 6
1934 Fine Arts Gallery of San Diego (San Diego
Museum of Art) August, *Charles Arthur Fries*, no. 15,
dated 1919
1935 San Diego, Thearle Music Store, November,
Paintings by Charles Arthur Fries, no. 34 ($175), as *The
Painted Gorge — Torrey Pines*

Bibliography
Fries Journal no. 853: *$100 Painted Gorge at Torrey
Pines* S[old]: *Kenneth Schulte*
Dixon, Ben F., *Too Late*, San Diego; privately published,
1969, il. no. 87

16 *In the Light*, c. 1925-6

Charles A. Fries
oil on canvas, 25¾ x 37¾ inches (65.5 x 96 cm),
l.r.: *C.A. Fries*
Jim Martin and Les Gadau

Provenance
Thackeray Gallery

Bibliography
Fries Journal no. 1218: *$350 Light of the Morning*

Remarks
The subject of this picture is the desert near Palm
Springs.

17 *Cuyamaca Mountain from Gilmore
Point*, c. 1925

Charles A. Fries
oil on canvas, 20 x 30⅛ inches (50.8 x 76.5 cm),
l.r.: *C.A. Fries*
Inscribed on reverse on label: *Artist
C.A. Fries/subject — Cuyamaca Mt./from
Gilmore Pt./Price — $125.00*
Private collection

Provenance
Artist; Dr. Beardsley; with Mission Gallery, San Diego

Exhibitions
1926 Fine Arts Gallery of San Diego (San Diego
Museum of Art), February 1926, for museum opening
according to a label on reverse

Bibliography
Fries Journal no. 516: *$200 Cuyamaca Mtn., Gilmore's
Pt.* S[old]: *Dr. Beardsley*

18 *Oaks at El Monte Park*, c. 1925

Charles A. Fries
oil on canvas, 9⅜ x 13½ inches (23.8 x 34.5 cm),
l.r.: *C.A. Fries*
Inscribed on reverse: *Oaks at El Monte Park
9½ x 13½*
Mr. and Mrs. William R. Dick, Jr.

Provenance
Artist; Mrs. Watson

Bibliography
Fries Journal no. 1238: *$40 Oaks at El Monte Park*
S[old]: *Librarian, Mrs. Watson*
One by this title mentioned in the *San Diego Union*,
10 October 1926

Remarks
Another version by this title is listed in Fries's journal
as no. 1244

19 *Afternoon Light*, c. 1925-30

Charles A. Fries
oil on canvas, 8 x 12 inches (20.4 x 30.5 cm), l.r.:
C.A. Fries
Inscribed on reverse: *C B t + (illegible)*
[Journal]*#507, Afternoon Light/8 x 12"*
Jane and Willis Fletcher

Bibliography
Fries Journal no. 507: *Afternoon Light*

20 *Desert from Vallecitos Point, Laguna
Mountain Resort*, 1928

Charles A. Fries
oil on canvas, 24⅞ x 34⅞ inches
(63.3 x 88.6 cm), l.r.: *C.A. Fries*
San Diego Museum of Art (1906: 008)

Provenance
Purchased from the artist

Exhibitions
1925 New York City, Ainslee Galleries, January
1929 Fine Arts Gallery of San Diego (San Diego
Museum of Art), 1-29 February, Paintings by Hilda van
Zandt and Charles A. Fries, no. 2, il., as "Desert from
Vallecitos Point"
1930 — 3 February-3 March, Exhibition of Paintings
and Sculpture by the Contemporary Artists of San
Diego, no. 12, il.
1934 La Jolla Art Association, September
1934 Fine Arts Gallery of San Diego (San Diego
Museum of Art), 14 August-14 October, Charles Arthur
Fries, no. 25, il., dated 1927
1935 Fine Arts Gallery of San Diego (Palace of Fine
Arts), California Pacific International Exposition, May-
November, Official Art Exhibition, no. 186, il.
1938 — (San Diego Museum of Art), May, Paintings by
Charles Arthur Fries, no. 19
1941 — (San Diego Museum of Art), December,
Charles Arthur Fries: A Memorial Exhibition, no. 42, il.,
dated 1928
1954 La Jolla Art Association, September

Bibliography
Fries Journal no. 1354: *$350 Desert from Vallecitos
Point, June 1928, 25 x 35*
Poland, Reginald H. San Diego?, 17 February 1929
—, "Charles Arthur Fries," *The Modern Clubwoman*
(November 1929), il., 4
Braun, Hazel Boyer, San Diego *Tribune-Sun*,
6 December 1941
Guide to Balboa Park, San Diego, California, 1941,
il., 18
Westphal, Ruth, *Plein Air Painters of California: The
Southland*, Irvine: Westphal Publishing, 1982, clr il. 196

Remarks
Fries's journal lists another picture with this title,
no. 1064, which was exhibited at the San Diego
Museum of Art from January to February 1976 for an
exhibition called *San Diego Scene: Art of the Thirties*,
which was lent by the San Diego City Schools.
According to the journal, it had originally been in the
collection of Mrs. Sadie Kenyon, a gift of the artist. The
picture (1064) was never in the local museum's
collection, even though the journal has a confusing note
that it had been exchanged by the museum for another.
In 1946, students of Point Loma High School subscribed
$80 toward its purchase as a memorial for a former
student, Ruby Gray Johnson. This entry was made by
the artist's daughter.

21 *Cliffs of the Ragged Rocks*, c. 1930

Charles A. Fries
oil on canvas, 9 x 11 ⁷/₈ inches (22.8 x 30.2 cm),
l.r.: *C.A. Fries*
Inscribed on reverse: *Cliffs of the Ragged Rocks/
9 x 12*

C. Klein Company Corporation

Provenance
Artist; Horton L. Titus, Coronado; Helen B. Titus (1933)
Bibliography
Fries Journal no. 1213: *$25 Cliffs of the Ragged Rocks
S[old]: Horton L. Titus, Coronado*

Maurice Braun

22 *Bay and City of San Diego* (also
known as *San Diego from Point Loma*)
1910

Maurice Braun
oil on canvas on board, 30 ¹/₈ x 34 ¹/₈ inches
(76.5 x 86.6 cm), l.r.: *Maurice Braun*
Mr. and Mrs. William R. Dick, Jr.

Provenance
Artist; sold by his daughter to Joseph E. Dyer, pioneer
furniture store owner
Exhibitions
1918 Los Angeles, Museum of History, Science and
Art, 16-31 January, *Exhibition of Paintings by Maurice
Braun*, no. 16
1918 San Francisco, Palace of Fine Arts, San Francisco
Art Association, 15 February-15 March, *Exhibition of
Paintings by Maurice Braun*, no. 23, as *The Bay and
City, San Diego, from Point Loma*
1918 New York City, Babcock Galleries, 1-18 May,
Exhibition of California Paintings by Maurice Braun
1924 San Diego, Museum of Art (California Building),
17 February-10 March, *Recent Paintings by Maurice
Braun*, no. 8
1926 La Jolla, Studio of Payson Ames
1926 San Diego, Peyton Boswell Galleries, c. 1926,
one-man show
1942 Springville (Utah) High School Art Gallery,
Exhibition of the Paintings of Maurice Braun, no. 15, as
Bay and City—San Diego
1943 San Diego Chamber of Commerce Office
1990 Laguna Beach, Laguna Art Museum, 12 October
1990-6 January 1991, *California Light, 1900-1930*,
fig. 80, 90 clr il.
Bibliography
American Art News, 4 May 1918
Philadelphia Record, 12 May 1918
New York Tribune, 15 May 1918
Brooklyn Eagle, [?] May 1918
San Diego Union, 1 June 1918
Art World & Decorations, (? June 1918), il. [?]
Dallas Morning News, 8 March 1925, il.
Braun, Hazel Boyer, San Diego *Evening Tribune*, [?],
1926
Kerr, Harold, [?]
Braun, Hazel Boyer, San Diego *Tribune-Sun*, 21 June
1943
Remarks
Reginald H. Poland, from the picture, notes of the 1942
exhibition at the Springville High School Art Gallery:
From a historical point of view, this is Maurice Braun's
most important painting. He had painted very little
landscape before he went to San Diego in 1909, shortly
after returning from Europe. He took a studio on Point
Loma overlooking the bay. After studying and revelling
in the beauty of it for some months, he created his first
important landscape. This painting is also significant as
a historical record of San Diego. The hills that are
covered with sagebrush in this painting are now thickly

dotted with attractive homes; the line of the bay is
entirely changed by dredging; a manufacturing plant and
an airfield now stand on the ground where there is only
blue water in the painting.
The picture was on view at the Chamber of Commerce
office, having been brought back from an Art Associa-
tion Loan in the Midwest at the Chamber's request. It is
the first important landscape he painted. During World
War II, all his large museum-sized canvases were loaned
to museums, art associations, and universities in the
Midwest for safe keeping.

23 *The Road to the Canyon*, c. 1915

Maurice Braun
oil on canvas, 24 x 30 inches (60.9 x 76.2 cm), l.l.:
Maurice Braun
Bob and Toni Crisell

24 *Rocky Heights*, 1910-29

Maurice Braun
oil on canvas, 25 ¹/₈ x 30 inches (63.8 x 76.2 cm),
l.r.: *Maurice Braun*
Inscribed on reverse: *M.H.T. de Young Memorial
Museum/Exhibition Maurice Braun 1877-1941/
Title: Rocky Heights/Artist: Maurice Braun/
owner Mrs. L. Edward Loring/1054 Grizzly
Blvd. /No. #3 Berkeley, Cal.*
The Braun family

Exhibitions
One by this title was exhibited in the following:
1938 Colonial Art Company, Oklahoma City,
October, *Paintings by Maurice Braun*, no. 13 ($250)
1938 Lauren Rogers Library and Museum of Art,
Laurel (Mississippi), November, *Paintings by Maurice
Braun*, no. 13 ($250)
1938 Art Department, Washburn College, Topeka
(Kansas), December, *Paintings by Maurice Braun*, no. 13
($250)
1939 Arnot Art Gallery, Elmira (New York), April,
Exhibition of Paintings by Maurice Braun, no. 7
1954 M.H. de Young Memorial Museum, San Fran-
cisco, March, *Maurice Braun Retrospective Exhibition
of Paintings*, no. 3, dated 1910-29

25 *Summer Moon over El Capitan
Mountain*, c. 1918

Maurice Braun
oil on canvas, 20 x 24 inches (50.8 x 61 cm), l.l.:
Maurice Braun
Fieldstone Company (88.08.01)

Provenance
With Sotheby Park Bernet, Los Angeles (1986); with
Orr's Gallery, San Diego (1987)
Bibliography
Sotheby Park Bernet, Los Angeles, 26 September 1986
Title [?], no. 232, il., as *California Landscape
Antiques & Fine Arts*, IV (January/February 1990), clr
il. 8, as *Summer Moon Over El Cajon Mountain*, and
dated c. 1925

26 *High Sierras from Soda Spring*,
c. 1918-1920

Maurice Braun
oil on canvas, 20 ¹/₈ x 24 inches (51.1 x 60.9 cm),
l.r.: *Maurice Braun*
C. Klein Company Corporation

27 *Land of Sunshine*, c. 1920

Maurice Braun
oil on canvas, 50 x 70 inches (27.0 x 77.8 cm),
l.r.: *Maurice Braun*
Label on reverse indicates the work may have
been included in the *Thirty-Third Annual
Carnegie or Pennsylvania Academy of Fine Arts
Exhibition*
Fieldstone Company Collection (86.07)

Provenance
With a Midwest family; with Arizona West Galleries
Inc., Scottsdale (1982); with George Stern Fine Arts,
Encino (1986)
Exhibitions
1923 Wichita Falls Art Association, Wichita Falls
(Texas) 21-31 March
Bibliography
Wichita Falls Record News, 1 April 1923.
Works were being packed and sent to different places,
those painted by Maurice Braun being sent to the Mac-
beth Gallery in New York for a one-man exhibit. A high
school student, Estelle Stanfield, described the picture
in a prize-winning essay entitled *The Land of Sunshine*,
which is reproduced below.
The picture that interested me most was "The Land of
Sunshine" by Maurice Braun. I will discuss some of the
reasons for my preference of this painting.
The bank of the brook, and the brook itself, leads the
eye into the picture. When it has the eye in the center of
the picture, where it can see the whole, the brook glides
behind a little ridge and trees so the interest can be
concentrated on the rest of the picture. While the eye is
following the brook, it sees clear, blue, rippling water as
it passes over high places in its course and dodges
another ridge, but always onward. While the brook
beautifies the picture, it seems to have a duty beyond,
and is moving forward to perform that duty.
The rocks in the foreground, of red, brown, and
brownish gold, blend beautifully with the green used in
the first trees. The trees on the left are a bright green,
which gives the effect of spring. One tree goes on till
branches form an umbrella shape, while [?] it is a large
brushing out at the ground and making a contrast with
the full stately tree. Smaller trees seem to have sprung
up around the two rocks. The trees on the side seem to
be young and concerned more with their own growth
and development. While on the other side only one
young tree appears, and that on the side of a tall tree, to
break the tree line. By the side of these are several other
trees with older-looking trunks and branches. These
branches seem to be for birds to sit on and sing or give
their love verses to the bird of their choice. There are
many places to build a little nest for the new home.
The rocks have the appearance of strength and realness.
When one looks at the rocks and grasses and nature so
reflected or copied in these, a rabbit is expected to come
hopping out into view. A large rock on one side and a
bank overgrown with beautiful brown shrubs on the
other that causes the brook to glide so gracefully into
the scene.
Between the trees and the first low mountains the
ground rises and falls and is covered with shrubs and
grass, varying in color from the natural green to the real
bright, yellowish green.
The mountains in the distance give the picture a beauti-
ful horizon. They are of a soft purple, while the ones
nearer being a purplish tan. The sky is a mellow or pale
blue near the horizon, and becomes bluer higher in the
sky. Wonderful shaped clouds of fleecy whiteness seem
to be drifting and floating over the clear sky. The sky
reflects its color in the stream, and the clouds reflect
their whiteness on the rocks, giving a grayed effect.
As the shadows of the trees and rocks are short, and the
greens are to a yellowish green, the sun must be about
halfway on its course.
One of the main reasons I liked this picture best is
because the artist left something to the imagination. In
our minds we place the birds in the trees, the rabbits
hopping behind the rocks, the fish in the clear stream
and the cows lying in the shade of the trees or drinking
from the brook.

The colors blending from brown through greens, to the tan and then to the purples, blend with a perfect freedom. The blue of the sky reflected in the stream, the white clouds reflecting on the rocks, and the sun casting his golden influence over the earth—the picture can truly be called the "Land of Sunshine."

28 Mountain Lilac—Palomar, c. 1920

Maurice Braun
oil on canvas, 25 x 30 inches (64.1 x 76.2 cm),
l.r.: *Maurice Braun*
Inscribed on reverse on stretcher bar:
25 x 30 Mountain Lilac $250.00 $500.00

Private collection

Provenance
Mrs. Henry B. Clark, Jr. (1936)

Exhibitions
One by this title was exhibited in the following:
1933 La Jolla Art Association (Library), one-man show, thirty-three paintings

Bibliography
One by this title was published in the following:
Poland, Reginald H., *San Diego Union*, [?], 1933

29 Plowed Fields, c. 1925

Maurice Braun
oil on canvas, 39 x 49³/₄ inches (99.2 x 126.4 cm),
l.r.: *Maurice Braun*

Thomas W. Sefton Collection (Bo-6 Sefton)

30 Early Springtime, c. 1923

Maurice Braun
oil on board, 7 x 9 inches (17.8 x 22.9 cm), l.r.:
Maurice Braun
Inscribed on reverse: *To Charlotte Le Claire Braun/from her father on her third birthday. Jan 19, 1923*

The Braun family

Exhibitions
One by this title was exhibited in the following:
1924 Museum Art Gallery, California Building, San Diego, 17 February - 10 March, *Recent Paintings by Maurice Braun*, no. 25
Fine Arts Gallery (Museum of Art), San Diego, *Exhibition of Paintings by Maurice Braun*, no. 6, lent by Talbot Mundy
[19??] Cannell & Chaffin Galleries, Los Angeles, 31 March - 26 April [?], *Recent Paintings by Maurice Braun*, no. 7
1924 Copley Gallery (Boston), 18 February - 1 March, *Paintings by Maurice Braun*, no. 11 ($300)

Remarks
The work in Mundy's collection was widely exhibited during the 1920s. A distinguished author and Point Loma resident who wrote such popular novels as *King of the Khyber Rifles* and *Winds of the World*, Mundy was also a friend of the Brauns and a voice in the cultural community.

31 Spring in the Forest, c. 1925

Maurice Braun
oil on canvas, 16¹/₈ x 20 inches (41 x 50.8 cm),
l.l.: *Maurice Braun*
Inscribed on reverse on stretcher bar: *Maurice Braun Spring #268 16 x 20*

The Braun family

Exhibitions
One by this title was exhibited in the following:
1954 M.H. de Young Memorial Museum, San Francisco, March, *Maurice Braun Retrospective Exhibition of Paintings*, no. 5, dated 1910-29

Remarks
The scene was painted near Potosi, Missouri, during one of the artist's eastern trips.

32 Mystic Fall, 1921 - 9

Maurice Braun
oil on canvas, 16¹/₈ x 20¹/₈ inches (41 x 51.1 cm),
l.r.: *Maurice Braun*
Inscribed on reverse: *To my daughter Charlotte on her 10th birthday Jan. 19th 1930*

The Braun family

33 At Ocean Beach, c. 1922

Maurice Braun
oil on board, 6 x 8 inches (5.4 x 20.4 cm), l.r.;
Maurice Braun
Inscribed on reverse: *To Charlotte Braun from her mother on her second birthday Jan. 19, 1922./L.E. Loring/at Ocean Beach/by Maurice Braun*

The Braun family

34 San Diego Shores, c. 1928

Maurice Braun
oil on canvas, 30¹/₈ x 36¹/₈ inches
(76.5 x 91.8 cm), l.r.: *Maurice Braun*

Private collection

Provenance
With Redfern Gallery, Laguna Beach

Bibliography
Petersen, M.E., "Maurice Braun," *Art of California*, II (August/September 1989), no. 4, clr il. 52

35 Harbor Scene, c. 1925 - 30

Maurice Braun
oil on canvas, 24¹/₄ x 30¹/₄ inches
(61.6 x 76.8 cm), l.r.: *Maurice Braun*

Dr. and Mrs. Albert A. Cutri and Dr. and Mrs. Robert Frickman

Provenance
One by this title was in the collection of Mrs. Leon Bonnet, San Diego; with DeVille Inc., Los Angeles

Exhibitions
One by this title was exhibited in the following:
1951 Fine Arts Gallery (San Diego Museum of Art), San Diego, November, *Tenth Anniversary of the Artist's Death*

Bibliography
One by this title was published in *San Diego Union*, 18 November 1951

36 Lake Cuyamaca—Old Hotel, c. 1930

Maurice Braun
oil on canvas on board, 20¹/₈ x 24 inches
(51.1 x 61 cm), l.r.: *Maurice Braun*
Inscribed on reverse: *20 x 24—Cuyamaca Lake*

Mr. and Mrs. Ferdinand T. Fletcher

Remarks
This work depicts the property owned and developed by Colonel Ed Fletcher, an early San Diego pioneer. The site was a popular recreation area for the East County. Cabins owned by the Fletchers were on the property, and the artist was frequently invited to use one. The hotel no longer exists.

37 Cuyamaca Lake, c. 1930

Maurice Braun
oil on canvas, 25¹/₈ x 30¹/₈ inches
(63.8 x 76.6 cm), l.r.: *Maurice Braun*
Inscribed on reverse: *25 x 30 Cuyamaca Lake*

Mr. and Mrs. Ferdinand T. Fletcher

Provenance
Artist; sold by his daughter to Ferdinand T. Fletcher from an exhibition in 1950. In the receipt book this work is listed as *Cuyamaca*.

Exhibitions
One by this title was exhibited in the following:
1930 Fine Arts Gallery, San Diego, February - March, *Exhibition of Paintings and Sculpture by the Contemporary Artists of San Diego*, no. 9
1932 La Jolla, June
1932 Del Mar
1936 H. Lieber Company, Indianapolis, one-man show
Cuyamaca Club, San Diego, 21 May - [?] June [19??], no. 17
1937 Municipal Art Gallery, Jackson (Mississippi), January, *Paintings by Maurice Braun*
1937 Lauren Rogers Library and Museum of Art, Laurel (Mississippi) *Paintings by Maurice Braun*, February, no. 9 ($150)

Bibliography
One by this title was published in the following:
Barney, Esther Stevens, San Diego *Evening Tribune*, 8 February 1930
Braun, Hazel Boyer, San Diego *Evening Tribune*, 9 July 193[?]
Indianapolis, unattributed and undated clipping, December 1936

38 Eucalyptus, c. 1930

Maurice Braun
oil on canvas, 20 x 16¹/₈ inches (51 x 41 cm), l.r.:
Maurice Braun
Inscribed on reverse on stretcher bar: *16 x 20 Eucalyptus*

Mrs. Charles W. Hickey

Remarks
There are references dating from 1915 to a large number of works by this title which were exhibited from New York to Los Angeles. Unfortunately, early catalogues and art writers often failed to copy titles accurately, as well as omitting descriptions and failing to reproduce works in publications as is commonly done today.

39 Distant Hills, c. 1935 - 40

Maurice Braun
oil on canvas, 25 x 30 inches (63.5 x 76.2 cm),
l.r.: *Maurice Braun*

Mr. and Mrs. Robert P. Sedlock, Jr.

Provenance
Artist; private San Diego collection; with Orr's Gallery, San Diego

Exhibitions
One by this title was exhibited in the following:
1923 Macbeth Gallery, New York City, 17 April - 7 May, *Paintings by Maurice Braun*, no. 17 ($250)

Remarks
Another work by this title, 20 x 24 inches and signed l.l., was with Stewart Galleries, San Diego, in 1977. It was published in color in *Antiques & Fine Art 4* (August 1977), 31. An advertisement for William A. Karges Fine Art, Carmel, California, in 1988 reproduced the same picture in color in *Antiques & Fine Art 5* (April 1988), 3.

40 *Palomar Sketch, c. 1930-5*
Maurice Braun
oil on board, 9 x 12 inches (22.9 x 30.5 cm), l.r.:
Maurice Braun
Inscribed on reverse: *9 x 12 Sketch at 2500/
Palomar*
Jane and Willis Fletcher

41 *The Desert, c. 1938*
Maurice Braun
oil on canvas, 25 x 30 inches (63.5 x 76.2 cm),
l.r.: *Maurice Braun*
Inscribed on reverse: *No. 9 The Desert/Maurice
Braun*
The Braun family

Exhibitions
One by this title was exhibited in the following:
1942 High School Art Gallery, Springville (Utah),
Exhibition of the Paintings of Maurice Braun, no. 26
1954 M.H. deYoung Memorial Museum, San Fran-
cisco, March, *Maurice Braun Retrospective Exhibition
of Paintings*, no. 10, dated 1930-9

42 *Desert and Mountains, c. 1938*
Maurice Braun
oil on canvas, 25 1/8 x 30 inches (63.8 x 76.2 cm),
l.r.: *Maurice Braun*
Inscribed on reverse: *25 x 30 Desert &
Mountains $250.00 $500.00*
Mr. and Mrs. David E. Porter

Exhibitions
One by this title was exhibited in the following:
1938 Orr's Gallery, San Diego, June-July, one-man
show, eighteen paintings
Bibliography
One by this title was mentioned in the following:
Haddock, Lois, San Diego *Sun*, 24 July 1938

43 *Departing Fleet, c. 1938-9*
Maurice Braun
oil on canvas, 16 x 20 inches (41.3 x 50.8 cm), l.l.:
Maurice Braun
Inscribed on reverse: *16 x 20 Departing Fleet*
The Braun family

Exhibitions
1938 Colonial Art Company, Oklahoma City, October
1938 Lauren Rogers Library and Museum of Art,
Laurel (Mississippi), November, *Exhibition of Oil
Paintings by Maurice Braun*, no. 20 ($100)
1939 Art Department, Washburn College, Topeka
(Kansas), December, *Paintings by Maurice Braun*, no. 20
($ 100)
1939 Arnot Art Gallery, Elmira (New York), April,
Exhibition of Paintings by Maurice Braun, no. 18
1939 Manchester (New Hampshire), May, *Exhibition
of Oil Paintings by Maurice Braun*
1954 M.H. deYoung Memorial Museum, San Fran-
cisco, March, *Maurice Braun Retrospective Exhibition
of Paintings*, no. 25, dated 1940-1
Remarks
This picture depicts an eastern scene showing an early
morning departure of four boats heading toward the
open sea. Following his eastern stays, where he
produced a number of coastal scenes, Braun would
develop pictures of imaginative sites incorporating
subjects and atmospheric moods from both the East and
West Coasts.

Alfred R. Mitchell

44 *Mission Valley, c. 1913*
Alfred R. Mitchell
watercolor on paper, 9 x 11 7/8 inches (sheet size)
(22.9 x 30.2 cm), l.l.: *Alfred R. Mitchell*
Inscribed on reverse: *One of the first pictures I
painted/Done about 1913—*
Private collection

45 *Eucalyptus Trees, c. 1920*
Alfred R. Mitchell
oil on board, 12 1/8 x .9 1/8 inches (30.8 x 23.2 cm),
l.r.: *Alfred R. Mitchell*
Private collection

46 *Mission Valley, before 1922*
Alfred R. Mitchell
crayon on board, 11 3/8 x 14 1/4 inches
(28.9 x 36.2 cm), l.r.: *Fred Mitchell*
Inscribed on reverse: *Mission Valley*
Private collection

47 *The Fullness of Autumn, c. 1920-2*
Alfred R. Mitchell
watercolor on paper, 7 x 7 5/8 inches (sheet size)
(17.8 x 19.3 cm), unsigned
Inscribed on reverse: *The Fullness of
Autumn./This is somewhat modern. It shows
the influence of the "New" Art. If it gives you
the impression of Autumn in its freshness,
softness and variety it has fulfilled its pur-
pose./Merry Christmas from/Fred.*
Private collection

Remarks
This sketch was painted when the artist was attending
the Pennsylvania Academy.

48 *Untitled (Landscape with Hills and
Trees), 1920-2*
Alfred R. Mitchell
watercolor on cardboard, 6 3/4 x 5 1/8 inches
(17.2 x 13.2 cm), unsigned
Inscribed on reverse: *Alfred R. Mitchell/From the
time I was in Maurice Braun's studio*
Private collection

49 *Landscape with Trees, c. 1921-2*
Alfred R. Mitchell
crayon on paper, 9 1/8 x 11 5/8 inches
(23.2 x 24.5 cm), l.r.: *Alfred R. Mitchell*
Dr. and Mrs. Albert A. Cutri

50 *December in San Diego, c. 1925*
Alfred R. Mitchell
oil on board, 13 x 16 inches (35 x 40.6 cm), l.r.:
Alfred R. Mitchell
Inscribed on reverse: (extensive)
Fieldstone Company (86.14.02)

Provenance
Mrs. Alfred R. Mitchell; Petersen Galleries, Beverly
Hills
Exhibitions
1973 Fine Arts Gallery of San Diego (San Diego Mu-
seum of Art), *Memorial Exhibition Alfred R. Mitchell*

51 *Our Garden at 29th Street, c. 1927*
Alfred R. Mitchell
oil on board, 8 x 10 inches (20.3 x 25.4 cm), l.r.:
Alfred R. Mitchell
Inscribed on reverse: *Our Garden at 29th
St/#536; The Front Porch/behind the
flowers/1035-29th Street/peach tree on left in
bloom/corner/29th and/C Streets*
Private collection

52 *On Our Porch, c. 1922*
Alfred R. Mitchell
watercolor on paper, 11 15/16 x 9 inches
(30.4 x 22.9 cm), l.r.: *Fred R. Mitchell*
Inscribed center at bottom: *On Our Porch*
Private collection

53 *Mountain Ranch, c. 1925*
Alfred R. Mitchell
oil on board, 16 x 20 inches (66.3 x 102.2 cm), l.l.:
Alfred R. Mitchell
Inscribed on reverse: *Mountain Ranch—/Alfred
R. Mitchell*
Roy and Adele Nelson

54 *The Canyon, c. 1927*
Alfred R. Mitchell
oil on canvas laid down on plywood, 34 1/4 x
38 1/4 inches (87 x 97.6 cm), l.l.: *Alfred
R. Mitchell*
Label on reverse: *The Canyon/by/Alfred
R. Mitchell/1035 29th St.,/San Diego Cal.*
First Unitarian Church of San Diego

55 *Delaware Valley, c. 1926*
Alfred R. Mitchell
oil on canvas, 40 x 50 inches (103.5 x 127.6 cm),
l.r.: *Alfred R. Mitchell*
San Diego Museum of Art (1927: 081)

Provenance
Artist; purchased by Friends of the Fine Arts Society for
the permanent collection, 1927
Exhibitions
1970 San Diego, Serra Museum, Tower Gallery, *Con-
temporary Artists of San Diego*
Bibliography
Fine Arts Gallery of San Diego, *Catalogue of Paintings
and Tapestries in the Permanent Collection*, 1927,
cat. no. 23, il., 22
Petersen, M.E. "Contemporary Artists of San Diego",
Journal of San Diego History, XVI (Fall 1970), no. 4, il. 7
San Diego Historical Society, *Sunlight and Shadow: The
Art of Alfred R. Mitchell, 1888-1972*, San Diego, 1988,
il. 24
Braun, Hazel Boyer, San Diego *Tribune*, 16 July,
4 December 1927
Krombach, Beatrice de Lack, San Diego *Sun*,
19 December 1927
Dunann, Donnelly, *San Diego Union*, 30 October 1938
Westphal, Ruth, *Plein Air Painters of California: The
Southland*, Irvine: Westphal Publishing, 1982, clr
il. 203.
Remarks
The old covered bridge *(lower left)* was replaced by an
iron structure prior to the acquisition of the painting by
the museum.

56 *The Mill*, c. 1926

Alfred R. Mitchell
oil on canvas laid down on masonite,
36 x 46 ⅝ inches (91.6 x 118.5 cm), l.l.: *Alfred R. Mitchell*

Paul and Reta Kress

Provenance
Mrs. Mitchell (1973)

Remarks
The subject of this painting is the mill on The Wissahicken River, near Philadelphia.

57 *Morning on the Bay*, c. 1923

Alfred R. Mitchell
oil on canvas, 50 ¼ x 58 ¼ inches
(127.6 x 148 cm), l.l.: *Alfred R. Mitchell*
Inscribed on reverse: *Morning on the Bay $360/Alfred R. Mitchell/San Diego, California*
Label on reverse of frame: *Orr's Gallery/Alfred Mitchell/7th St. between Date/& Cedar—looking Toward/Point Loma—circa 1923/$360*

The San Diego Historical Society, gift of Mrs. Alfred R. Mitchell (1984), no. 84.60

Exhibitions
1924 Fine Arts Gallery of San Diego, 1-24 August, *Summer Exhibition of Works by the Art Guild Members*, no. 68
Bibliography
San Diego Union, 10 August 1924, il.
Pourade, Richard, *The Rising Tide*, San Diego: Copley Press, 1967, clr il., pp. 18-19
Journal of San Diego History, XIX (Fall 1973), no. 4, cover il. in color

Remarks
The scene depicts Seventh Street between Date and Cedar looking west and showing the brick tower of St. Joseph's Church with North Island and the lee side of Pt. Loma visible in the background.

58 *Beside the Sea*, 1928-30

Alfred R. Mitchell
oil on canvas, 30 ¼ x 50 ⅛ inches
(76.9 x 127.3 cm), l.l.: *Alfred R. Mitchell*
Inscribed on stretcher bar: *Beside the Sea—/Alfred R. Mitchell*
Labels on reverse: *Mrs. L.A. Means/4237 Trias Street/San Diego, Calif. 92103; Exhibition: Alfred R. Mitchell/Date: Oct. 6-Nov. 4, 1973/Lender: Mrs. L.A. Means/Fine Arts Gallery of San Diego; Exhibited at the Fine Arts Gallery of San Diego 1973*

The W. F. and J.C. Jones family

Provenance
Mrs. L.A. Means (1973)

Exhibitions
1973 Fine Arts Gallery of San Diego (San Diego Museum of Art), *Alfred R. Mitchell Memorial Exhibition*
1973 La Jolla, Art Association Gallery, February, *Alfred Mitchell Memorial Exhibition*

59 *In Evening Light*, 1930

Alfred R. Mitchell
oil on canvas, 24 1/16 x 40 inches
(61.1 x 101.6 cm), unsigned

Private collection

Exhibitions
1973 San Diego Fine Arts Gallery, 4 October-6 November, *Alfred R. Mitchell Memorial Exhibition*

60 *El Capitan Dam*, c. 1930

Alfred R. Mitchell
oil on canvas, 40 x 50 inches; l.l.: *Alfred R. Mitchell*

Fieldstone Company (86.04.01)

Provenance
George Stern Fine Arts, Encino, California

61 *The Edge of the Sea*, c. 1930-6

Alfred R. Mitchell
oil on board, 16 x 20 inches (40.7 x 50.8 cm), l.l.: *Alfred R. Mitchell*
Inscribed on reverse: *The Edge of the Sea./Alfred R. Mitchell*

Christine Ukrainec

62 *Moonlight at Torrey Pines*, 1930-9

Alfred R. Mitchell
oil on board, 15 ¾ x 19 ⅝ inches (40 x 49.8 cm), l.l.: *Alfred R. Mitchell*

Mrs. Donald C. Burnham

Provenance
Mrs. Alfred R. Mitchell

63 *At Torrey Pines*, 1930-9

Alfred R. Mitchell
oil on canvas, 26 ⅛ x 40 ¼ inches
(66.3 x 102.2 cm), l.l.: *Alfred R. Mitchell*
Inscribed on reverse: *At Torrey Pines/—Alfred R. Mitchell*

W.F. and J.C. Jones family

Remarks
The building shown in the lower right foreground was an inn and the home of Guy Flemming, frequently visited by the Mitchells, and designed by Richard Requa, a leading San Diego architect. Flemming was in charge of affairs for all Southern California State Parks. Today the modified building is a Ranger station.

64 *Torrey Pines*, c. 1930-9

Alfred R. Mitchell
oil on board, 16 x 20 inches (40.7 x 50.7 cm), t.l.: *Alfred R. Mitchell*
Inscribed on reverse: *Torrey Pines/Alfred R. Mitchell*

Mrs. Charles W. Hickey

Provenance
There are several paintings by this title, for example one with John Cox 1929; another dated 1939; another described as overlooking Sorrento Valley exhibited 12 January 1942 and published in the *San Diego Union*, 22 February 1942.

65 *Calm Harbor*, c. 1931-5

Alfred R. Mitchell
oil on board, 16 x 20 inches (40.7 x 50.7 cm), l.r.: *Alfred R. Mitchell*
Inscribed on reverse: *Calm Harbor/Alfred R. Mitchell/San Diego, Cal.*

Mr. and Mrs. William B. Rick

66 *Study for the Baithouse*, 1938 (Summer)

Alfred R. Mitchell
oil on masonite, 8 x 20 inches (20.2 x 50.8 cm), unsigned
Inscribed on reverse: *Alfred R. Mitchell/The Bait House. #443 Alfred R. Mitchell/Preliminary study for the large painting owned by Mrs. Charles D. Mack D.W.W.*

Private collection

Exhibitions
One by this title (probably the finished picture) was exhibited in the following:
1939 Fine Arts Gallery of San Diego, December, *Art Guild Exhibition*
1940 La Jolla Art Association, Library, March
1978 Downey Museum of Art, 17 September-29 October, *Southern California Painting, Part II: Alfred R. Mitchell, 1888-1972*, no. 202
Bibliography
One by this title was published in the following:
Poland, Reginald H., *San Diego Union*, December 1939
Braun, Hazel Boyer, San Diego *Tribune*, 16 March 1940, as *Ocean Beach Bait House*

67 *Untitled*, c. 1938

Alfred R. Mitchell
oil on canvas, 20 x 24 inches (50.8 x 61 cm), l.l.: *Alfred R. Mitchell*

James and Estelle Milch

Remarks
Young girls are shown walking along the edge of the water.

68 *Early Morning—Mt. Shasta*, c. 1932

Alfred R. Mitchell
oil on canvas laid down on board, 42 ½ x 42 ½ inches (108 x 107.3 cm), l.r.: *Alfred R. Mitchell*
Label on reverse: *Early Morning—Mt. Shasta/Alfred R. Mitchell/1506 E. 31st St. San Diego, Cal/#370*

Jon E. Icardo

Provenance
Artist's estate; Mrs. Dorothea Mitchell

Exhibitions
1978 Downey Museum of Art, 17 September-29 October, *Southern California Painting, Part II: Alfred R. Mitchell, 1888-1972*, cat. no. 111, lent by Mrs. Mitchell

Remarks
According to the present owner, Mrs. Mitchell disliked the painting, although it was a favorite of the artist.

69 *Desert Dawn*, 1938 (Spring)

Alfred R. Mitchell
oil on board, 8 x 10 inches (20.5 x 25.5 cm), l.r.: *Alfred R. Mitchell*
Inscribed on reverse: *Desert Dawn/Alfred R. Mitchell*

Private collection

70 *Moonlight—Yosemite*, 1934

Alfred R. Mitchell
oil on board, 8 x 10 inches (20.3 x 25.2 cm), l.c.: *Alfred R. Mitchell*
Inscribed on reverse: *The viewer is in Camp 16. The foreground is the Maneed River. The little red streak is the reflection of a bonfire in a camp among the trees. The little light streak in the shadow-side of the great cliff is a view of a Yosemite Fall. Dorothea W. Mitchell.*

Private collection

71 *Desert Cliffs*, c. 1947

Alfred R. Mitchell
oil on board, 16 x 20 inches (41.2 x 50.8 cm), l.r.:
Alfred R. Mitchell
Inscribed on reverse: *Desert Cliffs—/Alfred*
R. Mitchell/San Diego, Cal.
Tag on reverse: *Title: Desert Cliffs/Medium: oil/*
Artist: Alfred R. Mitchell/Address: 1506 E. 31st
St. San Diego 2/Price $150.00/For Art Instruc-
tions Exhibition/Art Center in La Jolla 1960

The W.F. and J.C. Jones family

Provenance
Mrs. L.A. Means (1973)
Exhibitions
1960 La Jolla Art Center
1973 La Jolla, Art Association Gallery, February,
Alfred R. Mitchell Memorial Exhibition

72 *Mill at Caspar, Mendocino County—*
Morning, c. 1947

Alfred R. Mitchell
oil on board, 15¹⁵/₁₆ x 20 inches (40.5 x 50.8 cm),
l.r.: *Alfred R. Mitchell*
Inscribed on reverse: *Mill at Caspar, Mendocino*
County Morning. Alfred R. Mitchell/To my
Angel wife, who inspired me through and
through. A.R.M.

Dr. and Mrs. Albert A. Cutri

73 *Berkeley Campanile*, c. 1947-50

Alfred R. Mitchell
oil on board, 8 x 9⁷/₈ inches (20.3 x 25.2 cm), l.r.:
Alfred R. Mitchell
Inscribed on reverse: *Berkeley Campanili*

Dan Stephens

Provenance
Stewart Gallery, San Diego

74 *Nipomo Hills*, c. 1950

Alfred R. Mitchell
oil on canvas, 24¹/₈ x 36³/₁₆ inches
(61.2 x 92 cm), l.r.: *Alfred R. Mitchell*
Inscribed on reverse: *Nipomo Hills/Alfred*
R. Mitchell

Mrs. Albert Campell

Charles Reiffel

75 *North African Scene*, c. 1895

Charles Reiffel
oil on canvas, 5³/₄ x 7³/₈ inches (14.6 x 18.7 cm),
l.r.: *Charles Reiffel*

Paul and Reta Kress

76 *Railway*, 1910

Charles Reiffel
watercolor on paper, 10⁵/₁₆ x 13³/₄ inches (sheet
size) (226.2 x 35 cm), l.r.: *Charles Reiffel*
Inscribed on reverse: *Alfred R. Mitchell—Gift of*
Mrs. Reiffel

San Diego Museum of Art, gift of Mrs. Alfred
R. Mitchell (1977: 017)

Provenance
Artist; Mrs. Charles Reiffel; Alfred R. Mitchell;
Mrs. Alfred R. Mitchell

77 *My Neighbor's Garden*, 1926

Charles Reiffel
oil on canvas, 32 x 35 inches (81.3 x 91.7 cm),
l.r.: *Charles Reiffel*
Inscribed on reverse: *My Neighbor's*
Garden/Charles Reiffel

Mr. and Mrs. James Polak

Provenance
Glenn Mitchell
Exhibitions
1926 Fine Arts Gallery of San Diego (San Diego
Museum of Art), June-August, *First Exhibition of*
Artists of Southern California, no. 105
1926 Fine Arts Gallery of San Diego (San Diego
Museum of Art), *Seventh Annual Exhibition of Painters*
and Sculptors of Southern California, Art Guild Prize
for best painting
1942 Fine Arts Gallery of San Diego, June, *Charles*
Reiffel: A Memorial Exhibition of his Paintings, no. 23,
dated 1931
Bibliography
Poland, Reginald H., *San Diego Union*, 27 June 1926:
"His work has something of the elusiveness, rhythm
and subtlety of Ernest Lawson."
San Diego Sun, 13 July 1926
Remarks
Glenn Mitchell, San Diego real estate businessman, was
among the first to befriend the Reiffels after their arrival
in San Diego. He arranged living accommodation for
them in an old Victorian house on the neighboring Beck
property. In this picture the Mitchell home is shown on
the summit of the hill in the middle ground. The care-
taker's quarters *(lower left)* became the artist's studio.
The site today is Orange Avenue off Broadway in El
Cajon.

78 *Highland Dairy*, c. 1927

Charles Reiffel
oil on canvas, 25 x 30 inches (63.5 x 76.5 cm),
l.r.: *Charles Reiffel*
Inscribed on reverse: *Highland Dairy/Charles*
Reiffel: A.H. Gilbert.
Label on stretcher bar: *Alfred H. Gilbert/2408*
First Avenue/San Diego, California 4668

Mrs. Meg Woolman-Bowman

Provenance
From the artist to Dr. Alfred H. Gilbert in exchange for
dental service, according to the family. Dr. Gilbert was
the brother of San Diego Museum patrons Bess and
Gertrude Gilbert. The picture remained in the house
from Dr. Gilbert's death in 1960 until the death of
Mrs. Gilbert in 1977, when it went to his great niece,
the current owner.
Exhibitions
1928 Los Angeles, Newhouse Galleries, July-August,
Exhibition of Paintings by Charles Reiffel, no. 24
1930 Fine Arts Gallery of San Diego, *Exhibition of*
Paintings and Sculpture by the Contemporary Artists of
San Diego, no. 35
1932 Chicago, Marshall Field, 13 January-6 February,
Hoosier Salon Eighth Annual, Thomas MacButler
Memorial Prize
1932 Fine Arts Gallery of San Diego, *Catalogue of the*
Circulating Gallery of Portable Pictures and Sculpture,
no. 29
1934 San Diego, Art Cellar, *Paintings by Charles*
Reiffel
1942 Fine Arts Gallery of San Diego, *Charles Reiffel:*
A Memorial Exhibition, no. 29, dated 1931, lent by
Mrs. A.H. Gilbert.
Bibliography
San Diego Evening Tribune, 8 February 1930
San Diego Union, 9 February 1930, il.
Poland, Reginald H., *San Diego Union*, 4 December
1934
San Diego Evening Tribune, 3 November 1934, il.
San Diego Union, 4 November 1934, il.

Krombach, Beatrice de Lack, San Diego *Sun*, 19 June
1927: "You see El Capitan in the background. On the
crest of the hill, at another level, are a silo and barns."
Remarks
There is another version of this subject in the San Diego
County administration offices, dated 1927.

79 *Giant Cacti—Arizona*, c. 1927-30

Charles Reiffel
oil on canvas, 25 x 30¹/₈ inches (63.5 x 76.5 cm),
l.r.: *Charles Reiffel*
Inscribed on reverse: *Giant Cacti—*
Arizona/Charles Reiffel

Legler Benbough

80 *Mountain Dairy*, c. 1927-30

Charles Reiffel
oil on canvas, 34¹/₄ x 37 inches (87 x 94 cm), l.r.:
Charles Reiffel
Inscribed on reverse: *Mountain Dairy/Charles*
Reiffel

Paul and Reta Kress

Exhibitions
1932 Chicago, Marshall Field, *Hoosier Salon Eighth*
Annual Exhibition, no. 1, Thomas MacButler Memorial
Prize

81 *Morning, Nogales, Arizona*, 1928

Charles Reiffel
oil on canvas, 34 x 37¹/₈ inches (86.4 x 94.3 cm),
l.r.: *Charles Reiffel*

San Diego Museum of Art (1943: 029)

Provenance
Artist
Exhibitions
1928 Washington D.C., Corcoran Gallery of Art,
October-December, *Eleventh Annual Exhibition of*
Contemporary American Art, no. 103, il.
1929 Indianapolis, John Herron Art Institute, *Twenty-*
Third Annual Indiana Artists' Exhibition, Art Associa-
tion prize winner
1929 Buffalo, Albright Art Gallery, April-June,
Twenty-Third Annual Exhibition of Selected Paintings
by American Artists, no. 90
1929 New York City, National Academy of Design,
104th Annual Exhibition
1930 Chicago, Marshall Field, 25 January-12 February,
Hoosier Salon Sixth Annual
1931 Pittsburgh, Carnegie Institute, *15 October-*
6 December, Thirtieth Annual International Exhibition
of Paintings, no. 60, merit award ($1000)
1932 Los Angeles, Museum of History, Science and
Art, 19 April-15 June, *Thirtieth Annual Painting and*
Sculpture Exhibition, no. 13, $1000 award
1932 Art Institute of Chicago, 1932-3, *Forty-Fifth An-*
nual Exhibition of American Paintings and Sculpture,
no. 160, selected for a circulating exhibition
1935 San Diego, Palace of Fine Arts, California Pacific
Exposition, *Official Art Exhibition*, no. 187, il. pl. xx
1938 Palm Springs, 15 October-5 November, *Group*
Show of Paintings
1939 Santa Barbara, Faulkner Art Gallery, 5 June-
30 July, *Some Southwest Artists, Oils and Watercolors*,
no. 9
1942 Fine Arts Gallery of San Diego, *Charles Reiffel:*
A Memorial Exhibition, no. 11
1970 San Diego, Serra Museum, Tower Gallery,
1970-1, *Contemporary Artists of San Diego*
Bibliography
Palm Springs News, 27 October 1938
The Contemporary Artists of San Diego, San Diego,
privately published, c. 1929
John Herron Art Institute, *Bulletin of the Art Associa-*
tion of Indianapolis, Indiana, XVI (October/November
1929), no. 6, il.

San Diego Museum of Art, *Reproductions of Four Paintings by Charles Reiffel*, Examples in the Memorial Exhibition at the Fine Arts Gallery, June 1942, no. 11, il. *San Diego Union*, 14 November 1943, il., as *Early Morning, Nogales, Arizona*
Art Digest, XVII (January 1944), il. 13
San Diego Museum of Art, *Catalogue of American Painting*, 1981, il., as *Early Morning, Nogales, Arizona*
Westphal, Ruth (ed.), *Plein Air Painters of California: The Southland*, Irvine, Westphal Publishing, 1982, clr il., 208
Petersen, Martin E., *Journal of San Diego History*, XXXI (Winter 1985), il., 28

82 *Mountain Ranch after the Rain*, 1928

Charles Reiffel
oil on canvas, 32 x 40 1/8 inches (81.2 x 106 cm), l.r.: *Charles Reiffel*
Inscribed on reverse: *Mountain Ranch/After the Rain Charles Reiffel Mrs. Keith Spaulding Prize/California Art Club Los Angeles Museum 1928/E.M. Welker/4401 Brad —? San Diego 4, Calif.*

Paul and Reta Kress

Provenance
Artist; Miss Eugenia M. Welker, 1942
Exhibitions
1928 Los Angeles Museum of Science, History and Art, 8 November - 16 December, California Art Club, *Nineteenth Annual Exhibition*, no. 45, dated 1928, Mrs. Keith Spaulding Prize ($250)
1928 Phoenix, Arizona State Fair, second landscape prize ($75)
1930 Chicago, Marshall Field, 25 January - 12 February, *Hoosier Salon Sixth Annual Exhibition*
1942 Fine Arts Gallery of San Diego, June, *Charles Reiffel, A Memorial Exhibition of his Paintings*, no. 10, lent by Mrs. Eugenia M. Welker
Bibliography
California Southland, X (December 1928), 5
Indianapolis Star, 22 March 1942
Moure, Nancy D.W., *Artist's Clubs and Exhibitions in Los Angeles Before 1930*, Los Angeles, privately printed, 1974

83 *Near Old Town*, c. 1929

Charles Reiffel
oil on board, 17 7/16 x 19 7/16 inches (44.3 x 49.8 cm), l.r.: *Charles Reiffel*
Inscribed on reverse: *Near Old Town California/ San Diego./ Charles Reiffel/A 2/To Senator LeRoy Wright/with compliments and great esteem/Charles Reiffel*

Dr. Richard A. Smith

Provenance
Artist; Senator LeRoy Wright
Remarks
The Serra Museum, on the site of the original Mission San Diego in Presidio Park, dominates the landscape in Old Town where, from its lofty perch, it overlooks Mission Valley. Built in 1929, from a concept of John Nolen and a rough sketch by his associate Hale J. Walker, the building took shape when William Templeton Johnson, San Diego's leading architect, designed the structure seen today. At the time media accounts described it in glowing terms as "an outstanding modern example of the best of our heritage of Mission Architecture, admirably fitted to a commanding site, and expressing with remarkable vigor the fine dignity of Father Serra" (San Diego *Evening Tribune*, 1 July 1933). Johnson considered this museum among his finest achievements of the Spanish colonial style and some historians consider it the most successful expression in his chosen stylistic idiom. Highly picturesque, it became the most photographed building in San Diego from its dedication on 16 July 1929.

The artist dedicated the painting to Senator LeRoy A. Wright. Born in 1863 and the third oldest practicing attorney in San Diego, Wright was a native of London, Indiana. In the newspaper business in San Diego from 1887 to 1889, he was city editor of the *San Diego Union*. He was admitted to the bar in 1891, and he also served as president of the U.S. Grant Company and vice president of San Diego Title and Trust Company. For eight years Wright represented the 40th senatorial district in the state Senate.

84 *Witch Creek Mountain*, c. 1930 - 5

Charles Reiffel
oil on board, 20 x 24 inches (50.5 x 61 cm), l.r.: *Charles Reiffel*

Mr. and Mrs. David M. Miller

Exhibitions
San Diego, Little Gallery, date unknown, *Charles Reiffel*, no. 16

85 *The Rancher*, 1933

Charles Reiffel
oil on canvas, 20 x 24 inches (50.8 x 60.4 cm), l.r.: *Charles Reiffel*
Inscribed on reverse: *'The Rancher'/No. 18/1933/ Charles Reiffel/$75/18*

The San Diego Historical Society, gift of Elsie Nanning, 1986

Exhibitions
1942 Fine Arts Gallery of San Diego, June, *Charles Reiffel, A Memorial Exhibition of his Paintings*, no. 36, dated 1933
Bibliography
One by this title was identified as having appeared in the following:
Los Angeles, Museum of Science, History and Art, 1926, *Exhibition of Painters and Sculptors of Southern California*, William Harrison Preston Prize ($100). Painted near Alpine. (From an unidentified clipping in the artist's scrapbook owned by George Stern.)

86 *Banner Gorge*, 1932

Charles Reiffel
oil on board, 19 7/8 x 24 inches (50.5 x 61 cm), l.r.: *Charles Reiffel*
Inscribed on reverse: *To Mrs. Francis Roberts/ with love and best wishes from/Frances and Charles Reiffel/San Diego Calif/Dec 12/1932*

Dr. and Mrs. Albert A. Cutri

87 *Old Ranch — Mission Valley*, c. 1930

Charles Reiffel
Gouache on paper, 8 5/16 x 8 1/8 inches (sheet size) (22.8 x 20.7 cm), l.r.: *Charles Reiffel*
Inscribed on reverse: *Old Ranch — Mission Valley*

San Diego Museum of Art, gift of Mrs. Alfred R. Mitchell (1977: 020)

Provenance
Mrs. Alfred R. Mitchell

88 *Beach at Del Mar*, 1931

Charles Reiffel
oil on board, 10 x 14 inches (25.5 x 35.5 cm), l.r.: *Charles Reiffel*
Inscribed on reverse: *Beach at Del Mar/to Miss Arline Fay/from Mr. & Mrs. Charles Reiffel/June 1931*

Private collection

Provenance
Artist; Miss Arline Fay

89 *Edge of the Valley*, c. 1935 - 40

Charles Reiffel
oil on canvas, 25 1/4 x 30 1/4 inches (64.2 x 76.8 cm), l.r.: *Charles Reiffel*

Corporate collection, Union Bank, San Francisco

Provenance
Orr's Gallery
Exhibitions
1928 Los Angeles, Newhouse Gallery, July - August
Bibliography
Krombach, Beatrice de Lack, San Diego, (?), 19 May 1928
Remarks
A scene near Lakeside

90 *Where Desert and Mountain Meet (San Jacinto)*, c. 1930 - 5

Charles Reiffel
oil on board, 17 7/8 x 19 7/8 inches (45.4 x 50.5 cm), l.r.: *Charles Reiffel*
Inscribed on reverse: *San Jacinto/Charles Reiffel*; label attached to the reverse: *Where Desert and Mountain Meet/by Charles Reiffel*

Dr. and Mrs. Albert A. Cutri

91 *The Storm*, c. 1935

Charles Reiffel
watercolor on paper, 6 3/16 x 7 5/16 inches (15.8 x 18.6 cm), l.r.: *Charles Reiffel*
Inscribed on original mat: *The Storm*
Inscribed on reverse: *Charles Reiffel*

San Diego Museum of Art, gift of Mrs. Alfred R. Mitchell (1977: 016)

Provenance
Artist; Alfred R. Mitchell; Mrs. Alfred R. Mitchell

92 *Harbor Night*, 1937

Charles Reiffel
oil on board, 36 x 48 inches (91.5 x 12.2 cm), l.r.: *Charles Reiffel, 1937*
Inscribed on reverse: *Old National City/1936*

City of San Diego

Remarks
In 1939 Charles Reiffel gave the city of San Diego twenty-six paintings. These works were completed under the Federal Art Project, which had been organized to assist artists during the great Depression. Reiffel was affiliated with the program from 1937 through September 1939. His costs for the material for his works were reported to be $321.19.
The presentation of the work to the city was made by Claude N. Gordon, the project's area manager. They were accepted by Councilman Harley Knox for the city and the county offices at the Civic Center on Harbor Drive.

93 *Rainy Evening*, 1937

Charles Reiffel
oil on board, 36 1/8 x 48 inches (91.5 x 122 cm), l.r.: *Charles Reiffel, 1937*
Inscribed on reverse: *Rainy Evening/Charles Reiffel*

James and Estelle Milch

Exhibitions
One by this title was exhibited in the following:
San Diego, Little Gallery, date unknown, *Charles Reiffel*, no. 19

94 *San Diego Waterfront*, 1938

Charles Reiffel
oil on canvas, 32 x 36 inches (81.3 x 91.5 cm),
l.r.: *Charles Reiffel, 1938*
Mr. and Mrs. Thomas Page

Provenance
With the Thackeray Gallery, San Diego. George
Thackeray found it at a local hospital, where it had been
sitting around, crated, for years.

95 *Cormorant Cove, La Jolla*, 1936

Charles Reiffel
gouache on board, 18 x 24 inches (45.7 x 61 cm),
unsigned
Inscribed on reverse: *Camorant [sic] Cove/La
Jolla/Charles Reiffel/1936*
Dr. and Mrs. Albert A. Cutri

96 *Spring at Grossmont*, c. 1940

Charles Reiffel
oil on canvas, 25 x 30 1/4 inches (63.5 x 76.8 cm),
l.r.: *Charles Reiffel*
Inscribed on reverse on stretcher bar: *Spring at
Grossmont*; on reverse at center: *Charles Reiffel*
and *Among the Rocks* (crossed out)/*at Gross-
mont*/(crossed out/*Charles Reiffel* (crossed out)
Private collection

Exhibitions
Under title *Among the Rocks* one exhibited in the
following:
Date unknown, Los Angeles, Newhouse Galleries,
Exhibition of Paintings by Charles Reiffel, no. 7

97 *The Haunted Tower*, 1939

Charles Reiffel
Wax crayon on cardboard, 26 5/8 x 19 7/8 inches
(63.5 x 76.8 cm), l.r.: *Charles Reiffel*
Inscribed on reverse: *The Haunted
Tower/Charles Reiffel/1939*
Bram and Sandra Dijkstra

Exhibitions
1940 Fine Arts Gallery of San Diego, 7 June-
31 August, *Twelfth Annual Exhibition of Southern
California Art*, no. 46
Bibliography
Braun, Hazel Boyer, San Diego *Tribune-Sun*, 29 June
1940: "Charles Reiffel's dream castle has some fine
qualities of rhymic [sic] movement of lines and forms.
The deeply toned color effects suggest either moonlight
or the last light of day. It is definitely a fantasy. He calls
it 'The Haunted House.'"
Remarks
One of the "fairy like fantasies" described by one un-
known writer, done by the artist during his final years,
which were among "his prize winning works."
The observation of different moods and a tendency to-
ward abstraction in the latter works of Reiffel demon-
strate a direction of style which in essence culminates
in a natural progression of the artist's development. The
artist had long been interested in non-objective art and
decorative design. In his early years, while still in the
business world, he had designed and sold a necktie
design. His interest in the formal vocabulary of pattern
and design he applied to his lithography, oil painting,
pastel, and watercolor. Hand-made Christmas cards to
his colleagues during the 1930s and 1940s display non-
descriptive imagery manifesting an obvious delight in
color and pattern.

98 *Volcan Indian Reservation*, 1941

Charles Reiffel
oil on masonite, 25 x 30 inches (63.5 x 76.2 cm),
l.r.: *Charles Reiffel, 1941*
Inscribed on reverse: *Volcan Indian Reservation
1941/by Charles Reiffel*
Inscribed on reverse (label): *From Fine Arts
Gallery of San Diego/San Diego 3, California/To
Artist: Charles Reiffel (late)/Title: Volcan Indian
Reservation/Price: $400.00/Property of Glenn
Mitchell/144 Washington St/San Diego 3, Calif.*
Mrs. Carolynn Hawes

Provenance
Glenn Mitchell (father of Mrs. Hawes)
Exhibitions
1942 Fine Arts Gallery of San Diego (memorial show?)
(San Diego Museum of Art), June, *Charles Reiffel: A
Memorial Exhibition of his Paintings*, no. 70 (as *Volcan
Mountain* dated 1941) or 52 (as *Foot of Volcan* dated
1938)

99 *To Wander—In San Diego Back
Country*, 1938

Charles Reiffel
oil on board, 42 x 48 inches (106.7 x 12.2 cm),
l.r.: *Charles Reiffel, 1938*
Inscribed on reverse: *To Wander in San Diego,
Back Country/Charles Reiffel 1938*
James and Estelle Milch

Charles Arthur Fries—Selected Exhibition History

1874-75 Ohio Mechanics' Institute, Cincinnati. *Nineteenth Session of the School of Design.*
1898 Butt's Art Store, San Diego. One-man show.
Kennedy Art Rooms, San Francisco. One-man show.
1901 Thearle and Company's Music Rooms, San Diego. *Catalogue of Paintings by Charles Arthur Fries.*
1902 Art Institute, Chicago. *Catalogue of the Fourteenth Annual Exhibition of Watercolors, Pastels and Miniatures by American Artists*, April-June.
1903 Art Association, San Francisco. November.
1904 Oakland. *Fourth Annual Exhibition of Oakland Art Fund*, February.
Paint and Clay Club, New Haven. *Fourth Annual Exhibition*, April-May.
1905 Thearle and Company's Music Rooms, San Diego. One-man show, December.
1906 Art Association, Library, San Diego. *Second Winter, Exhibition of the Art Association*, December.
Thearle and Company's Music Rooms, San Diego. *Catalogue of Paintings by Charles Arthur Fries*, December.
1907 Library, San Diego. *Paintings by Charles Arthur Fries*, December 1907-January 1908.
1909 Thearle and Company's Music Rooms, San Diego. One-man show, March.
Alaska-Yukon-Pacific Exposition, California Building, Seattle. *Catalogue of Fine Arts Gallery and Exhibits of Arts and Crafts.* Silver Medal.
1911 Rice's Studio, Berkeley. One-man show, November.
Fine Arts Association, Seattle. Silver Medal.
1912 Pennsylvania Academy of Fine Arts, Philadelphia. *Catalogue of the 107th Annual Exhibition*, February-March.
Silby-Myars Galleries, San Diego. *Recent Paintings by Charles Arthur Fries*, October.
Delgado Museum of Art, New Orleans. One-man show.
1913 Marston Store, San Diego. *First Annual Exhibition of Paintings*, May.
Blanchard Gallery, Los Angeles. *Third Annual Exhibition of the California Art Club*, November-December.
1914 Hoover Art Galleries, Hollywood. *Exhibition of Paintings by Charles Arthur Fries*, January-February.
Hotel Botsford, San Diego. *Exhibition of Original Oil Paintings by Charles Arthur Fries*, March.
1915 Panama California Exposition, San Diego. Portrait Painters' Exhibition. Silver Medal.
Benbough's Furniture Store, San Diego. One-man show. March-April.

1916 Guild Rooms, 'B' Street School, San Diego. *Exhibition of Paintings by Charles Arthur Fries*, May.
1917 Kanst Art Gallery, Los Angeles. One-man show, October.
1919 El Prado Gallery and Studio, San Diego. One-man show.
Palace of Fine Arts, San Francisco. *Forty-Third Annual Exhibition of the San Francisco Art Association*, March-May.
Fine Arts Building, Museum of Man, San Diego. One-man show, September-November.
Fine Arts Building, Balboa Park, San Diego. *Exhibition and Sale of Paintings by Charles Arthur Fries*, November.
1920 Museum of History, Science, and Art, Los Angeles. *The California Art Club Eleventh Annual Exhibition*, October-November.
Fine Arts Building, Museum of Man, San Diego. *The California Art Club of Los Angeles*, November-December.
Fine Arts Building, Museum of Man, San Diego. *Exhibition and Sale of Paintings by Charles Arthur Fries*, December.
1921 Fine Arts Building, Museum of Man, San Diego. *San Diego Art Guild Exhibition*, May-June.
Fine Arts Building, Museum of Man, San Diego. *An Exhibition of the California Art Club of Los Angeles*, November-December.
1922 H. W. Reed (private home), Indio. *Paintings by Charles Arthur Fries*, March.
Friends of Art, San Diego. *Selected Works by Western Painters*, March.
Museum of History, Science, and Art, Los Angeles. *Catalogue of the Third Exhibition of Painters and Sculptors of Southern California*, April-May.
Little Gallery, San Diego. *Desert and Other Southern California Paintings by Charles Arthur Fries*, May-June.
Friends of Art, Fine Arts Building, Museum of Man, San Diego. *Exhibition of the California Art Club*, November-December.
1923 Orr's Art Gallery, San Diego. *Catalogue of Paintings by Charles Arthur Fries*, January-February.
Museum of Art, Los Angeles. *Fourth Exhibition of Painters and Sculptors of Southern California*, May-June.
Fine Arts Building, Museum of Man, San Diego. *Spring Exhibition of Works by Art Guild Members*, May.
Fine Arts Building, Museum of Man, San Diego. October.
Museum of Art, Los Angeles. *Fourteenth Annual Exhibition of the California Art Club*, November-December.
Arizona State Fair, Phoenix. *Ninth Annual Arizona Art Exhibition*, November.

1924 Museum Art Galleries, San Diego. *Paintings by Charles Arthur Fries*, January-February.
Friends of Art, New Mexico Building, San Diego. *Summer Exhibition of Works by Art Guild Members*, August.
Arizona State Fair, Phoenix. *Tenth Annual Arizona Art Exhibition*, November.
1925 Ainslie Galleries, New York City. *Paintings by Charles Arthur Fries*, January.
Friends of Art, New Mexico Building, San Diego. March.
Friends of Art, New Mexico Building, San Diego. *Charles Arthur Fries, Paintings*, March-April.
Arizona State Fair, Phoenix. *Eleventh Annual Art Exhibition*, November.
Little Gallery, San Diego. *Paintings by Charles Arthur Fries.*
1926 Fine Arts Gallery, San Diego. *Inaugural Exhibition*, February-March.
Springville High School, Springville, Utah. *Painting Exhibition*, April.
Fine Arts Gallery, San Diego. *Catalogue of the First Exhibition of Artists of Southern California*, June-August.
Fine Arts Gallery, San Diego. *Charles Arthur Fries and Charles Reiffel*, October.
1927 Little Gallery, San Diego. *Charles Arthur Fries and Richmond I. Kelsey*, March.
Springville High School, Springville, Utah. *Painting Exhibition*, May.
Fine Arts Gallery, San Diego. *Catalogue of the Second Annual Exhibition of Artists of Southern California*, June-August.
Art Association, Laguna Beach. *Building Fund Exhibition*, July.
Museum of Art, Los Angeles. *Eighteenth Annual Exhibition, California Art Club*, November 1927-January 1928.
1928 Fine Arts Gallery, San Diego. *Catalogue of an Exhibition of Paintings by Charles Arthur Fries*, January.
Fine Arts Gallery, San Diego. *Catalogue of the Third Annual Exhibition of Artists of Southern California*, June-August.
Pacific Southwest Exposition, Long Beach. *Catalogue of Invited Works by Painters, Sculptors and Craftsmen*, July-September.
1929 Fine Arts Gallery, San Diego. *Catalogue of the Exhibition of Paintings by Hilda Van Zandt and Charles Arthur Fries*, February.
Casa de Mañana, La Jolla. *Group Exhibition of Works by 8 San Diego Painters*, February-March.
Art Gallery, Laguna Beach. *Catalogue of Spring Exhibition, Laguna Beach Art Association*, April-May.
Art Gallery, Laguna Beach. *Catalogue of Summer Exhibition, Laguna Beach Art Association*, June-July.

Fine Arts Gallery, San Diego. *Catalogue of the Fourth Annual Exhibition of Southern California Artists*, June-August.
San Diego Hotel, San Diego. *Associate Artists of San Diego First Exhibition of Paintings and Sculpture*, July-August.
California State Fair, Sacramento. *Catalogue of Annual Exhibition of Paintings*, August-September.
Fine Arts Gallery, San Diego. *Exhibition of Paintings by Charles Arthur Fries*, October.
Fox Theatre, San Diego. *Catalogue of Art Works*, November.
Museum of Art, Los Angeles. *Twentieth Annual Exhibition of the California Art Club*, November-December.
1930 Fine Arts Gallery, San Diego. *Catalogue of an Exhibition of Paintings and Sculpture by Contemporary Artists of San Diego*, February-March.
Jules Kievits Fine Arts, Pasadena. *Exhibition of Paintings by Contemporary Artists of San Diego*, March.
Fine Arts Gallery, San Diego. *First Lay Members of the Contemporary Artists of San Diego Exhibition*, May.
Art League, Santa Barbara. *Exhibition of Paintings and Sculpture by Contemporary Artists of San Diego*, May.
Art Association, Library, La Jolla. One-man show.
Fine Arts Gallery, San Diego. *Fifth Annual Exhibition of Southern California Art*, June-August.
Little Gallery, San Diego. One-man show, December.
1931 Fine Arts Gallery, San Diego. *Sixth Annual Exhibition of Southern California Art*, June-September.
California State Fair, Sacramento. *Catalogue of the Annual Exhibition of Paintings*, September.
Art Association, Library, La Jolla. One-man show, November.
Theosophical Society Club House, San Diego. *A Selection of Watercolors*, November.
Fine Arts Gallery, San Diego. *Catalogue, Sixth Annual Exhibition by Members of the Art Guild of the Fine Arts Society*, November 1931-January 1932.
Downtown Gallery, San Diego. *Contemporary Artists of San Diego*, December.
Fine Arts Gallery, San Diego. One-man show, December.
1932 Bartlett Galleries, Los Angeles. *Exhibition of Paintings by Charles Arthur Fries*, February-March.
Fine Arts Gallery, San Diego. *Lay Members of Contemporary Artists of San Diego Exhibition*, April.
Fine Arts Gallery, San Diego. *Circulating Gallery of Portable Pictures and Sculpture.*
El Sueño Gallery, San Diego. *Charles Arthur Fries*, July-August.
California State Fair, Sacramento. *Catalogue of the Annual Exhibition of Paintings*, September.

Faulkner Memorial Art Gallery, Library, Santa Barbara. *Exhibition of Works of San Diego Artists, Lithographs by Maxine Albro*, September.
Art Association, Library, La Jolla. One-man show, October.
'C' Street Gallery, San Diego. *Contemporary Artists of San Diego*, November.
Fine Arts Gallery, San Diego. *Catalogue of the Seventh Annual Exhibition by Members of the Art Guild*, November 1932-January 1933.
'C' Street Gallery, San Diego. *Contemporary Artists of San Diego*, December.
1933 Holzwasser's Art Gallery, San Diego. January.
'C' Street Gallery, San Diego. *Contemporary Artists of San Diego*, February.
Fine Arts Gallery, San Diego. *Contemporary Artists of San Diego*, April.
Art Association, Library, La Jolla. *Charles Arthur Fries*, June.
Fine Arts Gallery, San Diego. *Seventh Annual Exhibition of Southern California Art*, June-September.
Art Gallery, Laguna Beach. Group show, August.
Faulkner Memorial Art Gallery, Library, Santa Barbara. *Invitational Group Exhibition*, August.
California State Fair, Sacramento. *Catalogue of the Annual Exhibition of Paintings*, September.
Fine Arts Gallery, San Diego. *Catalogue of the Eighth Annual Exhibition by Members of the Art Guild of the Fine Arts Society*, November-December.
Fine Arts Gallery, San Diego. One-man show, December.
1934 Fine Arts Gallery, San Diego. *Eighth Annual Exhibition of Southern California Art*, June-September.
Gallery, Laguna Beach. *Third Annual Festival of the Arts*, August-September.
Fine Arts Gallery, San Diego. *Charles Arthur Fries*, August-October.
California State Fair, Sacramento. *Catalogue of the Annual Exhibition of Paintings*, September.
Fine Arts Gallery, San Diego. *Contemporary Artists of San Diego*, October.
Green Studio Gallery, San Diego. One-man show, October.
Fine Arts Gallery, San Diego. *Ninth Annual Exhibition of the San Diego Art Guild*, 2nd Prize, November.
Home of Dr. and Mrs. Walsh, San Diego. *Charles Arthur Fries: One-man Exhibition*, December.
1935 Art Gallery, Laguna Beach. *Catalogue of the Laguna Beach Art Association*, February-March.
Greene Studio Gallery, San Diego. Group show, June.
Art Gallery, Laguna Beach. *Exhibition of the Laguna Beach Art Association*, August-September.
Greene Studio Gallery, San Diego. One-man show, August.

California State Fair, Sacramento. *Catalogue of the Annual Exhibition of Paintings*, August-September.
Thearle Music Company, San Diego. One-man show, September.
Art Gallery, Laguna Beach. *Catalogue of the October/November Exhibition of the Laguna Beach Art Association*, October-November.
Thearle Music Company, San Diego. One-man show, November.
1936 Art Gallery, Public Library, Palos Verdes Estates, Los Angeles. *Exhibition of Pictures by the Contemporary Artists of San Diego*, February-March.
Fine Arts Gallery, San Diego. *Catalogue of the Twenty-First Annual Exhibition by Members of the Art Guild of the Fine Arts Society*, February-March.
Art Association, Library, La Jolla. One-man show, July.
Fine Arts Gallery, San Diego. *Art Guild Exhibition*, Honorable Mention, November 1936-January 1937.
1937 Spanish Village Center Gallery, San Diego. *Contemporary Artists of San Diego*, April-May.
Fine Arts Gallery, San Diego. *Contemporary Artists of San Diego*, May.
California State Fair, Sacramento. *Catalogue of the Annual Exhibition of Paintings*, September.
Fine Arts Gallery, San Diego. *Catalogue of the Twenty-Third Annual Art Guild Exhibition*, November 1937-January 1938.
1938 Fine Arts Gallery, San Diego. *Paintings by Charles Arthur Fries*, May.
Art Gallery, La Jolla. One-man show, July.
Fine Arts Gallery, San Diego. *Catalogue of the Twenty-Fourth Annual Exhibition by Members of the Art Guild of the Fine Arts Society*, November 1938-January 1939.
1940 Golden Gate International Exposition, San Francisco. Catalogue entries:
 Maternal Instinct
 Country Park in Spring Valley
1941 Fine Arts Gallery, San Diego. *Charles Arthur Fries: A Memorial Exhibition*, December.
1943 Library, San Diego. One-man show, twelve works, January.
1948 Cathedral Mausoleum, San Diego. *Paintings of Springtime*, February.
1949 Fine Arts Gallery, San Diego. *Paintings by Charles Arthur Fries*, November-December.
Hoberg's Desert Resort, Borrego Springs. *Southern California Landscape*, December 1949-January 1950.
1952 La Mesa Foothills Art Association, Library, El Cajon. One-man show, September.
1954 Art Center, La Jolla. *Charles Arthur Fries: 100th Anniversary Exhibition*, July-August.
Southwestern Art Association, La Jolla. One-man show, August.
Art Center, La Jolla. *Charles Arthur Fries Memorial Exhibition*, September.

Prestel

ROCI
Rauschenberg Overseas Culture Interchange

Edited by Jack Cowart.

ROCI is Robert Rauschenberg's fifteen-year cultural exchange promoting world peace through art. In May 1991 ROCI will have its final and only comprehensive showing at the National Gallery of Art, Washington, D.C.

199 pages with 138 full-color and 23 b/w illus. 9 1/16 x 11 3/4 in/ 23 x 30 cm. ISBN 3-7913-1147-6. Cloth

Max Ernst
Edited and with an introduction by Werner Spies.

Published on the occasion of the retrospective exhibition celebrating the centenary of Ernst's birth, this monumental publication contains new essays about this pivotal figure in the development of twentieth-century art.

384 pages with 254 full-color and 189 b/w illus. 9 1/4 x 11 3/4 in/ 23,5 x 30 cm. ISBN 3-7913-1140-9. Cloth

Impressionism in America
The Ten American Painters

By Ulrich W. Hiesinger.

The revolutionary group of American impressionists known as "The Ten" broke with the conservative Hudson River School, causing social and political upheaval in the art world. The text is enlivened with quotations by the artists.

256 pages with 83 full-color and 87 b/w illus. 9 7/16 x 12 1/4 in/ 24 x 30,5 cm. ISBN 3-7913-1142-5. Cloth

Paul Klee
Dialogue with Nature

Edited by Ernst-Gerhard Güse.

Klee's colorful and imaginative nature works reflect the artist's fascination with the plant and animal world. This special body of work is explored in depth with expertly reproduced color plates.

184 pages with 58 full-color and 83 b/w illustrations. 9 1/16 x 11 7/16 in/23 x 28,5 cm. ISBN 3-7913-1141-7. Cloth

Africa Explores
20th-Century African Art

Edited by Susan Vogel.

The essays consider sub-Saharan art of this century. The paintings and sculptures are politically charged with historic events and provide a glimpse into a little-known body of work. Emphasis is placed on the arts produced within the past two decades.

300 pages with 228 full-color and 172 duotone illus. 8 7/8 x 11 3/4 in/22,5 x 30 cm. ISBN 3-7913-1143-3. Cloth

Closeup
Lessons in the Art of Seeing African Sculpture

By Jerry L. Thompson and Susan Vogel.

Essays and photographs teach the invaluable skill of looking at three-dimensional art. 110 African masterworks demonstrate the importance of examining a work from more than one perspective.

196 pp. with 123 full-color and 62 duotone illus. 9 1/2 x 12 in/ 23,5 x 30,5 cm. ISBN 3-7913-1150-6. Cloth

Conversations with Antoni Tàpies
By Barbara Catoir.

With an in-depth introduction to Tàpies, the author condenses and presents hundreds of hours of her conversations with Spain's leading contemporary artist. The conversations are neatly assembled in thematic chapters.

168 pages with 8 full-color and 110 b/w illustrations. 6 1/2 x 9 1/4 in/16,5 x 23,5 cm. ISBN 3-7913-1149-2. Paperback

Mughal Architecture
By Ebba Koch.

The Mughal Period (1526-1858) was the richest and most creative of the Indo-Islamic epochs. The author considers all building types of this period with special emphasis on the architecture of India and Pakistan. Excellent for the academic and the traveller.

160 pages with 21 full-color and 164 b/w illus. and 45 plans. 6 1/2 x 9 in/ 16,5 x 22,5 cm. ISBN 3-7913-1070-4. Paperback

Gold of Africa

Jewellery and Ornaments from Ghana, Côte d'Ivoire, Mali and Senegal in the Collection of the Barbier-Mueller Museum

By Timothy F. Garrard.

The exhibition is being circulated in the United States by the AFA.

248 pages with 196 full-color and 29 b/w illustrations. 9¼ x 12 in/23,5 x 30 cm. ISBN 3-7913-0914-5. Cloth

African Art

from the Barbier-Mueller Collection, Geneva

Edited by Werner Schmalenbach.

A wide-ranging survey of African tribal art, emphasizing wood sculpture and masks.

320 pages with 71 full-color, 134 duotone, and 90 b/w illustrations. 9 x 12 in/ 23 x 30 cm. ISBN 3-7913-0849-1. Cloth

ART/artifact

African Art in Anthropology Collections

Edited and with an introduction by Susan Vogel.

Provocative essays, richly illustrated, on the question of how to view art from other cultures.

196 pages with 128 full-color and 32 b/w illustrations. 9 x 12⅛ in/23 x 30 cm. ISBN 3-7913-0865-3. Cloth

Africa and the Renaissance: Art in Ivory

By Ezio Bassani and William Fagg.

Exquisite Afro-Portuguese ivory carvings created in the 15th and 16th centuries are the subject of this book.

256 pages with 102 full-color and 404 b/w illustrations. 9¼ x 12¼ in/23,5 x 30,5 cm. ISBN 3-7913-0880-7. Cloth

Power and Gold

Jewelry from Indonesia, Malaysia, and the Philippines from the Collection of the Barbier-Mueller Museum, Geneva

Text by Susan Rodgers. Photographs by Pierre-Alain Ferrazzini.

369 pages with 361 full-color and 138 b/w illustrations. 9 x 10⅞ in/23 x 27 cm. ISBN 3-7913-0859-9. Cloth

Islands and Ancestors

Indigenous Styles of Southeast Asia

Edited by Jean Paul Barbier and Douglas Newton. Foreword by Philippe de Montebello.

A richly illustrated survey of the art of Southeast Asia.

364 pages with 35 full-color and 309 b/w illustrations. 9⅛ x 12 in/23,5 x 30 cm. ISBN 3-7913-0899-8. Cloth

Chinese and Japanese Calligraphy

Spanning Two Thousand Years. The Heinz Götze Collection

Edited by Shigemi Komatsu, et al.

"Each entry is thorough, with many of the works having full translations. Entries are illustrated in good color, including multiple views." *Choice*

198 pages with 182 full-color and 27 b/w illus. 9 x 12 in/ 23 x 30 cm. ISBN 3-7913-1026-7. Cloth

The Egyptian Museum Cairo

By Dr. Mohamed Saleh and Hourig Sourouzian. Photographs by Jürgen Liepe.

The official catalogue, and the standard work on the collection.
Distribution in continental Europe and Egypt by Verlag Philipp von Zabern, Mainz.

268 pages, 290 full-color and 23 b/w illustrations. 8⅜ x 9¼ in/22,5 x 23,5 cm. ISBN 3-7913-0797-5. Hardcover

Titian

Prince of Painters

Edited by Susanna Biadene.

The catalogue of the Venice and Washington exhibition. Generously illustrated essays explore the life and work of the renaissance master.

"Like the exhibition itself, the catalogue teaches us much regarding pictorial techniques and conservation." *Jour. of Art*

452 pages with 207 full-color and 104 b/w illus. 8½ x 11⅝ in/ 21,5 x 29,5 cm. ISBN 3-7913-1102-6. Cloth

Frans Hals

By Seymour Slive.

Destined to be the definitive volume on the Dutch master.

"...one of the finest works of scholarship and connoisseurship we have been given in some time...Taste and intelligence of this kind...is...to be applauded."
 H. Kramer, *The Journal of Art*

420 pages with 108 full-color and 245 b/w illustrations. 9¾ x 11⅞ in/24 x 30 cm. ISBN 3-7913-1032-1. Cloth

The Lion of Venice

Edited by Bianca Maria Scarfì.

An in depth history and scientific analysis of the 2,000-year-old statue that is the symbol of Venice. The essays present fascinating information about the origins and symbolism of the bronze sculpture through copious illustrations and graphs of scientific findings.

256 pages with 134 full-color and 117 b/w illus. 8½ x 12½ in/21,5 x 31,5 cm. ISBN 3-7913-1114-X. Hardcover

Gothic and Renaissance Art in Nuremberg 1300-1550

Edited by Gerhard Bott, Philippe de Montebello, Rainer Kahsnitz, and William D. Wixom.

"This catalogue...is monumental even by the standards of today." J. Russell,
 The New York Times

500 pages with 148 full-color and 414 b/w illustrations. 9 x 12 in/23 x 30 cm. ISBN 3-7913-0765-7. Cloth

Leonardo-Studies

By Ludwig H. Heydenreich. Edited by Günter Passavant.

Fifteen scholarly essays about da Vinci's life and work accompanied by exquisite reproductions of this great Italian Renaissance master's drawings. Essays are printed in their original languages: English, French, German, and Italian.

192 pages with 3 color plates and 131 b/w illustrations. 8 x 11¼ in/21 x 28,5 cm. ISBN 3-7913-0764-9. Cloth

Caspar David Friedrich

By Helmut Börsch-Supan.

The author, an internationally acknowledged Friedrich expert, discusses in detail sixty-eight carefully chosen works by the foremost German Romantic artist.

"...[this book] offers much biographical material and splendid reproductions."
 The Wall Street Journal

208 pages with 68 full-color plates and 64 b/w illus. 9¼ x 11⅜ in/23,5 x 29,5 cm. ISBN 3-7913-1065-8. Cloth

Maurice Brazil Prendergast– Charles Prendergast

A Catalogue Raisonné

By Carol Clark, Nancy Mowll Mathews, and Gwendolyn Owens. Milton W. Brown, senior editor.

"A herculean achievement, that will long serve as a cornerstone in art history reference."
 Library Journal

812 pages with 100 full-color and 2,093 b/w illus. 9 x 12 in/ 23 x 30 cm. ISBN 3-7913-0965-X. Cloth in a case

Maurice Prendergast

By Nancy Mowll Mathews.

"Mathews has produced a splendid exhibition catalogue that...offers a chronological discussion of Maurice's ever-evolving style along with selected works represented by 130 glorious color plates."
 Library Journal

196 pages with 130 full-color and 43 b/w illustrations. 9 x 12 in/23 x 30 cm. ISBN 3-7913-0966-8. Cloth

Italian Art in the 20th Century

Painting and Sculpture
1900 - 1988

Edited by Emily Braun. Series editor Norman Rosenthal.

"With contributions from . . . leading scholars in the field of Italian art and cultural history, this is the most comprehensive . . . book on Italian modern art."
B. Schwabsky, *Arts Magazine*

472 pages with 216 full-color and 231 b/w illus. 9 x 12 in/ 23 x 30 cm. ISBN 3-7913-0907-2. Cloth

German Art in the 20th Century

Painting and Sculpture
1905 - 1985

Edited by Christos Joachimides, Norman Rosenthal and Wieland Schmied. Series editor Norman Rosenthal.

This volume explores the major art movements in German art from "Die Brücke" through Joseph Beuys and Minimalism.

518 pages with 293 full-color and 330 b/w illus. 9 x 12 in/ 23 x 30 cm. ISBN 3-7913-0743-6. Cloth

British Art in the 20th Century

The Modern Movement

Edited by Susan Compton. Series editor Norman Rosenthal.

"A lively, radical, well-researched, not seldom dismissive and passionate anthology."
J. Russell, *The New York Times*

457 pages with 277 full-color and 205 b/w illus. 9 x 12 in/ 23 x 30 cm. ISBN 3-7913-0798-3. Cloth

Masterpieces of 20th-Century Art

From the Kunstsammlung Nordrhein-Westfalen, Düsseldorf.

By Werner Schmalenbach.

176 masterpieces are presented in this fascinating book.

". . . excellent marriage between text and illustrations . . ."
Library Journal

356 pages with 176 full-color and 419 b/w illustrations. 9 x 12 in/23 x 30 cm. ISBN 3-7913-1062-3. Cloth

Museum Ludwig Cologne

Vol. 1: Paintings, Sculptures, Environments from Expressionism to the Present Day

By Siegfried Gohr.

272 pp. with 217 full-color and 8 b/w illus. 9 x 12 in/ 23 x 30 cm. ISBN 3-7913-0792-4. Cloth

Vol. 2: A catalogue raisonné. Text in German.

296 pp. with 501 b/w illus. in two-volume set only. ISBN 3-7913-0791-6. Cloth in case

Egon Schiele and His Contemporaries

Austrian Painting and Drawing from 1900 to 1930. From the Leopold Collection, Vienna

Edited by Klaus Albrecht Schröder and Harald Szeemann.

". . . an extensive and beautifully illustrated survey of the art produced in Austria during a unique era."
Austrian Information

296 pages with 139 full-color and 59 b/w illus. 9½ x 12 in/ 24 x 30 cm. ISBN 3-7913-0921-8. Cloth

Lyonel Feininger

By Ulrich Luckhardt.

An insightful and intriguing look at this twentieth-century master. His work is presented in exceptional reproductions.

"In addition to the new information about Feininger, the book is also important for underscoring the role that German artists played as illustrators for the popular press."
Choice

188 pages with 60 full-color and 90 b/w illus. 9½ x 12 in/ 24 x 30 cm. ISBN 3-7913-1022-4. Cloth

Georges Braque

Edited by Jean Leymarie.

An invaluable contribution to the literature on Braque, this book surveys Braque's entire œuvre. The text ist enlivened by reproductions of his paintings, drawings and sculptures. The artist's innovative painting techniques are explored.

280 pages with 123 full-color and 35 b/w illustrations. 9 x 11¼ in/23 x28,5 cm. ISBN 3-7913-0882-3. Cloth

Franz Marc

By Mark Rosenthal.

A lavishly illustrated monograph on the popular Blue Rider artist's work.

"... an excellent visual reference on Franz Marc ... which would be hard to find in many other sources."
Library Journal

160 pages with 64 full-color and 19 b/w illustrations. 9⅝ x 11½ in/24,5 x 28,5 cm. ISBN 3-7913-1024-0. Cloth

Franz Marc: Postcards to Prince Jussuf

By Peter-Klaus Schuster.

The complete set of Marc's intimate postcards to poet Else Lasker-Schüler.

"... [a book] to be cherished by anyone who prizes the interaction between poet and artist." *The New York Times*

104 pages with 29 full-color plates and 41 b/w illustrations printed on special paper. 6½ x 9¾ in/16,5 x 25 cm. ISBN 3-7913-0883-1. Hardcover

The Blue Rider

in the Lenbachhaus, Munich

By Armin Zweite. Commentaries and biographies by Annegret Hoberg.

"Excellent color illustrations with full commentaries ... make this a major survey of a time of ... cultural turmoil."
Library Journal

288 pages with 121 full-color and 77 b/w illustrations. 8¼ x 11⅜ in/21 x 29 cm. ISBN 3-7913-0850-5. Cloth

The Apocalyptic Landscapes of Ludwig Meidner

By Carol S. Eliel, with a contribution by Eberhard Roters.

This book examines for the first time Meidner's masterpiece series, the *Apocalyptic Landscapes* of 1912-1913.

104 pages with 17 full-color and 67 b/w illustrations. 10½ x 10½ in/27 x 27 cm. ISBN 3-7913-1025-9. Cloth

Paul Klee

The Düsseldorf Collection

By Werner Schmalenbach

Clearly written work-by-work commentaries on paintings and drawings from the collection of the Kunstsammlung Nordrhein-Westfalen offer insightful information about the artist and his work.

128 pages with 58 full-color and 34 b/w illus. 7¼ x 10⅜ in/18,8 x 26,5 cm. ISBN 3-7913-0704-0. Cloth

German Expressionist Prints and Drawings

The Robert Gore Rifkind Center for German Expressionist Studies

Vol. 1: Essays

230 pages with 63 full-color and 103 b/w illustrations. 10½ x 12⅜ in/25,5 x 31 cm. ISBN 3-7913-0974-9. Cloth

Vol. 2: Catalogue. By B. Davis.

846 pages with 5134 illus. 10½ x 12⅜ in/25,5 x 31 cm. Cloth. In two-volume set only. ISBN 3-7913-0959-5. Cloth in case

German Expressionism 1915-1925

The Second Generation

Edited by Stephanie Barron.

A richly illustrated volume exploring the work of the second generation of Expressionists in Germany, including Beckmann, Dix, and Grosz.

197 pages with 99 full-color and 427 b/w illustrations. 9 x 12 in/23 x30 cm. ISBN 3-7913-0874-2. Cloth

Art in Germany 1900-1936

From Expressionism to Resistance – The Marvin and Janet Fishman Collection

By Reinhold Heller.

"The album ... depicts the destitution, decay, and corruption of German life between the wars. Included are the vivid creations of Beckmann, Dix, and Grosz ..." *Library Journal*

260 pages with 110 full-color and 80 b/w illus. 9 x 12 in/ 23 x 30 cm. ISBN 3-7913-1098-4. Cloth

Marc Chagall
Arabian Nights

Four Tales from 1001 Arabian Nights

With a foreword by Norbert Nobis.

The magical world of Sheherazade's tales is brought to life in Chagall's stunningly beautiful lithographs.

176 pages with 13 seven-color plates and 13 b/w plates printed on specially made paper. 9¾ x 12⅞ in/25 x 32,5 cm. ISBN 3-7913-0842-4. Cloth in decorative case

Marcel Duchamp

Edited by Anne d'Harnoncourt and Kynaston McShine.

First published in 1973, to immediate acclaim, this continues to be the definitive book on the artist.

"... this book's various essays, chronology and plates are critical tools for studing Duchamp's life and work."
Library Journal

360 pages with 12 full-color and 417 b/w illus. 8½ x 11¼ in/ 22 x 28,5 cm. ISBN 3-7913-1018-6. Cloth

Fernand Léger
The Later Years

Edited by Nicholas Serota.

This extensively illustrated monograph concentrates on the important fifteen-year phase of Léger's work from 1940 to 1955, including the monumental painting cycles. Quotes from the artist provide insight into one of our century's most loved artists.

192 pages with 88 full-color and 109 b/w illus. 8¾ x 10¾ in/ 22,5 x 27,5 cm. ISBN 3-7913-0868-8. Cloth

Amedeo Modigliani
Paintings · Sculptures · Drawings

By Werner Schmalenbach.

Modigliani stands out among early 20th-century artists for his superb handling of color and his remarkable eye for composition. His works depict subjects that he endows with a unique, classical beauty that has been paralleled by no other artist. The vivid color reproductions convey Modigliani's tremendous talent, and intriguing commentaries by the artist's peers offer great in-

sight into the life and times of this important 20th-century figure.

"Schmalenbach untangles the complicated skeins of Modigliani's life and work with an examplary judiciousness; the artist's messy, demi-monde life is kept in its proper perspective vis-à-vis the important achievements of his art."
Elle

"[This] book focuses on Modigliani's artistic productivity, downplaying the sensationalism of his wild, short life. In fact, Schmalenbach asserts

Marc Chagall
My Life – My Dream
Berlin and Paris, 1922-1940

By Susan Compton.

Over 300 rarely seen gouaches and etchings from two of the richest decades in his career.

"Clear plates and intelligent text add insight into a neglected segment of Chagall's œuvre."
Library Journal

268 pages with 80 full-color and 330 b/w illustrations. 9½ x 11in/24 x 30 cm. ISBN 3-7913-1064-X. Cloth

Joseph Cornell

Edited and with an introduction by Kynaston McShine.

First published in 1980, this book remains the most comprehensive survey of Cornell's work. Lavishly illustrated, with a detailed biography of the artist.

"This book offers a lush look at an American original."
The Indianapolis News

296 pages with 32 full-color and 294 b/w illus. 8½ x 11 in/ 22 x 28 cm. ISBN 3-7913-1063-1. Cloth

Hans Hofmann

Cynthia Goodman, with essays by Clement Greenberg and Irving Sandler.

The work, life, and teaching of the "Dean of the New York School" of Abstract Expressionist painting. Accompanied a major exhibition organized by the Whitney Museum of American Art.

200 pages with 100 full-color and 35 b/w illustrations. 9½ x 11⅝ in/24 x 29,5 cm. ISBN 3-7913-1054-2. Cloth

that we can appreciate Modigliani's work without reference to his life story, a fascinating separation between art and artist. Art lovers should own this book, especially if they are interested in this highly regarded Jewish artist."
Miami Jewish Tribune

296 pages with 32 full-color and 294 b/w illustrations. 8½ x 11 in/22 x 28 cm. ISBN 3-7913-1063-1. Cloth

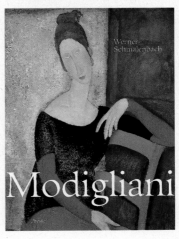

David Smith
Sculpture and Drawings

Edited by Jörn Merkert.

An important volume on one of America's most celebrated sculptors, who transformed industrial steel into colossal monuments and created new paths for the art of sculpture. A biography, essays, and conversations with the artist enhance the reproductions.

192 pages with 17 full-color and 176 b/w illustrations. 8¾ x 11⅛ in/22,5 x 28 cm. ISBN 3-7913-0793-2. Cloth

Josef Beuys 1936-1965
Ölfarben-Oilcolors

Text in German and English by Franz Joseph van der Grinten and Hans van der Grinten. Foreword by Heiner Bastian.

This oversized volume offers a lush visual study of some of the artist's most extraordinary oil paintings. The works were chosen by Beuys. Parallel text in German and English.

60 pages with 110 full-color plates. 10⁷⁄₁₆ x 14⁹⁄₁₆ in/ 26,5 x 36 cm. ISBN 3-7913-0561-1. Hardcover in case

Naum Gabo
Sixty Years of Constructivism

Edited by Steven A. Nash and Jörn Merkert.

A comprehensive exploration of the life and work of this pioneer of constructivism. This volume includes reproductions of his drawings and paintings, and a catalogue raisonné of his sculptures and constructions.

272 pages with 18 full-color and 260 b/w illustrations. 8¾ x 11 in/22,5 x 29,5 cm. ISBN 3-7913-0742-8. Cloth

Henry Moore: A Shelter Sketchbook

With commentary by Frances Carey. A Full-Color Facsimile.

An often overlooked collection of Moore's intimate drawings of London's homeless who were displaced during World War II. The works are reproduced on special paper to enhance the delicacy of his art in pen, ink, watercolor, and crayon.

160 pages with 68 color facsimile reproductions. 7⅞ x 7 in/20 x 17 cm. ISBN 3-7913-0867-X. Cloth

Tullio Pericoli: Woody, Freud and Others...

The connoisseur of caricature will treasure Pericoli's portraits of our greatest cultural heroes.

"Each drawing is a story one can read again and again."
Library Journal

156 pages with 61 full-color plates and 23 b/w illustrations. 9½ x 11¾ in/24 x 29,5 cm. ISBN 3-7913-1028-3. Paperback

Sempé – On Holiday

Preface by Jacques Réda.

A charming book for all who love fine caricature, for everyone who remembers holidays as the best weeks of his or her life, and for each and every fan of Sempé, the beloved *New Yorker* artist. His holiday series is without doubt one of his most delightful books.

88 pages with 47 full-color plates and 3 b/w illustrations. 9½ x 12½ in/24 x 32 cm. ISBN 3-7913-1099-2. Paperback

Wang Yani
Pictures by a Young Chinese Girl

With contributions by Roger Goepper, Heinz Götze and Wang Shiqiang.

Since age 4, Wang Yani has been a child prodigy and one of China's national treasures. Her remarkable drawings and watercolors have brought her international recognition.

116 pages with 61 full-color and 11 b/w illus. 8⅜ x 12 in/ 22 x 30 cm. ISBN 3-7913-0816-5. Hardcover.

Carnegie International 1988

Edited by Joan Simon and Sarah McFadden.

The catalogue for the fiftieth Carnegie Museum triennial exhibition held in Pittsburgh, 1988-1989. The catalogue presents intriguing essays about the artists, a group that includes Schnabel, Warhol, and Beuys.

202 pages with 122 full-color and 8 b/w illus. 9½ x 11 in/ 24,5 x 30,5 cm. ISBN 3-7913-0875-0. Paperback

Georg Baselitz

By Andreas Franzke.
Idea and concept by Edward
Quinn.

This monograph is the first
comprehensive survey of
Baselitz's work.

*264 pages with 189 full-color
and 51 b/w illustrations.
11⅝ x 12⅜ in/29 x 30,5 cm.
ISBN 3-7913-0947-1.
Cloth
Signed Edition:
ISBN 3-7913-1533-1.
Cloth*

Georg Baselitz

Druckgraphik-Prints-
Estampes 1963-1983

Edited by Siegried Gohr.

A careful consideration of the
powerful graphic works by one
of Europe's leading contempo-
rary artists. Baselitz's mastery
of printmaking is revealed in
the numerous reproductions.
Parallel text in German,
English, and French.

*172 pages with 20 full-color
plates and 128 b/w illus.
8¾ x 11 in/22 x 28 cm. ISBN
3-7913-1508-0. Paperback*

Rosemarie Trockel

Edited by Sidra Stich with es-
says by Elisabeth Sussman
and Sidra Stich.

Rosemarie Trockel is one of
the key figures in the feminist
art movement in Germany.
Her controversial works chal-
lenge established theories
about, sexuality, culture, and
artistic production.

*144 pages with 45 full-color
and 36 b/w illustrations.
8⅞ x 11¾ in/22,5 x 30 cm.
ISBN 3-7913-1144-1. Cloth*

Julian Schnabel

Works on Paper 1975-1988

By Jörg Zutter.

"This book offers commen-
tary, and the works them-
selves are beautifully repro-
duced."
Print Collectors Newsletter

"The thematically grouped
drawings offer insight into
Schnabel's artistic starting
points without being mere
sketches or studies for large-
scale paintings or sculpture.
Essays . . . discuss Schnabel's
graphic work and the import-

ance of this œuvre in the con-
text of contemporary American
and European art." *Choice*

"The essays in this catalogue
argue that Schnabel's work on
paper provides new avenues
for approaching his oblique and
unwieldy paintings and sculp-
tures . . . This [book] offers
a means of getting
acquainted." *Library Journal*

*112 pages with 72 full-color
and 16 b/w illustrations.
9⁷⁄₁₆ x 11 in/24 x 28 cm.
ISBN 3-7913-1061-5.
Hardcover*

Anselm Kiefer

By Mark Rosenthal.

The first comprehensive sur-
vey of this fascinating German
artist's career.

". . . the wonderfully detailed
catalogue . . . is an indispens-
able guide . . . a triumph of art
historical scholarship."
 H. Kramer, *The New Criterion*

*216 pages with 105 full-color,
175 b/w illustrations and
2 foldouts. 10⅝ x 11⅝ in/
26 x 29,5 cm.
ISBN 3-7913-0847-5.
Paperback*

Refigured Painting

The German Image
1960-88

Edited by Thomas Krens,
Michael Govan, and Joseph
Thompson.

180 paintings by 41 artists
demonstrate the range, qual-
ity, and vitality of the figurative
impulse in German art.

*292 pages with 180 full-color
and 62 b/w illustrations.
9 x 12 in/23 x 30 cm.
ISBN 3-7913-0866-1.
Cloth*

BERLINART 1961-1987

Edited by Kynaston McShine.

Painting, sculpture, film, and
performance art created in this
center of the international art
scene during the last quarter-
century.

*284 pages with 86 full-color
and 329 b/w illustrations.
9 x 12 in/23 x 30 cm.
ISBN 3-7913-1534-X.
Paperback*

Julian Schnabel

Works on Paper 1975-1988

Limited Edition.

Artist Julian Schnabel has
specially hand-painted the
covers of one-hundred copies
of **Works on Paper.** Each
cover design is a unique paint-
ing that is signed, numbered
and dated: each book has
been autographed with an in-
dividual greeting from the art-
ist. Only fifty copies will be
made available in the United
States.

Ordernumber: P1065-5S

Biedermeier 1815-1835

Architecture, Painting, Sculpture, Decorative Arts, Fashion

By Georg Himmelheber.

"Our best introduction to Biedermeier in architecture, painting, sculpture and the decorative arts."—
J. Russell, *The New York Times Book Review*

272 pages with 194 full-color and 171 b/w illustrations. 9 x 12 in/23 x 30 cm. ISBN 3-7913-1023-2. Cloth

Art Nouveau in Munich

Masters of Jugendstil

Edited and with an introduction by Kathryn B. Hiesinger.

This publication is a comprehensive survey of the furniture, metalwork, glass, textiles, ceramics and graphics created during the 1890s in Munich, a major center for art nouveau during this glorious era.

180 pages with 50 full-color and 147 b/w illustrations. 8⅞ x 11¼ in/22 x 28 cm. ISBN 3-7913-0881-5. Cloth

Fabergé – The Imperial Eggs

Introduction by Steven L. Brezzo. Contributions by Christopher Forbes, Johann Georg Prinz von Hohenzollern, and Irina Rodimtseva.

"This delightful catalog celebrates a reunion exhibition ... of 26 Fabergé eggs created for the Russian imperial family."
Library Journal

120 pages with 63 full-color and 64 b/w illus. 9 x 12 in/ 23 x 30 cm. ISBN 3-7913-1027-5. Cloth

Swedish Glass Factories

Production Catalogues 1915-1960: Orrefors, Kosta, Elme, Eda, Strömbergshyttan

Edited by Helmut Ricke and Lars Thor.

Complete production catalogues of the five manufacturers, a must for collectors. Text in English, German, and Swedish.

440 pages with reproductions of 926 catalogue pages containing over 20,000 illus. 8⅞ x 11¾ in/22,5 x 30 cm. ISBN 3-7913-0804-1. Cloth

Fashion in Film

Edited by Regine and Peter W. Engelmeier.

"Gorgeous black-and-white photographs ranging from the early days of the cinema right up to the present dramatically reveal the intimate connection ... between fashion and the movies." *Cosmopolitan*

"It is the finest such book I've ever seen." *Audience*

248 pages with 378 b/w illus. 8¼ x 11¹¹⁄₁₆ in/21 x 29,7 cm. ISBN 3-7913-1100-X. Hardcover

Vordemberge-Gildewart

The Complete Works

Edited by Dietrich Helms.

This meticulously researched catalogue raisonné is the definitive work on the German modern artist who participated in such important movements as de Stijl and Dada.

428 pages with 188 full-color and 354 b/w illustrations. 10 x 10 in/25,5 x 25,5 cm. ISBN 3-7913-0978-1. Cloth

Munich – Prestel City Guide

By Lillian Schacherl and Josef H. Biller.

Germany's best-loved city in a lavish guide. Easy-to-read maps and explanations of Munich's landmarks make this guide indispensable for all visitors to the city.

240 pages with 488 full-color and 80 b/w illustrations, and 37 maps. 5 x 9½ in/12,7 x 24 cm. ISBN 3-7913-0838-6. Paperback

Museums in Cologne

Edited by Hugo Borger.

An extensive guide to twenty-six collections in one of Europe's museum capitals. Reproductions of masterworks from the museums and enlightening text make this book an excellent travel companion to the city.

280 pages with 378 full-color illustrations. 5 x 9½ in/ 12,7 x 24 cm. ISBN 3-7913-0787-8. Paperback

Visionary San Francisco

Edited by Paolo Polledri.

This book offers a fresh look at urban planning in San Francisco during this century. Of special interest are visions of alternatives for the city by a team of architects and fiction writers: a noteworthy chapter discusses the impact of AIDS upon the city's urban fabric.

180 pages with 53 full-color and 70 b/w illus. 9 x 12 in/ 22,5 x 30 cm. ISBN 3-7913-1060-7. Cloth

New York Architecture 1970 to 1990

Edited by Heinrich Klotz, with Luminita Sabau.

In the United States and Canada this book is published by Rizzoli International Publications, New York.

336 pages with 271 full-color and 577 b/w illustrations. 8½ x 12½ in/22 x 32 cm. ISBN 3-7913-0989-7. Cloth

Museum Architecture in Frankfurt 1980-1990

Edited by Vittorio Magnago Lampugnani.

Contemporary museum architecture in thirteen variations — an exciting publication that presents the development of each project step by step. Critiques of the exhibition spaces and alternative designs are included.

200 pages with 49 full-color and 284 b/w illustrations. 9⅛ x 12 in/23 x 30 cm. ISBN 3-7913-1096-8. Cloth

Design Now

Industry or Art?

Edited by Volker Fischer.

"A view from Germany of all that is happening in the United States, Italy, Japan, Germany itself and elsewhere in the fields of furniture and product design . . . The pieces are interesting and interestingly presented here." *Interior Design*

328 pages with 308 full-color and 451 b/w illus. 9 x 12 in/23 x 30 cm. ISBN 3-7913-0922-6. Cloth

Boston Architecture 1975-1990

By Naomi Miller and Keith Morgan. Preface by Paul Goldberger.

Maps, site plans, photographs, aeriel views, and reproductions of drawings and models accompany a text in which the authors explore more than 100 recent buildings.

272 pages with 80 full-color and 160 b/w illustrations. 9¼ x 12 in/24 x 30 cm. ISBN 3-7913-1097-6. Cloth

Chicago Architecture 1872-1922

Birth of a Metropolis

Edited by John Zukowsky.

Gold Medal winner at the 5th World Biennale of Architecture and the AIA Citation for Excellence in International Architectural Books, this is an in-depth survey of the formative years of Chicago's modern architecture.

480 pages with 54 full-color and 531 b/w illus. 9 x 12 in/ 23 x 30 cm. ISBN 3-7913-0837-8. Cloth

Raymond Loewy

Pioneer of American Industrial Design

Edited by Angela Schönberger.

"Here, we have a compilation of twenty-one essays by a cross-section of authors, all of which provide insights into the quirky, mercurial genius whose primary aim, was to rid the world of so much junk, and introduce beauty." *Azure*

264 pages with 21 full-color and 291 duotone illus. 9 x 12 in/ 23 x 30 cm. ISBN 3-7913-1066-6. Cloth

Designed in Germany

Since 1949

Edited by Michael Erlhoff.

A fascinating survey of German design and designers from 1949 until the present.

"As a survey of the logic of German design and the beauty of its austere, unadorned forms, this book is must viewing." *Choice*

280 pages with 177 full-color and 702 b/w illustrations. 9½ x 12 in/24 x 30 cm. ISBN 3-7913-1067-4. Cloth

Distribution in:

Austria: Heidrich & Lechner, Vienna; **Canada:** te Neues Publishing Canada, Toronto; **France:** Interart, Paris; **Italy:** IDEA BOOKS, Milano; **Japan:** Yohan, Tokyo; **Netherlands and Belgium:** Nilsson and Lamm bv, Weesp; **Switzerland:** Dr. A. Scheidegger, Affoltern; **USA:** te Neues Publishing Company, New York; **United Kingdom, Ireland and all countries not listed above:** Thames and Hudson Ltd, London, for Prestel books in English; Please request the price list from Prestel Verlag, Munich.

Prestel Verlag, Mandlstrasse 26, 8000 Munich 40, Phone (89) 381709-0, Fax (89) 381709-35, Germany

1956 Art Institute, San Diego. *Paintings by the Late Charles A. Fries*, September.
1960 Spanish Village Art Center Association, San Diego. *Charles Arthur Fries*, September.

1962 North Park Art Center, San Diego. *Paintings by Charles Arthur Fries*, May.
1976 Fine Arts Gallery, San Diego. *The San Diego Scene: Art of the Thirties*, January-February.

1977 Serra Museum, Tower Gallery, San Diego. *Southern California: Seven Paintings by Charles Arthur Fries*, April.
Orr's Gallery, San Diego. *Early Drawings by Charles Arthur Fries*, May.

Maurice Braun—Selected Exhibition History

1911 Isis Theatre, San Diego. One-man show, June.
Pennsylvania Academy of Fine Arts, Philadelphia. Group show, November.
1914 Kanst Art Gallery, Los Angeles. One-man show.
Campel's Drapery Shop, San Diego. One-man show.
1915 Milch Gallery, New York City. *Paintings and Sketches of the Panama California Exposition in San Diego and Landscapes of Southern California.*
Panama Pacific Exposition, San Francisco.
1916 Artists Club, Denver. May.
Schlusser Galleries, San Francisco. One-man show, seventeen works, May.
San Francisco Art Association, Palace of Fine Arts, San Francisco. *Exhibition of California Artists*, June.
Art Guild Rooms, Balboa Park, San Diego. One-man show, thirty works.
Art Institute, Chicago.
Carnegie Institute, Pittsburgh.
Fine Arts Gallery, Southern California Building, San Diego. *California Panama Exposition Art Exhibition*. Catalogue entries:
 1 *The Road to the Mountains*
 16 *High Tide*
 32 *San Diego Hills*
Museum of Art, Cleveland. *50 Paintings by California Artists.*
Phoenix. *Exhibition of California Artists.*
1917 Kanst Art Gallery, Los Angeles. One-man show, a hundred works.
Museum Art Galleries, California Building. One-man show, eight works.
San Diego. Fourth Semi-Annual Exhibition of the San Diego Art Guild. Catalogue entry:
 1 *Long Valley Peak*
1918 Museum of History, Science, and Art, Los Angeles. *Exhibition of Paintings by Maurice Braun*, January. Catalogue entries:
 1 *Long Valley Peak*
 2 *Point Loma Hills*
 3 *Southern California Hills*
 4 *The Brook*
 5 *The Canyon*
 6 *Out There Beyond*
 7 *Across the Valley*
 8 *Eucalypti*
 9 *Rose Tinted Height*
 10 *Hills and Valley*
 11 *In the Valley*
 12 *El Cajon Mountain*
 13 *The Bay, San Diego*

 14 *Evening*
 15 *Foothills*
 16 *Bay and City of San Diego*
 17 *Rocks at La Jolla*
San Francisco Art Association, Palace of Fine Arts, San Francisco. *Exhibition of Paintings by Maurice Braun*, February-March. Catalogue entries:
 1 *Long Valley Peak*
 2 *Point Loma Hills*
 3 *Southern California Hills*
 4 *The Brook*
 5 *The Canyon*
 6 *Out There Beyond*
 7 *Across the Valley*
 8 *Eucalypti*
 9 *Hills and Valley*
 10 *In the Valley*
 11 *Along the Point Loma Shore*
 12 *El Cajon Mountain*
 13 *The Bay, San Diego*
 14 *Evening*
 15 *Foothills*
 16 *Rocks at La Jolla*
 17 *The Old Stump*
 18 *Storm Clouds, Mission Hills*
 19 *San Diego River*
 20 *Point Loma Hills*
 21 *In El Cajon Valley*
 22 *Along the Road*
 23 *The Bay and City, San Diego, From Point Loma*
 24 *In the Grove*
 25 *Glorietta Bay, San Diego*
 26 *Autumn, Southern California*
 27 *The Canyon Side*
 28 *From Mt Tamalpais*
 29 *Sunlit Hills*
 30 *Autumn Sunlight*
Babcock Gallery, New York City. *Exhibition of California Paintings by Maurice Braun*, May.
California State Fair, Sacramento. 1st Prize, November.
Art Institute, Chicago. *Contemporary American Art*, group show, December.
Babcock Gallery, New York City. Four works.
Exposition Park, Los Angeles. Group show.
National Academy, New York City.
1919 Kanst Art Gallery, Los Angeles. *Ten Painters Club*, April.

Rembrandt Hall, Pomona College, Claremont. One-man show, November.
Kanst Art Gallery, Los Angeles. *20 Landscapes by Maurice Braun*, December.
Art Guild Rooms, Balboa Park, San Diego. One-man show, twelve works.
Museum of Fine Arts, Detroit, and Albright Art Gallery, Buffalo. *Annual Contemporary Exhibition of American Painters.*
1920 Orr's Gallery, San Diego. One-man show, twenty works, September.
Fine Arts Gallery, Balboa Park, San Diego. *The California Arts Club of Los Angeles*, November-December. Catalogue entries:
 8 *Torrey Pine Canyon*
 9 *Along the Shore*
1921 Public Library Art Room, St Louis. One-man show, September.
Healy's Gallery, St Louis. One-man show, November.
Academy of Fine Arts, Sacramento Building, San Diego. One-man show.
1922 Arnot Gallery, Elmira, New York. One-man show.
Wadsworth Atheneum (Annex), Hartford. One-man show.
1923 Wichita Falls Art Association, Wichita Falls, Texas. One-man show, March.
Boston. *Thirteenth Annual Exhibition of the Connecticut Academy of Fine Arts*, April.
Macbeth Gallery, New York. *Paintings by Maurice Braun*, April-May. Catalogue entries:

1	*Sunny Day in Autumn*	$ 150
2	*The First Snow*	125
3	*The River Bank*	250
4	*Late Autumn*	400
5	*Evening*	800
6	*Autumnal Woods*	400
7	*Early Spring*	250
8	*October Elms*	400
9	*October*	1500
10	*Across the Valley*	400
11	*Brook in Winter*	250
12	*The Brook*	400
13	*Comstock Hill*	1000
14	*Connecticut River*	400
15	*A Day in March*	350
16	*A Winter Afternoon*	150
17	*Distant Hill*	250

Wiley Galleries, Hartford. One-man show, November.
Art Association (Fake's Furniture Company), Dallas. One-man show.

1924 Museum Gallery, California Building, San Diego. *Recent Paintings by Maurice Braun,* February-March. Catalogue entries:

1 *October*
2 *Springtime*
3 *Connecticut River*
4 *Comstock Hill*
5 *Winter Evening—New England*
6 *Autumn Woodland*
7 *Eucalyptus*
8 *San Diego Bay and City from Point Loma*
9 *Mountains, California*
10 *San Diego Hills*
11 *Eucalyptus*
12 *Elms*
13 *Red Barns*
14 *Silvermine River*
15 *Autumn*
16 *Autumn*
17 *Along the Road*
18 *California Mountains*
19 *The First Snow*
20 *Snow Clad Hills*
21 *Winter*
22 *Brook in Autumn*
23 *Autumn*
24 *Foster Canyon*
25 *Early Springtime*
26 *Springtime*
27 *Mountains (Toward Evening)*
28 *Early Autumn*
29 *California Hills*
30 *Nocturne*
31 *Mountain Pasture, Colorado*
32 *Winter, New England*
33 *Brook in Spring*
34 *Nocturne*
35 *Autumnal*
36 *Rock Ledge*
37 *The River*
38 *Autumn*
39 *Spring*
40 *Autumn*
41 *Misty Day*
42 *New Moon*
43 *Mountains*
44 *Late Fall*
45 *Autumn*
46 *Autumn*
47 *Trees in Autumn*
48 *Late Autumn*

Copley Gallery, Boston. *Paintings by Maurice Braun,* February-March. Catalogue entries:

1	*Colorado Landscape*	$ 450
2	*Norwalk River*	450
3	*California Landscape*	375
4	*In the Spring*	350
5	*Frozen River*	300
6	*Late Autumn*	300
7	*A Village Street*	175
8	*A Clear Day in Autumn*	175
9	*Down Library Lane*	175
10	*Trees*	150
11	*Early Springtime*	300
12	*Winter Afternoon*	175
13	*The Hills*	150

14	*The First Snow*	150
15	*June Day*	175
16	*Springtime*	450

Miller Sterling Gallery, Phoenix. One-man show.
Museum of Art, California Building, San Diego. One-man show, seventy-five works.
Riverside Inn, Riverside, California. One-man show.

1925 Halaby Galleries, Dallas. One-man show.
Vail Galleries, Wichita. One-man show.

1926 La Jolla Art Association, Library Building, La Jolla. *Maurice Braun,* January. Catalogue entries:

A Bit of the Sea
Autumn in New England
California Landscape
Connecticut River
Distant Hills
Elms in Autumn
Eucalypti
Eucalypti and Hills
Eucalyptus Grove
In the Hills
Indian Summer
Lake Hodges
Mamorneck
Mountain Valley
Mountains
Near Escondido
November Landscape
Orange, New Jersey
The River
The River Bed
Rocky Ledge
The Sycamore
Sycamores in Autumn
Sunlit Spaces
Winter on a Misty Day

Women's Club, Tucson. One-man show, March.
Fine Arts Gallery, San Diego. *Catalogue of the First Exhibition of the Artists of South California,* June-August. Catalogue entries:

19 *Morning Light*
20 *The Gorge*

Peyton Boswell Galleries, San Diego. One-man show, June.
Fine Arts Gallery, San Diego Art Guild. *San Diego. No. 10,* December.
Peyton Boswell Galleries, San Diego. One-man show. Catalogue entries:

Surf on the Pacific Shore
Texas Bluebonnets
Gray Day
Eucalypti
Edge of the Valley
The Hillside

Payson Ames, La Jolla.
Carmelita House, Pasadena. One-man show.
University Club, San Diego.

1927 Fine Arts Gallery, Balboa Park, San Diego. *Second Annual Exhibition of the Artists of Southern California,* June-August. Catalogue entries:

10 *Sycamore*
11 *Springtime in the Hills*
12 *Winter, Comstock Hill*

County Museum of Art, Los Angeles. *California Art Club Eighteenth Annual Exhibition,* November 1927-January 1928. Catalogue entry:

46 *Autumn at Mt Kisco, New York*

Chicago Galleries, Chicago. *Catalogue of the Fourth Semi-Annual Exhibition of the Artist Membership of the Chicago Galleries Association,* December 1927-January 1928. Catalogue entry:

16 *Morning Light*

1928 Fine Arts Gallery, San Diego. *A Catalogue of an Exhibition of Paintings by Maurice Braun,* February-March. Catalogue entries:

1 *Mt Kisco*
2 *Connecticut River*
3 *Southern California Hills*
4 *Mountain Heights*
5 *Mrs Braun and her Children*
6 *Early Springtime*
7 *Mountain Lake*
8 *Winter*
9 *Blue Bonnets, Texas*
10 *The Beech Tree*
11 *Eucalyptus*
12 *Golden Hill*
13 *November*
14 *Approaching Winter*
15 *The Pacific, Coronado Islands*
16 *Dahlias*
17 *The First Snow*
18 *Lake Hodges*
19 *Connecticut Valley*
20 *Sycamores and Mountains*
21 *Mesa Grande*
22 *Sycamores*
23 *Spring at Old Lyme*
24 *Alpine*
25 *Autumn in Connecticut*
26 *Young Oaks in Autumn*
27 *In El Cajon*
28 *El Capitan*
29 *At Palm Springs*
30 *Elms in Autumn*
31 *Autumn in New England*
32 *Cottonwoods* (drawing)
33 *La Jolla Cliffs* (drawing)
34 *Rocks and Stream, Colorado* (drawing)
35 *Sketch*
36 *Sketch*
37 *Sketch*

Institute of Art, Dayton, Ohio. *Exhibition of Paintings by Maurice Braun,* February. Catalogue entries:

1	*Mountain Lake*	$ 800
2	*October*	800
3	*California Landscape, Sycamores*	800
4	*Clouds*	700
5	*October Elms*	500
6	*Autumn, Connecticut River*	500
7	*Eucalyptus*	500
8	*Mountain Heights*	500
9	*Valley and Mountains*	500
10	*The Gorge*	500
11	*Autumn in New England*	400

12 *Frozen River, Norwalk,*
 Connecticut 300
13 *Winter Morning* 300
14 *Mountains, Southern California* 300
15 *Catalina Mountains, Tucson,*
 Arizona 300
16 *Rocks and Trees, California* 200
17 *Winter Afternoon* 200
18 *Tucson Mountains, Arizona* 200
19 *An Old Barn, Connecticut* 200
20 *Indian Summer* 125
21 *Red Oaks* 85
22 *Autumn Colors* 85
23 *Sycamores in Autumn* 500

Fine Arts Gallery, San Diego. *Catalogue of the Third Annual Exhibition of Artists of Southern California,* June-August. Catalogue entry:
 11 *The Sycamores*
Chicago Galleries Association, Chicago. *Survey of 3 Members: Maurice Braun, Pauline Palmer, William P. Silva.*
Ainslie Gallery, Los Angeles. One-man show.
1929 La Jolla. One-man show, February.
San Diego Hotel, San Diego. *First Exhibition of Paintings and Sculpture of the Associated Artists of San Diego* (changed name to Contemporary Artists of San Diego), July-August.
Biltmore Hotel, Los Angeles. Vose sponsored show.
Kievats Art Galleries, Pasadena. One-man show.
Witte Memorial Exhibition, San Antonio. $2000 award.
Fine Arts Gallery, San Diego. *Fourth Annual Exhibition of California Artists.*
Pacific Beach, San Diego. One-man show.
1930 Fine Arts Gallery, San Diego. *Catalogue of an Exhibition of Paintings and Sculpture by the Contemporary Artists of San Diego* February-March. Catalogue entries:
 6 *Valley in the Hills*
 7 *Gloucester Harbor*
 8 *Winter*
 9 *Cuyamaca Lake*
 10 *Beeches at Mount Kisco*
Art Association, Library, La Jolla. February.
Gumps, San Francisco. *Paintings by Maurice Braun,* February.
Art Association, Library, La Jolla. *Contemporary Artists of San Diego,* March.
Fine Arts Gallery, San Diego. *Fifth Annual Exhibition of Southern California Artists,* June-August. Catalogue entry:
 10 *Late Afternoon*
Contemporary Artists of San Diego Gallery, San Diego. August.
County Museum of History, Science, and Art, Los Angeles. Group show, November.
Little Gallery, San Diego. December.
Public Library, San Diego. Group show, December.
Southerd Studio, San Diego. Group show, December.
Chicago Galleries Association, Chicago. *Ninth Semi-Annual Exhibition,* $350 award.

1931 Art Association, Library, La Jolla. *Contemporary Artists of San Diego,* January.
Ainslie Gallery, San Diego. February.
Fine Arts Gallery, San Diego. *Art Guild Exhibition,* April.
Fine Arts Gallery, San Diego. *Contemporary Artists of San Diego,* May.
Art Association, Library, La Jolla. One-man show, June.
Fine Arts Gallery, San Diego. *Sixth Annual Exhibition of Southern California Art,* June-September. Catalogue entry:
 9 *Springtime*
Fine Arts Gallery, San Diego. *Sixth Annual Exhibition by Members of the Art Guild of the Fine Arts Society of San Diego,* November-December. Catalogue entry:
 18 *Mountain Ranch*
Loma Portal Arts and Gift Shoppe, San Diego. *Reiffel and Braun,* November.
1932 Contemporary Artists of San Diego Gallery, San Diego. One-man show, January.
Fine Arts Gallery, San Diego. *Contemporary Artists of San Diego,* January.
Holzwasser's Store, San Diego. Group show, February.
Gardena High School, Gardena, California. *Southern California Artists,* April.
Art Association, La Jolla, and Treasure Shop, Del Mar. One-man show, July-August.
Faulkner Memorial Art Gallery, Santa Barbara. One-man show, September.
Ilsey Gallery, Los Angeles. October.
Fine Arts Gallery, San Diego. *Seventh Annual Exhibition by Members of the Art Guild of the Fine Arts Society,* November 1932-January 1933. Catalogue entries:
 16 *Point Loma Canyon*
 17 *Water Front, New England*
 18 *Barren Hills*
1933 Art Association, Library, La Jolla, One-man show.
Fine Arts Gallery, San Diego. *Seventh Exhibition of Southern California Artists,* June-September. Catalogue entry:
 11 *In Harbor*
Brooks Memorial Art Gallery, Memphis. One-man show.
Lauren Rogers Library and Art Gallery, Laurel, Mississippi. *Maurice Braun,* December. Catalogue entries: ·
 1 *A Nook in the Harbor* $ 100
 2 *Waterfront* 250
 3 *Gray Day* 200
 4 *Marine, La Jolla* 200
 5 *A Bit of the Valley* 50
 6 *Sycamore Hill* 200
 7 *Autumn Hillside* 350
 8 *Springtime* 500
 9 *Sycamore* 500
 10 *Canyon Bottom* 200
 11 *A Hillside* 50
 12 *Anemones and Daffodils* 150
 13 *Mountain, Late Afternoon* 200
 14 *Norwalk River, Connecticut* 250
 15 *Brook in Winter* 100
Art Association, Library, La Jolla. One-man show.

Montgomery Museum of Fine Arts, Montgomery, Alabama. One-man show.
1934 Park Manor, San Diego. One-man show, January-February.
Palos Verdes Gallery, Palos Verdes, California. $100 award, April.
Biltmore Salon (hotel), Los Angeles. Group show, May.
Cuyamaca Club, San Diego. One-man show, May.
County Museum of Art, Los Angeles. *Art Teachers Association Fifteenth Annual,* May-June.
 The Dock
Fine Arts Gallery, San Diego. *Eighth Annual Exhibition of Southern California Art,* June-September. Catalogue entries:
 11 *Mission Bay*
 12 *Wharf Buildings*
Art Gallery, La Jolla. One-man show, July.
Western Foundation of Art, Los Angeles. Group show, September.
Fine Arts Gallery, San Diego. *Contemporary Artists of San Diego,* October-November.
Fine Arts Gallery, San Diego. *Art Guild Exhibition,* November. First Prize: *Along the River.*
H. Lieber Company, Indianapolis. One-man show.
Mills College, Oakland. Group show.
Fine Arts Gallery, San Diego. *Southern California Artists Exhibition,* First Prize.
1935 Academy of Western Painters, Los Angeles. Group show, February.
Mary Greene Studio, San Diego. One-man show, February.
Trease Studio, San Diego. One-man show, March.
Los Surenos Art Center, Old Town, San Diego. Group show, May-June.
Mary Greene Studio, San Diego. Group show, June.
California State Fair, Sacramento. Honorable Mention, September.
Los Surenos Art Center, San Diego. Group show, November.
Theosophical Club, San Diego. *Autumn Sketches Made in New England,* November-December.
Fine Arts Gallery, San Diego. *Art Guild Exhibition,* December 1935-January 1936.
1936 Mary Greene Studio, San Diego. January.
Country Club, La Jolla. February.
Fine Arts Gallery, San Diego. *Art Guild Exhibition,* February.
Los Surenos Art Center, San Diego. March.
Mary Greene Studio, San Diego. One-man show, April.
Mary Greene Studio, San Diego. One-man show, July.
Trease Studio, San Diego. July.
Los Surenos Art Center, San Diego. *Guild Portrait and Figure Exhibition,* October.
Orr's Gallery, San Diego. Group show.
Frances Webb Gallery, Los Angeles. Group show, November.

Foundation of Western Artists, Los Angeles.
Group show, November-December.
Theosophical Lodge, San Diego. Three-man
show, November-December.
H. Lieber Company, Indianapolis. One-man
show.
California State Fair, Sacramento.
1937 Fine Arts Gallery, San Diego.
*Catalogue of the Twenty-Second Annual
Exhibition by Members of the Art Guild of
the Fine Arts Society of San Diego,*
November 1936-January 1937.
Catalogue entries:
 9 *Long Shore*
 10 *The Crystal Vase*
(Braun chaired the jury of this show.)
Friday Morning Club, San Diego. One-man
show, January.
Lauren Rogers Library and Museum of Art,
Laurel, Mississippi. *Paintings by Maurice
Braun,* February. Catalogue entries:
 1 *Sailing the River* $ 250
 2 *La Jolla Cliffs* 250
 3 *Lingering Shades* 250
 4 *Breaking Wave* 250
 5 *Snapdragons and Roses* 150
 6 *Still Life* 150
 7 *Evening along the Shore* 150
 8 *Spanish Wine Jug and Apples* 150
 9 *Cuyamaca Lake* 150
 10 *The Dawning* 150
 11 *Southern California Valley* 150
 12 *Hills near Alpine* 100
 13 *Autumn Colors* 100
 14 *Waterfront Buildings* 100
Fine Arts Gallery, San Diego. *Contemporary
Artists of San Diego,* May.
Spanish Village, San Diego. *Salon des Refusés,*
group show, June.
Persian Gallery, La Jolla. One-man show, July.
Fine Arts Gallery, San Diego. *Southern
California Exhibition,* July-September.
Orr's Gallery, San Diego. *Recent Still Lifes,*
July.
Spanish Village, San Diego. *Contemporary
Artists of San Diego,* group show, July.
Fine Arts Gallery, San Diego. *Twenty-Third
Annual Exhibition by the Members of the Art
Guild of the Fine Arts Society of San Diego,*
November 1937-January 1938.
Catalogue entries:
 5 *The River*
 6 *Begonias*
Fine Arts Gallery, San Diego. One-man show.
1938 Fine Arts Gallery, San Diego.
Contemporary Artists of San Diego, April.
Orr's Gallery, San Diego. One-man show,
June-July.
Fine Arts Gallery, San Diego. Group show,
October.
Spanish Village, San Diego. *Landscapes and
Still Lifes,* one-man show, October.
Colonial Art Company, Oklahoma City;
Lauren Rogers Library and Museum of Art,
Laurel, Mississippi, November; and Washburn
College, Topeka, December. *Paintings by
Maurice Braun.* Catalogue entries:

 1 *Apples,* 20" x 14" $ 150
 2 *Yellow Robe,* 20" x 14" 150
 3 *Thawing (Winter),* 25" x 30" [?]
 4 *Breaking Wave,* 16" x 20" 100
 5 *The Surf,* 25" x 30" 250
 6 *Rocks and Wave,* 20" x 24" 150
 7 *Home Waters,* 25" x 30" 250
 8 *Evening on the River,* 20" x 24" 150
 9 *San Diego Water Front,* 25" x 30" 250
 10 *Evening Light,* 16" x 20" 100
 11 *Up the Valley,* 25" x 30" 250
 12 *Toward Evening,* 20" x 24" 150
 13 *Rocky Heights,* 20" x 30" 250
 14 *California Landscape,* 16" x 20" 100
 15 *Shirley Poppies,* 20" x 24" 150
 16 *Bouquet,* 20" x 24" 150
 17 *Begonias,* 20" x 24" 150
 18 *Marine,* 16" x 20" 100
 19 *Morning on the River,* 16" x 20" 100
 20 *Departing Fleet,* 16" x 20" 100
 21 *Off Shore,* 16" x 20" 100
Fine Arts Gallery, San Diego. *Catalogue of the
Twenty-Fourth Annual Exhibition by
Members of the Art Guild of the Fine Arts
Society,* November 1938-January 1939.
Catalogue entry:
 6 *Grey Day*
1939 Golden Gate International Exposition,
California Building, San Francisco.
Exhibition, February-December.
Catalogue entry:
 53 *Valley in the Hills* (il.)
Arnot Gallery, Elmira, New York, *Exhibition
of Oil Paintings by Maurice Braun,* April.
Catalogue entries:
 1 *Marine*
 2 *Breaking Wave*
 3 *Apples*
 4 *Rocks and Wave*
 5 *Home Waters*
 6 *Shirley Poppies*
 7 *Rocky Heights*
 8 *Bouquet*
 9 *San Diego Water Front*
 10 *The Yellow Robe*
 11 *Up the Valley*
 12 *Begonias*
 13 *The Farm in Winter*
 14 *Evening on the River*
 15 *The Surf*
 16 *Toward Evening*
 17 *Off Shore*
 18 *Departing Fleet*
 19 *California Landscape*
 20 *Evening Light*
 21 *Morning on the River*
Fine Arts Gallery, San Diego. *Eleventh
Annual Exhibition of Southern California
Art,* May-September. Catalogue entry:
 9 *River in Winter*
Spanish Village, San Diego. One-man show,
twenty-eight oils, thirty-seven drawings,
November.
1940 Fine Arts Gallery, San Diego. *Twelfth
Annual Exhibition of Southern California
Art,* June-August. Catalogue entry:
 7 *The City*
1942 Art Center, Oklahoma City, January;
Lauren Rogers Library and Art Museum,

February; and Oxford, Mississippi. *Memorial
Exhibition of Paintings by Maurice Braun.*
Catalogues entries:
 1 *Autumn* $ 100
 2 *Morning Light* 100
 3 *Morning Mists* 100
 4 *Eucalyptus* 100
 5 *San Diego Water Front* 250
 6 *Old Cronies* 250
 7 *Water Front Buildings* 100
 8 *Along the Shore* 150
 9 *The Blue Grass* 150
 10 *Dahlias* 150
 11 *Burmese Buddah* 150
 12 *Polychrome Angel* 150
 13 *The Day Breaks* 250
 14 *Harbor Life* 250
 15 *Across the Bay* 250
 16 *Bayside Buildings* 150
 17 *Dry Dock* 150
 18 *The Pacific at Point Loma* 250
 19 *Low Tide* 100
 20 *Breaking Wave* 250
 21 *Marine* 100
 22 *River Landing* 250
 23 *Point Loma Cypress* 150
 24 *Windswept Hills* 250
 25 *Autumn in Sweetwater Valley* 200
 26 *Purple Mountain* 250
 27 *The Back Lot* 150
 28 *After the Rain*
(Last show organized by Braun; details
carried through and arranged as a memorial by
his wife.)
High School Art Gallery, Springville, Utah.
An Exhibition of Paintings by Maurice Braun,
May. Catalogue entries:
 1 *Bouquet*
 2 *Pacific Coast*
 3 *California Coast*
 4 *California Landscape*
 5 *Up the Valley*
 6 *Mountain Heights*
 7 *Rocky Heights*
 8 *Green and Blue*
 9 *Tree Forms* (last work)
 10 *Yellow Tree*
 11 *River in Winter*
 12 *Foothills*
 13 *Coast Range*
 14 *Springtime*
 15 *Bay and City — San Diego*
 16 *At the Pier*
 17 *Mesa Grande*
 18 *The Winding Road*
 19 *Across the Street*
 20 *Landscape*
 21 *Eucalyptus*
 22 *Rock Ledge in Autumn*
 23 *The White Cloth*
 24 *Wet Weather*
 25 *Still Life*
 26 *The Desert*
 27 *Down the Valley*
 28 *Gray Day*
1947 Hickory, North Carolina.
Orr's Gallery, San Diego. *Memorial*

Exhibition.
1951 Fine Arts Gallery, San Diego. *Tenth Anniversary of the Artist's Death*, November. Men's Art Institute, San Diego. *Memorial Exhibition.*
1954 M. H. deYoung Memorial Art Museum, San Francisco. *Maurice Braun Retrospective Exhibition of Paintings*, March. Catalogue entries:
 1910-29
 1 *Mountain Top*
 2 *Sycamore*
 3 *Rocky Heights*
 4 *Springtime Fog*
 5 *Spring in the Forest*
 1930-39
 6 *Desert, New Mexico*
 7 *The River in Winter*
 8 *After the Thaw*
 9 *Evening Light*
 10 *The Desert*
 11 *The Old Spanish Wine Jug*
 12 *Along the River*
 13 *San Diego Hills*
 14 *The Breaker*
 15 *Rocks*

 16 *On the River*
 17 *Shirley Poppies*
 18 *Eucalyptus Grove*
 19 *At Day's End*
 20 *The T'ang Horse*
 1940-41
 21 *Mountains from Palomar*
 22 *Desert Forms*
 23 *Old Cronies*
 24 *Fishing Cove*
 25 *Departing Fleet*
 26 *Along the Shore, San Diego Bay*
 27 *After the Rain*
 28 *The Old Tree*
 29 *San Diego Boat Harbor*
 30 *Marine*
 31 *High Tide*
 32 *The Last Unidentified Sketch*
1972 Pomona College Art Gallery, Montgomery Art Center, Claremont, California. *Los Angeles Painters of the 1920s*, April-May. Catalogue entries:
 12 *Along the Merced River* (1918)
 13 *San Diego Hills*
1976 Fine Arts Gallery, San Diego. *The San Diego Scene: Art of the Thirties*, January-

February. Catalogue entries:
 Bayside Buildings, 20" x 24"
 Fishing Village, 25" x 30"
 Full Moon, 25" x 30"
 Gray Day, 25" x 30"
 Landscape, 25" x 30"
 Mountain Slopes, 25" x 30"
 Point Loma, 25" x 30"
1977 Fine Arts Gallery, San Diego. *Crayon Sketches by Maurice Braun*, October-November.

* as listed by number in Laurel *Leader-Call*, 2 December 1933. Indicates it travelled to Jackson, Mississippi, January 1934; Museum Art Association (Municipal Clubhouse). Montgomery Museum of Fine Arts, Montgomery, Alabama. One-man show.

Alfred R. Mitchell—Selected Exhibition History

1915 Panama California Exposition, San Diego. Silver Medal.
1927 Little Gallery, San Diego. *Exhibition of Paintings by Alfred R. Mitchell*, 16 October-17 November.
1928 Pacific Southwest Exposition, Long Beach.
1929 Casa de Mañana, La Jolla. One-man show, February-March.
Fine Arts Gallery, San Diego. *Exhibition of Paintings by Alfred R. Mitchell*, September.
Fox Theatre, San Diego. *Catalogue of Art Works*, November.
1930 Art Association, Tucson. *California Artists*, January.
Jules Kievits Galleries, Pasadena. *Exhibition of Paintings and Sculpture*, March.
1931 Art Association, Library, La Jolla. One-man show, February.
Art Association, Library, La Jolla. *Contemporary Artists of San Diego*, March-April.
Fine Arts Gallery, San Diego. *Contemporary Artists of San Diego*, April.
Los Angeles. *Fiesta de Los Angeles*, September.
Fine Arts Gallery, San Diego. *Sixth Annual Art Guild Exhibition*, Appleton S. Bridges Award, November 1931-January 1932.
Contemporary Artists of San Diego Gallery, San Diego. December.
Fine Arts Gallery, San Diego. *Sixth Annual Exhibition of Works by Southern California Artists.*

1932 Art Association, Library, La Jolla. One-man show, February.
Holzwasser's Store, San Diego. February.
Contemporary Artists of San Diego Gallery, San Diego. One-man show, March.
Fine Arts Gallery, San Diego. *Contemporary Artists of San Diego*, April.
Faulkner Memorial Art Gallery, Santa Barbara. *Contemporary Artists of San Diego*, September.
1934 Art Association, Library, La Jolla. One-man show, February.
Biltmore Hotel, Los Angeles. *California Art Club*, June.
Art Association, Library, La Jolla. August.
Festival of Arts, Laguna Beach. August-September.
Western Foundation of Arts, Laguna Beach. *San Diego Painters*, September.
Fine Arts Gallery, San Diego. *Contemporary Artists of San Diego*, October.
Mary Greene Gallery, San Diego. October.
Art Association, Laguna Beach. October-November.
1935 Art Association, Library, La Jolla. One-man show, January.
Park Manor, San Diego. One-man show, April. Laguna Beach.
1936 Mary Greene Gallery, San Diego. *Alfred R. Mitchell* and *Maurice Braun Exhibition*, January.

Art Association, Library, La Jolla. One-man show, February.
Fine Arts Gallery, San Diego. *Twenty-First Annual Art Guild Exhibition*, March.
Art Association, Laguna Beach. June-July.
Fine Arts Store, San Diego. August.
San Diego Club, San Diego. September.
Fine Arts Gallery, San Diego. *Art Guild Show*, December 1936-January 1937. Leisser-Farnham Prize.
1937 Art Association, Library, La Jolla. One-man show, February.
Spanish Village Gallery, San Diego. *Contemporary Artists of San Diego*, April.
Fine Arts Gallery. San Diego. *Contemporary Artists of San Diego*, May.
1938 Fine Arts Gallery, San Diego. *Contemporary Artists of San Diego*, April.
Fine Arts Gallery, San Diego. *Art Guild's Fourth Annual—Landscape Painters*, May.
Spanish Village Gallery, San Diego. Group show, October.
1939 Art Association, Library, La Jolla. One-man show, February.
Buck Hills Falls, Pennsylvania. *Buck Hills Falls Annual*, Purchase Prize ($200), Summer.
Fine Arts Gallery, San Diego. *Southern California Artists*, September.
Fine Arts Gallery, San Diego. *Art Guild Show*, December.
Dayton Brown Studio, Coronado. One-man show.
Golden Gate International Exposition, San Francisco. *American Painting*, 1939-40.

1940 Art Association, Library, La Jolla. One-man show, March.
Art Association, Laguna Beach. First Honorable Mention.
1941 Art Association, Library, La Jolla, One-man show, February.
Art Center, La Jolla. One-man show, June.
Fine Arts Gallery, San Diego. *Invitational Exhibition of San Diego Painters,* November.
1942 Art Association, Library, La Jolla. One-man show, February.
Carl M. Thorp Gallery, San Diego. One-man show, March.
Art Association, Laguna Beach. August.
Art Center, La Jolla. Group show, August.
1943 Art Association, Library, La Jolla. One-man show, February.
Fine Arts Gallery, San Diego. *Group Show of San Diego Painters,* July.
1945 Art Guild, Chula Vista. 1st Prize.
Art Association, Library, La Jolla. One-man show, February.
1946 Art Guild, Chula Vista. First Prize.
1948 Fine Arts Gallery, San Diego. *San Diego Art Guild,* January.
El Centro. *San Diego Painters,* April.
Festival of the Arts, Laguna Beach. Invitational honor.
1949 Art Association, Library, La Jolla. One-man show, February.
State Fair, Sacramento. September.

1950 Art Guild, Women's Club House, Chula Vista. *Art Guild Show,* February.
Art Association, Library, La Jolla. One-man show, February.
Hoberg's Desert Resort, Borrego Springs. One-man show, March.
Fine Arts Gallery, San Diego. *San Diego Art Guild All Media Exhibition,* March.
Art Guild, Women's Club House, Chula Vista. One-man show, April.
Southern California Exposition, Del Mar. First and third prizewinner, July.
Art Gallery, Laguna Beach. One-man show, August.
Art Guild, Women's Club House, Chula Vista. September.
1951 Art Association, Library, La Jolla. One-man show, February.
Art Guild, Women's Club House, Chula Vista. One-man show, March.
Businessman's Art Club, San Diego. One-man show, March.
Southern California Exposition, Del Mar. 1st Prize, July.
1952 Art Association, Library, La Jolla. One-man show, February.
Southern California Exposition, Del Mar. Third Prize, July.
1953 Art Association, Library, La Jolla. One-man show, February.

1954 Art Association, Library, La Jolla. *Thirty-First One-man Show,* February.
1955 Southern California Exposition, Del Mar. Honor Award, June.
1956 Art Center, La Jolla. Prize for landscape.
Art Institute, San Diego. *Fiesta del Pacifico,* Award of Distinction.
1957 Art Association, Library, La Jolla. One-man show, July.
Art Institute, House of Charm, San Diego. Three-man show, September.
1960 Art Institute, San Diego. *County-Wide Exhibition,* First Award.
Public Library, Main Branch, San Diego. One-man show, September.
1962 Art Association, Library, La Jolla. *Thirty-Eighth One-Man Show,* February.
1965 Art Association, Library, La Jolla. One-man show, February.
1966 Art Association, Library, La Jolla. One-man show, February (last one held here).
1973 Fine Arts Gallery, San Diego. *Memorial Exhibition,* November.
1978 Museum of Art, Downey, California. *Southern California Painting, Part II: Alfred R. Mitchell,* September-October.
1988 Historical Society, San Diego. *Sunlight and Shadow: The Art of Alfred R. Mitchell, 1888-1972,* June-July.

Charles Reiffel—Selected Exhibition History

1897 Library, Buffalo, New York. *Joint Exhibition of the Fine Arts Academy and the Buffalo Society of Artists.*
1909 Albright-Knox Art Gallery, Buffalo, New York. *Fifteenth Annual Exhibition of the Buffalo Society of Artists.*
1910 Corcoran Art Gallery, Washington, DC. *Third Exhibition: Oil Paintings by Contemporary American Artists,* December 1910-January 1911.
1913 Corcoran Art Gallery, Washington, DC.
1914 The MacDowell Club, New York City. *Exhibition of Paintings and Sculpture,* November.
1915 San Francisco. *Panama Pacific International Exposition.*
1916 Library, New Canaan, Connecticut. *New Canaan Society of Artists Exhibition,* August.
1917 Art Institute, Chicago. Silver Medal.
Corcoran Art Gallery, Washington, DC. *Sixth Biennial Exhibition.*
Society of Independent Artists, New York City.
1918 Society of Independent Artists, New York City.

1920 Solon Borglum Studio, Silvermine, Connecticut. *Silvermine Group of Artists Exhibition,* August-September.
1921 John Hanna Galleries, Detroit. One-man show.
Institute of Art, Detroit. One-man show.
1922 Dudensberg Galleries, New York City. *Recent Paintings by Charles Reiffel,* February.
Carnegie Institute, Pittsburgh. Honorable Mention.
1923 Pennsylvania Academy of Fine Arts, Philadelphia.
1924 Ehrich Galleries, New York City. *Exhibition of Recent Paintings by Silvermine Artists.*
Venice, Italy. *International Exhibition.*
1925 Marshall Field, Chicago. *Hoosier Salon First Annual,* March.
1926 Marshall Field, Chicago. *Hoosier Salon Second Annual,* March.
Los Angeles. *Seventh Exhibition,* April-May.
Fine Arts Gallery, San Diego. *First Exhibition of Artists of Southern California,* June-August. Art Guild Prize.
Carnegie Institute, Pittsburgh. *Twenty-Fifth International Exhibition of Paintings,* October-December.
Payson Ames Studio Gallery, La Jolla. *Works by Maurice Braun and Charles Reiffel.*
The Little Gallery, San Diego.

1927 Marshall Field, Chicago. *Hoosier Salon Third Annual,* January-February.
[Museum of Science History, and Art?], Los Angeles. *Seventh Annual Exhibition,* April-May.
Fine Arts Gallery, San Diego. *Catalogue of the Second Annual Exhibition of Artists of Southern California,* June-August.
California Art Club, Los Angeles. *Eighteenth Annual Exhibition,* November 1927-January 1928.
Fine Arts Gallery, San Diego. *Second Annual Exhibition of Southern California Artists,* Mr. and Mrs. P. F. O'Rourke $500 Purchase Prize.
Stendahl Galleries, Los Angeles. *Paintings by Charles Reiffel.*
1928 Marshall Field, Chicago. *Hoosier Salon Fourth Annual,* January-February. Shaffer Prize ($500).
[Museum of Science, History and Art?], Los Angeles. *Ninth Annual Exhibition,* April-May.
Fine Arts Gallery, San Diego. *Catalogue of the Third Annual Exhibition of Artists of Southern California,* June-August.
Corcoran Gallery of Art, Washington, DC. *Eleventh Exhibition of Contemporary American Painting,* October-December.

California Art Club, Los Angeles. *Nineteenth Annual Exhibition*, November-December. Mrs Keith-Spaulding Prize ($250).
Ebell Club, Los Angeles. *Exhibition of Paintings by Charles Reiffel.*
Fine Arts Gallery, San Diego. *Paintings by Charles Reiffel.*
Washington DC. *Centennial Exhibition.*
1929 Albright-Knox Gallery of Art, Buffalo, New York. *Twenty-Third Annual Exhibition of Selected Paintings by American Artists*, April-June.
[Museum of Science, History, and Art?] Los Angeles. *Painters and Sculptors of Southern California Tenth Annual Exhibition*, April-May.
Fine Arts Gallery, San Diego. *Catalogue of the Fourth Exhibition of Artists of Southern California*, June-August.
San Diego Hotel, San Diego. *First Exhibition of Paintings and Sculpture by the Associated Artists of San Diego*, July-August.
John Herron Art Institute, Indianapolis. *Twenty-Third Annual Exhibition of Indiana Artists*, October-November. First Award.
Fine Arts Gallery, San Diego. *Exhibition of Paintings by Charles Reiffel*, November.
California Art Club, Los Angeles. *Twentieth Annual Exhibition*, November-December.
Fine Arts Association, Tucson. *A Private Collection of Paintings by Some Living American Artists of Southern California*, c. 1929.
Fine Arts Gallery, San Diego. *First Exhibition of Paintings and Sculpture by the Associated Artists of San Diego.*
Gallery of Fine Arts, Columbus, Ohio. *A Private Collection of Some of the Living Artists of Southern California.*
National Academy of Design, New York City. *104th Annual Exhibition.*
1930 Marshall Field, Chicago. *Hoosier Salon Sixth Annual*, January-February.
Fine Arts Gallery, San Diego. *Exhibition of Paintings and Sculpture by Contemporary Artists of San Diego*, February-March.
Jules Kievets Gallery, Pasadena. *Exhibition of Paintings and Sculpture by Contemporary Artists of San Diego*, March.
[Museum of Science, History, and Art?], Los Angeles. *Eleventh Annual Exhibition of Painters and Sculptors*, April-May.
California Art Club, Los Angeles. *Twenty-First Annual Exhibition*, November-December.

Biltmore Salon, Los Angeles. *Painters of the West Ninth Annual Exhibition*, December 1930-January 1931. Gold Medal.
1931 Marshall Field, Chicago. *Hoosier Salon Seventh Annual Exhibition*, January-February.
Fine Arts Gallery, San Diego. *Catalogue of the Sixth Annual Exhibition of Artists of Southern California*, June-September.
Carnegie Institute, Pittsburgh. *Thirtieth International Exhibition of Paintings*, October-December.
California Art Club, Los Angeles. *Twenty-Second Annual Exhibition*, through December.
1932 Marshall Field, Chicago. *Hoosier Salon Eighth Annual Exhibition*, January-February.
[Museum of Science, History, and Art, Los Angeles?]. *Painters and Sculptors of Southern California Thirteenth Annual Exhibition*, April-June.
Fine Arts Gallery, San Diego. *Catalogue of the Circulating Gallery of Portable Pictures and Sculptures*, April.
Santa Cruz, California. *All California Fifth Annual Exhibition.*
Art Institute, Chicago. *Forty-Fifth Annual Exhibition of American Paintings and Sculpture*, October 1932-January 1933.
1933 Carnegie Institute, Pittsburgh. *Thirty-First Annual Exhibition of American Paintings and Sculpture.*
1934 Public Works of Art Project, Los Angeles. *Fourteenth Region — Southern California*, March.
Biltmore Salon, Los Angeles. *First Annual All-California Art Exhibition*, May-June.
Orr's Gallery, San Diego. *Paintings by Charles Reiffel*, July.
Art Cellar, San Diego. *Informal Art Exhibition of Paintings of Charles Reiffel*, November.
Fine Arts Gallery, San Diego. *Paintings by Charles Reiffel*, November.
Fine Arts Gallery, San Diego. *Contemporary Artists of San Diego.*
Park Manor, San Diego. *Works by Charles Reiffel.*
1935 Academy of Western Painters, Los Angeles. *First Annual Exhibition*, January.
[Museum of Science, History, and Art?], Los Angeles. *Sixteenth Annual Exhibition of Painters and Sculptors of Southern California*, April-June.
Palace of Fine Arts, Fine Arts Gallery, San Diego. *Catalogue of the Official Art Exhibition of the California Pacific International Exposition*, May-November.

Von Briesen Studio, San Diego. One-man show, August.
Library, La Jolla. *Charles Reiffel*, October.
San Diego State College, San Diego. *Works by Arthur Dow, Donal Hord, and Charles Reiffel.*
Green Gallery, San Diego.
1936 Los Sueños Art Center, Old Town, San Diego. *Works by Charles Reiffel, Ivan Messenger, and Maurice Braun.*
1937 Fine Arts Gallery, San Diego. *Contemporary Artists of San Diego.*
Fine Arts Gallery, San Diego. *Wax Drawings by Charles Reiffel.*
1938 Marshall Field, Chicago. *Hoosier Salon Fourteenth Annual Exhibition*, January-February. Shaffer Prize ($500).
Desert Inn Gallery, Palm Springs. October-November.
Fine Arts Gallery, San Diego. *Contemporary Artists of San Diego.*
John Herron Art Museum. *Wax Crayon Painting by Charles Reiffel.*
1939 Marshall Field, Chicago. *Hoosier Salon Fifteenth Annual Exhibition*, January-February.
Faulkner Memorial Art Gallery, Santa Barbara. *Some Southwest Artists: Oils and Watercolors.*
1940 Foundation of Western Art, Los Angeles. *Seventh Annual Exhibition of Southern California Landscape and Figure Painters*, April-May.
San Francisco. *Golden Gate International Exposition.*
Messenger Studio, Spanish Village, San Diego. One-man exhibition.
1942 Fine Arts Gallery, San Diego. *Charles Reiffel: A Memorial Exhibition of his Paintings*, June.
1968 Washington County Museum of Fine Arts, Hagerstown, Maryland. *The Railroad in American Art.*
1976 Fine Arts Gallery, San Diego. *The San Diego Scene: Art of the Thirties*, January-February.
1985 Fort Worth Art Center, Fort Worth. *The Iron Horse in Art*, January-March.
1987 Albright-Knox Art Gallery, Buffalo, New York. *The Wayward Muse: A Historical Survey of Painting in Buffalo.*
[?] Folsom Galleries, New York City. *Exhibition of Paintings by Charles Reiffel.*
[?] Newhouse Galleries, Los Angeles. *Exhibition of Paintings by Charles Reiffel.*

Charles Arthur Fries—Selected Bibliography

A.C.G. *San Diego Union*, 10 August 1924.

American Art News (September 1929).

Anderson, Anthony. *Los Angeles Times*, 8 November 1908; 7 October 1917.

Andrews, Julia Gethman. *San Diego Union*, 1 and 15 November 1936.

Baker, Naomi. San Diego *Evening Tribune*, 20 July 1954; 2 September 1960.

Barney, Esther Stevens. San Diego *Evening Tribune*, 27 July, 5 October, 9 November 1929; 25 January, [?] February 1930.

Berkeley Gazette, 6 September 1911.

Berkeley Independent, 6 September 1911.

Bierman, Daisy Kessler. *San Diego Union*, 30 November 1921; 21 May 1922; [?] September 1923; 21 March 1927.

Braun, Hazel Boyer. San Diego *Evening Tribune*, [?] September 1926; 18 June, 6 August, 17 and 31 December 1927; 21 January, 23 June, 15 September, 6 October, 24 November, 28 December 1928; 2 February, 29 June, 20 July 1929; 12 April, 7, 14, and 21 June, 9 August, 22 November, 13 December 1930; [?], 12 October, 21 and 28 November, 12, 19, and 26 December 1931; 20 February, 5 March, 23 and 30 July 1932; 15 December 1933; 26 May, 25 August, 1, 8, and 23 September, 15 and 20 October, 17 and 24 November 1934; 2 February, 1 and 8 June, 3 and 17 August, 21 September, 5 and 12 October, 7 December 1935; 10 April, 15 and 29 May, 14 August, 18 September 1937; 6 December 1941; 4 July 1942; 13 August 1944.

Bush, Ester Mugan. *Chain of Blue*, 12 November 1919.

—. *Santa Fe Magazine* (November 1917).

Campbell-Shields, A.B. *San Diego Union*, 5 and 14 March 1925.

El Caraval (June 1928): cover ill.

Cincinnati Illustrated News, 3 July 1886; 26 March, 9 April, 28 May 1887.

Cincinnati Illustrated Sunday News, 5 and 19 June, 10, 17, and 24 July, 14 August, 18 September, 2, 9, 16, and 23 October, 6 November 1887.

Clark, Irene M. *San Diego Union*, 28 March 1937; 26 July [193?].

Cooper, Francis. San Diego *Sun*, 11 December 1931.

Dixon, Ben F. *Too Late*. San Diego: San Diego Historical Society, 1969.

Escondido *Times Advocate*, 3 July 1925.

Fenn, W. J. [?], [?] May 1923.

Fine Arts Gallery of San Diego: *Catalogue of the Paintings and Tapestries in the Permanent Collection*. San Diego: Fine Arts Gallery of San Diego, 28 December 1927, no. 16, ill.

Fries, Charles Arthur. San Diego *Sun*, 30 December 1916.

Haddock, Lois. San Diego *Evening Tribune*, 10 December 1938.

Halseth, Odd S. San Diego *Evening Tribune*, 23 March 1923.

Hollywood Citizen, 9 and 16 January 1914.

Hord, Donal. San Diego *Evening Tribune*, 4 April 1931.

—. San Diego *Sun*, 16 November 1935; 22 March 1936.

Indio *Date Palm*, 20 March 1920.

Jackson, Eileen. *San Diego Union*, 15 January 1933.

Jennings, Jan. San Diego *Evening Tribune*, 29 April 1977.

Kahle, Kathleen Morrison. San Diego *Sun*, 7 June, 9 and 16 August, 27 September, 23 December 1933.

—. *San Diego Union*, 27 November, 14 and 28 July, 11 August, 8 September, 6 October 1934; 25 May, 17 August, 21 September 1935.

Kesler, Robert. "Charles Arthur Fries— Writer, Artist, Philosopher," *The Wrangler* (June 1977).

Krombach, Beatrice de Lack. San Diego *Sun*, [?] February 1919; 18 December 1920; 7 December 1926; 4 and 10 January, 27 August, 4 and 10 December 1927; 10 January, 3 March 1928.

La Jolla Light, 26 August 1954.

Loring, Marg. San Diego *Sun*, 9, 15, and 16 May, 18 July, 29 August 1937; 15 May 1938.

Los Angeles Times, 30 September 1917.

Mathis, William. [?], 27 January 1924.

McGarvey, Julia. *San Diego Union*, 12 October 1930.

McHugh, Kay. San Diego *Sun*, 5 December 1931.

McKenney, Lilian Verna. [?], [?] January 1925.

Messenger, Ivan. San Diego *Sun*, 9 February 1925; 2 and 23 March 1935.

Millier, Arthur. *Los Angeles Times*, [?] 1932.

Mitchell, Alfred R. *San Diego Union*, 1 December 1931.

Morris, Ralph. San Diego *Independent*, 8 and 22 January, 7 October 1928.

New Orleans [?], 14 March 1920.

New York American, 25 January 1925.

New York *Herald-Tribune*, 18 and 25 January 1925.

New York Times, 24 January 1925.

Page, Octavie. San Diego *Evening Tribune*, 29 October, 21 November, 19 and 26 December 1932; 4 and 7 January, 11 February, 10 June 1933.

—. San Diego *Sun*, 8 August 1932.

Patterson, Robert H. San Diego *Sun*, 9 November 1929.

—. *San Diego Union*, 8 June 1930.

Paulding, Litti. *Santa Barbara Daily News*, 10 September 1932.

Petersen, Martin E. "Contemporary Artists of San Diego," *Journal of San Diego History* 16 (Fall 1970).

Poland, Reginald H. *The Modern Clubwoman* (November 1929).

—. San Diego *Independent*, [?] June 1926.

—. San Diego *Sun*, 22 November, 13 December 1930; 4 and 6 May 1931.

—. *San Diego Union*, 11 June 1926; 19 September 1927; 21 August 1928; 3 February, 4 August, 6 September, 13 October 1929; 2 February, 7 December 1930; 22 November 1931; 13 August, 3 and 31 December 1933; 11 February, 25 April, 5, 12, and 19 August, 2 September, 21 October, 21 December 1934; 6 January, 4 August 1935; 14 May 1936.

Portersfield, W. H. San Diego *Sun*, 19 March 1925.

Reynolds, Dorothy. *San Diego Union*, 9 August 1936.

—. San Diego *Sun*, 15 November 1936.

Robertson, Thomas B. *San Diego Union*, 27 November 1949.

San Diego *Evening Tribune*, 19 February 1904; 18 February 1919; 28 February 1925; 8 June, 4 December 1927; 16 June 1928; 30 March, 28 November, 1 and 18 December 1931.

San Diego History News 13 (May 1977).

San Diego *Independent*, 3 December 1927; 20 January 1928; 19 May 1955.

San Diego *Pointer* (Pt Loma High School publication), 10 May 1946.

San Diego *Sun*, 15, 19, and 24 December 1906; 26 March 1914; 24 March 1922; 28 February, 25 March 1925; 29 September 1926; 4 December 1927; 6 and 28 February, 1 October 1929; 7 November, 1 December 1931; 26 April 1932; 8 and 14 August 1934; 2 August 1935; 23 December 1936.

San Diego Union, 25 October 1898; 26 January, 24 and 30 December 1906; 15 and 21 December 1907; 27 May 1908; 19 February 1909; 20 November 1910; 25 March 1914; 25 June, 15 and 20 August, 7 September 1917; 24 November 1920; 23 January, 11 December 1921; 10 and 31 March, 9 April 1922; 17 November 1923; 10 August 1924; 26 March 1925; 10 October, 12 December 1926; 5 June 1927; 16 December 1928; 2 and 13 October, 2 November 1929; 2 February, 14 October, 10 December 1930; 3 and 31 May, 2, 5, and 27 December 1931; 31 January, 24 July, 17 August, 10 and 13 November 1932; 9 and 12 January,

13 June, 11 August 1933; 28 April, 12 and 14 August, 17 November, 21 December 1934; 12 July 1935, 13 May, 4 July, 13 November 1936; 8 May 1938; 24 December 1939; 7 February 1940; 10 April, 3 July 1977.

Sherman, Elizabeth. *San Diego Union,* 25 August 1935.

Strong, Hugh. *San Diego Union,* [?] April 1934.

The Sun Dial, 6 April 1922.

Titus, Aime B. *San Diego Magazine* (September 1927).

—. *San Diego Union,* 29 September 1929.

Trease, Sherman. *San Diego Union,* 29 March 1936; 18 April, 5 September 1937; 30 October 1938.

Wallace, Etta Mae. San Diego *Sun,* 4 March 1933.

Maurice Braun—Selected Bibliography

American Art News, 4 May 1918; 10 January 1920; 4 June 1921; 21 April 1923; 1 November 1923.

Anderson, Anthony. *Los Angeles Sunday Times,* 10 December 1911; 25 February 1917; 20 January 1918.

Andrews, Julia Gethman. *San Diego Union,* 11 January, 26 April, 31 May, 4 September, 11 October 1936; 24 September 1939; 1 December 1940.

Art News, 4 May 1929, 22.

Art World (June 1918).

Arts and Decorations (June 1918).

Barney, E. S. San Diego *Evening Tribune,* 27 July, 21 December 1929; 1, 8, and 15 February; 22 March 1930.

Binghamton Sun, 2 November 1938.

Boston Evening Transcript, 21 April 1923.

Bowdoin, W. *New York World,* 15 May 1918.

Braun, Hazel Boyer. "The Home Coming of Maurice Braun," *Southwest Magazine* (March 1924), 7ff.

—. "A Notable San Diego Painter," *California Southland* [?], 12ff.

—. San Diego *Evening Tribune,* [?] 1926; 13 May, 18 June 1927; 2 and 23 February, 11 May, 8 and 29 June, 6 and 20 July, 7 and 14 September 1929; 17 May, 14 June, 9 and 30 August, 6 September, 11 October, 8, 22, and 29 November, 6 and 13 December 1930; 14 February, 2 May, 20 June, 7 July, 12 September, 3 October, 21 November, 19 and 26 December 1931; 20 February, 5 March, 16, 23, and 30 April, 18 June, 2 and 9 July 1932; 12 January, 2, 17, and 24 February, 10 March, 19 and 26 May, 9 and 16 June, 7 and 14 July, 4 and 11 August, 8 and 30 September, 15 October, 17 November 1934; 12 January, 2, 9, 16, and 23 February, 30 March, 25 May, 1 and 8 June, 6, 20, and 27 July, 12 October, 30 November, 3, 14, and 28 December 1935; 11 January, 8 February, 7 March, 25 April, 2, 16, and 23 May, 27 June, 4 July, 10 and 24 October, 1, 7, and 31 November 1936; 2 and 16 January, 15 March, 10 April, 1 May, 18 September, 4 and 11 December 1937; 18 January, 2 and 30 April, 4, 11, 18, and 25 June, 30 July, 27 August, 10 September, 1 October 1938; 28 September, 4 and 11 November 1939.

—. San Diego *Tribune-Sun,* 9 March, 27 April, 4 May, 15 and 29 June, 13 and 27 July, 7 September, 23 November 1940; 15 and 22 February; 8 and 22 March, 3, 10, and 31 May, 14 and 22 June, ? November 1941; 21 June 1943.

Braun, Maurice, "American Art Attains Recognition," *The Modern Clubwoman* (October 1928), 7-8.

Brary, W. G. Unidentified source.

Brooklyn Eagle, 20 and 23 November 1915, [?] May 1918.

Brooklyn Standard Union, 23 November 1915.

California Southland (October 1924).

Chanute Daily Tribune, 20 January 1920.

Chicago Daily Tribune, 29 May 1928.

Chicago Evening Post, 6 April 1929.

Chicago Sunday Tribune, 1 April 1928.

Claremont *Student Life,* 14 November 1919.

Colorado Springs Gazette, 18 June 1921.

Comstock, Helen. "Painter of East and West," *International Studio* (March 1925).

Cook, Alma M. *Los Angeles Herald and Express,* 1 March 1931; 29 October 1932.

Cortissoz, Royal. *New York Tribune,* 4 January 1920.

Dallas Morning News, 11 and 14 February 1932; 8 March 1925.

Dallas Times Herald, 11 and 15 February 1923.

De Lack, Jon. "Maurice Braun of San Diego and His Aesthetic Landscapes," *Society* [?], 13ff.

Denver *Rocky Mountain News,* 3 July 1921.

Duncan, Donnelly. *San Diego Union,* 30 October 1938.

El Caravel (November 1927), 7-14.

Elmira (New York) *Advertiser,* 6 April 1939.

Elmira (New York) *Star-Gazette,* 29 November 1922.

Elmira (New York) *Telegram,* 3 December 1922.

Farrar, Sara. Denver *Rocky Mountain Dem[ocrat?],* 7 May 1916.

Greenwalt, Emmett A. *The Point Loma Community in California 1897-1942.* Berkeley: California University Press, 1955.

Haddock, Lois. San Diego *Sun,* 9 October 1938.

Hartford Daily Courant, 9 and 11 October 1922; 3 and 15 November 1923.

Hartford Daily Times, 5 October 1922.

Hartford Times, 2 and 4 October 1922.

Hillcrest News (San Diego), 28 November 1941.

Hord, Donal. San Diego *Evening Tribune,* 4 April 1931; 4, 11, and 19 January, 15 March 1936.

Humboldt Union, 19 January 1922.

Hunt, Adalea Andrews. *Dallas Morning News,* 6 March 1926.

Hutchings, Emily Grant. *St Louis Daily Globe-Democrat,* 18 September, 6 November 1921; 18 June 1922.

Independent (San Diego), 18 July, 26 September 1926.

Indianapolis Sunday Star, 4 April 1934.

E. J. (Eileen Jackson?). *San Diego Union,* 16 February 1930; 28 November 1940.

Jordon, Vera. *The Erie Dispatch,* 1 February 1920.

Kahle, Kathleen Morrison. San Diego *Sun,* 4 October 1933; 4 February, 4 and 10 March, 2 and 23 June, 1, 14, and 21 July, 23 September, 6 and 20 October, 24 November 1934; 18 March, 25 May, 8 June, 21 September 1935.

Kerr, Harold. San Diego *Independent,* 19 March 1939.

Krombach, Beatrice de Lack. San Diego *Sun,* 7 November 1916; 18 September, 18 December 1920; 5 February 1921; 25 June 1926.

La Jolla Journal, date unknown.

"Landscapes by Maurice Braun," *Western Art,* 10-11.

Lane, Alexander. *San Diego Union,* 28 November 1937.

Laurel (Mississippi) *Leader-Call,* 2 and 16 December 1933; 2 November 1938.

Lennon, R. A. *Chicago Evening Post Magazine of World Art,* 3 April 1928.

Linderman, Verne. Santa Barbara *Morning Press,* 8 September 1932.

Loring, Marg. San Diego *Sun,* 6 December 1936; 2, 9, and 16 May, 18 July, 29 August, 5 and 19 December 1937; 16 January, 3 and 10 April, 29 May 1938; 12 February 1939.

Los Angeles Times, 18 February 1917; 6 April, 14 December 1919; 13 April 1924; 14 March 1926; 25 March 1928; 2 June 1929.

"Maurice Braun: Prober of Nature's Soul," *National Motorist* (June 1931).

Maxwell, Everett C. *The Graphic*, 9 December 1911.

McGarvey, Julia. *San Diego Union*, 12 October 1930.

Mercury (Magazine of the Los Angeles Athletic Club) (August 1921).

Messenger, Ivan. San Diego *Sun*, 19 May 1934; 9, 16, and 23 February, 2 March 1935.

Monrovia Evening Post, date unknown.

Montgomery Advertiser, 31 October 1933.

Mundy, Talbot. *San Diego Union*, 2 March 1924.

New York American, 11 January 1920.

New York Evening Mail, 13 November 1915.

New York Evening World, 22 November 1915.

New York Globe, 19 November 1915.

New York Herald, 5 May 1918.

New York *Morning Telegram*, 20 June 1918.

New York Press, 15 November 1915.

New York Times, 4 January 1920.

New York Times Magazine, 24 March 1918.

New York Tribune, 21 November 1915; 15 May 1918; 22 April 1923.

New York World, 6 May 1913; 21 November 1915; 5 May 1918.

Page, Octavie. San Diego *Evening Tribune*, 21 November 1932.

Pasadena Star News, 17 May 1926; 21 March 1929.

Paulding, Litti. *Santa Barbara Daily News*, 10 September 1932.

Petersen, Martin E. "Contemporary Artists of San Diego," *Journal of San Diego History* 16 (Fall 1970), 3ff.

Philadelphia *Moment*, 11 May 1918.

Philadelphia *Record*, 12 May 1918.

Poland, Reginald H. *Christian Science Monitor*, 19 August 1929.

—. "The Divinity of Nature in the Art of Maurice Braun," *Theosophical Path* 34 (May 1928), 473ff.

—. San Diego *Sun*, 27 April, 15 June 1929; 22 November, 13 December 1930; 15 November 1932.

—. *San Diego Union*, 19 June 1927; 19 April, 9 June, 4 August 1929; 2 February, 16 November 1930; 1 January, 4 April, 4 and 6 May 1931; 7 February 1932; 11 February, 11 March, 13 and 20 May, 1, 15, and 22 July, 19 August, 21 October 1934; 10 February, 9 May, 15 November, 19 and 26 December 1937; 20 February, 10 April 1938; 4 May 1941.

Powell, Mary. *St Louis Star*, 6 November 1921.

Reynolds, Dorothy. San Diego *Sun*, 17 and 24 May, 28 June, 19 July, 6 September, 1 and 8 November 1936; 24 June 1938.

Rhea, Marian Buroughs. *Tucson Citizen*, 24 March 1926.

Riverside Daily Press, 18 March 1924.

Riverside Enterprise, 17 March 1924.

Robertson, Thomas B. *San Diego Union*, 11 and 18 November 1951.

St Louis Daily Globe-Democrat, 23 October 1921.

St Louis Dispatch, 4 September 1921.

St Louis Star, 4 and 11 September 1921.

St Louis Times, [?].

Salt Lake Tribune, 17 May 1942.

San Antonio Evening News, [?].

San Diego *Evening Tribune*, 12 June 1911; 12 November 1918; 31 January, 18 September, 27 November 1920; 24 July [1927?]; 22 November 1931; 19 March 1932; 24 April 1940; 8 November 1941 (obituary).

San Diego Magazine (September 1927), 10-12.

San Diego News, 13 January 1918.

San Diego *Sun*, 19 July, 2 August 1916; 3 September 1917; 20 March 1918; 19 February 1927; 28 February, 7 and 20 June 1929; 29 December 1931; 6 February, 15 and 26 April 1932; 18 September 1934; 15 and 22 February 1935; 12 April, 31 May 1936; 15 October 1937; 27 October 1938.

San Diego *Tribune-Sun*, 24 April, 24 November 1940; 8 and 21 November 1941 (obituary).

San Diego Union, 18 June 1911; 15 June 1912; 19 October, 24 December 1914; 2 February, 26 December 1915; 11 June, 5, 14, and 29 July 1916; 25 August, 24 November 1917; 7 April, 11 June, 17 July, 13 November 1918; [?] February, 28 April 1919; 18 January, 19 September, 12 December 1920; 18 December 1923; 17 February, 24 March, 10 August 1924; 12 March, 16 July, 12 December 1926; 19 February 1928; 25 February, 3 March, 12 May, 20 June 1929; 16 and 23 February, 4 and 10 May, 14 and 21 December 1930; 15 March, 8 and 31 May, 28 June, 19 July 1931; 31 January, 6, 7, and 28 February, 5 June, 13 November, 16 December 1932; 26 May, 7 July 1933; 9 May, 18 September, 17 November 1934; 28 April, 5 May, 29 July, 6 September, 6 December 1935; 16 February, 23 March, 23 June, 13 November 1936; 27 June, 30 August, 26 December 1938; 31 October 1938; 16 and 24 March, 28 April, 8 August, 25 and 29 November 1940; 8, 9, 19, and 20 November 1941; 20 April 1947; 18 and 20 November 1951; 1 January 1952; 8 December 1985, il.

San Francisco Chronicle, 16 February 1930.

Superintendent's Bulletin (San Diego), 14 December 1951.

Trease, Sherman. *San Diego Union*, 19 and 26 September 1937.

Vogue (June 1915).

Wallace, Etta Mae. San Diego *Sun*, 15 August 1934.

Wichita Beacon, 6 December 1925.

Wichita Daily Times, 18 March 1923.

Wichita Eagle, 12 January 1927.

Williams, Michael. *San Francisco [Chronicle?]*, 20 May 1916.

Winchell, A. C. Unidentified article.

Alfred R. Mitchell—Selected Bibliography

A.C.G. *San Diego Union*, 10 August 1924.

Andrews, Julia Gethman. *San Diego Union*, 28 June, 18 October 1936; 7 March 1937; 4 June, 24 September 1939; 24 March, 17 November 1940; 2, 9, and 23 February, 29 June, 20 and 27 July 1941; 21 June, 23 August 1942; 19 May 1946.

Baker, Naomi. San Diego *Evening Tribune*, 22 and 26 August, 13 September, 24 October 1950; 27 February, 27 March 1951; 2 February, 23 June, 20 and 26 September, 2 and 4 October 1952; 31 January, 7 February, 25 April, 13 June, 10 October 1953; 6 February 1954; 28 September 1957;

1 December 1959; 15 September 1960; 2 February 1962; 31 January, 1 February 1963; 29 January, 6 June 1965; 15 September 1957; 6 March, 9 October, 6 November 1970.

—. San Diego *Tribune-Sun*, 8 February, 11 April 1950.

Barney, Esther Stevens. San Diego *Evening Tribune*, 27 July 1929; 25 January, 1 and 8 February, 22 March 1930.

Braun, Hazel Boyer. San Diego *Evening Tribune*, 3 and 16 July, 22 October, 26 November, 4 and 17 December 1927; 23 and 26 May, 23 June, 7 July, 24 November, 15 and 29 December 1928;

29 January, 2 and 16 February, 9 March, 15 and 29 June, 6, 13, and 20 July, 7 and 14 September 1929; 5 and 12 July, 9 August, 6 September, 11 October, 22 and 29 November, 6 and 13 December 1930; 8 August, 3 October, 28 November, 5 and 19 December 1931; 30 January, 6 and 27 February, 5 and 12 March, 23 and 30 April, 25 May, 22 and 28 August, 11 September 1933; 26 January, 2, 9, and 24 February, 21 April, 12 and 26 May, 11 August, 8 September, 1, 15, 20, and 27 October, 1 and 8 December 1934; 5, 12, 19, and 26 January, 2, 9, and 23 February,

7 and 17 March, 23 May, 1 June 1935;
18 January, 8 and 22 February, 7, 14, 21,
and 28 March, 2 and 16 May, 4 July, 10 and
17 October, 1 and 7 November 1936; 6, 13,
19, and 27 February, 6 March, 10 April,
9 and 16 October, 27 November,
4 December 1937; 12 and 26 February,
5 and 12 March, 2 April, 4 June, 16 July,
10 September, 1 October 1938; 11, 12, and
25 February, 15, 22, and 29 April, 17 June,
9 and 16 September 1939.

Braun, Hazel Boyer. San Diego *Tribune-Sun,*
16 December 1939; 9, 16, and 25 March,
15 June, 24 November 1940; 15 and
22 February, 31 May, 14 June, 5, 12, and
19 July, 15 November, 13 December 1941;
31 January, 7, 14, 21, and 28 February, 7,
14, 21, and 28 March, 4, 11, and 25 April,
16 May, 27 June, 8, 15, and 22 August,
3 October 1942; 13, 20, and 27 February,
3, 10, 17, and 24 April, 19 July,
14 September, 20 October 1943.

Britton, James. *San Diego and Point Magazine*
(4 May 1951).

Brown, Nadine. *San Diego Journal,* 14 April
1950.

Christian Science Monitor, 22 August 1927.

Clark, Irene N. *San Diego Union,* 15 October
1936; 28 March 1937.

Cutts, Anson B., Jr. San Diego *Tribune-Sun,*
31 May 1944.

Darby, Louise. *San Diego Union,* 18 June
1939.

Dunann, Donnelly. *San Diego Union,*
30 October 1938.

Genauer, Emily. *San Diego Union,* 11 April,
16 May 1954.

Haddock, Lois, San Diego *Sun,* 9 October
1938.

Hillcrest Star News, 6 March 1942.

Hord, Donal. San Diego *Evening Tribune,*
4 April 1931; 4, 11, and 19 January, 1, 8,
15, and 29 March 1936.

E. J. (Eileen Jackson?). *San Diego Union,*
16 February 1930.

Jackson, Eileen. *San Diego Union,*
28 November 1940.

Kahle, Kathleen Morrison. *San Diego Union,*
29 January 1928.

——. *San Diego Sun,* 26 April, 14 June,
9 August, 14 September 1933; 24 February,
2 June, 8 and 23 September, 6, 20, and
27 October 1934; 18 and 25 May, 8 June
1935.

Kerr, Harold. Unidentified newspaper
clipping.

Krombach, Beatrice de Lack. San Diego *Sun,*
4, 10, and 18 June, 8 July, 15 October,
19 December 1927; 3 March, 14 July 1928.

Lewis, Helen. *San Diego Union,* 8 September
1929.

Linderman, Verne. Santa Barbara *Morning
Press,* 8 September 1932.

Loring, Marg, *San Diego Union,* 13 August
1944.

——. San Diego *Sun,* 17 and 31 January, 9 and
16 May, 18 and 25 July 1937; 3 April,
8 May 1938; 5, 12, and 26 February, 16, 23,
and 30 April, 18 June, 17 September 1939.

Los Angeles Times, 10 December 1931.

McGarvey, Julia. *San Diego Union,*
12 October 1930.

McHugh, Kay. San Diego *Sun,* 5 December
1931.

Messenger, Ivan. San Diego *Sun,* 1 December
1934; 12, 19, and 26 January, 2, 9, 16, and
23 February, 2 and 16 March, 6 and
13 April 1935.

Mitchell, Alfred R. *San Diego Union,*
1 December 1931.

Morris, Ralph. San Diego *Evening Tribune,*
19 June 1928, ill.

——. San Diego *Independent,* 22 January 1928.

Olten, Carol. *San Diego Union,* 27 January
1973.

Page, Octavie. San Diego *Evening Tribune,* 4,
7, and 14 January, 11 and 25 February,
29 April, 5 and 12 August 1933.

Paterson, Robert Hunter. *San Diego Union,*
4 May 1930.

——. San Diego *Sun,* 3 May 1930.

Petersen, Martin E. San Diego *Evening
Tribune,* 8 May 1970.

——. *San Diego Union,* 6 August 1972.

Poland, Reginald H. San Diego *Independent,*
5 July 1927.

——. *San Diego Union,* 19 June 1927; 22 and
29 July 1928; 14 July 1929; 2 and
9 February, 7 December 1930; 1 January,
29 November 1931; 1 January, 7 February,
24 April 1932; 19 February 1933;
11 February, 15 August, 2 September,
21 October, 2 December 1934; 13 January,
10 November 1935; 16 May, 5 December
1937; 6 and 20 March, 3 and 10 April,
15 May 1938; 5, 12, 19, and 26 February,
15 March, 23 April, 17 and 31 December
(ill.) 1939; 2, 10, and 17 March, 21 July
1940; 6 and 17 July, 10 August,
23 November 1941; 22 February, 8 March,
26 July, 9, 16, and 30 August,
27 September, 4 October 1942; 18 July,
14 and 21 November 1943; 18 and
25 February 1945; 9 March 1947;
24 October 1948; 4 September 1949.

——. San Diego *Sun,* 13 December 1930;
4 April, 4 May 1931.

Reser, Luella. San Diego *Sun,* 4 December
1927.

Reynolds, Dorothy. San Diego *Sun,* 17 and
31 May, 5 July, 9 and 16 August,
[? October] 1936.

Robertson, Thomas B. *San Diego Union,*
11 and 18 January, 11 April, 31 October, 7
and 28 November 1948; 6 and 20 February
1949; 26 February, 19 March, 23 and
30 April 1950; 8 April 1951; 27 January,
4 May, 22 June, 13 July, 7 and
14 September, 5 October, 9 November
1952; 1 and 8 February, 1 March,
15 November 1953; 31 January, 7 February
1954.

San Diego *Evening Tribune,* [? June/July] 1926;
18 June, 7 July 1927; 9 December 1930;
30 March, 30 May, 28 November,
18 December 1931; 11 July 1936;
16 November 1937; 5 March 1938;
21 January 1939; 7 July 1950; 4 July,
10 October 1951; 2 July 1952; 31 January
1964.

San Diego *Independent,* 17 July 1927;
24 January 1964.

San Diego Journal, 21 August 1945.

San Diego *Progress-Journal,* 14 November
1943.

San Diego *Reader,* 8 February 1973.

San Diego Shopping News, 31 December
1947.

San Diego *Sun,* 7 July, 10 December 1927;
14 April 1928; 5 January, 7, 15, and
20 June, 31 August, 14 September,
2 November 1929; 31 March, 26 April
1932; 5 August 1933; 23 May, 10 July,
2 August 1935; 15 October 1937;
30 October 1938.

San Diego *Tribune-Sun,* 10 April 1943;
4 April, 20 August 1945; 17 October,
9 November 1946; 29 December 1947;
7 January, 6 October, 3 November 1948;
25 January 1949; 11 April 1950.

San Diego Union, 7 July, 1 September 1927;
2 and 15 April, 31 August, 11 November,
16 December 1928; 12 June, 4 and
25 August, 3 and 14 November 1929;
23 February, 2 and 16 March, 4 and 19
May, 10 December 1930; 8, 10, and 31
May, 6 September, 5 December 1931;
1 and 31 January, 28 February, 6, 8, 16, and
20 March, 1 April, 7 August 1932; 4, 9, and
15 January, 21 May, 3 and 11 August,
11 September 1933; 4 and 25 March,
1 April, 9 May, 8 August 1934; 28 April,
2 June, 7 and 12 July 1935; 23 April,
27 June, 3 and 4 July, 16 September,
13 October 1936; 21 January 1937; 13 May
1938; 27 November 1939; 14 August 1941;
30 May 1942; 6 November 1943;
23 August 1945; 17 October 1946;
8 January, 8 October, 6 and 8 November
1948; 2 January, 11 October 1949;
14 March, 15 April, 9 July, 3 September
1950. 11 February, 5 July, 12 and
14 October 1951; 3, 4, and 5 October 1952;
16 August, 7 October 1953; 14 June 1954;
26 June 1955; 28 July, 28 September 1957;
1 and 15 November 1970; 14 April 1971;
12 November 1972.

Sorenson, George. *San Diego Union,* 10 and
17 October 1954.

Titus, Aime B. *San Diego Union,* 3 and
15 September 1929.

Trease, Sherman. *San Diego Union,* 29 March
1936; 18 April, 19 and 26 September 1937;
6 March 1938.

Charles Reiffel—Selected Bibliography

Reiffel's scrapbook, which contains many useful articles, notes, and photographs, is an essential source of information about the artist's early career. I am grateful to George Stern for sharing it.

Ainsworth, Ed. *Los Angeles Times*, 4 August 1934.

Andrews, Julia G. *San Diego Union*, 31 March 1935.

Art Digest (July 1928).

— (April 1942, obituary).

— (January 1944).

Baker, Naomi. San Diego *Evening Tribune*, 6 November 1964.

Barney, Esther Stevens. San Diego *Tribune*, 2, 16, and 23 November 1929.

Berman, Anne E. *Art & Auction* (June 1988).

Bishop, Hubert E. "The Early History of the Silvermine Art Colony," *The Silvermine* (August 1938).

Braun, Hazel Boyer. *Argus* (a monthly journal of arts published in San Francisco) (1928).

—. *Parent-Teacher Courier* (1929).

—. San Diego *Evening Tribune*, [?] September 1926; 15 January, 23 April 1927; 3, 17, and 24 November, 30 December 1933; 7, 13, 14, and 21 July, 3 November, 30 June 1935; 2 January 1936.

—. San Diego *Tribune-Sun*, 21 March 1942.

Buffalo Courier-Express, 19 March 1942.

Burnet, Mary Q. *Art and Artists of Indiana*. New York City: The Century Company, 1921.

California Art & Architecture (May 1935).

California Southland 108 (December 1928).

City of Buffalo Directory (1904-10).

Contemporary Artists of San Diego. San Diego: published privately, c. 1929.

Corcoran Gallery of Art, Washington, D.C. *A Catalogue of the Collection of American Paintings in the Corcoran Gallery of Art*, 1973.

Coran, James L. and Walter A. Nelson-Rees. *If Pictures Could Talk*. San Francisco: Toppan Printing Co., 1989.

Dwyer, Eileen. *Argus* (April 1929).

Fine Arts Gallery, San Diego. *Reproductions of Four Paintings by Charles Reiffel*, June 1942.

"First Annual All-California Art Exhibition," *Los Angeles Art Bulletin* 15 May-15 June 1934.

Heilbron, Carl H. (ed.). *History of San Diego County*. San Diego: Press Club, 1936.

Indianapolis Museum of Art. *Catalogue of American Painting*, 1970.

Indianapolis Star, 7 and 22 May 1938; 22 March, 9 August 1942.

Indianapolis Sunday Star, 6 February 1938; 15 March 1942.

Indianapolis Times, 16 March 1942.

International Studio 217-21 (May-June 1915); 229-32 (March-June 1916); 249-52 (November 1917-February 1918); 266 (March 1919).

Jackson, E. D. "The Art of Charles Reiffel," *Argus* (April 1929).

Kahle, Kathleen Morrison. San Diego *Sun*, 21 July 1934; 17 August 1935.

—. *San Diego Union*, 13 November 1927.

Kelley, Gerald. San Diego *Sun*, 20 August 1934.

Kerr, Harold. San Diego *Evening Tribune*, 28 January 1938; 23 January 1939.

Krane, Susan. *The Wayward Muse: A Historical Survey of Painting in Buffalo*. Buffalo, NY: Albright-Knox Gallery, 1987.

Krombach, Beatrice de Lack. San Diego *Sun*, 19 June [192?].

La Jolla Light, 10 October 1955.

Los Angeles Art News (1932).

Los Angeles Sunday Times, 3 July 1927.

Masterworks of California Impressionism: The Morton H. Fleischer Collection. Phoenix: Franchise Finance Corporation of America Publishing Co., 1986.

Messenger, Ivan. San Diego *Sun*, 4 July 1934.

M'Garvey, Julia T. *San Diego Union*, 24 May [1935?].

Millier, Arthur. *Argus* (July-August 1928).

Moure, Nancy D. W. *Artists Club and Exhibitions in Los Angeles Before 1930*. Los Angeles: published privately, 1974.

Petersen, Martin E. "Contemporary Artists of San Diego," *Journal of San Diego History* 16 (Fall 1970).

—. "Success at Mid-Life: Charles Reiffel, 1862-1942," *Journal of San Diego History* 31 (Winter 1985).

Poland, Reginald H. *Christian Science Monitor*, 3 July 1926.

—. *San Diego Union*, 17 January 1927; 28 November 1928; 1 January, 3 and 10 November 1929; 25 February, 9 and 18 November 1934.

San Diego *Evening Tribune*, [?] January 1926; 3 November 1928; 16 February 1929; 1, 8, 9, and 16 February 1930; 30 June, 7 July, 10 August, 3 and 9 November 1934; 12 January, 2, 23, and 25 February, 9 and 16 March, 8 June, 6 July, 10 and 17 August, 9 October, 16 November, 7 December 1935; 7 and 21 March, 16 May, 27 June, 4 July, 7 and 14 November 1936.

San Diego *Independent*, [?] May 1926.

San Diego *Sun*, 24 April, 13 July, 20 September 1926; 4 February, 29 September 1928; 31 January, 25 February 1929; 3 and 20 August, 31 October 1934; 5 January, 9 February, 2, 9, and 23 March, 4 and 25 May, 8 June, 17 August, 9 October, 2 December 1935; 4 January, 15 March, 12 July, 8 November 1936.

San Diego *Tribune-Sun*, 6 June 1942; 23 August 1943.

San Diego Union, 27 June, 15 August 1926; 16 December 1928; 21 and 31 January, 3 February, 6 October, 3, 4, 14, and 24 November 1929; 19 and 26 January, 23 February, 16 March 1930; 1 July, 2 and 10 August, 4 and 9 November 1934; 24 February, 28 April, 25 August, 10 November 1935; 27 June, 9 August, 18 October, 1 and 10 November 1936; 19 February 1938; 4 April, 17 November 1940; 16 and 31 March, 28 April, 6 June 1942.

Silvermine Guild of Artists, New Canaan, Connecticut. *Silvermine Past 1700-1920*, 8 October 1978.

Stevens, Esther Barney. San Diego *Evening Tribune*, 2 November 1929.

Titus, Aime B. *San Diego Magazine* (September 1927).

Westphal, Ruth (ed.). *Plein Air Painters of California: The Southland*. Irvine: Westphal Publishing, 1982.

General References

American Art Annual, vols XII, XXVI, XXVIII, XXX. Washington: American Federation of Arts, 1916, 1932, 1934.

Bénézit, E. *Dictionnaire critique et documentaire des peintres, sculpteurs, dessinateurs et graveurs*. Paris: Librairie Gründ, 1976 edition.

Coran, James L. and Walter A. Nelson-Rees. *If Pictures Could Talk*. San Francisco: Toppan Printing Company, 1989.

Dowdy, Doris Ostrander. *Artists of the American West*, 3 vols. Athens: Swallow Press/Ohio University Press, 1974, 1981, 1987.

Fielding, Mantle. *Dictionary of American Painters, Sculptors, and Engravers*. New York: Paul A. Struck, 1945.

Hughes, Edan Milton. *Artists in California 1786-1940*. San Francisco: Hughes Publishing Company, 1986.

Mallet, Daniel Trowbridge. *Mallet's Index of Artists*. New York, 1948.

McCall, Dewitt Clinton, III. *California Artists 1935 to 1956*. Bellflower, California: Jones and McCall Enterprises, 1981.

Moure, Nancy Dustin Hall. *Dictionary of Art and Artists in Southern California Before 1930*. Los Angeles: printed privately, 1975.

Samuels, Peggy and Harold. *The Illustrated Biographical Encyclopedia of Artists of the American West*. New York: Doubleday & Company Inc., 1976.

Smith, Ralph Clifton. *A Biographical Index of American Artists*. Charleston: Granier & Company, 1967.

Westphal. Ruth (ed.). *Plein Air Painters of California: The Southland*. Irvine, California: Westphal Publishing, 1982.

Who's Who in American Art, 1, 1936-7.

Young, William. *A Dictionary of American Artists, Sculptors, and Engravers*. Cambridge, Massachusetts: William Young Inc., 1968.

Lenders to the Exhibition

Private Collections:

Legler Benbough
The Braun Family
Mrs. Donald C. Burnham
Mrs. Albert Campbell
Dr. and Mrs. Albert A. Cutri
Mr. and Mrs. William R. Dick, Jr.
Bram and Sandra Dijkstra
Mr. and Mrs. Ferdinand T. Fletcher
Jane and Willis Fletcher
Dr. and Mrs. Robert Frickman
Les Gadau
Mrs. Carolynn Hawes
Mrs. Charles W. Hickey
Jon Icardo
W. F. and J. C. Jones Family
Robert and Arlene Kesler
Paul and Reta Kress
James Martin
James and Estelle Milch
Mr. and Mrs. David M. Miller
Roy and Adele Nelson
Mr. and Mrs. Thomas Page
Mr. and Mrs. James Polak
Mr. and Mrs. David E. Porter
Mrs. Alice King Psaute
Mr. and Mrs. William B. Rick
Ray Rosenberg
Mr. and Mrs. Robert P. Sedlock, Jr.
Thomas W. Sefton Collection
Dr. and Mrs. Richard A. Smith
Dan Stephen
Christine Ukrainec
Mrs. Meg Woolman-Bowman

Other Collections:

C. Klein Company Corporation
City of San Diego
Fieldstone Company
First Unitarian Church of San Diego
Orr's Gallery
San Diego Historical Society
San Diego Museum of Art
Union Bank of San Francisco